Global Art and the Cold War

Published in 2018
by Laurence King Publishing Ltd
361–373 City Road
London EC1V 1LR
Tel +44 20 7841 6900
Fax +44 20 7841 6910
E enquiries@laurenceking.com
www.laurenceking.com

A catalog record for this book is
available from the British Library.

ISBN 978 1 78627 229 4
Designed by Nicolas Franck Pauly
Printed in Hong Kong

Acknowledgments

I must begin by thanking Tim Barringer for the invitation to write this book; he has long provided me with models of scholarship, academic generosity, and conviviality. At Laurence King, I am grateful to Kara Hattersley-Smith for her initial editorial guidance and enthusiasm for the project. Donald Dinwiddie helped transform an overlong manuscript into a streamlined book, doing so with grace, efficiency, and good humor. Giulia Hetherington did an excellent job sourcing the book's images, some of which required significant detective work and negotiation skills. Angela Koo's copy-editing made the text infinitely clearer, and Nicolas Franck Pauly's elegant design is striking and modern. The final physical product shows the diligence and attention of Simon Walsh, who led the book through production. Outside of Laurence King, I also would like to thank Jim Gibbons for his thorough review of the manuscript at a crucial stage in the project.

A Reynolds Leave from my teaching duties in the Department of Art at Wake Forest University for the teaching year of 2015–16 was crucial to my completion of the book, and a Summer Writing Grant in 2017 from the Wake Forest University Humanities Institute provided support at the very end of the writing process. Former students were involved as well: Caroline Perkins did an excellent job assisting me with research during the academic year 2015–16, and Reece Guida also helped out in the summer of 2017. I am also grateful for supportive friends and colleagues in my home department and throughout the university, especially Paul Bright and Leigh Ann Hallberg for their friendship and letting me use their downtown studio as an office during my leave, and David Lubin for our productive discussions about how to conceptualize the project, and reminders to find the art in art-historical writing.

Outside of Wake Forest, emails and conversations with numerous friends, especially Romy Golan, Jennifer Josten, and Rob Slifkin, have added much to the book. David Joselit, Christine Mehring, and Alex Nemerov continue to shape my thinking about art. I am also grateful to Ksenia Nouril for the invitation to speak at the opening of her exhibition on Soviet art at the Zimmerli Museum at Rutgers University, where I presented some material from Chapter 2. The entire curatorial staff at the Zimmerli, especially Jane Sharp, have been great resources.

Friends, including those listed above, and my family proved important during this project, as I experienced some major health problems while writing. The Dean's office at Wake Forest made things as easy as possible, and many local friends dropped off meals to help out. Additionally, weekly dinners with Susan Harlan were key to my recovery and sanity. Special mention must also go to my parents John and Karen Curley, sister Jennifer Dearle, and in-laws Jack and Mary O'Neill whose endless support and love anchored me during this difficult period.

Morna O'Neill is many things all at once – best friend, shrewd editor, art historical interlocutor, and amazing wife. She continues to inspire me with her brilliance, generosity, and love. Our twin boys were born just months before I began this project. While the prolonged negotiations over toys or food sometimes remind me of the Cold War, Elliot and Theodore continue to be an endless source of love, joy, and wonder. It's impossible not to smile in their presence. I dedicate this book to them.

Global Art and
the Cold War

John J. Curley

Laurence King Publishing

Global Perspectives series

Contents

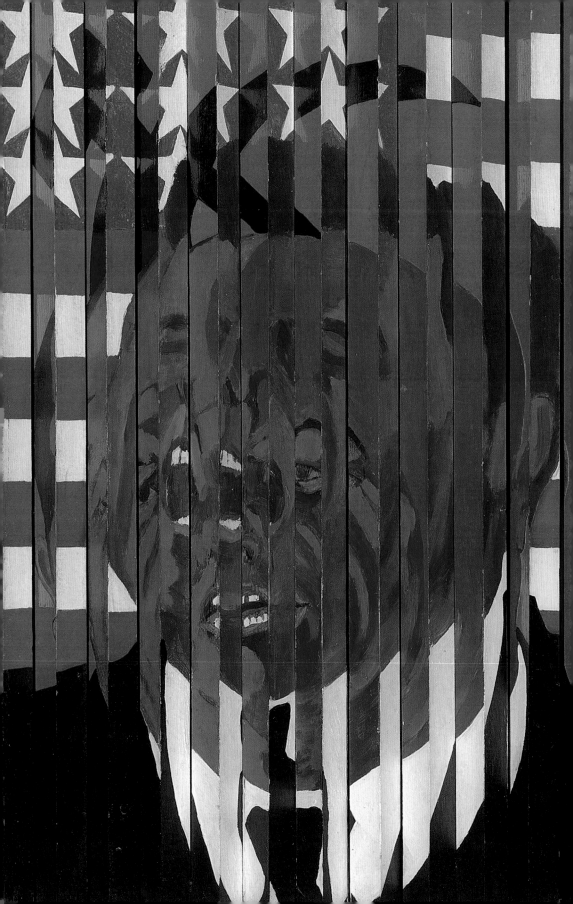

The Cold War as a Way of Seeing

A painter introduced one of the Cold War's most enduring, powerful, and popular metaphors: the Iron Curtain. Winston Churchill—a passionate and prolific amateur painter in addition to his role as British prime minister and international statesman—invoked the term in 1946, in a speech given in Missouri, with American president Harry Truman in attendance:

> *...an iron curtain has descended across the continent. Behind that line lie all the capitals of the ancient states of Central and Eastern Europe. ... [A]ll are subject, in one form or another, not only to Soviet influence but to a very high and, in many cases, increasing measure of control from Moscow.*

Churchill's Iron Curtain provided a vivid image of a fiercely divided Europe after World War II. To the east, in countries like Hungary, Poland, Czechoslovakia, and what was soon to become East Germany, the Soviets imposed communist rule. And in the Western half of Europe, the nations of France, Great Britain, Italy, and the future West Germany aligned themselves with the United States and at least the basics of its capitalist economic system. For more than 40 years, Churchill's provocative image defined the Cold War's binary logic, even encompassing the world beyond Europe, save for those nations that attempted to remain neutral. In the popular imagination, people and goods passed through the barrier only with great difficulty. It is not hard to imagine how

Gerald Laing
Souvenir (of the Cuban Missile Crisis Oct 16-28 1962), 1962
(detail, see page 11).

7

Churchill's Iron Curtain became conflated with the Berlin Wall when it was erected in 1961. Metaphor became reality.

While the global situation was more complicated, this binary conception of the world nevertheless wielded significant historical consequences. The Cold War is the central story of the second half of the twentieth century—essential for explaining what happened around the world and why. Even disputes that, at their start, had little or nothing to do with the Cold War, morphed into important battlegrounds for the conflict. But what was the Cold War? Put very simply, it was the ideological battle between the United States and the Soviet Union (and their respective allies) that started at the end of World War II in 1945 and ended with the fall of the Berlin Wall in 1989 and the subsequent dissolution of the Soviet Bloc. While both nations had fought together in World War II to defeat Nazi Germany, each rushed in to fill the vacuum left by Hitler's defeat and the resulting political upheaval, and did so with their own interests in mind. Who would control the reconstruction of postwar Europe? Would it be rebuilt to reflect American-style democratic capitalism or Soviet-style socialism? These questions lay at the heart of the Cold War's origins, and they also carried great consequences beyond the continent, as Japan's defeat in World War II left its own void in Asia, and Western powers became unable or unwilling to maintain their hold on colonies or client states in Asia, Latin America, and Africa. In the eyes of the two superpowers, other nations—whether new or old—needed to choose sides in the Cold War.

The conflict intensified by 1948 and remained fierce until its end, though a period in the 1970s, known as détente, saw the renewal of diplomatic relations and the signing of agreements between Cold War adversaries. Even a short list of major events of the Cold War can bring back a sense of the period's anxiety and tension: the Korean War in the early 1950s; Soviet invasions to quell democratic protests in East Berlin (1953), Budapest (1956), and Prague (1968); the failed CIA-orchestrated invasion of Cuba known as the Bay of Pigs in 1961; successful CIA-backed regime changes in Iran (1953), Guatemala (1954), Congo (1960), as well as at least condoning others such as Brazil (1964) and Chile (1973); the Cuban Missile Crisis in 1962; the Vietnam War, which dominated the mid- to late 1960s, as well as other

postcolonial conflicts subsumed by the Cold War; and the Soviet invasion of Afghanistan in 1979. Looming over all these events, as well as more "minor" ones, was the threat of nuclear apocalypse. By 1949 both sides had the Bomb, and by the mid-1960s possessed sufficient weaponry to end the world many times over. Thus even small flare-ups evoked existential questions of life and death on the scale of the human species itself.

The Cold War pitted two so-called "master narratives" against each other. Did capitalism, with its discourses of private property and individual choice, represent the highest form of human organization? Or was communism—which had denounced class-based hierarchies and the profit motive—the more evolved philosophy? Capitalism and communism have common roots. Both are products of Western modernization, and both rely on utopian notions: The former promises individual choice and the possibility that anybody can become wealthy, and the latter claims equality, meaningful labor, and collective life without greed as its goals. In this sense, the Cold War was waged over the meaning of "progress," and was as much a semantic battle over language and the interpretation of the world, as it was a political–military struggle. And when, by the end of the 1960s, the illusions of both utopian visions seemed to be violated, whether by Soviet tanks in the streets of Prague, or American bombs in Vietnam, the very terms of the Cold War's existence came under interrogation. The conflict's empty rhetoric and false oppositions—abundantly clear by the end of 1968—encouraged advanced thinkers, such as Jacques Derrida, to suggest the relativity of all ideologies and the illusionary nature of binaries. Put simply, the Cold War helped spur postmodernism, as the art of the 1970s and beyond demonstrates.

As the Cold War progressed, countries well beyond Europe were forced to engage, wittingly or unwittingly, with this binary imposed by the two global superpowers. Some chose sides based on ideology or more practical concerns such as the promise of economic aid; others had the decision made for them, whether through military action from outside or through internal coups secretly engineered by American or Soviet officials. Countries that attempted to remain neutral often found themselves drawn into Cold War political battles despite their best efforts. The doctrine of containment, formulated by the American diplomat

George Kennan at the start of the Cold War, reiterated Churchill's Iron Curtain metaphor. Sending a long cable from Moscow in 1946, Kennan advocated preventing further Soviet territorial and ideological advances through containment: Communism, not unlike a disease, could be controlled by quarantine. This idea loosely guided American foreign policy for the length of the conflict. With its connotations of strict demarcation, the term became a metaphor for the Cold War more broadly—a world divided into two distinct camps with no overlap.

The Cold War's binary rhetoric failed, however, to describe reality accurately: Local situations demanded more nuanced and specific understandings. For example, in the Vietnam War, many soldiers in the communist north were fighting for national independence and self-determination, not for the ideological reasons usually ascribed to the conflict. Initially, the Vietnamese communist leader Ho Chi Minh even looked to the United States as a model for its own anti-colonial revolution, identifying Americans as the "guardians and champions of world justice" in a letter to President Harry Truman in 1946. Such anti-colonial sentiments, not Cold War beliefs, likewise fueled many Afghan "freedom fighters" in their war against the Soviets in the 1980s. Many of these anti-Soviet soldiers soon also became anti-American. In 1988, some of them founded Al-Qaeda, the primary enemy of the United States in the years before and following the terrorist attacks on September 11, 2001—thus confirming divergent reasons for wanting the Soviet presence out of Afghanistan. The Cold War was thus a way of seeing the world. This ideological lens transformed complex constellations of global and local events into a manageable framework: Soviet communism versus American capitalism. The *visual* qualities suggested by the phrase "ideological blindness"—a phrase that came into popular use at the very start of the Cold War, describing how rigid political beliefs can twist perception and interpretation in irrational ways—leads to a consideration of the importance of images, specifically art, to the conflict.

The British Pop artist Gerald Laing addressed the very issue of ideological blindness in an important painting from late 1962 entitled *Souvenir (of the Cuban Missile Crisis Oct 16–28 1962)*, featuring both protagonists of the global showdown over the presence of Soviet missiles in Cuba: John Kennedy and Nikita

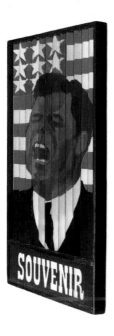
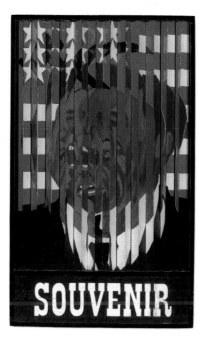
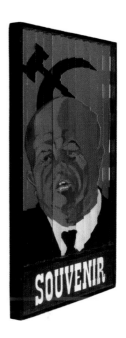

Khrushchev. Because the work is painted on angled vertical slats, viewers see an image of Kennedy and an American flag when they are to its right, but from its left they encounter Khrushchev in front of the Soviet standard. Both representations take the form of simplified political propaganda, more reminiscent of caricatures than carefully studied portraits. In addition to mapping Cold War sides onto physical space, determined by the viewer's position in the gallery, *Souvenir* dramatizes how viewers can interpret the same painting in radically different ways: Once one understands how the painting works, one can *choose* to see Kennedy or Khrushchev.

However, we should also consider the effect of the painting when viewed straight-on, which is how most people typically approach a work hanging on a wall. From this perspective, the painting is literally pulled in two ideological directions, resulting in a jumbled mess—almost like a period television flickering between two stations. The painting suggests that the fiercely partisan view imposed by the Cold War is not a natural way to regard the world; individuals have to look at the painting

Gerald Laing
Souvenir (of the Cuban Missile Crisis Oct 16-28 1962), 1962, oil on wood, and oil on canvas laid over board, in the artist's painted frame, 25 x 15 in. (63.5 x 38.1 cm). Private Collection.

11

U-2 photograph of Cuba, October 14, 1962. Dino A. Brugioni Collection, the National Security Archive, Washington, D.C.

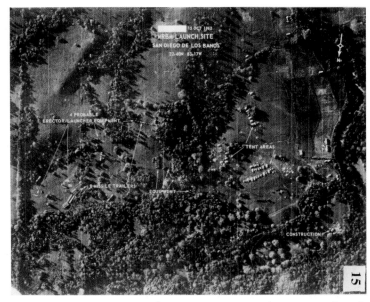

askance—stepping away from a more natural exercise of one's vision—to see an uncomplicated representation of the leaders of capitalism and communism. The painting's central view better represents the everyday experience of the Cold War, especially in countries other than the Soviet Union and the United States: a resistance to aligning oneself rigidly on either side of the conflict. Between the two poles, reality was contentious and scrambled. In 1957, just a few years before Laing painted his canvas, the French filmmaker Chris Marker made a similar point in his documentary *Letter from Siberia* when he repeated footage of road workers in a Siberian city three times, each with a different voice-over: one from a staunchly Soviet perspective, one from an American one, and the third straddled between the two. Marker's film exposes the way that even "objective" imagery—whether in photographs or films—can be twisted by narration or captions.

One of the twentieth century's most consequential photographs can help clarify the stakes of Laing's painting in terms of its relation to the Cuban Missile Crisis, as referenced in its title. At first glance, the high-altitude photograph—featuring a landscape with fields, trees, and roads—does not seem especially interesting, at least not without captions to explain or contextualize it. This photograph, however—taken by an American U-2 spy plane high above communist Cuba on October 14, 1962—proved to be a crucial piece of evidence. Analysts at the

National Photographic Interpretation Center in Washington, D.C., examining miles of photo transparencies with visual aids, found important needles in a giant intelligence haystack: the subtle visual signatures of offensive Soviet missile systems. This photograph helped establish that the Soviets were secretly installing nuclear weapons in Cuba.

U.S. government officials needed this image to be perceived as a truthful document across the world, and soon made it, as well as other similar photos, public. But the picture itself, especially when stripped of the captions supplied by professional interpreters, proves nothing to untrained eyes. When first shown this image and others at the White House, President Kennedy suggested that one of the sites in question looked like a "football field," not a missile site. A high-ranking CIA official even admitted that any non-specialist would have to take it "on faith" that the image showed what its captions said it did. So while this picture helped prove to the world (and the United Nations) the existence of offensive missiles in Cuba, it is shocking that this nearly abstract photograph—and other similar examples—were never seriously questioned publicly. The perceived certainty of the image's captions suppressed its pictorial ambiguity.

In the early years of the Cold War, the art historian E. H. Gombrich remarked that what viewers bring to an image—including their visual training and political ideology—helps dictate how that image is interpreted. Gombrich called this automatic "completion" by the viewer, "the beholder's share." In terms of the Cold War, a Soviet viewer would more likely be skeptical about the validity of images taken over Cuba than an American would, for example. Ideology had always guided the interpretation of images, but perhaps never yet on the Cold War's systematic, global scale. While an extreme case, this aerial surveillance photo highlights not only a missile crisis but also a broader *image* crisis in the Cold War. Important examples were not only ambiguous, but were also interpreted through ideological filters as "fact."

When discussing art, Winston Churchill seems to have understood the fluid nature of images. While certainly not an avant-garde painter, he viewed painting as an activity where the quirks and ambiguities of vision could be explored. He addresses this notion in *Painting as a Pastime*, an essay from the early 1920s, published as a stand-alone book soon after his

Iron Curtain speech. In a remarkable passage that Gombrich also discussed in his book *Art and Illusion* (1960), Churchill describes painting in conspiratorial terms:

> *The canvas receives a message dispatched usually a few seconds before from the natural object. But it has come through a post office en route. It has been transmitted in code. It has been turned from light into paint. It reaches the canvas [as] a cryptogram. Not until it has been placed in its correct relation to everything else that is on the canvas can it be deciphered, is its meaning apparent, is it translated once again from mere pigment into light.*

If Churchill's view of the geopolitical world was bound by the absolute nature of the emerging Cold War binary, then his understanding of painting was decidedly more nuanced. His painter is certain neither about representation nor the stability of the visual world; instead he or she resembles a spy who waits for enigmatic letters to arrive, decodes these "cryptograms," then translates them into a specific language of painting. A consideration of Churchill's words on painting, in tandem with his Iron Curtain speech, reveals a complex fluidity lurking just beneath his image of a simple binary world. And by theorizing the medium via a language of image transmission (images are "dispatched" and "come through a post office") he relates painting to other image cultures that were used propagandistically on both sides during the Cold War: press photographs, television screens, and satellite images. Images—even those that are presented as stable and factual—can be flexible, contradictory, and changeable. Or to use the popular language of the Cold War, images—including works of art—can be *spies* that hide secrets in plain sight. It may be no coincidence that one of the most infamous Soviet spies in this period was the renowned British art historian and Queen's curator Anthony Blunt. Blunt's activities included serving as the courier for a key Soviet asset inside the British secret service, and probably alerting Britain's most notorious double agent of the period, Kim Philby, of his imminent arrest, allowing Philby to escape to Moscow from Beirut. Blunt's understanding of the mutability of images—how paintings can house and manage contradictions,

ideological and otherwise—might have provided a model of deception that allowed him to work undetected for years.

Churchill's dual existence as a politician and a committed amateur painter is a fitting way to introduce a book about art and politics during the Cold War. (Interestingly, American president Dwight Eisenhower, in office between 1953 and 1961, was also an avid painter of landscapes.) Despite the apparent certainty of Churchill's anti-communist political position—which divided the world between absolute good and absolute evil—his theory of art works against such binary conviction. And yet Churchill's apparent contradiction was consistent with the functioning of the conflict. Cold War factions required certainty in their messages, and yet such clarity, whether visual or ideological, was impossible to achieve. Considering art's dual role in both constructing and dismantling the illusions of the Cold War, this book will present works as not only reflecting a binary reality, but as helping shape, wage, and resist the conflict.

Some thinkers from the period understood the conflict in such a way—as one fought at the level of representation. As media theorist Marshall McLuhan wrote in 1964, the Cold War was "really an electric battle of information and images." Because there were no direct, sustained military confrontations between the United States and the Soviets (other than proxy wars like Vietnam and Afghanistan), the conflict was largely waged on the level of intelligence gathering and media representations—propagandistic efforts from both sides to convince the world, and perhaps themselves, of the correctness and historical inevitability of their respective paths. Even nuclear deterrence was predicated on conveying a credible *image* of nuclear strength and was not necessarily dependent on the actual number of weapons. And things were rarely what they seemed in this battle of images, as Cold War historian John Lewis Gaddis suggested when he compared the conflict to a theater in which "distinctions between illusions and reality were not always obvious." Pioneering Cold War art historian Serge Guilbaut agreed with such an assessment, comparing the conflict to an "almost Hollywood super-production." While some art objects served ideological ends, many works of art from the period pulled back the Iron Curtain to expose the limits and dangers of the Cold War's superficial and overly simple binaries.

Against Modernism and the Cold War

Recent historians such as Heonik Kwon have provocatively argued against the very existence of the "Cold War," or at least against the idea that the conflict was a global, all-encompassing struggle that, on its own, determined the fate of millions around the world. Not least, he points out that the Cold War was in no way "cold" for the millions who died in conflicts in Vietnam, Korea, Guatemala, and elsewhere. While the idea of the Cold War was globally significant, what the conflict actually meant on the ground varied significantly across distinct locales. Cold War historians, in Kwon's estimation, must consider not only the Western (American and European) "centers" of the conflict, but also the distinct and messy stories that emerge from the "peripheries" of Asia, Latin America, and Africa.

Kwon's definition of the Cold War aligns with the changing understanding of artistic modernism during these same years in a useful way. Both the Cold War and modernism were viewed as monolithic, international structures—originating from centers and expanding to peripheries—that could be used to interpret global events, whether civil wars or artistic practices. In other words, as historians have begun to recognize the importance of specific local contexts in relation to events once ascribed purely to the global struggle between capitalism and communism, art historians likewise have bristled against universal notions of postwar modernism, focusing instead on the ways that site-specific narratives both dovetail and work against Western models.

This book reflects such dual logic. First, its interrogation of canonical artists demonstrates how major art movements such as Abstract Expressionism, Pop art, Conceptualism, and Neo-Expressionism both shaped and were shaped by the evolving Cold War. The formation of this particular Western artistic canon—as well as its Soviet Bloc counterpart—relied upon the very structures of the conflict. The story of postwar art and the Cold War are mutually interdependent; when studied together, both are illuminated. It is no coincidence, either, that many of the artists whose work engaged with the conflict were men; the Cold War's rhetoric—dependent upon mythologies of military strength, ideological certainty, and impenetrable boundaries—certainly played into fantasies of masculine power. While this book discusses a number of women artists from both ideological

sides, the large number of men considered reflects the sexism of both the culture of the Cold War and dominant accounts of modernism.

Second, this book complicates the standard artistic narrative by integrating other regions and voices into the story—forging dialogues across Cold War sides and discussing certain Asian, African, and Latin American works of art. This position likewise applies to art from the Eastern Bloc (the Soviet Union, Hungary, Czechoslovakia, East Germany, and so on), which has been, until recently, ignored in standard accounts of postwar practices. These alternative stories reveal that the dominant narrative of modernism itself—like the Cold War—was a Western construction, complete with all of the prejudices of such a position. Many of these hybrid works from Cold War peripheries engage both the international language of modernism and site-specific traditions of their particular nation of origin, thus articulating a conflicted identity: one that simultaneously expresses some degree of transnational modernity, but also a nationalism that can counter the Cold War imperialism of the United States or the Soviet Union.

The Cold War was an inescapable force that wielded varying degrees of influence on the production and reception of art objects around the world. Since the conflict was a battle between two opposed models for modernity—capitalism and communism—any art practice that positioned itself as "modern" ostensibly engaged with the conflict. Some artworks directly addressed the iconography and key figures of the Cold War, others were drafted into the conflict without the consent of their makers, and others still embodied some aspect of the conflict in their very material or construction. Of course, certain art objects have more to do with the Cold War than others, and it is these that occupy the pages that follow, constituting a selection of works that demonstrates the importance of art to any consideration of this important historical period.

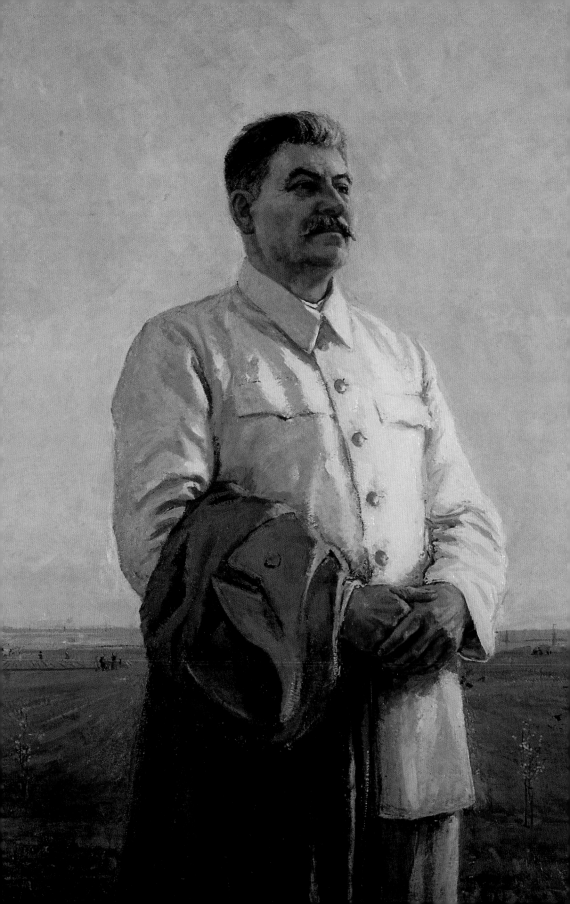

Marking Territory: American Abstraction, Soviet Figuration, and the Early Cold War

Art history and the Cold War were meant for each other: both depend upon comparison. Art historians, at least since the pioneering work of Heinrich Wölfflin, often discuss works in pairs, so that the formal qualities of a movement, national school, or individual artist can emerge through the contrasts or affinities revealed by such a dual focus. The modern discipline of art history has long been organized through slide comparisons: the rigid organization of Neoclassical paintings have been set against the more dynamic compositions associated with Romanticism, for example. Popular understandings of the Cold War, then and now, likewise depend on a slide comparison of sorts—American capitalism versus Soviet communism—that reveals, and to some extent creates, sharp contrasts between the two ideologies. As a result, the art history of the Cold War has often been reduced to a specific kind of comparison: American abstraction versus Soviet figuration. A version of this opposition, using as its examples two paintings from around 1950, will set the stage for this chapter: Jackson Pollock's *Autumn Rhythm* (1950) versus the Soviet canvas *Youth of the World—for Peace* (1951), painted by a group of four artists (FIGS. 1.1 and 1.2). These works demonstrate the respective artistic styles of the United States and the Soviet Union during the early years of the conflict: Abstract Expressionism and Socialist Realism.

The monumental scale of each work—Pollock's canvas measures more than 17 feet (5.2 meters) across and *Youth of the World—for Peace* nearly 20 feet (6.1 meters)—implies that both

Fedor S. Shurpin
The Morning of our Native Land, 1948 (detail).
See fig 1.10

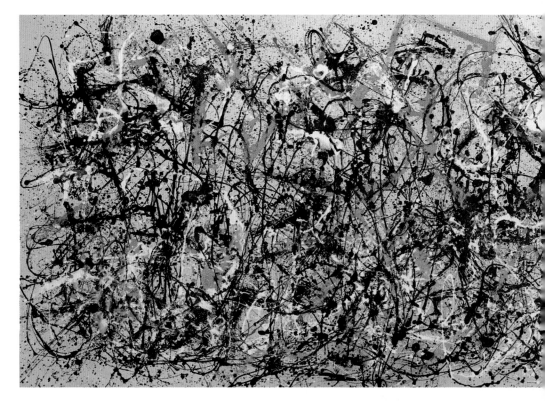

Fig. 1.1
Jackson Pollock
*Autumn Rhythm (Number
30)*, 1950, enamel on
canvas, 105 x 207 in.
(266.7 x 525.8 cm).
Metropolitan Museum of
Art, New York.

are important artistic statements. But what did each say to its Cold War audiences? It depended who was looking. *Autumn Rhythm*, according to communist critics, was the equivalent of meaningless scribble, demonstrating the decadence and anti-humanist values of capitalism. For those in the West, the canvas could represent the culmination of modern art's chain of artistic innovations, an emblem of individual autonomy and liberty. The reception of *Youth of the World—for Peace* was also polarized along Cold War lines; it was viewed either as supporting a murderous regime through a regressive, figurative style, or as epitomizing an art painted for and by the working classes as a means to teach and inspire. When critics conjoined art and the Cold War in the conflict's first two decades, they often discussed American abstraction and Soviet figuration as ideological opposites, judging one to be "good" and the other "bad"—both politically and artistically. Each style wielded significant ideological power.

Youth of the World—for Peace certainly looks like propaganda. Scores of happy, enthusiastic children and young adults march in a parade, with one holding aloft a large portrait of Josef Stalin

in the front, off center to the left. The work's title reveals the ostensible aim of the depicted gathering—vigorous support for world peace. In the late 1940s, the Soviets launched a sustained campaign that touted their desire for global accord, in opposition to what they saw as the aggressive and militaristic policies of the United States and its Western allies. (In truth, the peace campaign was largely a smokescreen obscuring Soviet militarization—including its development of nuclear weapons.) The flags in the painting are also significant. The presence of examples from communist nations—the Soviet Union and China—would seem obvious, but the artists also picture French, British, Italian, and even American flags in the parade. The painting thus presents a fantasy of a Soviet-led international consensus, a truly popular world movement that includes young people from the United States and Western Europe. According to the logic of the canvas, citizens from both sides of the Iron Curtain want peace, but the corporate titans who rule the Western capitalist states (who need imperialism to fuel industrial growth) do not. It is unclear if such a parade actually took place, but in many ways this is beside the point: the artists, whose crisp style has been influenced by the look of photography, *paint* the event into existence. Such dreamworlds are the stuff of Socialist Realism, which dictated that artists should paint not how things actually are, but how they should be.

A partisan understanding of *Autumn Rhythm* is not as readily available, but the painting, when seen through the filter of the Cold War at midcentury, possesses a powerful ideological charge. Pollock's canvas came to emblematize a specifically American freedom of expression. By this account, Pollock's marks—made by dripping and dribbling paint—are not dictated by outside forces like the state, but governed by his individual actions alone. Pollock's upbringing in Cody, Wyoming—a city named after the cowboy Buffalo Bill Cody—only emphasized such maverick connotations. While the canvas demonstrates the importance of

expressive individuality, it also suggests that this individuality has been tempered and managed. Pollock's process could have led to pictorial chaos, but the result is a balanced picture made up of carefully interlaced visual elements. Note, for instance, how Pollock takes care to leave significant portions of his canvas unpainted, especially around its corners and edges. *Autumn Rhythm* is evidence of an autonomous artist at work, who is expressing his autonomy in part by using the rules and conventions of art to govern his unruly process. The painting's massive expanse of canvas and copious use of materials register its importance and, in a Cold War context, can appear to celebrate American individualism. And during the early years of the conflict, such ideas were superficially linked to notions of American democracy.

Another difference between the works is key. *Youth of the World—for Peace* actively attempts to negate a crucial principle guiding Pollock: the bourgeois notion of the individual artist working alone in his or her studio. This painting, like many postwar Socialist Realist works, was painted by a "brigade" of artists, here four practitioners working on a single large canvas. The individual wills of the painters are filtered through this small collective; no single artistic identity dominates the canvas. The painting's subject suggests a socialist dream of masses working together for a common aim, and its conditions of production emphasize the same exaltation of cooperative labor. *Autumn Rhythm* and *Youth of the World—for Peace* may have found themselves on opposing sides of the Cold War and its stark artistic divide of abstraction versus figuration, but both rely on the utopian notions of their respective political systems: expressive American individuality in the case of Pollock's painting, or the greater communal good achieved through overcoming individual desires in the Soviet work.

To make such a comparison, as was common during the early years of the Cold War, however, is to reduce artistic style to a manifestation of a specific ideology. This chapter will both explore and challenge this notion by recounting the emergence

and codification of Abstract Expressionism and Socialist Realism. The Cold War's rigid mindset shaped the interpretation and reception of art in both the United States and the Soviet Union, often simplifying the complex, varied histories of these two styles. And the tensions inherent in this artificial equation of art with ideology became especially clear when either style emerged in or was "exported" to countries on the periphery of the Cold War.

The years surrounding 1950—the primary ground of this chapter—witnessed the full emergence of the Cold War and some of its most contentious and paranoid moments. Josef Stalin and the American senator Joseph McCarthy helped create atmospheres of conspiracy and mistrust in their respective countries; mainland China went communist; West Berlin (controlled by the Americans, British and French) was cut off by the Soviets, prompting a rescue operation of food and supplies delivered via an American airlift; and the Korean War produced the young conflict's first significant body count, to name a few significant headlines from the period. During these early years of the Cold War, the ideological fervor on both sides reached fever pitch, out of which emerged the conflict's sharpest artistic distinctions.

Fig. 1.2
Lithographic reproduction in *La Femme Soviétique*, 1952 of David D. Gabitashvili, Konstantin M. Makharadze, Georgi K. Totibadze, and Aleksei I. Vepkhvadze *Youth of the World-for Peace*, 1951, oil on canvas, 118 x 236 in. (300 x 600 cm). Formerly collection of the Lenin Museum, Tbilisi.

The Socialist Roots of American Abstraction

A comparison of two paintings by Mark Rothko, separated by 11 years, tells another story about art during the Cold War—one that dismantles certain assumptions about American abstract art. In *Subway Scene* from 1938, Rothko depicts a common urban locale, a subway station (FIG. 1.3). While vaguely expressionist in its loose handling of paint, this unmistakably figurative canvas is committed to depicting a social world. In 1949, Rothko painted *No. 3/No. 13*, what appears to be a fully abstract canvas exploring the formal relationships among stacked forms and layered colors (see FIG. 1.5). Other American painters associated with Abstract Expressionism—Pollock, Franz Kline, and Willem de Kooning, for instance—transformed their work in similar ways during this period. A work like *Subway Scene* makes the rise of Abstract Expressionism and its subsequent global prominence seem far from inevitable. Figurative art occupied the main stage of American artistic practice during the 1930s, and many artists, like Rothko, loosely aligned their work with international communism.

Fig. 1.3
Mark Rothko
Subway Scene [Entrance to Subway], 1938, oil on canvas, 34 x 46¼ in. (86.4 x 117.5 cm). Collection Kate Rothko Prizel.

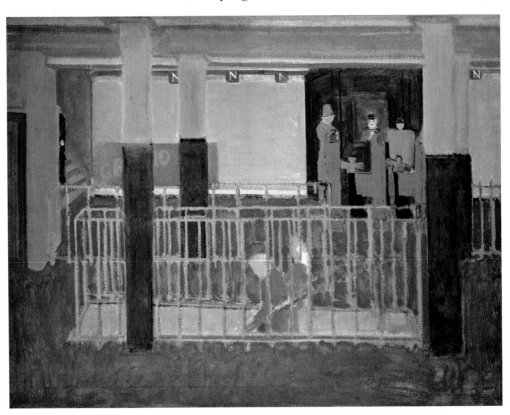

The story of the 1930s in America is, inevitably, the story of the Great Depression. During this period, many intellectuals and politicians were exploring socialism as an alternative to capitalism. If capitalism and its abuses had caused such destitution and poverty, why remain committed to such a system? The programs of President Franklin Roosevelt's New Deal provided a social safety net for those in need and attempted to level the economic playing field between rich and poor. Artists even produced murals and documentary photographs with ample government support during these years. The flourishing of leftist sympathies spurred progressive American artists to engage with the Soviet philosophy that art should deal with issues of class and other social inequities, and be understood by a wide public. The prominent art historian Meyer Schapiro, for example, advocated for such a committed aesthetic in the mid-1930s, condemning abstract art as a means for the wealthy elite to escape political concerns.

The most visible examples of such socially engaged art include Dorothea Lange's photographs, which documented and gave voice to the Depression's crippling poverty; Ben Shahn's prints and paintings, which tackled topical issues until the artist's death in 1969; and the murals by Mexican artists such as Diego Rivera, David Alfaro Siqueiros, and José Clemente Orozco, who were well known in the United States. The muralists proved an especially important example for politically engaged artists, as their modernist styles and ideological content forged a distinct artistic language for the newly socialist government of Mexico. Murals—especially those housed in national buildings—appealed to progressive artists, as their public ownership resisted the luxury status and aristocratic perceptions of easel painting. These Mexican artists also received commissions in America; Jackson Pollock, for instance, traveled to see Orozco's mural *Prometheus* (1930) at Pomona College in California. This fresco fuses a modernist conception of loosely cubist space with a socialist allegory. After all, Prometheus stole fire from the wealthy and all-powerful gods and gave it to the people. The form of the picture reiterates its content: Prometheus attempts to liberate himself from the confines of the flat pictorial space, pushing against the mural's upper edge. While Orozco relies on classical mythology to make his political point, *Prometheus* was viewed as art for the masses in both form and content.

Although more prosaic, Rothko's *Subway Scene* also engages in politically progressive figuration, depicting the isolation of the daily commute in New York. A solitary pair walks through the barrier of the subway's turnstiles; another two individuals pass each other on the stairwell down to the train platform. While Rothko employs a self-consciously sketchy style—the blue and yellow pillars seem to predict his later floating rectangles—he is committed to conveying some idea of a working-class mode of transport. He is practicing an urban realism—a world of shared social space and experience—not the seemingly apolitical realm of abstraction.

Rothko took steps to align his art with progressive politics. Around 1936, he joined the American Artists' Congress (AAC), a group of artists associated with the Popular Front that advocated a realist aesthetic and an engagement with topical issues. Popular Front groups emerged internationally in the 1930s under the aegis of the Soviet Union as an attempt to forge a broadly communist coalition against fascism in Europe, especially Nazi Germany and Franco's Spain. While Rothko's paintings were not explicitly ideological in a Popular Front sense, he supported the aims of the AAC. Other eventual Abstract Expressionist artists were politically active at this time, too: Jackson Pollock, for instance, worked on an anti-capitalist float for a May Day parade in 1936. Considering the hardships of the Great Depression and the disturbing growth of fascism in Europe, many American artists in the 1930s regarded socialism as a viable and, indeed, necessary alternative to the capitalist and fascist systems wreaking so much havoc in the West.

In just a few years, however, Rothko and other left-leaning artists would largely abandon politically engaged realism. Rothko resigned from the AAC in 1940 and began painting more fantastical pictures. Initially, these featured thickly painted fragments of strange mythological creatures, but by the mid-1940s, his paintings had become wispy, nearly abstract dreamscapes such as *Vessels of Magic* (FIG. 1.4). What caused Rothko's shift from realism to near abstraction? First, artists began to understand the violent and repressive reality of Stalin's Soviet Union and thus the lie of its supposed socialist utopia; the violent purges and show-trials of 1936 to 1938, which aimed to eliminate any hint of dissention, were widely reported in the American press.

Fig. 1.4
Mark Rothko
Vessels of Magic, 1946,
watercolor on paper,
38¾ x 25¼ in. (98.4
x 65.4 cm). Brooklyn
Museum, New York.

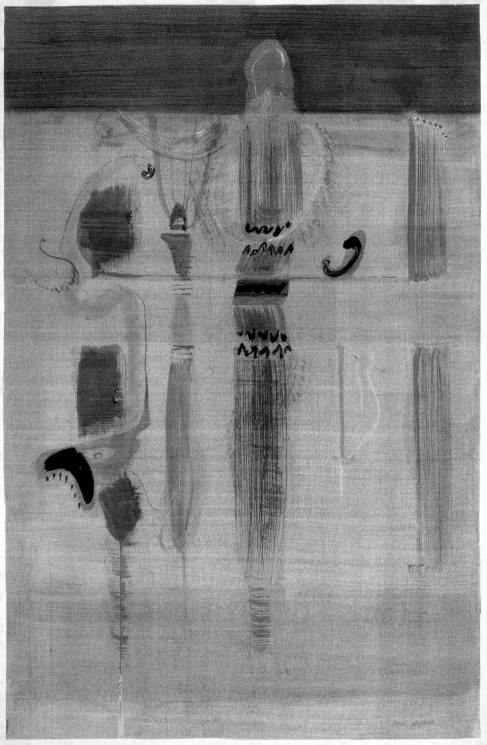

The decisive end of the Popular Front, however, came with the Soviet–Nazi non-aggression pact, signed in 1939. While it did not make the two nations allies, this agreement (broken by Hitler in 1941) nevertheless conjoined the ideological opposites of communism and fascism in some sense. As a result, socially inflected realism became difficult to justify in this confused political climate. (Hitler's mandate for a classically inspired artistic practice also damaged the prospects for figurative painting at the time.) Artists like Rothko faced important questions: How could they register their political commitments in their work? How could they paint in a progressive manner that was not tied to Soviet or Nazi figuration?

For Rothko and other American artists, the initial answer was Surrealism, which provided artistic strategies for expressing the workings of the unconscious mind. Influenced by the writings of Sigmund Freud and Carl Jung, Surrealism developed and flourished in France in the 1920s. The concept of automatism was key to these artists—relinquishing conscious control over process in order to try to render the workings of the unconscious as an image. By the early 1940s many of Surrealism's most significant practitioners, including its founder André Breton and the painter Roberto Matta, had moved to New York to escape the war in Europe. With its allusions to primitivized totemic figures situated in an ambiguous space, Rothko's *Vessels of Magic* engages Surrealist ideas. Here the artist barely hangs onto figures, willing them into existence via an economy of means—the central form is constructed with just a few brushstrokes and a schematic head, for instance. In part, this work addresses how easily the mind can endow the barest of painted marks with a representational function; the brushstrokes retain their autonomy and suggest odd creatures. The title might even address painting's alchemical power—is the medium itself a magic, transformative vehicle?

This kind of nearly abstract Surrealism also allowed left-leaning artists to engage with "unorthodox" communism, as it was known at the time: models of communism outside the grip of Stalinism. In the 1930s, this alternative largely meant Trotskyism, named for Leon Trotsky, the former head of the Red Army who was exiled in 1929 for challenging Stalin and for his charge that the Soviet Union had traded true socialism for a cumbersome Stalinist bureaucracy. In an essay co-written with Breton in 1938,

Trotsky argued that art must be "free" in a revolutionary society, not chained to a prescribed style such as Socialist Realism. Demonstrating the changeable, free nature of a painted mark, *Vessels of Magic* perhaps fulfills Trotsky and Breton's mandates for a new, socialist modern art.

Trotsky's version of communism inspired the early writings of Clement Greenberg, who would soon become American abstract art's most influential critic. In two essays published in 1939 and 1940, Greenberg postulated a socialist theory of art and culture. He argued that only difficult ("avant-garde") art could resist the dual traps of totalitarian aesthetics and capitalist mass culture, both of which he branded "kitsch." Furthermore, avant-garde art embraced the specific qualities of its medium. If narrative was the purview of literature, and convincing space that of photography and film, then painting, by Greenberg's logic, needed to embrace those qualities that distinguish it from other media—namely its flatness. Paintings should not tell stories, in other words. On this basis, Rothko's *Vessels of Magic*—with its naked brushstrokes that emphasize the canvas's surface and defy understanding—would qualify as avant-garde. The work, for Greenberg, could thus construct an area of revolutionary freedom that resisted totalitarian and capitalist kitsch alike. This canvas might not look political, but in the context of the mid-1940s, it was. Although Greenberg would become a patriotic cold warrior in the 1950s, he espoused socialism in 1939. Thus, in a peculiar trajectory of history and ideas, his brand of Marxism helped generate the art that would eventually become the anti-Soviet emblems of American freedom and autonomy during the Cold War.

By the time Rothko painted *No. 3/No. 13* in 1949, he had jettisoned any explicit reference to the figure or to representational space (FIG. 1.5). Critics and viewers alike in the 1950s regarded his mature style of stacked and blurred rectangles—a formal arrangement he explored without exception for the rest of his life—as abstract. Gazing upon *No. 3/No. 13*, viewers found themselves enveloped in its painted void, fumbling for something to grasp visually—a feeling also engendered when standing in front of Pollock's flat tangle of lines. In this disconcerting process, they perhaps became aware of their own solitary bodies in front of the canvas. Put simply, Rothko provides a moment for viewers to be confronted with their own freedom—an aesthetic parallel

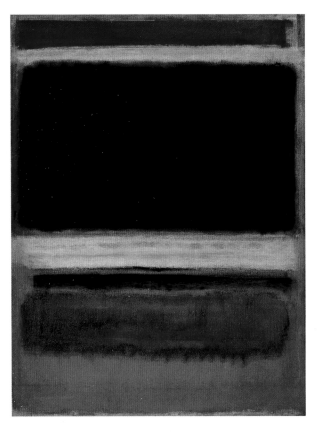

Fig. 1.5
Mark Rothko
No. 3/No. 13, 1949, oil
on canvas, 85⅜ x 65 in.
(216.5 x 164.8 cm).
Museum of Modern Art,
New York.

to standing on the edge of a cliff.

Rothko's own words about his paintings, however, contradict their seeming abstraction. To the confusion of both contemporary critics and viewers, he insisted that paintings like *No. 3/No. 13* were *not* abstract, especially since he viewed abstraction as a sterile, dehumanizing, and decorative mode. Scholars have discovered vestigial or obliterated figures within Rothko's mature paintings, but more interesting is his reliance on a rhetoric of realism reminiscent of the 1930s to describe his abstraction. For Rothko, if a painting did not have a "subject," it could all too easily be transformed into a meaningless emblem of wealth, as his Popular Front counterpart Meyer Schapiro argued in 1936. It is as if *No. 3/No. 13* employs a coded or secret figuration, to which the artist alone holds the key. Rothko's lifelong insistence on the "realism" of his abstract paintings subtly implies that these works had their origins in models of art and socialism popular in the 1930s.

Robert Motherwell marked the political commitments of that decade more explicitly in his most celebrated series of abstract paintings of the 1950s and 1960s: the *Elegies to the Spanish Republic*. He painted more than 100 canvases in this series between 1948 and 1967 (and made even more examples later)—all predominately black and white, deploying similar motifs of ovoid forms punctuated by strong verticals. With their large and expressive brushwork, scale, and resistance to figurative interpretation, these are "classic" Abstract Expressionist paintings—or at least have come to be understood as such. By referring to one of the important political commitments for artists associated with the Popular Front in the 1930s—the fight for

the Spanish Republic against General Franco and the fascists, which ended in defeat—Motherwell also reminds viewers of the loosely Marxist origins of American abstraction. And as "elegies," they suggest a sense of mourning, not just for the many victims of the conflict but also for a lost moment of possibility. They might even express the regret that what had once been a socialist model of abstraction had been transformed—forcibly—into a capitalist one at the dawn of the Cold War.

The Modernist Origins of Socialist Realism

Like Abstract Expressionism, the longer history of Soviet Socialist Realism complicates the binaries of art produced during the Cold War. Just as the politically engaged realism of the 1930s was a necessary precursor to American abstraction, any prehistory of Soviet Socialist Realism must consider radical art practices, including abstraction. Another comparison, this time with two works by the Soviet artist Gustav Klutsis, made 13 years apart, demonstrates a shift just as dramatic as Rothko's. In 1919, Klutsis assembled *Dynamic City* (FIG. 1.6)—a collage of drawn and painted elements, and in 1932, he designed *The Victory of Socialism in Our Country Is Guaranteed* (see FIG. 1.9)—a mass-produced poster based on a collage. The evolution here, from largely

Fig. 1.6
Gustav Klutsis
Dynamic City, 1919,
cut-and-pasted
photographs, paper,
aluminum foil, gouache,
and pencil on paper,
14⅘ x 10⅕ in. (37.6
x 25.8 cm). Latvian
National Museum of Art,
Riga.

abstract forms to propagandistic clarity, is striking for the opposite reasons that make Rothko's transformation so intriguing. As with art in the United States, Socialist Realism also carries the essence of its Cold War other—abstraction and avant-garde practices—in its bloodstream. While this shift occurred before the start of the Cold War, its repercussions and legacies continued until the conflict's end.

In *Dynamic City*, Klutsis demonstrates his interest in abstract paintings by Kazimir Malevich. In 1914, three years

before the October Revolution, Malevich was moving toward abstraction, having absorbed Picasso and Braque's Cubist deconstruction of the picture plane and the Italian Futurists' fragmented depictions of movement. In *Composition with the Mona Lisa* from 1914, Malevich combines text, shapes, and other marks to produce a loose grid of overlapping forms. But one detail especially stands out: a collaged bit of a postcard featuring Leonardo's famous painting, crossed out twice in red paint by Malevich himself. With this act of negation, the artist expresses his disdain for all that the *Mona Lisa* had come to stand for—naturalism, notions of traditional beauty, and art's connections to power and exclusivity. The artistic and the emerging communist avant-gardes are aligned in this work: both desire an overthrow of the established order. Malevich emphasizes this message by including a snippet of newsprint beneath the *Mona Lisa* that can be translated "apartment changing hands"—suggesting that Mona Lisa and all she represents is moving out. What will take her place?

Malevich painted his most dramatic statement in 1915—the famous and iconic *Black Square* (FIG. 1.7). When compared to other paintings of the period—even Picasso's and Braque's Cubist works—the *Black Square* goes further, asking important questions in the process: What is the limit-case for painting? Does a flatly painted shape even constitute a work of art? *Black Square* thus negates the history of painting since the Renaissance, nihilistically reducing the medium's complexity to a single, off-kilter square. As such, the work conceptually anticipates, by two years, the radical destruction effected by the October Revolution. By the same token, *Black Square* also foreshadows the Revolution's optimism, depicting a *tabula rasa* upon which a wholly new society could be built. The work issues a challenge: Can one invent a new system of painting—indeed, even

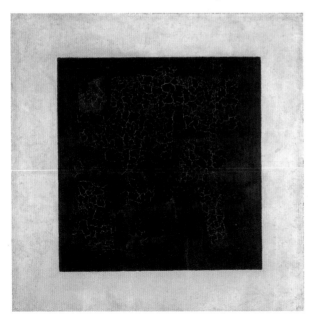

Fig. 1.7
Kazimir Malevich
Black Square, 1915, oil on linen, 31⁵⁄₁₆ x 31⁵⁄₁₆ in. (79.5 x 79.5 cm). The State Tretyakov Gallery, Moscow.

a new linguistic system—that could reflect a fundamental paradigm shift to a communist society? *Black Square* might even be considered the first utterance of this new communist language. Malevich understood this symbiosis of iconoclasm and idealism—that destruction was necessary for the building of utopia; he identified *Black Square* as painting's "zero degree."

In *Dynamic City*, Klutsis takes the abstract language associated with Malevich and transforms it, post-Revolution, into an emblem of a city undergoing modern transformation. If a city on a map is conventionally indicated by a single black dot, Klutsis has his metropolis expand beyond these limits, using oblong shapes (made from aluminum foil or cut from newspapers) that extend into blank spaces of possibility. The artist observed that in this instance (and in related works) he was seeking "absolutely new forms," which explains his use of Malevich's avant-garde language. In addition to abstract shapes, Klutsis also included elements of photomontage; viewers see small-scale men at work and images of tall buildings. Modernization was crucial for the nascent and struggling Soviet state, as these figures make explicit. In hindsight, but looking toward the future, there is some Cold War irony here: Klutsis's montaged images of workers and skyscrapers are American in origin, the industrial might of the United States was the envy of the world at the time.

Klutsis's inclusion of aluminum foil in *Dynamic City* indicates a broad Soviet desire to expand the tools of art to those associated with industry—and to move away from bourgeois materials such as oil paint and marble. Beyond this, a real need had developed in the Soviet Union by the mid-1920s for art to be *useful* and not merely decoration, or a marker of class distinction, as expressed by the revolutionary poet Vladimir Mayakovsky: "We do not need a dead mausoleum of art where dead works are worshipped, but a living factory of the human spirit—in the streets, in the tramways, in the factories, workshops, and workers' homes." Klutsis's versatility—he was an accomplished painter, sculptor, collagist, and printmaker—was ideal for such a utilitarian conception of art. The artists who dedicated themselves to producing useful objects during the early Soviet period became known as "Constructivists," and they were committed to negating art's aura—or quasi-mystical quality—which had been in place since at least the Enlightenment.

33

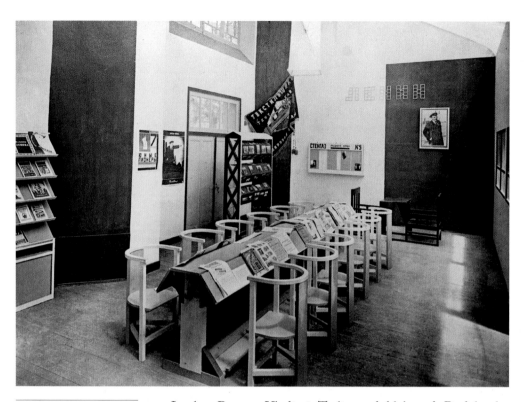

Fig. 1.8
Aleksandr Rodchenko
Workers' Club,
1925, installation
at the Exposition
Internationale des
Arts Décoratifs et
Industriels Modernes,
Paris.

Lyubov Popova, Vladimir Tatlin, and Aleksandr Rodchenko are among the most famous Constructivists. Popova designed textiles and clothes for workers; Tatlin planned an unrealized tower that would have served as a central building for the Communist government and a symbol for a new world order; and Rodchenko, in addition to making posters and photographs, built a prototype for a break room for factory workers. This *Workers' Club* from 1925 is a good example of the utopian aims of Constructivist artists (FIG. 1.8). With its functional furniture—whose simplicity exposes how it was assembled—Rodchenko created a space where workers could read newspapers, play chess, watch propaganda films, or hear lectures. In other words, this was an environment that could help educate and shape them, molding them into the dedicated workers the Party needed. Constructivism positioned the artist as an engineer—a productive citizen who built useful things to further the aims of the Revolution.

Rodchenko's *Workers' Club*, however, never progressed beyond the prototype stage. To understand the failure of the *Workers' Club* and of Constructivism more generally is to understand the

rise of Socialist Realism. These failures stemmed partly from a lack of resources; the funding of experimental art projects was not a priority in a fledgling state. No matter how useful a workers' club might be, factory machinery would always be considered more urgent. And, second, some perceived the idiom of Constructivism to be an elitist language, too theoretical and difficult for peasants accustomed to figurative art—religious icons, for example. The basic and unadorned forms of Rodchenko's furniture might represent an efficient use of affordable wood, but for a tired worker, an upholstered chair would be more comfortable and familiar.

Klutsis's *The Victory of Socialism in Our Country Is Guaranteed* from 1932 shows how avant-garde forms had been abandoned by the 1930s (FIG. 1.9). The open-ended abstraction and playful optimism of *Dynamic City* has vanished. Instead, the artist superimposes a photographic portrait of Stalin over a teeming crowd.

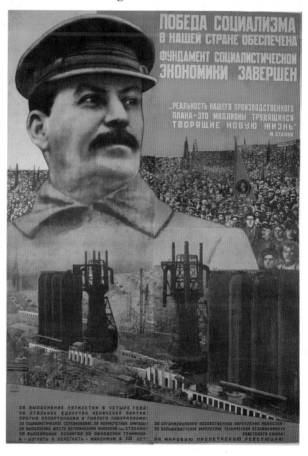

Looming above a large industrial complex, the leader's picture delivers a clear message: Stalin is powerful, and he, according to the text, will guarantee the victory of socialism. Mass-produced posters were plastered on city streets and workplaces, with profound effects. As with advertising, repetition creates a lasting impression. How else would an American consumer link Marlboro cigarettes with cowboys? Considering that Stalin was violently suppressing all opposition at the time—through Party purges, forced labor sentences, and executions—such posters helped to create an alternate reality. This is not how life was, but how Stalin and Party officials wanted it to be seen. Klutsis himself experienced Stalin's iron fist firsthand, as he

was secretly (and falsely) charged and executed in 1938 for membership in a fascist, nationalist group associated with his homeland of Latvia.

The dreamworld of Klutsis's poster is typical of Socialist Realism. Stalin banned all independent artist groups in 1932, and a 1934 decree mandated strict adherence to this official style. Under the program of Socialist Realism, the only way an artist could make a living was to join the official union, which mandated that all works supported "the platform of Soviet power." As a result, the Party commissioned thousands of paintings, sculptures, and other works of art from the early 1930s until the end of the Cold War that helped prop up the regime and its ideology. As discussed in later chapters, underground artistic organizations appeared in the 1960s and became prevalent in the 1970s, but, on the whole, official Soviet art during the Cold War adhered at least partially to the tenets of Socialist Realism. Stylistically, its works harked back to the nineteenth-century group of anti-czarist Russian artists known as the Wanderers, of which Ilya Repin remains the best known. His realism recalled the works of his

Fig. 1.10
Fedor S. Shurpin
The Morning of our Native Land, 1948, oil on canvas, 66 x 91 in. (168 x 231 cm). The State Tretyakov Gallery, Moscow.

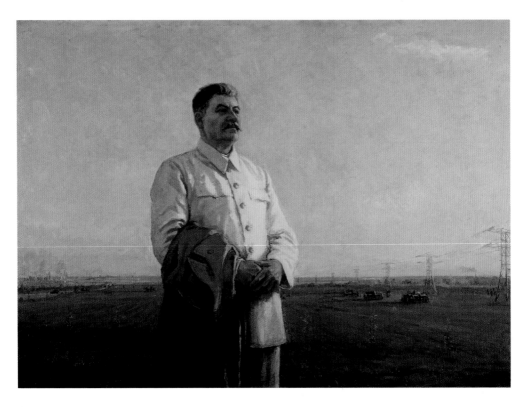

French contemporary Gustave Courbet, both artists attempting to convey the everyday toil of working individuals. While the exact formal parameters of Socialist Realism depended on the political mood of the time, artists were rarely permitted to move beyond the sketchy surfaces of Impressionism. Socialist Realism, at least stylistically, thus disregarded any of the formal innovations pursued by artistic avant-gardes after 1870.

The years following World War II—which witnessed the emergence of the Cold War and the highpoint of Stalin's personality cult—have been described as a particularly dogmatic period of Socialist Realism, with a strict enforcement of rules and prohibitions that eased somewhat only after Stalin's death in 1953. These postwar paintings were the least modern and most propagandistic in the entire history of Soviet Socialist Realism. Fedor Shurpin's *The Morning of our Native Land* from 1948 (FIG. 1.10) is typical; Stalin is pictured looking into the distance to a utopian and socialist future, indicated by the working and electrified collective farm behind him. Shurpin endows Stalin with a monumental presence, something akin to a statue lording over the landscape (not unlike the actual statues of the leader erected throughout Soviet Union and the Eastern Bloc); his clasped hands and the bright sunlight falling on his jacket draw upon traditional artistic signs of divinity. This is propaganda of the first order.

Socialist Realism was not, however, an entirely regressive practice. As Boris Groys provocatively argued in the early 1990s, the aesthetic owed much to the avant-garde and radical practices of Malevich, Rodchenko, and others. If the Constructivists and other avant-garde movements of the early twentieth century wanted to remake the world through art—to fuse artistic practice with everyday life—then this definition also encompasses Stalin's project. According to Groys, Stalin and the Party were themselves artists, working with an entire society as their medium, whether this meant people, architecture, books, newspapers, visual signage, or anything else. If artists traditionally transform their materials into the illusion of something else—Michelangelo turning marble into flesh, for instance—Stalin attempted to transform an entire culture into a dreamworld of socialism, with little or no regard for the human costs.

The rhetoric surrounding Socialist Realism suggests that the Soviets subscribed to aspects of this interpretation. Andrei Zhdanov, one of the most influential Party officials on cultural policy, described the transformative power of Socialist Realism in 1934, writing that its products of art and literature attempted the "ideological remolding and education of working people in the spirit of socialism." Stalin, characteristically, was more blunt, calling writers—and by extension, artists—"engineers of human souls." And this engineering went beyond works of art in galleries. Paintings were often commissioned with the intention that they would be reproduced mechanically, whether as posters, postcards, or illustrations in magazines or newspapers. In this context, where is the work of art? Is the work the "original" painting, or the mass-distributed versions that reached Soviet citizens far beyond Moscow and Leningrad? Furthermore, when reproduced in black and white in newspapers or magazines, Socialist Realist paintings looked like photographs—especially because "news" photographs were also regularly airbrushed or otherwise altered. In such a context, *The Morning of our Native Land*, when published, could readily be confused with a photograph of Stalin. Such a blurring of painted "fiction" and photographed "truth" demonstrates the power of the Party to shape reality in any way it saw fit. These advanced ideas traveled far beyond the educated elites; such avant-garde strategies were on regular display in the official Party newspaper *Pravda*.

Despite seeming conservative and backward-looking, Socialist Realism was a complex practice that actually accomplished what many early twentieth-century avant-garde practices never did: it dismantled the distinction between art and everyday life. If the forms of modern art were alien to Socialist Realism, some of its strategies were not. To note this is by no means to celebrate what happened under Stalin. On the contrary, it demonstrates that modernist dreams and totalitarian nightmares are two sides of the same coin. Socialist Realism presented a parallel universe where the dictator's brutal methods were unimaginable. As a network of images working in concert with one another, Socialist Realism wielded incredible power.

Universalizing Aesthetics

The core of both postwar American abstract painting and Soviet Socialist Realism were informed by their Cold War counterpart, but these connections were largely repressed until the years of détente in the 1970s. At Rothko's 1961 retrospective at the Museum of Modern Art in New York (MoMA), for instance, curators failed to show any of his early figurative works, and abstract or Constructivist works disappeared from public view or critical consideration after World War II in the Soviet Union. During the late 1940s and 1950s, American and Soviet curators, critics, and cultural officials also stressed the universality of their respective versions of abstraction and figuration—a positioning dedicated to convincing the international community that each was correct, not only aesthetically, but also ideologically.

Abstraction in the United States started off at a disadvantage at the start of the Cold War, because broad swaths of the American public failed to appreciate it. Some even believed that abstract works were deviant and "communistic." In 1949, George Dondero, a congressman from Michigan, delivered a fiery speech that connected many of the movements of modern art—Cubism, Dadaism, and abstraction—with communist subversion. In 1952, he even declared that a Soviet conspiracy designed to undermine American values was responsible for the emergence of such forms of modern art. Quickly, defenders of abstraction, including Alfred Barr at MoMA and other American museum curators, mounted a public defense, touting abstraction's moral high ground in newspapers and specialist publications. Violent dictators—Hitler and Stalin above all—had prohibited modern art under their regimes. Therefore, abstract painting *must* be humanist and ethical, and thus on the side of democracy and freedom. In 1949, Barr and MoMA board member (and eventual American vice president) Nelson Rockefeller lobbied Henry Luce, the founder of *Time* and *Life* magazines, to draw connections between Abstract Expressionism and democratic "free enterprise" in his vast media empire. Such efforts helped abstraction to garner some popular success by the early 1950s, especially evident in *Life*'s feature on Pollock in 1949. Nevertheless, realism did not go away in the United States during these early years of the Cold War. For example, Norman Rockwell remained the nation's most popular artist in

the 1950s, producing paintings that were reproduced regularly on covers of the *Saturday Evening Post*.

Two American critics played instrumental roles in establishing the specific, universalizing rhetoric that transformed paintings by Rothko, Pollock, and others into stealthy manifestations of American propaganda: Harold Rosenberg and Clement Greenberg. Rosenberg's influential 1952 essay "The American Action Painters" provided a crucial framework for understanding abstraction. While Rosenberg did not mention any painters by name, his words would certainly have inspired thoughts of Pollock moving around and stepping into his canvases, especially given the publication of photographs of the artist at work. According to Rosenberg, American painters had transformed the canvas into "an arena in which to act." They did not decide upon their subject beforehand; instead, the painting would emerge from their confrontation with an empty canvas. In the aftermath of the Holocaust and the ever-present fear of nuclear annihilation (after the Soviet Union developed their own atomic bomb in 1949), all an artist could do was to register the existential anxiety of the age by emphasizing the uncertainty inherent in the process of painting. Pollock's drips and spatters in *Autumn Rhythm*, by Rosenberg's logic, were gestures "of liberation, from Value—political, aesthetic, moral." Other American art historians followed Rosenberg's line; Meyer Schapiro turned away from his Marxist positions of the 1930s and likewise described the "liberating quality" of abstract painting in 1957. And the curator's introduction to a Jackson Pollock exhibition at MoMA in 1956 tied such notions to nationalism, declaring that the artist's brush style embodied "refreshingly and unregenerately American qualities."

Greenberg's criticism continued to develop during the 1940s and 1950s, as he became increasingly interested in promoting American art at the expense of European practices. He believed that Rothko and Pollock had synthesized the styles of Picasso, Matisse, Mondrian, and others—bringing modernism to some kind of ultimate American fulfillment. Thus, Greenberg's concerns diverge significantly from Rosenberg's; instead of action, the best American painters privileged contemplation—mainly concerning the processes and limitations of painting itself. As was already evident in his writings from the 1930s, this meant

emphasizing painting's flatness, optical effects, and evolutionary refinement over time. The connection of such esoteric aesthetic concerns to the Cold War was explicitly revealed in 1961, when Greenberg read his essay "Modernist Painting," which summarized his critical positions, over the Voice of America radio network, potentially reaching artists and critics in Eastern Europe.

While Rosenberg's and Greenberg's critical models had little in common, they worked well in tandem. Both implied, in different ways to different audiences, that American abstraction was a kind of universal language. In popular accounts, Rosenberg's "action painting" was stripped of its complexity, becoming shorthand for an art that expressed the subjective feelings of the isolated and alienated individual—drips of paint connoting expressed emotion. Even someone with little exposure to the tropes of modernism could understand *Autumn Rhythm* as a monumental portrait of an individual's feelings. Greenberg's belief that American abstract painting marked the culmination of artistic development since the Italian Renaissance also gave it a universal, art-historical credence. Rosenberg's and Greenberg's theories implied that Pollock and others had discovered painting's essence—an expressive or refined common denominator that allowed it to transcend linguistic and cultural barriers.

In a sense, the painted marks of an autonomous, free, and *American* individual became the vocabulary of an international language—just as English was becoming the international language of commerce. The Marshall Plan, which provided unprecedented American support for the economic recovery of Western Europe beginning in 1948, paralleled the "triumph" of American abstract painting. In additional to monetary support, this program also mandated the presence of American cultural products in participating countries. (After receiving the funds, French cinemas had to show a minimum number of American films per year, for example.) As American economic power became increasingly linked with the nation's cultural values, Abstract Expressionism became the artistic mode that represented the new empire's notion of individuality. And the seeming apolitical nature of these paintings—their abstraction—made for especially effective propaganda. That U.S. government agencies provided MoMA and other American museums with covert support to organize international exhibitions of abstract art in Europe in

the 1950s, then, should come as no surprise. (Institutions also sent shows internationally without such official support.) While the propagandistic effectiveness of these exhibitions is impossible to gauge, it is perhaps telling that when the East German painter Gerhard Richter saw Pollock's paintings in 1959 in West Germany, he later recalled: "I might almost say that those paintings were the real reason I left the GDR [East Germany]. I realized something was wrong with my whole way of thinking."

When it came from the Eastern Bloc, abstraction was even better propaganda. After mass protests against Soviet control in October 1956 and subsequent negotiations led by the reform leader Władysław Gomułka, Poland was granted a degree of autonomy in governance. And abstract paintings full of drips and spatters began to be tolerated in official shows, as long as they did not comprise more than 15 percent of an exhibition's total. With abstract painting also flourishing in Czechoslovakia around 1960, the meaning of such works in the context of the Eastern Bloc mirrored what it had become in American propaganda: these artists viewed themselves as rebelling against state-imposed control. In 1961, MoMA even staged an exhibition of work from the Eastern Bloc: *Fifteen Polish Painters* which featured only abstract canvases, despite a continued presence of Socialist Realism and more modern brands of realism in Poland. Tadeusz Kantor became the best known of these artists, developing his style of painting after seeing abstract art in Paris in 1955 (FIG. 1.11). Here, the artist emphasizes blobs of color with Pollock-like dripped lines. While important in Polish political and artistic contexts of the late 1950s, Kantor's and others' works in the show were dismissed by many American critics as derivative. Some reviews also condemned the fact that these works of art were drafted to serve explicit Cold War aims. Nevertheless, MoMA's exhibition implied that, when given the choice, an artist in the Eastern Bloc

Fig. 1.11
Tadeusz Kantor
Informel, 1958, oil on canvas, 29½ x 43¼ in. (75 x 110 cm). Private Collection Dr Werner Jerke, Recklinghausen, Germany.

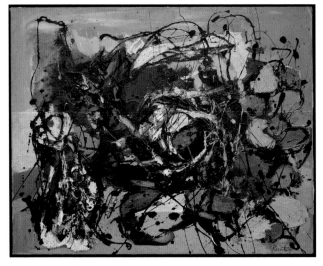

Fig. 1.12
Raúl Martínez
Untitled, 1957, oil
on canvas, 48 x 85 in.
(121.9 x 215.9 cm).
Private Collection.

would reject representational styles, thus positioning abstraction as the international language of liberation.

But painting influenced by Abstract Expressionism was not necessarily on America's side in the Cold War, as the work of Cuban artists in the 1950s can attest. In the years after World War II, before the revolution led by Fidel Castro, Cuba was closely aligned with the United States. The dictator Fulgencio Batista, who came to power in a 1952 coup, joined the American Cold War effort by outlawing the Communist Party on the island. But artists such as Raúl Martínez embraced the forms of American abstraction precisely as a means to resist Batista. The rivulets of running paint in his *Untitled* from 1957 could signify an individual's autonomy and agency in the face of American-backed oppression (FIG. 1.12). *Untitled* thus resembles a work of Abstract Expressionism but its specific Cuban context challenged the Cold War alignment of such forms.

Soviet critics also discussed Socialist Realism as a universal language, though one altogether different from its abstract counterpart. In 1950, Stalin published an essay (certainly written by others) called "Marxism and Questions of Linguistics," which outlined how language transcends its particular social conditions. In other words, the Russian language could serve the socialist cause just as well as it had czarist/capitalist forces before the October Revolution. Echoing Marx's stipulation that language be "practical," Stalin argues that language must

be deployed plainly: that is, writers should avoid exploring its limitations and ambiguity. While the essay does not address images, Soviet critics of the time applied these theories to art. A realist style of painting thus exemplifies a "practical" means of communication, able to deliver content clearly and efficiently. Recognizing content should not require the viewer much effort, according to this theory. To view the art of painting in terms of its communicative efficiency could justify the academic realism of a canvas such as *Youth of the World—for Peace* (see FIG. 1.2). Like the style on view in the celebrated nineteenth-century canvases of Ilya Repin, Socialist Realism was the "natural" way of painting for the communist world, the way art should be. Other styles—especially those that called attention to the medium itself—had been corrupted by capitalist bourgeois culture.

Soviet art historians similarly extolled Socialist Realism by retelling the history of art from a Marxist perspective of class struggle and capitalist imperialism. The only Soviet art journal during the Cold War, *Iskusstvo*, for instance, highlighted works of art that engaged issues of class from the ancient period up to the present, ignoring practitioners who fell outside such narrow criteria. In the process, artists like Rembrandt, Goya, and Courbet became Socialist Realists *avant la lettre*, whereas the distortions and abstraction of modern artists were symptomatic of capitalism's problems. The tattered clothes of Rembrandt's *Prodigal Son* (housed in the Hermitage in then-Leningrad) could thus demonstrate the effects of the son's profligate and capitalistic excesses. His return home—indeed, to his father dressed in red—is a return to the ethical, communal idea of family. Meanwhile, *Youth of the World—for Peace* reveals socialism's eventual victory, as well as the solution to the son's selfish problems in Rembrandt's picture. If communism marked the logical endpoint of social progress, according to Marx, then Socialist Realism claimed the same elevated status within the realm of art.

Socialist Realism was also justified through its connection to the theories of Vladimir Lenin, the leader of the October Revolution and first head of the Soviet Union. According to his "theory of reflection," art does not merely reflect social conditions and ideology but also plays an active role in transforming them. Since everyday objects become inflected by context and vice versa, details matter in Socialist Realism. Even though the power

lines and farm equipment in *The Morning of our Native Land* (see FIG. 1.10) are but minor pictorial elements, for instance, they are crucial to the "correct" reading of the painting. They demonstrate the transformed nature of the landscape and should inspire viewers to help make this vision a reality. Some critics have discussed such veiled symbolism—or the hidden meanings—in works of Socialist Realism by comparing it to the quasi-photographic paintings of the late Middle Ages by the likes of Jan van Eyck. In such detailed paintings as *The Arnolfini Portrait* from 1434, period viewers would search the seemingly mundane interior for clues to the presence of God, whether occasioned by a candle or some other object. Socialist Realism works in a similar fashion: viewers literally bring pictures to socialist life through a transformative act of interpretation. Seeing the socialist reality in a painting—power lines as an emblem of communal progress—trains one to perform similar acts in everyday life.

Due to their reliance on the theories of Stalin and Lenin, Socialist Realist works were discussed only in terms of their narrative and figurative content. In fact, Soviet art critics were permitted to discuss only the subject matter, implied story, and symbols evident in any work of art. To discuss the ways that stylistic elements—color or treatment of surface, for example—contribute to the meaning would be to commit the sin of "formalism." And formalism was a hallmark of bourgeois decadence, as it indicated a selfish lack of social utility. The campaign against formalism—whether in art or criticism—had been important since the implementation of Socialist Realism in 1934, but arguably reached its high point in the years before Stalin's death in 1953. In works of art, formalism meant bodily distortions, the flattening of the picture plane, or even Impressionist-style brushwork. Soviet officials also ensured that artists would have difficulty even viewing examples of formalism; Moscow's Museum of New Western Art—with its important collection of Picasso, Matisse, Malevich, and others—was closed by state decree in 1948. Its modern masterpieces largely disappeared from view until the end of the Cold War.

A "formalist" abstraction, therefore, would pose a daunting challenge to a Soviet critic trained to interpret content alone. In such a framework, *Autumn Rhythm*, or *No. 3/No. 13*, resembles a desolate, apocalyptic landscape, devoid of humans. And this is

exactly how Soviet writers discussed such paintings, transforming them into indictments against capitalism. The logic went as follows: Capitalism alienates individuals, and as this alienation becomes more profound with the expansion of markets, humans increasingly disappear from works of art. Abstract art thus goes beyond the degraded and fragmented bodies of Expressionism and Cubism; individuals vanish altogether. For Soviet commentators, it made sense that Western industrialists bought this kind of art, because to do so was to transform an image of extreme alienation into a decorative sign of wealth.

While the adherence of Eastern Bloc artists to the strict protocols of Soviet Socialist Realism fluctuated with political currents and local needs (the example of East Germany will be explored below), Moscow sent exhibitions of Socialist Realist art to cities in Poland, Hungary, East Germany, and other satellite countries between 1949 and 1953, as well as to the outer Soviet provinces in central Asia. Artists throughout the Bloc also made painted copies of important Soviet paintings for local

display, and, of course, official art magazines published reproductions of the latest and greatest images of Socialist Realism. While this style encountered resistance when forcibly imported, as was made clear with the emergence of abstraction in Poland, Soviet authorities nevertheless attempted to establish Socialist Realism across its European sphere of influence. And, to a more limited degree, Soviet critics celebrated the commitment to class-derived content, if not the modern distortions, of communist artists working in places like France and Italy. Picasso became one of the world's most famous card-carrying communists when he joined the French Communist Party in 1944, but (as the next chapter will detail) his "formalist" style remained troubling for Soviet officials.

Sly Subversion

At first glance, a comparison of two additional paintings reinforces the Cold War binaries outlined above: Pollock's *The Wooden Horse: Number 10a* from 1948, and Fyodor Reshetnikov's *Dear Stalin* from 1950 (FIGS. 1.13 and 1.14). As discussed, Pollock's painting records the action of an autonomous individual; Reshetnikov, worlds away, humanizes a brutal dictator, depicting him enjoying a letter from a child admirer. With a little scrutiny, however, these paintings can also be seen to work against such prescribed notions.

When turned on its side (with its right end rotated to the top), Pollock's work is transformed. A clear image of a single stick figure emerges—a circle at top, with a linear torso, two arms, and two legs beneath. (Pollock was likely aware of this, as a period photograph of his studio shows the painting in this orientation.) Considering that Pollock seems to be smuggling figuration within an ostensibly abstract painting, the attached wooden horsehead proves to be more than a gag. It might also

Fig. 1.13
Jackson Pollock
The Wooden Horse: Number 10a, 1948, oil and wood on canvas, mounted on Masonite, 35½ x 70 in. (90 x 178 cm). Moderna Museet, Stockholm.

Fig. 1.14
Fyodor P. Reshetnikov
Dear Stalin, 1950, oil
on canvas, 48 x 43 in.
(122 x 110 cm). Current
location unknown.

refer to the most famous wooden horse in history: the Trojan Horse. In the context of the Cold War, might Pollock be implying that figuration is hidden just beneath the surface of apparent abstraction? Is abstraction the Trojan horse hiding figuration? In the 1950s, Pollock himself suggested as much: "I'm very representational some of the time, and a little all of the time."

Especially in the early years of the Cold War, some Americans feared that abstract painting might be a Trojan Horse of a different kind. Echoing Congressman Dondero's paranoia, a city councilman in Los Angeles claimed in 1951 that abstract paintings could contain secret maps that would detail strategic weaknesses of U.S. sites for the Kremlin. An abstract painting by the American artist Ellsworth Kelly, shipped from France, was detained in customs in Boston for similar reasons that same year. While these stories today seem outlandish, they reveal that some American viewers had become exceedingly anxious about abstract painting and what it represented. Although abstraction came to stand for American values of freedom by the end of the 1950s, abstract canvases could also, in the minds of some, commit treason.

If Pollock smuggles a figure into *The Wooden Horse*, then Reshetnikov also commits his own act of Cold War subversion, hidden in plain sight: formalism. An observant viewer—which Soviets had been trained to be—would certainly see the drawing on Stalin's desk that had been sent with the child's letter. With its childish, naïve forms, this drawing-within-the-painting would have been derided as "formalist" if exhibited on its own. Such "primitive" figuration was in vogue throughout Western Europe in 1950—the influential work of Jean Dubuffet, for example, featured schematic and playfully exaggerated figures (see FIG. 2.4). Reshetnikov thus sneaks an example of an illicit, formalist style into a portrait of Stalin himself. In a later cartoonish work entitled *Secrets of Abstraction* (1961), Reshetnikov

demeans Pollock-like paintings as the product of machines and animals, but nevertheless still faithfully represents the forms of drip paintings. Put simply, there were any number of ways to sneak formalism into accepted Socialist Realist paintings. While subtle, these moments could provide artists and certain viewers with at least a symbolic act of subversion. They also recall, following Argentine author Jorge Luis Borges, that censorship forces artists to discover new metaphors to register dissent.

Astute viewers can also intuit the strict conditions under which Socialist Realism was produced, perhaps somewhat humanizing Reshetnikov and other Soviet artists. Of course, *Dear Stalin*—and many other paintings—contributed to Stalin's cult of images, allowing the Party to spin mythologies that would cover up hardship and brutal repression. But if artists wanted to make any living at all, especially before the emergence of underground groups in the 1960s, they had to produce such works in order to secure access to a studio, materials, or an audience. By this logic, does the mere presence of Stalin in a Socialist Realist painting register the repressive conditions that governed its production? As Reshetnikov was completing *Dear Stalin*, a convincing representation of the dictator would have gradually emerged. Vyacheslav Mariupolski's *A Leader in the Pioneers (Her First Report)* from 1949 also demonstrates this notion (FIG. 1.15). Once Mariupolski completed the poster in the background, the eyes of Stalin would have looked down on the painter as he worked, both literally and metaphorically. To paint Stalin was to invite his image and implied criticism into one's studio space, perhaps encouraging self-censorship. Stalin's visage in a work can become a visual excuse, implying that artists had to paint this way, as the dictator was watching them. Once such a degree of doubt enters the interpretative process, the meaning of paintings can be transformed. Does the young woman

Fig. 1.15
Vyacheslav M. Mariupolski
A Leader in the Pioneers (Her First Report) (second variant), 1949, oil on canvas, 36½ x 27⅞ in. (92.7 x 70.8 cm). Springville Museum of Art, Utah.

in Mariupolski's canvas show fear or reticence in delivering her report? Her tight hold upon her script might suggest as much. Is this woman an allegorical self-portrait of the artist under Socialist Realism—always performing under the gaze of the authorities? Is the "x" created by the bow in the young woman's hair on the bottom of Stalin's portrait a deliberate slight? While a viewer might only see a picture of a loyal young woman testifying to her solidarity with the Party, other readings are indeed possible. Whether intentional or not, Socialist Realist canvases from this period are filled with moments that might, within the right frame of reference, be critical of—or at least acknowledge—the tight control exercised over Soviet art at this time.

In the annals of Socialist Realist criticism, a number of works have been subjected to what can only be labeled paranoid interpretations—not unlike the irrational, treasonous readings of abstract painting recounted above. Although occurring before the Cold War, Vera Mukhina's famous sculpture *Worker and Collective Farm Girl* caused a stir among Party officials when it topped the Soviet pavilion at the 1937 World's Fair in Paris. Some alleged that Leon Trotsky's profile was evident in the forms of the drapery. And in 1935, a now lost painting apparently revealed a secret skeleton that was clutching Stalin (though only when the work was photographed). For officials, this implied that the artist harbored treasonous intentions, even if unconsciously. Socialist Realist paintings were required to be slavishly supportive of the Party and its aims, but the strictures placed upon them could also produce unintended moments of dissent.

To sum up, individuals on both sides reinforced a stylistic binary in the early years of the conflict, and so, American abstraction and Soviet Socialist Realism remained locked in their respective silos. To consider any overlap between them would be to question the universality and truth of either style, as well as the system it represented. But as mentioned in the Introduction, Winston Churchill once remarked that paintings are a code; they translate some aspects of experience into paint. And codes, whether abstract or figurative, can be misinterpreted. Such mistranslations became more explicit and intentional as the Cold War continued, as later chapters will detail.

Exporting Styles

Artists in both European blocs—as well as farther afield—became participants in this Cold War battle of abstraction versus figuration. Their artistic choices, however, proved more complicated than the simple replications of accepted artistic formulas. Artists in each locale had to deal with social and political contexts, constraints, and contradictions that lay outside explicit Cold War concerns. Such thorny narratives played out in sites across the Cold War world, and yet, in the art-historical accounts of the period, these site-specific issues have often been neglected in favor of a simplified and totalizing view of Western abstraction versus Eastern Socialist Realism.

Germany was in a state of shock after World War II. Not only had the infrastructure and urban fabric of its cities been devastated by the Allied war machine, but its citizens—whether committed Nazis, resistors, or somewhere in between—were also traumatized by a postwar landscape of death and destruction, alongside the revelation of the Holocaust. The burgeoning Cold War only added to the complexity. In 1945, Berlin and Germany itself were divided into four zones: American, British, French, and Soviet. In 1949, the three Western zones were consolidated into the Federal Republic of Germany (FRG, or West Germany) and the Soviet zone became the German Democratic Republic (GDR, or East Germany). Divided Germany, and especially a divided Berlin whose western sector was completely surrounded by a hostile East Germany, emerged as the most visible theater of the Cold War—a crystallization of the conflict in a specific and historic locale. The art of West and East Germany in the 1950s largely followed the binary division between abstraction and Socialist Realist figuration, respectively. These aesthetic mandates of the Cold War, however, brushed up against the graphic and traumatic reality of the recent past. German art waged the Cold War in the 1950s, but it also contended with the long shadow of the Nazi era.

Abstraction emerged in West Germany after the war, with solid anti-Nazi credentials. Hitler had deemed such art—along with Dada, Surrealism, and Expressionism—"degenerate," as it did not fit with the Third Reich's racialized view of culture. For Hitler, modern art was the product of some physical or mental deficiency in the artist. But the tenor of the

abstract canvases—like Fritz Winter's *Figuration in Front of Blue* from 1953 (FIG. 1.16)—also served a particular German need. If Pollock's pools and skeins of paint teeter between coherence and incoherence, Winter's image provides a more solid sense of balance; its loosely defined black grid stabilizes its composition, for instance. The artist himself, as well as critics, suggested that such balance conveyed apparently universal absolutes of beauty and truth, derived from nature. Such an idea corresponds with abstraction as an "international language," and, in fact, this notion was first popularized in West Germany, where it embodied an explicitly Cold War thrust. According to a book on the subject published there in 1958, abstraction was "only unable to prevail where the powers of totalitarian police states prescribed the marching routes for artists"—that is, East Germany and the Soviet Union. The major recurring international exhibition Documenta was founded in 1955 as a means to promote just such ideas of modern and abstract art, and it was staged in Kassel, only miles from the East German border. For West German critics, abstraction repudiated both Nazism and—by aligning itself with notions of individual liberty—communism.

However, if abstraction is a language that transcends history, then Winter's paintings also attempt to transcend, or repress, Germany's recent past. Winter's own wartime tale supports such an understanding: He fought for Hitler's Third Reich and remained a prisoner of war in the Soviet Union until 1949. Winter's linking of abstraction to timeless ideas of harmony thus became an apt strategy for viewers to overlook history, specifically the war and Nazi crimes. In such a context, abstraction becomes a soothing balm, a form of amnesia. So while Winter's paintings helped equate abstraction with the recent emergence of (West) German freedom, they also must be interpreted in their local context. Perhaps the artist's own conflicted history—fighting for the Nazis and transformed, by default, into an American ally after the war—is emblematic of the strangeness of the sudden

friendship between the United States and its former enemies in West Germany.

In East Germany, things were also complicated. If abstraction was perceived to be anti-Nazi, so were German communists, as they had mounted resistance to Hitler before and during the war. But cultural officials in the Soviet sector quickly mandated that Socialist Realism would be the only acceptable style in East Germany. While there were notable exceptions, East German Socialist Realism initially followed Soviet models, depicting contented individuals working together to construct a new society. In other words, like their West German counterparts, these artists did not deal with the realities of wartime suffering and genocide, although they worked in a figurative mode. East German artists, though, had a style problem that those in the West did not have: the representational forms of Socialist Realism seemed too close to those endorsed by Hitler only a few years before. Although the socialist content of the work sufficiently differentiated it from Nazi art, many artists were deeply troubled to find themselves being compelled to paint in a figurative style that would have passed Nazis censors.

A greater tolerance for modernist experimentation gradually emerged in official paintings in the early 1950s, as visible in Rudolf Bergander's *House Peace Committee* from 1952 (FIG. 1.17). The painting's content was praised in all quarters—a collective comprising young and old citizens discussing issues raised in *Neues Deutschland*, the East German Communist Party newspaper. However, Bergander's loose treatment of paint, stylized bodies, and lack of detail proved controversial. The patchy and frenetic brushwork of the blue background in the upper right corner could stand alone

Fig. 1.17
Rudolf Bergander
House Peace Committee,
1952, oil on canvas,
51³⁄₁₆ x 67 in. (130 x
170 cm). Galerie Neue
Meister, Dresden.

as its own formal experiment. Bergander's stylistic deviation has a specific history, as it recalls a cleaned-up version of the prewar German Expressionism of Georg Grosz or Käthe Kollwitz. Both of these influential figures were committed socialists, which helped make Bergander's formal "deviations" acceptable, after a lengthy debate published in an art magazine. While Socialist Realism was still the required style in East Germany, it became less beholden to Soviet examples so that it could secure an identity independent from Nazi predecessors. Thus, the specific German context complicated simple Cold War narratives of artistic production.

The situation in Japan and China was perhaps more striking, and further complicates the idea that a distant country could export its dominant artistic style without encountering significant local friction. Japan attacked China in 1937, and thus began a brutal war that would end only with Japan's defeat at the close of World War II in 1945. American forces, under General Douglas MacArthur, occupied and administered Japan until 1952—transforming it from a divine-right monarchy into a democratic and capitalist ally of the United States. In 1949, General Mao, after a long Civil War, secured control of mainland China, and declared the communist People's Republic of China. Suddenly, the Soviet Union was not the only major country to be born out of a successful communist revolution. Both Japan and China had their own long history of artistic development outside of European models, and these traditions—along with the mandated Cold War styles—shaped postwar Japanese abstraction and Chinese figuration.

Gutai emerged in 1954 in the shadow of Japan's wartime destruction. The members of this self-consciously avant-garde group embraced different techniques and aims, but a performative brand of abstract painting linked many of the artists. Shozo Shimamoto, for instance, produced works by throwing glass bottles full of paint at floor-bound canvases, and Kazuo Shiraga pioneered a way to make gestural paintings with his feet, such as *Work II* from 1958 (FIG. 1.18). Since feet are harder to control than hands, these works register a more active, instinctual body than even works by Pollock. Gutai paintings by the likes of Shimamoto and Shiraga thus raise the stakes on Rosenberg's notion of action painting—more directly equating the physical

Fig. 1.18
Kazuo Shiraga
Work II, 1958, oil on
torinkokogami paper,
72 x 95⅗ in. (182.9
x 242.8 cm). Hyogo
Prefectural Museum of

moment of painting with a gesture of freedom. While these artists were familiar with the work of Pollock and other American and European abstract painters by 1954, their work also builds upon specifically Japanese traditions of Zen calligraphy and Buddhist investigations into the spiritual manifestations of matter. Shiraga's paintings—and Gutai works more broadly—thus emerge as postwar hybrids, mash-ups of the Pacific and Atlantic worlds.

And these works register their specific Japanese context, namely the traumatic rupture of 1945. American forces wreaked utter destruction on Japan at the end of the war, dropping atomic bombs on Hiroshima and Nagasaki that obliterated each city in an instant. Shiraga's striking black swirls cannot but reference a body in trauma. The break was also cultural. After years of state propaganda touting Emperor Hirohito as a deity, he was forced to abdicate and renounce his divinity. Adding to the upheaval, the American occupation rapidly transformed the fabric of traditional Japan, including the adoption of a new constitution that codified American democratic values. Shiraga's foot-painting can thus also register a sense of global hybridity: it is American in style but decenters notions of Western abstraction along an Asian axis, and the shift to painting with feet, rather than hands, mirrors Gutai's desire to open up to new perspectives. As the Cold War progressed, as the rest of this book will detail, additional international artistic networks emerged.

When works by Gutai artists were first exhibited in New York in 1958, critics largely viewed them as a Japanese version of Abstract Expressionism, at a moment when this movement was starting to wane. But to view Gutai as merely derivative or as part of an international moment of gestural abstraction is to overlook not only its connections to Japan, but also this group's explicit intention to work against center–periphery models. In the initial manifesto, founder Yoshihara Jiro offered Gutai as a "proposal" to the West—an attempt to forge international bridges and cross-cultural exchange. So while Gutai's work fulfills the Cold War mandate of abstraction flourishing in a newly democratic society, it also anticipates the increasing ways that peripheries began to destabilize both artistic and political norms of the Cold War in the later phases of the conflict.

After China's revolution in 1949, Chinese art was severed from its past, as traditional forms of landscape painting and international modernist styles (popular in the 1920s and 1930s) became untenable under Mao's communist regime. European styles of figuration, namely derived from Soviet Socialist Realism, were imported—facilitated by a systematic program of an exchange of artists between the two countries in the early 1950s. Soviet art theory and criticism were also translated and widely published in China. While some resulting works could be viewed as Soviet paintings with Chinese subject matter—the figure of Mao replacing Stalin, for instance—others found themselves caught between long traditions of Chinese art and the new Socialist Realist mandate that art must serve the working classes. A good example of such hybridity is Shi Lu's *Beyond the Great Wall* from 1954 (FIG. 1.19). Using the customary Chinese medium of ink on paper, Shi paints a landscape with elements derived from traditional examples of the genre, such as the background's atmospheric mountains rendered with an efficient economy of light brushstrokes. The pastoral scene in the foreground reads as more "Soviet." A family, sitting among roaming livestock,

Fig. 1.19
Shi Lu
Beyond the Great Wall,
1954, ink and color
on paper, 36 x 51⅓
in. (91.6 x 130 cm).
National Art Museum of
China, Beijing.

Fig. 1.20
Renato Guttuso
Filofigurativo o antifigurativo…
(*Figurative or Anti-figurative…*), 1950, ink on paper, 11 x 18 in. (30 x 46 cm). Private Collection.

marvels at the industrial progress brought to the outreaches of China, symbolized by an approaching train, just out of view. While Chinese artists in the 1950s often relied upon an awkward synthesis of Soviet-style Socialist Realism and more nationalist styles, the dual languages present in the painting—its differing aesthetic spheres literally separated by train tracks—predicts future problems. Chinese art shifted with global politics in the 1960s. As Mao asserted increased independence from Soviet control, troubling any stable notion of center and periphery in the communist world, Chinese art also broke with Soviet models, as will be discussed in Chapter 4.

According to the Cold War rhetoric of the 1950s, America and its allies aligned themselves with abstraction, and the Soviet Bloc championed a strict figurative style. Critics and cultural officials on both sides deemed the emergence of each style, and the ideology each came to embody, as inevitable—both the culmination of historical progress and the registering of the natural order of things. If the rhetoric of containment required a fierce separation of capitalism and communism, with no overlap, then the art associated with each side followed suit. But as this chapter has demonstrated, such connections between style and ideology

are neither straightforward nor a given, and the artistic reality was far more complicated. The Italian communist painter Renato Guttuso (discussed further in the next chapter) demonstrated just this notion in a cartoon from 1950 (FIG. 1.20). At its center, a Janus-faced bespectacled man, with a donkey's face and ears, considers two paintings. One side looks at a canvas featuring a female nude, and the other gazes upon an abstract collection of lines, with the corresponding text at the top reading, "figurative or anti-figurative..." Guttuso continues this thought at the bottom, which translates as, "always hear with the same ears." The emphasis on ears is important, implying that *rhetoric* enforces these artificial distinctions of the Cold War—not actual looking. And since the ears belong to an ass, Guttuso suggests the stupidity and artificiality of these entrenched and powerful binaries. As the rest of this book will reveal, most of the art that engages with the conflict either actively challenges these stylistic conventions, or concerns itself with different issues altogether.

Chapter 2

Art, Technology, and the Cold War

I n 1951, Pablo Picasso painted *Massacre in Korea*—a canvas that charts a middle course between the two primary artistic styles of the Cold War, modernist abstraction and Socialist Realist figuration (FIG. 2.1). Picasso's subject is the Korean War, a major event of the early years of the Cold War. The war resulted from Korea's division into Soviet- and American-controlled sectors at the end of World War II, similar to the postwar situation in Germany. With Stalin's permission, the leader of the North, Kim Il-Sung, ordered an attack on the South in 1950 as a way to unify Korea under communism. Stalin and Kim believed that the Americans would not respond militarily, but they were mistaken. American-led United Nations troops quickly intervened to stop the communist advance, with Chinese soldiers joining the North Korean side soon thereafter. This bitterly fought contest resulted in a stalemate, and it gave the Cold War one of its first significant body counts: over 36,000 Americans, 600,000 Chinese, and around two million Koreans died. North Korea's surprise attack—just a year after China went communist—seemed to confirm the West's suspicions of Soviet ambitions to export and expand communism throughout the world. Picasso's painting could not have been more topical.

Massacre in Korea purports to depict an American atrocity in Korea, where American servicemen reportedly killed many civilians, including women and children. The painting thus recalls Picasso's *Guernica* (1937), his monumental lament for the Spanish victims of a bombardment during the Spanish Civil War by General Franco's German and Italian fascist allies.

Enrico Baj
Nuclear Forms, 1951
(detail).
See fig 2.3

61

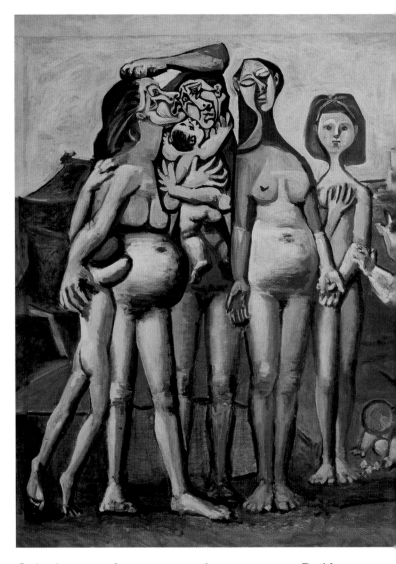

Only this time, Americans are the perpetrators. Building on art-historical precedents, namely Francisco Goya's *The Third of May* (1814), Picasso divides his painting into two halves—one containing a firing squad, the other its victims. This partisan picture aligns with Picasso's politics at the time; he was not only the most famous artist in the world in 1951, but also had become one of the world's most famous communists after joining the French Communist Party in 1944. *Massacre in Korea* proved highly controversial when exhibited in Paris soon after its completion, generating international headlines both celebrating and condemning Picasso's committed anti-American stance.

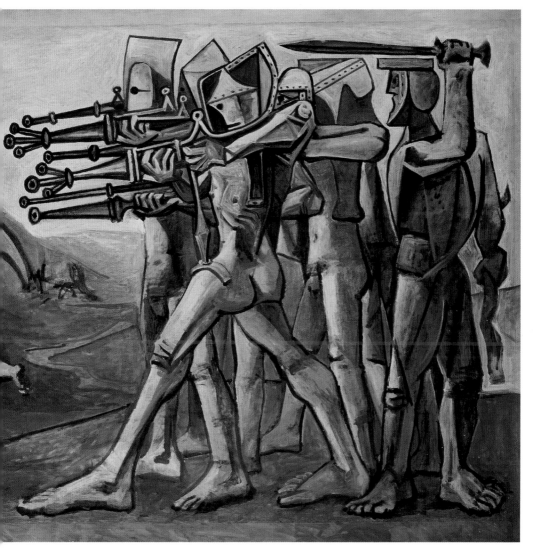

While Soviet officials generally approved of *Massacre in Korea*'s content, they did not approve of the picture's style, as Picasso employed modernist distortions and exaggerations that did not adhere to the strict aesthetic of Socialist Realism. The flatly painted ground and sky, for example, do not construct a convincing landscape; instead, they call attention to the picture's artifice. The painting was also ambiguous in another way, as nothing identified the murderous soldiers as specifically "American." *Massacre in Korea* thus created discomfort on both Cold War sides; Americans took issue with the painting's content (they denied any such atrocity), the Soviets with its style.

Mirroring the painting's ambiguity, Picasso himself, according to art historian Serge Guilbaut, was a kind of Cold War "double agent," dealing with communist authorities one day and wealthy art collectors and opulent galleries the next. The painting itself even switched Cold War sides in 1956, when Polish students paraded a reproduction through the street to protest the Soviet invasion of Hungary.

With *Massacre in Korea* and other works that initially supported the cause of communism, Picasso became a viable, visible model in this early Cold War period for artists seeking an escape from the stylistic straightjackets of abstraction and Socialist Realism. In 1948, Picasso succinctly explained why communism did not affect his artistic style: "I don't try to advise the Russians on economics. Why should they tell me how to paint?" Artists from across Europe in the early 1950s—most notably André Fougeron in France, and Renato Guttuso in Italy—also combined the fractured forms of modern art with charged political content that criticized the capitalist world. Guttuso especially experienced widespread fame in the 1950s, with solo exhibitions across Western Europe. His work had even been shown at the Museum of Modern Art in New York in 1949. He felt it was absurd to have to choose between American-style abstraction and Soviet figuration. As expressed in a drawing discussed in Chapter 1 (see FIG. 1.20), he believed this division to be patently artificial, based on stubborn ignorance and willful blindness. Therefore, many of his large-scale paintings address specific left-wing Italian political concerns in a loosely Cubist and expressionist style. Considering that the Communist Party of Italy was perhaps the strongest in Europe after World War II, and that its loss in the 1948 national elections has been tied to covert American activities, Guttuso's now-marginalized paintings are important artifacts of the period. They remind viewers of an artistic and political situation far more complicated than simple Cold War binaries. Adherents to Guttuso's brand of engaged realism even populated the ranks of artists in the United States and Great Britain during the 1950s, although art history textbooks rarely say so. In the American pavilion at the 1954 Venice Biennale, for example, the Abstract Expressionist paintings of Willem de Kooning shared the space with the socially concerned, left-wing pictures of Ben Shahn.

Picasso, Guttuso, and many other avowedly communist artists of the period employed political and figurative practices that did not align with the traditional, quasi-photographic practices of official Soviet artists around 1950. If *Massacre in Korea* confuses the broad artistic divisions of the Cold War, it nonetheless relies on another binary that also proved significant in the early years of the conflict: machines versus humans. Despite the presence of a simple sword in the hands of a soldier at the picture's right, Picasso's other executioners resemble robots—clad in cold, gray metal, with their futuristic multi-barreled guns nearly fused to their bodies. By including only nude women and children in the group of victims, Picasso emphasizes the division between the hardness of military technology and the vulnerability of human flesh: masculine agents of war set against the traditional image of non-combatants. This painting thus condemns not only an American atrocity in Korea but also, perhaps, a broader Cold War threat posed by technological agents of destruction. (American president Harry Truman publicly threatened to use nuclear bombs during the Korean War, and in 1950, a few months before the war began, Picasso was denied a visa to visit the United States as part of a group seeking to lobby Washington against further development of such weapons.) New martial technologies on both sides—whether more powerful rockets, higher-yield nuclear weapons, or sophisticated radar nets for tracking the enemy—helped structure the Cold War, and transcended the conflict's ideological differences. With the threat of nuclear annihilation now affecting everyone on the planet, *Massacre in Korea* restages the Cold War as a sweeping tableau of humans everywhere at the mercy of new military machines.

Also significant in bridging the cultures of Cold War adversaries was the development of cybernetics. As defined by the American scientist Norbert Wiener in 1948, cybernetics posited parallels between the natural and computer worlds—considering ways that, say, the human body, machines, and political interactions are all subject to similar mechanisms of control and regulation. Scientifically exploring these links could improve the efficiency and accuracy of individuals and machines alike across society. Both Cold War sides embraced cybernetics as an efficient and automatic means of optimal military readiness; planning for a swift, total, and global nuclear war, for instance, required

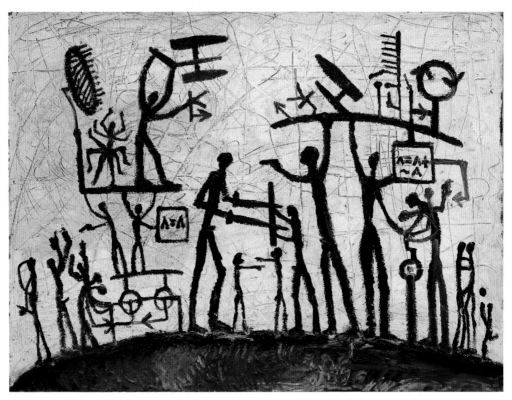

Fig. 2.2
A. R. Penck
World Picture, 1961,
oil on hardboard, 48 x
63 in. (122 x 160 cm).
Kunsthaus Zürich.

complex algorithms that minimized the effect of unpredictable human traits like emotion. And a credible position of nuclear deterrence depended on just such automation to ensure that the other side would not consider threats of atomic retaliation as bluffs. Cybernetics, as a closed system of rationality, also provided a model for understanding the Cold War itself: the conflict could be viewed as a kind of cybernetic system in which all global events were governed by the larger struggle between capitalism and communism.

Cybernetics and its embrace of rationality became an escape hatch for artists during the Cold War. The East German artist A. R. Penck (born Ralf Winkler), who was familiar with Wiener's writings, is a case in point. In 1961, working outside of official channels, he completed his *World Picture*, a painting that engages with the Cold War and cybernetics (FIG. 2.2). Like Picasso's *Massacre in Korea*, Penck divides his picture in two, with separate groups of stick figures facing each other—guns, swords, and missiles drawn. Despite the potential belligerence, however, the two sides are locked in nearly symmetrical stasis. Completed soon

after the construction of the Berlin Wall, this picture reduces the Cold War to a code-like schema. Refusing to take a side, Penck tries to analyze the conflict with dispassionate objectivity; in 1965 he wrote that he had "moved away from things artistic" and was instead applying himself to "mathematics, cybernetics, and theoretical physics." *World Picture* may show the world divided into two camps, but the artist's cybernetic commitment to systematic thinking renders them indistinguishable. By employing a language of technology, Penck deviates from the official East German style of Socialist Realism without subscribing to the abstraction of the capitalist West. Like Picasso, he finds his own viable alternative to the reigning aesthetic binary.

During the Cold War, advances in technology—whether computers or weapons—produced artistic responses that brought the competing sides into something approaching alignment; technology became a kind of universal language of its own that rendered questions concerning abstraction and figuration obsolete. This chapter will address artists whose practices engaged with the vast horizon of Cold War technologies—some taking optimistic positions, others remaining more skeptical. Especially important are those artists, like Penck, whose work embraced technological languages to get around the stylistic mandates of the Cold War. A key contradiction of the conflict, however, emerges in any consideration of art and technology at this time: Even as advances in electronics, telecommunications, and space travel promised a utopian liberation from bodily and political constraints, these same technologies were bound up with the threat of nuclear Armageddon. Technology, the bearer of new freedoms, might also end human life itself.

Transforming the Invisible—"Nuclear Painting"

The director of the Japanese film *Godzilla* (1954), Ishirō Honda, commented that the film's title character—itself a monstrous by-product of nuclear testing—was an attempt to evoke the atomic bomb by making "radiation visible." The ambiguous and novel forms of gestural abstraction, especially in the early 1950s, became another way to do so. Jackson Pollock made such a connection at this time, stating in an interview that the "old forms of the Renaissance or of any past culture" were inadequate to

express the advances of technology in the twentieth century: "the airplane, the atom bomb, the radio." A painting such as *Autumn Rhythm* (see FIG. 1.1) could bear such atomic metaphors. Lacking a horizon, Pollock's painting, with its swirls and patterns, evokes the hidden worlds of both microscopic and galactic dimensions—both part of the scientific realm of radiation waves. Alternatively, the artist's careful balancing of chaos (pouring and dripping paint) and control (elegant patterns) could be read as symbolizing attempts to manage the explosive power of a nuclear chain reaction. The popular and learned West German magazine *Magnum* connected gestural abstraction to an atomic blast at the end of the 1950s, pairing a painting by the popular artist Wols (German-born, working in Paris) with a photograph of a nuclear detonation's mushroom cloud.

In 1951, two Italian artists directly linked their gestural painting to the atomic bomb. Enrico Baj and Sergio Dangelo founded the Nuclear Art Movement in Milan, publishing the "Technical Manifesto of Nuclear Painting" the following year. Echoing Pollock's pleas for new modes of expression, Baj and Dangelo declared their aim to "reinvent" painting so that it would address the forms of the "atomic universe." While many artists across the world eschewed traditional approaches to the medium in the early 1950s—some even literally attacking their canvases to register their existential disgust with a post-Holocaust, post-Hiroshima world—few others explicitly reframed painting as a primary tool to express the peril of the nuclear age. In *Nuclear Forms* (1951), Baj places Pollock-like drips and pools of enamel paint against a bright yellow backdrop that, especially in light of the title, resemble two mushroom clouds in a bright, yellow-hot sky (FIG. 2.3). While in a certain context Pollock's drips could signify an individual's freedom, for Baj similar marks suggest the opposite: something humans cannot control. As Baj and Dangelo wrote in their manifesto: "Truth no longer belongs to you: it is in ATOM." This radioactive truth defies stable artistic categories, with Nuclear Painting cutting sheer across the divisions of abstraction and figuration. Baj's canvases call to mind films such as *The Blob* (1958), which showcased a formless mass of toxic sludge on a rampage. In both the film and Baj's works, radiation's transformative powers— mere matter coming to life—capture the period's anxiety toward

Fig. 2.3
Enrico Baj
Nuclear Forms, 1951,
oil and enamel on
canvas, 27½ x 19⅔ in.
(70 x 50 cm). Archivio
Baj, Vergiate.

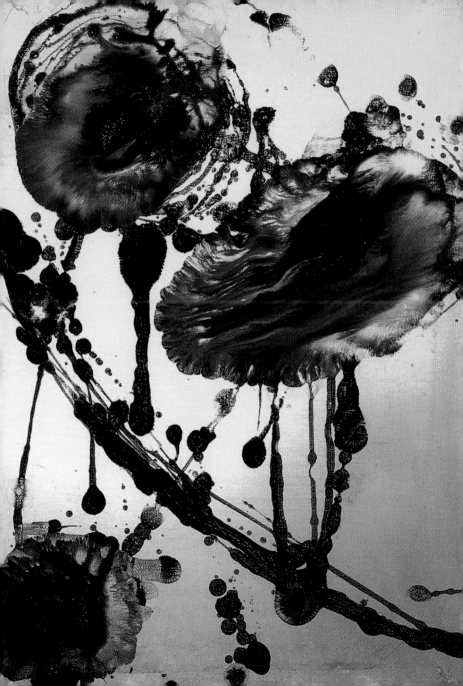

its precarious nuclear present, perched to plunge headlong into an apocalyptic future.

Baj was loosely affiliated with a European movement known as Art Informel. Primarily theorized by the French critic Michel Tapié in a 1952 book called *Art of Another Kind*, Art Informel included practitioners who were committed neither to abstraction nor figuration but rather to a common attitude of indifference to traditional notions of artistic beauty and perspectival space—an attempt to find an authentic voice in a world whose cultural foundations had entirely collapsed by 1945. While several abstract painters were associated with the movement (Wols, for instance), two of the most popular—Jean Fautrier and Jean Dubuffet—were committed to a gritty, deliberately debased figurative practice. If Guttuso's and Picasso's explicitly political paintings provided one model for postwar figuration, then Fautrier and Dubuffet offered something very different, rooted in notions of modernist alienation.

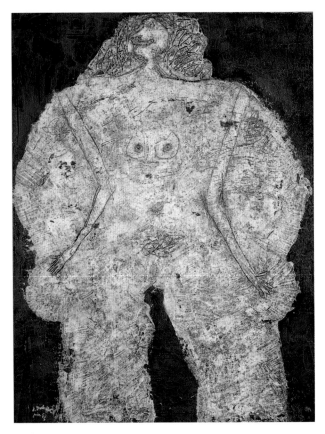

Dubuffet's paintings of women from 1950, known collectively as his *Corps de Dame* series, expresses just such a rejection of artistic decorum. In a typical painting from the series, a morass of muck and mire—organized around a primitive, grotesque, and flattened image of a woman—renders a subject usually associated with beauty as a childish, muddy mess (FIG. 2.4). Some of this desire to confront the viewer with palpable matter emerges from dealing with the horrific reality of the Holocaust—a trauma so massive that it threatened to remain an abstraction. Dubuffet consciously sought to pervert high culture, thus exposing the complicity of art with barbarism before and during World

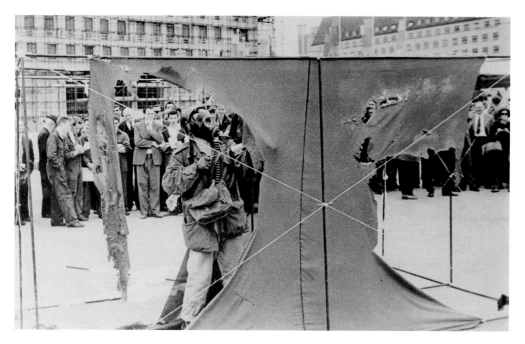

Fig. 2.5
Gustav Metzger demon-
strates his "Auto-De-
structive Art" on the
Southbank, London, on
July 3, 1961.

War II. His woman also suggests a genetic mutation gone wrong in some charred, post-atomic landscape—note how her fatty flesh has far outgrown her arms, for instance; while the artist asserts his brute individuality, it seems futile in the context of a past or future disaster. The bomb might be cutting-edge technology, but the instinct to drop it—not to mention its apocalyptic aftermath—remains outside of rational, civilized imaginings. American President Truman acknowledged as much after the initial test of the atomic bomb in 1945: "machines are ahead of morals by some centuries."

By the early 1960s, certain artists and critics had come to realize that one could not simply "paint" or "sculpt" to register the bomb in their work; the styles associated with Pollock and Art Informel had become too linked with the booming art market and American ideologies of "freedom." Gustav Metzger—a German-born, London-based artist—reconfigured abstraction as both mechanical and violent in a legendary performance on London's Southbank in 1961. Wearing battle fatigues and a gas mask, Metzger attacked three large, standing frames of nylon with a spray can of hydrochloric acid (FIG. 2.5), clearly referencing the well-known photographs of Pollock at work in his studio. Metzger called his practice "Auto-Destructive Art"—the point

being that the work of art, whether over the course of minutes or years, should eventually destroy itself or disintegrate. In his London performance, the nylon began to vanish within seconds of coming into contact with the acid, reimagining Pollock's private actions of creation as a public act of near-complete destruction. The bomb was on Metzger's mind; in one of his manifestos, he wrote, "Auto-destructive art is an attack on capitalist values and the drive to nuclear annihilation." Pollock's marks thus not only connote individual freedom, but also a dangerous, technocratic American belligerence; a culture constantly perched on the edge of nuclear apocalypse required an art that consumed and destroyed itself. Other artists from around 1960 also reframed the "freedom" of gestural painting as violence. The drips in works by French artist Niki de Saint Phalle, for example, were the result of shooting paint-filled balloons with a rifle, thereby exposing the violent underbelly of the rugged, cowboy individualism associated with American artists like Pollock.

The Cybernetic Imagination
While Dubuffet and Baj registered Cold War anxiety by blurring the distinction between abstract materiality and primitive creatures, other artists expressed the period's unease in another way: a more direct conflation of human forms and machines. At first glance, British artist Eduardo Paolozzi's *St. Sebastian, No. 2* from 1957 (FIG. 2.6) seems to be a mutated humanoid in the spirit of Dubuffet's woman. But this larger-than-life-size bronze sculpture is decidedly mechanical, comprising primarily the fossilized impressions of machine parts—wheels, radios, gears, and other components—to create a crude midcentury version of the human/machine hybrids that would later feature in films like *Blade Runner* (1982). If one Cold War nightmare consisted of a decimated world full of irradiated and mutated beasts, another depicted a world where technology has displaced humans. By figuring the innards of a human as parts of disused machines, Paolozzi taps into the period's interest in cybernetics—especially its equation of humans and machines, which eventually led to the coining of the term "cyborg" in 1960. While cybernetics could provide utopian models in which human foibles and irrationality—not to mention race and class—might be transcended,

Paolozzi's sculpture reminded viewers of the dark, anti-human side of the Cold War's reliance upon technology. *St. Sebastian, No. 2*'s charred and fused remains also suggest how mechanical rationality might lead to apocalypse. Although arrows could not kill the Christian martyr Saint Sebastian, not even a cyborg can survive a hydrogen bomb, the so-called "super bomb" first tested by American and Soviet forces in 1952 and 1953, respectively.

In both the Soviet Union and the United States, cybernetics spawned computerized networks and game simulations that helped shape policies governing weapons deployment, troop movements, and foreign aid. The linked network of radar systems, interceptor fighters, processing computers, and guided missiles that would detect and potentially deflect a surprise nuclear attack was one such system. Computers and systematic thinking could therefore plot a course for a safer and more efficient world, whether under the guise of capitalism or communism. If Paolozzi imagined the dystopian side of a cybernetic future, certain American and Soviet artists were more optimistic in the early 1960s—connecting art and science as a means to enrich both.

The critic Clement Greenberg had provided a theoretical model for understanding the development of postwar American painting: Pollock and others embraced pure abstraction while emphasizing painting's inherent properties—its flatness, for instance (see FIG. 1.1). But how would American painting continue to evolve after Pollock? Greenberg found his answer in two artists based in Washington, D.C.—Morris Louis and Kenneth Noland—who abandoned the chaos and messiness of

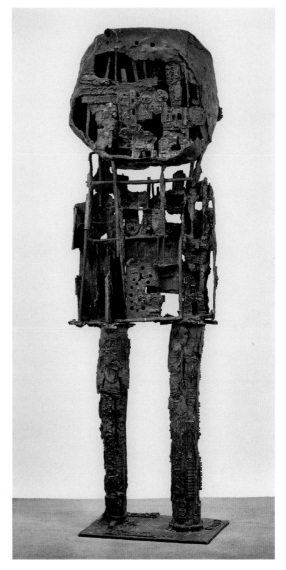

Fig. 2.6
Eduardo Paolozzi
St. Sebastian, No. 2,
1957, bronze, 86¾ x 28
x 20 in. (220.3 x 71.1
x 50.8 cm). Solomon R.
Guggenheim Museum, New
York.

Fig. 2.7
Morris Louis
Saraband, 1959, acrylic
resin on canvas, 8 ft
5⅛ in. x 12 ft 5 in.
(256.9 x 378.5 cm).
Solomon R. Guggenheim
Museum, New York.

drip paintings and other modes of gestural abstraction, adopting more sterile and mechanical practices. In *Saraband* from 1959 (FIG. 2.7), Louis poured layers of color to create a veiling effect, but his marks lack the texture and tactility associated with Pollock and other Abstract Expressionists. The presence of the human hand is no longer evident; the painting seems to be the product of only the materials themselves. The canvases of Pollock and his circle were too human—too flawed—for Greenberg's increasingly hermetic system. If art still expressed something of the human condition, it was to be mediated through a rigid, mechanical logic.

This rationality was at the heart of Greenberg's 1960 essay "Modernist Painting." While situating American art as the fulfillment of the European tradition, he explicitly connected the best American abstract works to the scientific method: Art and science belonged to the "same specific cultural tendency." A refined painting like Louis's *Saraband* was the product of something akin to the processes of science—a closed system of self-criticism that built upon previous results. Because Pollock's drip method had been a successful experiment, artists should

build upon this innovation. By letting his acrylic paint seep into the weave of the unprimed canvas (something he learned from fellow painter Helen Frankenthaler), Louis did just this—achieving a more fundamental flatness than Pollock. This "science" of painting mandates artistic purity; nothing outside the discourse of art should intrude into the closed system. While *Saraband*'s forms do not necessarily look computerized, they are built on a cybernetic logic whereby a *system* generates different canvases from a discrete number of changing variables.

By comparing his preferred type of painting to science, Greenberg's criticism also invited readers to consider the dark side of advanced technology and science, embodied above all in nuclear weaponry and the threat of global mass destruction. Such technologies were front and center on the agenda of President Kennedy's administration, aptly given the space-age moniker "The New Frontier," and frequently appeared in mass-media outlets, especially *Life* magazine. Responsibility for military strategy increasingly shifted from generals with battlefield experience to "whiz kids" (such as Secretary of Defense, Robert McNamara) who relied upon computer models to make tactical decisions, while think tanks (especially the RAND Corporation, which studied, among other things, the efficiency and destructive power of a potential nuclear strike through a crunching of the relevant numbers) increasingly dictated national defense policy. Their calculations transformed the Cold War into algorithms, detached from human questions of ethics or morality. If Pollock's *Autumn Rhythm* could represent ideologies of freedom, then Louis's *Saraband* is perhaps a fitting parallel to the technocratic turn in American nuclear strategy after Kennedy's election.

Soviet Socialist Realism was also a kind of science—or, at least, a closed system—where artists combined different fixed elements to create a hermetic world that was parallel to, but separate from, lived reality. To make a successful Socialist Realist painting, artists could (and did, repeatedly) combine images of happy Soviet citizens and representations of Lenin or Stalin in different architectural or outdoor settings. *Youth of the World—for Peace* and *A Leader in the Pioneers (Her First Report)* (see FIGS. 1.2 and 1.15) are both versions of this formula. After Stalin died in 1953, the authorities loosened such rigid strictures. Nikita Khrushchev, who emerged as Stalin's

successor, shocked his homeland (and the world) in 1956 with his "secret speech." Speaking for several hours, he denounced the crimes and excesses of Stalin's regime, ushering in what became known as the "Thaw" in the Soviet Union and a number of satellite states. This included "de-Stalinization," which entailed the removal of images of the dictator and a general relaxing of attitudes toward repression and censorship. As a result, many Socialist Realist artists shed the style's usual pomp, sheen, and artificiality in favor of more sober or honest portrayals of life. Nevertheless, official paintings remained very conservative and propagandistic.

The Thaw also brought changes to the scientific community, and not least an interest in cybernetic systems and computers. During Stalin's rule, cybernetics was officially deemed an "ideological weapon of imperialist reaction"—an American plot to dehumanize workers by reducing them to a type of "machine." During the Thaw, however, cybernetics became not only an important tool for Soviet scientists, but also a common model for productive thinking across disciplines, as evinced by numerous articles in the Soviet mass press and a popular 1961 book entitled *Cybernetics in the Service of Communism*. This built upon the significant Soviet scientific victories in the late 1950s and early 1960s: the launch of Sputnik, the world's first satellite, in 1957, and Yuri Gagarin's historic voyage into outer space in 1961. Scientists, as well as young Soviet artists, viewed cybernetics' rationality as a means to escape the dogmatic, irrational pronouncements of the Party. While not officially sanctioned in art schools, new forms of Soviet abstract art soon reflected this drive toward scientific clarity.

For instance, the Moscow-based artist Yuri Zlotnikov painted *Signals System Series* (1957–62), a group of small abstract works (FIG. 2.8). While visually harking back to the revolutionary work of Kazimir Malevich (see FIG. 1.7), these works reconfigure the older geometric forms of modernist abstraction as fodder for cybernetic investigations. Zlotnikov aimed to remove any traces of individual expression in his works in an attempt to "reveal the laws of psychophysiological motor behavior and the nature of reactions to color and form." In the pictured example, red, orange, blue, and black dots float in a vast, blank field as a means to explore how the basics of painting—colors and the positioning

of compositional elements—communicate a message to an audience: how, in other words, a work "signals." If Socialist Realism purported to be a transparent language, Zlotnikov's work provides a corrective, laying bare the system and structures of painting in an attempt to understand them scientifically. Since cybernetics sought to forge connections across disciplines, Zlotnikov collaborated with scientists and mathematicians. Clubs associated with weapons-development laboratories exhibited some of his paintings, and scientists even tested some of his perceptual theories. The artist, however, rejected these affiliations when he realized that they rendered him complicit with the building of horrific instruments of war.

Francisco Infante-Arana was another Soviet abstract artist who established relationships with scientists, working in an official state context as part of the All-Union Scientific Research Institute of Industrial Design, which was established in 1962. This group, which had set up more than 200 laboratories across the Soviet Union by 1967, allowed artists to experiment with avant-garde forms in the name of research. Like Zlotnikov's paintings, Infante-Arana's works were shown publicly in

Fig. 2.8
Yuri Zlotnikov
From the *Signal System Series*, 1957-62, gouache and tempera on paper, 35⅘ x 26¼ in. (91 x 68 cm). The Tsukanov Art Collection.

Art, Technology, and the Cold War

scientific or industrial sites, not traditional gallery spaces. Many of his early works take the form of spirals, appearing to have been created by electronic pulses or light waves, not human hands. In the mid-1960s, he created a body of more than 60 works entitled *Project of the Reconstruction of the Starry Sky*, which depicted various configurations of stars at night (FIG. 2.9). Despite their vague landscape-with-silhouetted-trees format, these paintings nevertheless engage painting's basic potential to communicate, similar to Zlotnikov's simple marks. The night sky, like the discipline of painting itself, has long been a site for constructing meaning out of chaos: The identification and naming of constellations are attempts to organize thousands of visible stars around recognizable figures. Infante-Arana goes a step further, imagining new constellations where stars line up in rigid, regular patterns—expressing the artist's utopian desire to further perfect nature through rationality. Instead of adhering to the rigidity of Socialist Realism (or any ideological program), Infante-Arana's works express a mode of communication that lies beyond the differences of the Cold War, and indeed extends to the cosmos above all. The infinite possibilities of outer space, much publicized thanks to the Space Race, could lead to new definitions of bodies, nations, and the like.

Infante-Arana also co-founded the Movement group in Moscow in 1964, whose members experimented with actual machines to produce interactive environments. Due to the mandate that artists must follow the tenets of Socialist Realism, such works of art—some of which actively confused humans and machines—were classified as "decorations," "designs," or "research," so as not to attract attention. Movement even staged artistic performances at the Kurchatov Institute of Atomic

Energy, with engineers there helping the artists realize their ambitious plans. However, using an advanced atomic research lab as a means to escape the straitjacket of Socialist Realism entailed the repressing of technology's dystopian aspects. Movement's cybernetic performances celebrated, or at least turned a blind eye, to the institute's research into building a more perfect apocalypse.

When looking at austere abstract paintings in either the United States or the Soviet Union during the first part of the 1960s, ideologies related to cybernetics enabled artists to produce works which transcended Cold War artistic divides. While Greenberg's criticism and the work of Louis (perhaps unwittingly) attempted to make art into a kind of science and thus further purify its forms, the Soviet examples of Zlotnikov and Infante-Arana more directly engaged the scientific community as a way to escape the strictures of Socialist Realism. Unlike Louis, who was part of the American art establishment—he was one of Greenberg's chosen inheritors of Pollock's mantle—Infante-Arana was an outsider, bristling against the confines of the official doctrine of Socialist Realism. Nevertheless, both artists engaged painting as a system, as a set of conventions that their works would unveil.

The well-traveled French artist Yves Klein can chart the links between sober abstraction and the destructive side of cybernetics. Klein's most iconic works are his monochrome paintings, most in the same deep shade of blue known as International Klein Blue (IKB). Klein discovered an experimental way—using clear resin and dry pigment—to create lush fields of color that enveloped viewers in a blue world unanchored by horizons or figures and seemingly not grounded to their canvas support. In 1957, Klein signed Enrico Baj's manifesto for Nuclear Painting. Considering the vast differences in their artistic techniques—an expanse of solid color versus gestural marks—why would Klein sign? In 1958, he provided an answer, relating his monochromes to a future nuclear war, suggesting an association between the nothingness and immateriality signified by his paintings and the aftermath of an atomic apocalypse. Klein also wrote to the international body in charge of detecting nuclear test blasts with an ironic proposition: he offered to paint bombs around the world in his signature blue so that they could be easily located. Klein also ruminated on a world enveloped in IKB-tinted fallout, in

which an irradiated earth would be transformed into something like one of his monochromes. He ended his letter by stating that "the disintegration of matter will give us the most extraordinary monochrome realizations that humanity—and I dare say the cosmos—will have ever known." Klein here acknowledges what bourgeois audiences expect from art: a feeling of transcendence, disconnected from the mundane activities of everyday life. But Klein does so in an absurd and jarring fashion—aestheticizing nuclear weapons, explosions, and fallout in hyperbolic prose—as if to highlight how inappropriate it is to seek transcendence from art in the atomic age. Indeed, in comparing an atomic apocalypse to the aims of his own work, Klein's Swiftian wit uncovers the period's dangers of conflating art and science. If the Cold War's parade of nuclear test blasts—on display regularly in the global mass media—offered the public a window onto spectacular technological sublimity, would not art itself be superseded?

Cold War Constructions

Because the works of Morris Louis and Franciso Infante-Arana suggest connections between art and technology, they should be considered in relation to Soviet Constructivism, at least as the term was understood during the 1950s and 1960s. Originally, "Constructivism" referred to the revolutionary works of Russian avant-garde artists such as Vladimir Tatlin and Aleksandr Rodchenko, who hoped to transform the idea of the artist from a maker of luxury goods to an engineer who helps create an equitable, class-conscious world by fashioning useful objects (Rodchenko's design for a break room for workers being a good example; see FIG. 1.8). In the hands of artists and critics during the Cold War, however, the term "Constructivism" lost these radical connotations. It came to identify any work of art that used industrial materials or that seemed to rely extensively on mathematics and rationality. Indeed, as the art historian Benjamin Buchloh noted in a 1986 essay, certain key figures (especially the Russian émigré sculptor Naum Gabo) transformed Constructivism into yet another way to establish notions of artistic autonomy, neutering its connections to socialism and a mass audience. Constructivism's original utopian aims were thus reconstituted: at one time revolutionary in a communist

sense, it now represented a vague idea of art imagining societal transformations through abstraction and ideal geometries. By this logic, even the famous Dutch artist Piet Mondrian would qualify as a Constructivist.

Postwar Constructivist painting was abstract, but distinct from the more gestural, emotive brand of American painting associated with Jackson Pollock. In light of its loose connections to the radical Soviet practice of the 1920s—at least in name—and its differences from American-style painting, artists around the world adopted this new, watered-down Constructivism to express a "Third Way." Put simply, they could engage with the artistic forms of modernism (as Socialist Realism could not) without needing to align themselves with the ideological baggage of Abstract Expressionism or similar European models of painting and sculpture. While many artists in different locales experimented with Constructivist forms for myriad reasons, a common link among many was just such a desire for a "non-aligned" creative practice. These rational geometries, then, run parallel to a political agreement reached in Belgrade in 1961, when several countries—including India, Egypt, Cuba, and Yugoslavia—founded the Non-Aligned Movement. Several years in the making (beginning with an international conference in 1955 in Bandung, Indonesia), the agreement committed its signatories to a course that would be independent of Cold War bipolarity.

These political and artistic desires for a Third Way converged in several specific sites—countries throughout Latin America and Yugoslavia, for instance. Josip Broz Tito, Yugoslavia's communist leader, sent ripples around the Cold War world when he withdrew his country from the Soviet Bloc in 1948. Tito remained suspicious of modern art, however, and Yugoslav artists initially continued to operate under Stalinist modes of repression, until later economic and cultural liberalizations. Thus, Socialist Realism (albeit with more stylistic latitude than Soviet models) held sway in Yugoslavia until at least the early 1950s. A group of Croatian artists and architects calling themselves Exit 51 (after the year of their formation) rejected these figurative practices and instead looked back to Mondrian and the Bauhaus by championing geometric abstract art as a mode of experimentation that could link different areas of social practice.

Ivan Picelj's *Composition XL-1* is indicative of the group's paintings (FIG. 2.10). On the surface, its hard-edged field of black, brown, and white shapes seems stable and fixed; on a closer look, however, visual confusion sets in. Does the white exist in the background or foreground? Are the components stable or flickering? The Neo-Constructivist forms championed by Exit 51 soon achieved near-official status in Yugoslavia, offering an apt artistic language for the nation's declaration of Cold War independence. While a negation of Socialist Realism, such sterile, geometric exercises, however, were not necessarily radical. In Yugoslavia and other Eastern Bloc countries such as Poland, such geometries became, in art historian Piotr Piotrowski's phrase, a kind of "tactical liberalism," which helped legitimize repressive regimes. Since works like *XL-1*, with its abstract and de-politicized forms, did not openly criticize communism, they served as a means to demonstrate, however superficially, "progressive" reforms to the West—helping secure the loans and trade pacts essential to Yugoslavia's sovereignty. By the 1960s and for the rest of the Cold War, Yugoslavia was situated both geographically and ideologically between the two blocs, with each side viewing it with suspicion.

The rational forms of Constructivism also flourished throughout Latin America in the postwar period. The Madí group in Argentina was founded in 1946, the "Ten Concrete Painters" emerged in Cuba in 1959, and other groups formed in Venezuela, Uruguay, and elsewhere. As in Yugoslavia, this style partially served as a mediating force between Cold War poles. It was a way to assert a "Latin American" identity that was not subsumed within American interests. It could symbolize progress and other values tied to the increasing industrialization and

Fig. 2.10
Ivan Picelj
Composition XL-1,
1952-56, acrylic on
wood, 39⅖ x 31⁹⁄₁₀ in.
(100 x 81 cm). Museum
of Contemporary Art,
Zagreb.

modernization of the region's metropolises. As noted in the Introduction, the most consequential Cold War battles were fought not in Europe, but Asia, Africa, and Latin America; the importance of these emerging countries resided in the fact that they could potentially upset the fragile Cold War balance of power.

The Guatemalan coup in 1954 typified United States policy in Latin America. The CIA helped overthrow Guatemala's massively popular, freely elected president Jacobo Árbenz, because his socialist land reforms threatened the profits of a powerful American corporation, the United Fruit Company. Instead of questioning the policies of this private company, known locally as "the Octopus," Eisenhower and his cabinet suspected "communist infiltration" of the countryside. Over 200,000 Guatemalans died in the ensuing civil wars and violent dictatorships over the next 40 years. The United States also took more indirect approaches in the region: supporting reliable, pro-American dictators instead of unpredictable democracies that might freely elect a communist. After Fidel Castro's popular revolution overthrew the Cuban president and American ally Fulgencio Batista in 1959, just 90 miles away from Florida, such containment policies became more entrenched in the region, as Americans feared "another Cuba" in Latin America for the remainder of the Cold War. Despite increasing interdependence with the United States in terms of markets, tourism, and cultural products, many Latin Americans could not stomach American hypocrisy. How could the United States accuse the Soviet Bloc of brutally repressing the democratic rights of individuals while allowing the same behavior in Latin America in the name of fighting communism? Diego Rivera, one of the Mexican muralists discussed in Chapter 1, condemned American actions in the region in powerful paintings, including his stridently anti-American take on the Guatemalan coup, ironically titled *A Glorious Victory* (1954). Like Guttuso, Rivera rejected the strict Soviet codes of Socialist Realism to make his political points.

Brazil, the region's largest nation, was eager in the 1950s to establish itself on the world stage, and to do so with at least some independence from the Cold War belligerents. The building of a new capital city, Brasília, with architecture designed by Oscar Niemeyer, made a powerful statement; its futuristic

forms, unveiled in 1960, constructed a radically novel image for the nation that was untethered to its colonial past and Cold War present. The crisp lines and geometries of Brazilian Constructivism corresponded to Brasília's optimistic architecture and the nation's desire for continued economic development and progress along rationalist, modernizing lines. In addition, the recurring international exhibition founded in 1951 on the model of the Venice Biennale, the São Paulo Bienal, was instituted, in part, to situate Brazilian art in the context of American and Western European practices.

Waldemar Cordeiro's *Visible Idea* of 1956 is typical of the movement (FIG. 2.11). On a deep red background the artist painted a series of white spiraling lines. He then rendered the same form in black, but rotated it 180 degrees. The canvas goes beyond the mere appearance of a studied rationality; the shapes themselves embody the ratio of the "golden rectangle," a proportional relationship found across nature, studied since the time of the ancient Greeks. Cordeiro is representative of the São Paulo school of Constructivists, who emphasized theory and precisely calculated models over lived experience or intuition. A competing group, based in Rio de Janeiro and calling themselves the "Neo-Concretists," arrived at a different model of Constructivism in 1959. They engaged with geometry but were also dedicated to dismantling its inflexible assumptions.

Lygia Clark used Constructivist forms, but only as they were experienced through an acting, living body. Her *Animals* series from the early 1960s comprises individual sculptures, each different, made up of hinged metal plates that can be manipulated by the viewer. *Sundial* (1960) can lie flat or come into three-dimensional life in its unique combination of configurations (FIG. 2.12); as the series title suggests,

each sculpture is, in its own way, alive, while also enabling the beholder to experience the primal, creative act of manipulating sculptural form. While Cordeiro and Clark both deploy geometry in their artworks, the latter reinvests postwar Constructivist forms with radical notions of interactivity. Lygia Pape, another Brazilian artist associated with the Neo-Concretists, also produced works of geometric art that invited manipulation from viewers in the years surrounding 1960.

In the same years that Clark constructed her *Animals*, Brazil set itself on a course that was increasingly independent of the United States, especially under the presidency of João Goulart. Battling economic problems, he announced government takeovers of oil refineries and some under-utilized land, which to American officials, including President Lyndon Johnson, sounded like a tack toward communism. A military coup toppled the Goulart government in 1964, and while it was not officially sponsored by the United States, Johnson was quick to give the new dictatorial regime his "warmest wishes." These political developments bear on an understanding of Clark's work. Not

Fig. 2.12
Lygia Clark
Sundial, from the
Animals series,
1960, aluminum
with gold patina,
dimensions variable,
approximately 20⅞ x 23
x 18⅛ in. (52.8 x 58.4
x 45.8 cm). Museum of
Modern Art, New York.

only did she encourage active, democratic participation, but her dismantling of geometric and mechanical certainties undercuts the idea that art has a fixed position, political or otherwise. Her *Animals* become a metaphor for the dynamics of the Cold War as understood from different vantages: from a studied, theoretical distance, they appear rigid—but when experienced and handled directly, numerous possibilities emerge. As the 1960s progressed, Clark's and Pape's models of participatory aesthetics became a mode of resistance to the increased violence and repression of the Brazilian regime. They, along with fellow Neo-Concretist Hélio Oiticica, dismantled the forms of postwar Constructivism to find subversive, embodied strategies outside of the conflict's technological structures. For instance, in 1967, Pape cut geometric slices in a large white sheet, into which individuals placed their heads and marched through Rio. Known as *Divider*, this work formulated a social and urban organism out of a diverse collection of individuals. Interactivity with an art object had morphed into something approaching a protest.

While not necessarily using the geometric forms of Constructivism (as in Yugoslavia and Brazil), a number of important artists in India and Egypt nevertheless embraced technology in their works. Both nations had only recently cast off a British colonial presence and, like Yugoslavia, were important members of the Non-Aligned Movement. They viewed quick industrial and economic development as a means to achieve independence in the Cold War. Beginning in 1951, the first Indian prime minister, Jawaharlal Nehru, instituted a series of five-year plans—a concept derived from Stalin's own attempts to jumpstart Soviet industry in the late 1920s. Artists in the 1950s and 1960s, notably M. F. Husain, fused forms appropriated from Western modernism—such as Constructivism—with traditional Indian subject matter, producing works that did not take artistic sides in the Cold War.

Egypt's Gamal Abdel Nasser emerged as the most powerful figure in the Arab world—and a major Cold War player in the 1950s. Soon after achieving independence in 1952, he appealed to the United States for funds to help build the Aswan High Dam, a major technological project that would control flooding, help with agricultural irrigation, and provide an important source of electricity. But he complicated this request by buying

Soviet weapons from Czechoslovakia, thus confusing American officials with his intentions. With his diplomatic recognition of Mao's China, Nasser's independence went too far for the Americans, and after President Eisenhower canceled the promised aid, the Soviets were happy to step in with the necessary funding. While Nasser's Egypt remained officially non-aligned, it tilted toward the Soviets. His next provocative move was to nationalize the Suez Canal. A desire to keep this vital shipping lane under European control prompted an invasion from British, French, and Israeli forces in October 1956—with no advanced forewarning given to Eisenhower. The Americans and Soviets stepped in to defuse the crisis, leaving Nasser more powerful than before: He was credited with standing up to and humiliating former colonial powers, and even bringing Cold War enemies together for his own nationalist cause. It is no wonder that Nasser emerged as the undisputed leader of Arab nationalism, inspiring Arab-majority countries in the Middle East and Africa to be independent of both Soviet and American domination.

The dam and the Suez Canal became central metaphors for Egyptian nationalism and subjects for important works of art. The Cairo College of Art even sent students to Aswan in the mid-1960s to capture the building of the dam for posterity. While some of these artists employed styles more indebted to Socialist Realism, Effat Nagi's *The High Dam* from 1966 embraces a more industrial aesthetic (FIG. 2.13). While the work lacks the crisp geometric forms of the Cold War versions of Constructivism discussed earlier, Nagi nevertheless captures a dynamic, literal image of *construction*. Painted in mostly black linear strokes, with some blue and white highlights, the work, at first glance, looks to be a densely packed Cubist work—flat with shapes and lines locked into a tight, non-regular grid. But close inspection reveals topical details: small figures in the top left corner, as well as the cranes, scaffolding, and spindles that would be expected at such a site. The diagonals, especially the rectangle that dominates the central part of the composition, produce the picture's formal dynamism—its deviations from symmetry. This shape, when viewed in the context of the Aswan High Dam, can be viewed as a massive pylon being pulled into its correct place. While this version of Constructivism is more narrative than other international models, *The High Dam* demonstrates

Fig. 2.13
Effat Nagi
The High Dam, 1966,
acrylic on wood, 47¼ x
47¼ in. (120 x 120 cm).
Barjeel Art Foundation,
Sharjah, UAE.

a simultaneous desire for artistic and political independence in the Cold War. Such an aim fuelled Nasser's inauguration of the short-lived Mediterranean Biennale in 1955 in Alexandria, an art exhibition that attempted to find artistic affinities across the region—again, outside of Cold War bipolarity. Featuring representation from Egypt, France, Greece, Spain, and Yugoslavia, among others, the event attempted to forge a new geopolitical bloc through works of art.

Art as Irrational Technology

Technology structured the way both sides waged the Cold War, and its products and systematic thinking informed artistic production across and beyond the conflict's divide. Furthermore, the combined nuclear threat of the American and Soviet arsenals (and, eventually, those of other nations) linked the entire world under a potential mushroom cloud of annihilation. But scientific innovations also ignited imaginations around the world—as new images of the cosmos inspired dreams of transcending traditional boundaries.

While a diverse set of art practices rooted in the traditional media of painting and sculpture—from Pollock and his Abstract Expressionist cohort to postwar Constructivism in Latin America—engaged with this horizon of Cold War technology, some artists in the 1950s and 1960s used technology more directly in their work to make sculptures that were machines. Known under the umbrella term "kinetic art," such works were produced around the world—throughout Western and Eastern Europe, Latin America, Japan, and elsewhere. In addition to forging connections between art and science, these kinetic artists established international networks through exhibitions, magazines, and manifestos. Such cross-border connections (including those across the Cold War divide) attempted to rewire the Western art world to escape the dominance of American artistic practices in the 1960s.

Group Zero, established in 1958 by several West German artists, is a good example to consider here, as its linked network eventually included a roster of international practitioners. These artists made works that channeled the technological euphoria that accompanied scientific progress, especially space exploration, through the use of new artistic materials such as electric lights and motors. The artists associated with *New Tendencies*—a series of five exhibitions staged between 1961 and 1973 in Zagreb, Yugoslavia—expressed similar attitudes. Featuring many kinetic, as well as Constructivist, works from across the world, these exhibitions embraced cybernetics and, by the end of the 1960s, even actual "computer art." In the spirit of Yugoslavia's political non-alignment, technology again was employed as a means to transcend Cold War barriers: The exhibitions attempted to establish Zagreb as an alternative artistic hub, and included artists from both sides of the Iron Curtain.

The Swiss artist Jean Tinguely also used machines to make his kinetic sculptures, but in a way that critiqued the realities of Cold War technology. In front of more than 200 invited guests in the Sculpture Court of the Museum of Modern Art in New York, he set in motion his *Homage to New York* in 1960. Tinguely, who was affiliated with Yves Klein and with Group Zero, worked with Bell Laboratories engineer Billy Klüver to construct a giant mechanized contraption out of junk and other found objects, including a bathtub, weather balloon, player piano, motor, and numerous bicycle wheels (FIG. 2.14). At the appointed time, this towering construction came to life and began to destroy itself through violent shaking and planned explosions. When a fire broke out unexpectedly, firemen extinguished the blaze and ended the spectacle after a mere 27 minutes. With the artist calling it a "simulacrum of catastrophe," this unnerving display of destruction in the heart of New York City alluded to the nuclear threat—as would Gustav Metzger's acidic performance in London the following year.

Tinguely made such links explicit when he traveled to the Nevada desert in 1962, not far from a testing ground for American atomic weapons. There, he built and destroyed another kinetic sculptural contraption expressly for an NBC television program (*Study for the End of the World, No. 2*). While referencing nuclear warheads, Tinguely's rickety, useless machines parody their more advanced cousins, replacing the slick cybernetic networks of national defense with something cartoonishly violent. Considering their audiences at MoMA and on television, Tinguely's spectacles call attention to the period's obsession with destruction—how *Life* magazine regularly featured color pictures of atomic test blasts during these same years, for instance. But the unpredictable and useless nature of Tinguely's machines emphasize the same, albeit repressed, qualities in those machines of national defense. Are nuclear weapons not useless themselves, as they would obliterate life if actually launched?

Tinguely's irrational machines offer an apt critique of both capitalism and communism—showing not only how the two systems are similar, but also how an illusory logic of objectivity and progress pervaded the technological worlds of both. In a famous exchange with American Vice President Richard Nixon in 1959—the "Kitchen Debate" at the American National

Exhibition in Moscow—Nikita Khrushchev asked: "Don't you [Americans] have a machine that puts food into the mouth and pushes it down?" At the same time, Americans believed communists to be machine-like in their deterministic application of ideology, no matter the cost in human suffering; one need only consult period novels and films with assassination plots involving robotic, brainwashed Soviet agents, the best known being *The Manchurian Candidate* (novel, 1959; film, 1962). As the 1960s drew to a close, the lines separating rational and irrational technologies became increasingly blurred. Indeed, the nuclear doctrine of Mutually Assured Destruction was popularly known by its acronym MAD.

In *Massacre in Korea*, Picasso depicted innocent victims and their robotic executors, suggesting the global threat that technology posed to all during the Cold War. By the end of the 1960s, this nightmare had become increasingly real: Soviet and American forces each possessed enormous nuclear arsenals that could destroy the world many times over. Any utopian belief in technology or the transformative power of art, now overshadowed by apocalyptic undercurrents, was rendered naïve.

Fig. 2.14
Jean Tinguely
Homage to New York, 1960, performance at the Museum of Modern Art, New York. Photo by David Gahr.

91

Think. THINK. THINK.

Bew

the TOUCH appeal

IT SMELLS

Dozens of small details add up to

The Cold War and Global Pop Art

Technology, and perhaps the camera above all, shaped the Cold War in profound ways. Certain photographs—such as the U-2 images that alerted U.S. officials to the presence of Soviet missiles in Cuba (see p.12)—wielded overt political power. But other, more innocuous images were also crucial to the waging of the conflict. The images in *Life* magazine are instructive in this regard, especially given the magazine's reach and influence in the United States during the 1950s and 1960s. *Life* took a strongly anti-communist perspective in its reportage, which was illustrated with some of the Cold War's key photographs. Yet its aim was more expansive than simple partisanship—the magazine sought to "see life and the world," according to founder Henry Luce's original prospectus. To do so, its editors published photographs, many in color, covering a wide spectrum of subjects—a Hollywood starlet and a struggling farmer, the Galapagos Islands and a small Colorado town, the work of Michelangelo and the drawings of children. The magazine's most memorable stories were important, instructive, and—through photographs that demanded the viewer's attention in both form and content—visually spectacular. In addition, its pages were full of advertisements, many with eye-catching photographs of their own. In *Life*'s presentation of midcentury America to itself, the United States was fighting the Cold War to defend the American way of life, but it did so to the accompaniment of many consumerist and other diversions. In fact, through its advertising content, *Life* pictured liberty and consumer choice to be one and the same. Imitations of the magazine

Richard Hamilton
Beware of Shutitis,
from *This is Tomorrow*
catalogue, 1956,
Whitechapel Art
Gallery, London
(detail).
See fig 3.2

(itself based on German and French models from the 1920s) appeared throughout the capitalist world after World War II—*Stern* in West Germany, and *Paris Match* in France, for example.

Life's model of using humanistic photojournalism to help narrate its stories was also adopted in the Soviet Union after Stalin's death. The chief editor of the Party's primary newspaper, *Pravda*, commented in 1961 that a good photograph is a truthful political document that also looks like a work of art. In other words, a photograph's composition matters, even in a country known to be suspicious of artistic "formalism." Fidel Castro more directly attested to *Life*'s effectiveness. In 1959, he is reported to have held aloft a copy of the magazine in front of his fellow revolutionaries in Cuba and said: "I want something like this." The editors at *Pravda* and Castro all realized that *Life*'s mode of photojournalism—employing the "universal" qualities of photography, a medium that seemed to report simple "facts"—produced effective propaganda, for whatever cause. As was the case with technology and cybernetics (as discussed in Chapter 2), a reliance upon photography in the mass media also linked Cold War adversaries in a joint enterprise.

This media landscape was essential for the development of Pop art, with artists from around the world in the 1960s mining picture magazines and newspapers for artistic strategies and raw subject matter. Andy Warhol's works—especially his silkscreen paintings—have become the paradigmatic Pop artworks. In *Green Disaster #2* (1963), he not only cuts a photograph out of a newspaper for his source, but the silk-screen process mimics the repetition of the printing press (FIG. 3.1). If the Cold War was really a war of "information and images," as Marshall McLuhan suggested in 1964, then Pop art must be central to the conflict.

Pop art played a significant role during the Cold War in two primary ways. First, its works dismantled the Cold War's rigid boundaries, both artistic and political. Pop art as a whole challenged the division, especially pronounced in the 1950s, between abstraction and figuration. Featuring recognizable imagery, the work of many American, Japanese, and Western European artists—not to mention some from the Eastern Bloc—rejected the notion that genuinely modern art must be abstract. And the best Pop did not necessarily repudiate abstraction, but merely reframed it as something that was found in everyday life. In terms of political borders, Pop

art exposed the ways that McLuhan's "information and images" circulated around the world. The Iron Curtain may have blocked the movement of people, but it could not stop all media transmissions: Smuggled magazines and broadcast signals helped make a purportedly impermeable border more porous. A shared international iconography—the Coca-Cola bottle, President Kennedy, and Marilyn Monroe—demonstrates that there was a common language across the Cold War world, much of it associated with the American media landscape. Of course, artists in different sites employed this shared language for an array of political aims: some critical of one or other Cold War system, some supportive, and many adopting a more nuanced position than outright rejection or endorsement.

Fig. 3.1
Andy Warhol
*Green Disaster #2
(Green Disaster Ten
Times)*, 1963, silk
screen and acrylic on
canvas, 107⅜ x 79⅛
in. (272.6 x 201 cm).
Museum für Moderne
Kunst, Frankfurt am
Main.

Second, Pop art served a didactic function: to slow down vision and educate the Cold War eye, as evidenced by a number of works associated with a group of artists, architects, designers, and critics in London known as the Independent Group (IG). Often considered the first Pop artists, the IG mounted small seminars and exhibitions, beginning in 1952, that encouraged an active mode of contemplating images. For them, an American car advertisement from *Life* magazine was as worthy of careful scrutiny as a painting by Picasso. In 1956, as part of an exhibition called *This is Tomorrow*, the IG-affiliated artist Richard Hamilton made two collages for the catalogue: the famous *Just What Is it That Makes Today's Homes So Different, So Appealing?*, which depicted a living room stuffed with consumer products and brand logos, and the lesser known *Beware of Shutitis*. The latter features a man's head with collaged arrows and thought-bubbles (FIG. 3.2). Hamilton's additions invoke the massive amount of information our senses gather for the brain to filter and process. How can one perceive the true nature of reality, the collage asks,

Fig. 3.2
Richard Hamilton
Beware of Shutitis,
from *This is Tomorrow*
catalogue, 1956,
Whitechapel Art
Gallery, London, offset
lithograph.

especially in a world dominated by the multisensory distractions of the mass media?

When one considers the specific man represented in *Beware of Shutitis*, the importance of the Cold War context to the IG's activities becomes readily apparent. Hamilton appropriated the head of Josip Broz Tito, the communist leader of Yugoslavia, who (as discussed in the previous chapter) had broken away from the Soviet Bloc in 1948. For Hamilton, the artistic equivalent of a "Third Way" outside either U.S. or Soviet hegemony was to make works that slow down the viewer's perception, exposing how propaganda and advertising operate, for instance. In a sense, Tito becomes a surrogate for the IG artists themselves, bringing new urgency to the "independent" half of the group's name. If viewers could process images slowly—and so come to understand the power of the visual—then they would be emulating Tito's geopolitical stance in relation to the Cold War's image culture. The collage also demonstrates that a sustained examination of found images allowed artists to outflank the conflict's stylistic norms of abstraction and figuration.

Although Pop art is usually discussed in terms of its American and British "originators"—especially Warhol and Hamilton—this chapter takes a more global approach in order to focus more on specific national contexts than on questions of influence and emulation. All the artists discussed in this chapter arrested images from the flow of everyday life and transformed them into "art." This strategy is, at its core, allegorical: placing familiar images in a newly fashioned art context empowers the viewer to see them in novel and counterintuitive ways. The object or image may not be radically transformed, but it can slyly accept new inflections when contemplated as a work of art. Considered in this way, Pop art is conspiratorial and right in line with the early Cold War's paranoid mindset; the banal can become quietly subversive when all traces of utility have evaporated. Like the spy equipment used extensively in the conflict—a camera in a coat button, or a listening device inside a clock—Pop art can transform the everyday into something else. Maybe the recontextualized image in a work of Pop highlights the ways its repeated appearance in the mass media subtly propagates ideology? Perhaps it reminds viewers of the powerful but phony lure of the commodity object? In terms of Warhol's mechanically repeated depictions of a deadly car crash in *Green Disaster #2*, viewers, among other things, might realize the ways violence is embedded in any commodity, and especially in the automobile, which had become so important to American conceptions of freedom. This allegorical aspect of Pop extends beyond the capitalist consumer landscape, too, as will become clear with discussions of work by Soviet artists. No matter where it comes from, Pop art is representative of a contested moment in the Cold War: one falling between the ostensibly ideological certainty of the 1950s and the questioning and activism that emerged in the late 1960s.

The Cold War Family of Photography

While not traditionally considered an example of Pop art, the important exhibition *The Family of Man* featured a number of its characteristics. This show of photographs originated in 1955 at the Museum of Modern Art (MoMA) in New York and subsequently traveled to nearly 40 countries over the next seven years, including cities in Europe, the Soviet Union, Central

Fig. 3.3

Installation view of
the exhibition *The
Family of Man*, on view
January 24 to May 8,
1955, at the Museum of
Modern Art, New York.
Photographic Archive,
Museum of Modern Art
Archives, New York.

America, and India. Seen by at least nine million people, the exhibition was a global sensation. Organized by the photographer and MoMA curator Edward Steichen, it displayed 503 photographs taken by 273 photographers from 68 countries, many sourced from the archives of *Life* magazine. By picturing customs and activities shared by people from around the world—eating, working, dancing, for instance—Steichen suggested a common humanity that cuts across ideological and political lines (FIG. 3.3). His act of appropriating photographs from a media archive, stripping them of contextual captions, and placing them in a new art context is akin to the modus operandi of Pop art. And because he included images from the Soviet Union, China, and other communist nations, the Pop gesture of Steichen's exhibition seemed to be a statement against the us-versus-them divisions of the Cold War.

Despite the show's ostensible neutrality, however, it subtly agitated for an American vision of the world—consistent, for example, with the individualism so important to the nation's founding mythology (an individualism that also inflected the prevalent understanding of Pollock's drip paintings). Put simply, Steichen's groupings of photographs transformed the meaning of the individual specimens. For instance, Steichen included

August Sander's *Bricklayer's Mate* from 1928 in the exhibition. But in the context of *The Family of Man*, where it is surrounded by other images of laborers (see FIG. 3.3), the photograph is no longer situated within Sander's larger archival, class-based project, undertaken during Germany's Weimar era; rather, it celebrates the singular worker and supports capitalist individualism. *The Family of Man* was thus an exercise in image containment, with Steichen carefully managing the meanings of his chosen photographs.

Groups of photographs depicting citizens voting or protesting against oppression—the latter including an iconic image of an East German protester throwing a rock at a Soviet tank in 1953—are the rare moments that explicitly revealed the ideological nature of *The Family of Man*. The exhibition traveled, with funding from the United States Information Agency, to several contested Cold War sites, including Guatemala City in 1955 (soon after the U.S.-sponsored coup), West Berlin (also 1955), and even Moscow (1959). Just as Castro had enthused over *Life* magazine, communist authorities marveled at the popularity and propagandistic promise of Steichen's exhibition; a U.S. State Department official even noted the similarity between Steichen's show and Socialist Realist aesthetics. Copycat exhibitions were eventually mounted in both East and West Germany, and the show in the former was even initially given the title "The Socialist Family of Man."

The Family of Man, as well as picture magazines such as *Life*, depended upon photography's ability to create images without calling attention to the intentional acts of framing and darkroom development that produced them. To posit universal truths about the world, photographs had to be understood as natural products themselves, and this purported transparency allowed for a sly and subtle mode of Cold War propaganda. In reaction to this, some photographers produced images in the late 1950s and early 1960s that "admitted" to embodying an incomplete, false, or coerced truth. While a number of photographs by the Swiss-born artist Robert Frank were included in *The Family of Man*, his work thereafter—especially in his 1958 book *The Americans*—called attention to the contingent nature of photography. Featuring more than 80 photographs, the book was the product of a road trip across the United States. Its photos often feature

other framed images in their field: posters, flags, windows, and other flat surfaces. By including these images-within-images, Frank reminds us that a photograph is just one utterance among many in the visual world.

Frank's *Trolley—New Orleans*, for instance, not only questions *The Family of Man*'s optimism with a depiction of a segregated trolley in the American South, but also acknowledges the limitations of photography as a vehicle of truth. For example, the photograph alludes to what is *not* pictured directly within the frame—abstract reflections in windows and shiny metal surfaces literally reflect and refract what is on Frank's side of the camera. Furthermore, thanks to the artist's framing, the straight row of trolley windows resembles a strip of 35-millimeter film, suggesting five different photos existing within a single print. This photograph might register the fact of deep racial prejudice in a land touting freedom and equality, but it also alludes to what the camera cannot capture outside of Frank's viewfinder. It admits photography's constructed nature.

Fig. 3.4
Garry Winogrand
Democratic National Convention, Los Angeles, 1960,
photograph.

A photograph by the American Garry Winogrand also appeared in *The Family of Man*, but much of his later work, like Frank's, attacked the values which that exhibition had ascribed to the medium. In 1960, Winogrand photographed John F. Kennedy accepting the Democratic nomination for President (FIG. 3.4). Centered in the image, viewers see the back of the future President; while at bottom, a flickering television screen captures Kennedy's other side—his famous face, mid-speech. A crowded bank of television and still cameras, with their gazes all trained on the candidate, dominate the fuzzy background of the image – that is, in front of Kennedy. By combining two different views of the same subject in a single image, while also alluding to the massive quantities of other images being generated at that same moment,

Fig. 3.5
Evelyn Richter
Women's Day Event,
Leipzig, 1962,
photograph, 11⅞ x 15⅝
in. (30.2 x 39.8 cm).
Evelyn Richter Archiv
der Ostdeutschen
Sparkassenstiftung im
Museum der bildenden
Künste, Leipzig.

Winogrand lays bare both the constructed and arbitrary nature of photography. It exposed the average photograph as conveying, at best, a partial truth.

The East German photographer Evelyn Richter worked in a similar mode in the aftermath of *The Family of Man*, which she saw during a visit to West Berlin. An image such as *Women's Day Event, Leipzig* from the early 1960s appears to be straightforward (FIG. 3.5). The standing woman seems to be a model socialist citizen—participating in a political discussion under the fatherly eyes of East German leader Walter Ulbricht (in a propaganda poster) and among the next generation of young comrades gathered in her midst. But since Richter worked in a climate of censorship, her images often feature subtle formal and conceptual gestures that unravel their apparent claims upon careful inspection. Ulbricht's eyes are the only ones directed toward the photographer, reminding viewers of the state's control over photography and this image's status as propaganda, not fact. Richter repeatedly returned to this picture-within-a-picture strategy to reveal the pasteboard façade—and indeed, the bankruptcy—of socialist visual culture. Considering that her images were rarely censored, an image like *Women's Day Event, Leipzig* reminds viewers that a photograph can question its own legitimacy—and even question its governing ideology—if scrutinized long enough.

Another woman photographer from the Eastern Bloc also worked against the certainties expressed by *The Family of Man*

in the early 1960s: Czechoslovakia's Běla Kolářová. In 1957, she photographed children playing games, producing images that would have blended in with Steichen's exhibition as well as any show of Socialist Realist photography. Soon thereafter, however, she turned to making photographs without a camera—using small domestic objects to cast images on light-sensitive paper. By 1962 these became increasingly geometric and abstract; employing the use of a turntable and directed light, Kolářová's objects projected circular patterns on spinning photographic paper. If Robert Frank demonstrated how ambiguity lurked within even the most straightforward images, then Kolářová presented abstraction as the dialectical flipside to so-called documentary photos. Her use of everyday objects such as paper clips in her image-making also aligns her practice more explicitly with Pop art, making the familiar over into something strange.

Aesthetics of Indifference

Robert Frank and Evelyn Richter were just two of the many photographers who engaged with the photojournalistic language of *The Family of Man* to demonstrate something that Steichen's show was careful to conceal: photography's constructed and contingent nature. Likewise, painters in both the Soviet Union and the United States in the 1950s worked through their respective cultures' dominant styles of painting—Socialist Realism and Abstract Expressionism—as a means to call attention to the limitations of each, establishing new paradigms that paved the way for distinctive forms of Pop art.

Around the time of Stalin's death, Geli Korzhev was working on a canvas featuring an artist in a run-down studio, painting a portrait of the tyrannical Soviet leader. Called *In the Days of War*, this oil sketch glorified the challenges Socialist Realist artists endured during World War II. No matter the sacrifices and hardships, painters did their patriotic part. The painting related to the sketch, completed in 1954, is different. Since Stalin had died the year before, the depicted artist now sits in front of a blank canvas, seemingly unsure what to paint (FIG. 3.6). The dictator has been erased, which makes literal the culture of de-Stalinization that would take hold after Khrushchev's "secret speech" in 1956. While not exactly a work of Pop art (it is still Socialist Realism), the

Fig. 3.6
Geli Korzhev
In the Days of War,
1954, oil on canvas, 73
x 59 in. (186 x 150 cm).
Uzbekistan State Museum
of Art, Tashkent.

painting nevertheless marks a shift in Soviet culture. The absence at the heart of the work—the blank canvas—directs the viewer's gaze to the areas around it, namely to the everyday objects in the studio: the still life in the window, the artist's coat, shabby propaganda posters, and a box of paints, for instance. The artist's projected shadow on the white canvas also warrants mention, suggesting a need for artists to engage with the contingency of their own experiences. Furthermore, "war" in the painting's title is ambiguous, considering the date; if it refers to the Cold War, then the canvas might be attempting to reposition Socialist Realism as predicated upon the scenes and objects of everyday life, not the sanitized, parallel reality of happy workers and benevolent leaders. Instead of the usual partisan fare, Korzhev gives viewers a work that appears indifferent to its sociopolitical moment, or at least

Fig. 3.7
Mikhail Roginsky
Green Wall, 1965, oil
on canvas mounted on
panel, with electrical
outlet, 43⁵⁄₁₆ x 70¹⁵⁄₁₆
in. (110 x 180.2 cm),
Zimmerli Art Museum at
Rutgers University,
Norton and Nancy
Dodge Collection of
Nonconformist Art from
the Soviet Union.

uncertain about it. However, the authorities did not question the loyalty of Korzhev's practice, so whatever indifference this painting might project, it was veiled enough not to raise official concerns.

By the early 1960s, some "unofficial" Soviet artists—those working without the support of the Party and outside any official exhibition structure—took Korzhev's logic to its endpoint, zooming in to focus on individual objects. Both Vladimir Weisberg and Mikhail Roginsky, for example, painted things in a deadpan style, without any surrounding context. Weisberg painted objects like a radio or a sack of potatoes; Roginsky, a stove, pot, or pack of matches. If objects in Socialist Realism typically adopted allegorical and revolutionary meanings—a hammer transcends its practical function to become an inspirational symbol—in the hands of these two artists they shed any such pretense, instead revealing the dreary nature of Soviet life. By the middle of the decade, Roginsky went even further in *Green Wall*, recreating a wall from a communal apartment made of plywood, paint, and an actual electrical socket (FIG. 3.7). While the wall encloses, in some sense, an abstract monochrome painting, its more important innovation is a Pop-like attention to the mundane surroundings in which Soviet artists made their work. Compared to bombastic examples of Socialist Realism (still prevalent in 1965) or even Korzhev's more hesitant practice, *Green Wall* is subversively silent.

Meanwhile, Jasper Johns was working on his own artistic statement of political indifference in New York between 1954 and 1955: his deadpan rendition of an American flag (FIG. 3.8). Painting such a subject at this precise moment was a provocative gesture. Johns started the work in the midst of Senator Joseph McCarthy's paranoid and overblown charges that communists had taken over the highest levels of American government. Freedom of speech was violated and the lives and careers of innocent individuals were ruined—all under the guise of "patriotism." By the time Johns had completed the painting, McCarthy had been formally reprimanded. *Flag* appears tattered and dirty, perhaps intended as a corrective to typical images of the American standard, or to show what McCarthy and the like had done to American ideals. As a homosexual, Johns would have been acutely stung by McCarthy's twisted form of national loyalty; gays were considered "social deviants" by American cold warriors and were often accused of being communists.

Flag also tackles American painting debates of the 1950s. The powerful critic Clement Greenberg championed flat, abstract painting during this decade (see Chapters 1 and 2), and *Flag*

Fig. 3.8
Jasper Johns
Flag, 1954-55,
encaustic, oil, and
collage on fabric
mounted on plywood,
three panels, 42¼ x
60⅝ in. (107.3 x 153.8
cm). Museum of Modern
Art, New York.

seems to be following the critic to the letter. What is a flag if not a flat surface with abstract patterns? And yet, not only did Johns select a charged political subject for the mid-1950s, he also cannily undermined Greenberg's influential (and stifling) theories by engaging abstraction as something that may be found in a common object. *Flag* thus interrogates American patriotism *and* the ways that works of American abstract art had been pressed into Cold War service as emblems of freedom. The work both questions the relevance of pure abstraction and heralds new subject matter drawn from popular culture. When viewers look closely at the painting, such an understanding becomes even more apparent.

Johns did not create this work with oil paint on canvas; rather, he used a tedious process of collage and encaustic. First, he collaged the flag's constituent parts—its stars and stripes—from fragments of New York newspapers. He then painted over the collaged flag in the appropriate colors of encaustic, a medium comprised of pigment dissolved into hot wax. Encaustic, when it dries, is semitransparent, so some newspaper content remains visible under the colored surface. These collaged fragments of newspapers are derived not from important Cold War stories, but rather from more marginalized aspects of the newspaper, mainly small advertisements and comic strips. Given the unusual process of its making, then, *Flag* concerns the covering and obscuring of media content. For the artist, both the American flag (and the ideas and practices of patriotism associated with it) and abstract painting (ie., the flat stripes) repress certain marginalized aspects of culture. Only if viewers look closely, seeing *through* the flag's flat stripes, do they see other aspects of American life. Abstraction and patriotism in America were both forms of blindness in 1955—covering up ambivalence, whether in terms of sexuality or nationalism, in the age of McCarthy.

In the 1970s, the art historian Moira Roth discussed the work of Johns—as well as his close associates Robert Rauschenberg and Cy Twombly—as negating the explicit power plays and paranoid culture of the McCarthy era. If Pollock's drip paintings came to represent the singular artistic vision of a straight, free American male, Johns used found materials (newspapers) and a common pattern (the American flag) to formulate what Roth labeled an "aesthetic of indifference"—representing anti-expression, as well

as the experience of being silenced. Geli Korzhev's *In the Days of War* presents the flipside of Johns's indifference. Instead of hiding details beneath a painted surface, Korzhev erases Stalin so as to enable contingent objects in the studio to assume a new prominence. Both artists engage and move beyond their respective Cold War styles (Socialist Realism and Abstract Expressionism). Soviet and American Pop would not be far behind.

Capitalist and Communist Pop

Late 1962 was an important moment in both the American and Soviet art worlds. In New York, an exhibition opened at the Sidney Janis Gallery called *The New Realists*, which featured Warhol and other artists engaged with the everyday world of objects. It was perceived as a repudiation of the rarefied forms of Abstract Expressionism. About a month later, Nikita Khrushchev visited an art exhibition in Moscow with only a slightly different title—*The New Reality*—which included some objects produced outside the official channels of the academy and Socialist Realism. Walking around, Khrushchev became angry and perplexed at the modernist distortions on view, dismissing them with crude language. He even suggested that the artists responsible should be exiled or imprisoned. Khrushchev's actions signaled an end to the Thaw that had existed since Stalin's death, and in the years that followed, unofficial art practices largely migrated underground. Eschewing the sanitized, optimistic forms of Socialist Realism, many of these artists, like their Western counterparts in *The New Realists*, engaged the prosaic materials in their midst instead. Despite drawing from different quarries of materials, these Soviet and American examples of "Pop" art aligned themselves with everyday realities, thus escaping the dominant artistic narratives of the Cold War up to that point. The differences and intersections between the practices of two of the most important artists of this period—Andy Warhol in the United States, and Ilya Kabakov in the Soviet Union—demonstrate the way in which Pop's rejection of nationalistic styles in the 1960s was vital to the art made during the Cold War.

Born Andrew Warhola to Central European immigrants, Warhol grew up in a working-class neighborhood of heavily industrialized Pittsburgh. In the 1940s, he received broad training

in the visual arts at the city's Carnegie Institute of Technology (his degree was in "Pictorial Design") where he was exposed to the socially progressive art practices of Ben Shahn and others. After graduation, Warhol moved to New York, where he became a successful commercial artist, best known for delicate renditions of women's shoes that appeared regularly as advertisements in the *New York Times* in the mid- to late-1950s. Warhol's drawings not only stoked consumer desire for upmarket footwear—with any traces of labor or utility erased from his depictions—but also taught him the importance of the mass-media context for his commercial work, which would prove crucial to his later efforts as an artist. If one of his drawings appeared next to a newspaper story about a fatal bus crash—as was the case in 1955—then it can be said that such work, and advertising more generally, served to distract readers from the violent realities of American life. To paraphrase media theorist Marshall McLuhan in 1964, the effectiveness of advertisements in the print media requires the "bad news" often featured in newspapers and magazines. Early in his career, then, Warhol grasped consumerism's relationship to larger social and political realities, including the anxieties of the Cold War. Eat, drink, and *consume*, for tomorrow we die.

Despite significant financial success as a commercial artist, Warhol shifted gears in the early 1960s and attempted to break into the more rarefied New York art world. Did a desire to critique capitalism contribute to this decision? Inspired by Jasper Johns's and Robert Rauschenberg's use of everyday materials, Warhol brought his commercial techniques to painting—not only as a way to deflate the pompous, individualist claims of Abstract Expressionism, but also to highlight the broader social implications of capitalism in its postwar phase. *Coca-Cola (2)* from 1961, among the first of his Pop paintings, is based on an advertisement for the ubiquitous soft drink (FIG. 3.9). Coke's presence in the mass media was already immense by 1960; the bottle and logo appeared on billboards and in shops, as well as print and television advertisements. Warhol's odd source for this particular painting highlights the drink's ambitious commercial reach: an ad in a small Pittsburgh newspaper called *Byzantine Catholic World*. Warhol's canvas was nearly six feet high, and is thus in one sense an act of respect for Coke's social importance. Considering his source, might Warhol be treating the soda bottle like a revered Byzantine icon?

Fig. 3.9
Andy Warhol
Coca-Cola (2), 1961,
casein and crayon on
linen, 69½ x 52¼ in.
(176.5 x 132.7 cm).
Andy Warhol Museum,
Pittsburgh.

By introducing the subjects and style of commercial art into the realm of painting, Warhol dramatized the commodity status of art and, indeed, the consumerist packaging of individual expression. By the early 1960s, paintings by Pollock and other Abstract Expressionists were in high demand; the artists' subjective marks—Pollock's elegant drips or Mark Rothko's fuzzy rectangles—became artistic trademarks, something unique to that individual. Indeed, *Coca-Cola (2)* is a transitional work for Warhol, as it retains smudges, erasures, and crayon shading that betray the artist's hand at work. The painting suggests that individual action, like that claimed by Pollock in his works, remains possible, but only if mediated through and tempered by the commodity form. Any illusion that a painter might stand outside of culture—outside of the reach, say, of Coca-Cola's advertising—is revealed to be mere myth. In 1962, Warhol showed *Coca-Cola (2)* to his friend the filmmaker Emile de Antonio, along with a more recent canvas that featured a pristinely rendered example of the same bottle, without the smudges and nervous scribbles. De Antonio preferred the second iteration and apparently exclaimed, "It's our society, it's who we are." By taking a consumer icon and simply re-presenting it on a large scale, stripped of its usual advertising context, Warhol exposes its commercial power. How can individual action—especially as embodied in the popular ideas underlying "Action Painting" (see Chapter 1)—function in such a world?

De Antonio identified himself as a Marxist, and Warhol's own words about Coca-Cola also betray an interest in class: "the President drinks Coke, Liz Taylor drinks Coke, and just think, you can drink Coke, too. A Coke is a Coke and no amount of money can get you a better Coke." For the artist, Coca-Cola represented a Cold War paradox: It was the capitalist commodity par excellence that nonetheless made the socialistic gesture of dissolving class barriers. In 1963, Warhol was even more explicit about the uncanny correspondences between the capitalist and communist worlds, noting that under both Cold War systems, individuals were becoming more standardized. While communism minimized individual differences in the name of the collective, capitalist products like Coke did the same in the name of profit. Different motivations, same results. It is no wonder that Warhol coined a name for his practice of painting common

products around 1962 (before "Pop" caught on) that turned upon just this irony: "Commonism." That Warhol's paintings have now become emblems of stratospheric wealth, obtainable only by the super-rich—selling sometimes for tens of millions of dollars—only demonstrates capitalism's power to transform critique into cash.

Warhol's practice shifted again in 1962. Not only did he turn to the photomechanical process of silk-screening, but he also began his *Death and Disaster* series, which depicted wrecked automobiles, suicides, and other violent subjects. To produce *Green Disaster #2* (see FIG. 3.1), for instance, Warhol selected a graphic newspaper photograph of a car accident, then ordered a silk screen to be produced, which was used to pattern the same image ten times on a green canvas in a grid. While he achieved subtle variations and nuanced effects (both accidental and intentional), the use of the silk screen further removed Warhol's hand from the artistic process. In only a few years, American art had gone from fetishizing the individual artist's mark as an embodiment and symbol of freedom to a very different place. Now an artist was mechanically replicating photographs from the mass media and presenting the results as a "painting." As Warhol said in 1963, "I want to be a machine." Clearly, his work at this moment, with his cybernetic desires, also engages the questions of art and technology raised in the previous chapter. With its explicit mechanical aspects, Warhol's work is the uncanny, unruly brother to the paintings of Morris Louis (see FIG. 2.7). But Warhol, like Jean Tinguely (see FIG. 2.14), also implies the violence of such a technophilic mindset: The machine on view—the crashed automobile—has claimed a victim, visible in the bottom center of each silk-screen registration. And like Tinguely's technology, Warhol's replication machine is flawed, rendering blurry images that barely cohere visually.

If automobiles were powerful symbols of the American way of life both at home and abroad in the early 1960s, then *Green Disaster #2* dramatizes the everyday death and destruction that capitalist desire attempts to keep at bay. In an important essay from 1987, Thomas Crow argued that Warhol's *Death and Disaster* series demonstrates that "sudden and irreparable injury" is intertwined with the freedom associated with American automobile culture. The commodity may try to repress trauma, but

Warhol's paintings, especially amid the constant Cold War fear of a sudden nuclear apocalypse, disclose that death may erupt at any time. Another of his paintings, *Red Explosion*, figures the ultimate disaster in the months following the Cuban Missile Crisis: an atomic blast's signature mushroom cloud repeated more than 30 times. This painting takes Warhol's dark vision even further than *Green Disaster #2*; the mushroom cloud not only connotes death and disaster but was also a media star. With spectacular photographs of nuclear tests appearing regularly in magazines in the 1950s and early 1960s, *Red Explosion* dramatizes how Americans could transform even the ultimate weapon into a media spectacle rivaling Coca-Cola or Marilyn Monroe.

After surviving the dislocations and hardships of World War II in the Soviet Union, Ilya Kabakov was admitted to the prestigious Surikov Art Academy in Moscow in 1951 at the age of 17. His decision to study illustration gave him more latitude than students enrolled in the academy's more rigid painting program. Nevertheless, Kabakov was indoctrinated in the tenets of Socialist Realism and was warned of the dangers of "formalism"; Stalinist fervor was high during his early years at Surikov. After graduation in 1957, Kabakov—like Warhol—achieved success as an illustrator. While he did produce some explicitly political material, he primarily made illustrations for children's books. Communist officials rewarded his efficiency and dutiful service with full membership of the Union of Artists by 1965. Kabakov enjoyed a more advantageous position than most non-official artists, as his Union membership and acclaimed graphic production afforded him ample material benefits and more freedom to do what he wished in private. The artist has described having a "double life" at this time: even as he produced illustrations that helped provide for his family, he was making other artworks that captured the absurdity of Soviet life in the 1960s. Kabakov attributes his official success to his internalization of Soviet aesthetics, which enabled him to give the authorities what they wanted very quickly: utterly harmless and anonymous images.

Kabakov's Pop works differ significantly from typical Western examples, as the Soviet artist does not engage photographic technologies. In part, this had to do with Socialist Realism's preexisting relationship to photography and the print media. Chapter 1 detailed the ways in which paintings such as Fedor

Shurpin's *The Morning of our Native Land* (see FIG. 1.10) were photographically disseminated through postcards and reproduction in print-media outlets. When reproduced, especially in black-and-white versions on cheap newsprint, Socialist Realist paintings could already be readily confused with photography. Such a conflation of mediums is evident when one confronts the heavily airbrushed photographs of Stalin, or even the "painting" of Chairman Mao that remains in Tiananmen Square in Beijing. Like Warhol's *Green Disaster #2*, these Socialist Realist images are hybrids of painting and photography. If global Pop can generally be defined as reacting against official and dominant aesthetics, then it makes sense that the Soviet variety in the 1960s did not address photography, as it was already inextricably intertwined with Socialist Realism.

In the mid-1960s, Kabakov produced a number of unofficial works that—considering their deadpan presentation of everyday life—are examples of Soviet Pop art. *Pipe, Stick, Ball, and Fly* from 1966 (FIG. 3.10) clearly depicts each object named in the title, with the pipe being an actual ceramic example fastened

Fig. 3.10
Ilya Kabakov
Pipe, Stick, Ball, and Fly, 1966, objects (ceramic, textile reliefs), oil, and enamel on plywood, 51⅕ x 70⁹⁄₁₀ x 7³⁄₁₀ in. (130 x 180 x 20 cm). Museum Ludwig, Cologne.

The Cold War and Global Pop Art

to the plywood surface. With no text (other than the title) or explicit ways to link these four ordinary objects, Kabakov presents viewers with an interpretive mystery that fundamentally attacked the mindset of Socialist Realism. In official Soviet painting, artists transformed everyday objects into concrete embodiments of ideology—whether farm equipment or a hammer used by an overachieving laborer. *Pipe, Stick, Ball, and Fly* attempts to liberate the interpretive process from the grip of dogmatic ideology. In reality, images and objects are not circumscribed by a single meaning, but instead provide an array of possibilities. Along these lines, as Matthew Jesse Jackson has noted, Kabakov's depicted objects engage in linguistic games. For example, "under the fly" was a common expression connoting drunkenness in the Soviet Union, and the Russian word for "fly" sounds similar to the word for "torment." *Pipe, Stick, Ball, and Fly* suggests (at least to those few Soviet citizens who actually viewed it) modes of subversive interpretation. If René Magritte, in *The Treachery of Images* (1928–29), gave his painting of a tobacco pipe the caption *Ceci n'est pas une pipe* ("this is not a pipe"), then Kabakov's pipe of the plumbing variety also transcends its material existence and enters the free-ranging world of allegory. Is the composition organized by the increasing weight of its components, left to right? Is there some narrative that can coherently incorporate all of these elements? Considering the dreamworlds peddled by Socialist Realism, is *Pipe, Stick, Ball, and Fly* any less absurd than the officially sanctioned fantasies of the regime?

The work also embodies what Kabakov achieved in his many unofficial drawings from this period—an anonymity that purported simply to present certain concrete aspects of Soviet life. Warhol's *Green Disaster #2* avoided the established hallmarks of individual expression in order to depict the excess and violence of capitalism; Kabakov, on the other side of the Iron Curtain, employs a similar strategy to describe the depressing barrenness of the Soviet consumer landscape—an actual broken pipe, clumsy relief representations of a gray stick and a two-toned ball, and a flat depiction of an insect nuisance. This work, like Kabakov's other non-official artworks from this period, records a key contradiction of Soviet life: despite the repeated touting of practical rationality and abundance for all, life under communism

was absurd and impoverished. Although Kabakov knew some examples of Western art, even some American Pop, he chose not to copy them. Instead, like Warhol, he pulled back a curtain to reveal the discrepancies between ideological rhetoric and the more complicated reality it sought to conceal.

While Warhol and Kabakov each thrived within the respective official cultures of capitalism and communism, their artworks set out to bite the hands that fed them. Warhol used the language of commercial art to critique commodity fetishism, while Kabakov employed the anonymity of official illustration to expose the reality behind the lie of Socialist Realism. While the content and aims of their practices differ, their works from the early to mid-1960s demonstrate a shared strategy that bridged the Soviet–American artistic divide: the use of common objects and images to express a waning faith in Cold War ideologies.

Gerhard Richter and Christo—between East and West

Some artists experienced both sides of the Cold War firsthand, having trained in Socialist Realism, but then experimented with abstraction and other "formalist" styles after defecting to the West. Several of these artists rejected both Cold War orthodoxies of style, and instead embraced forms now associated with Pop art. Among the most prominent of these are two figures who are now household names: Gerhard Richter and Christo. Their works from the 1950s and 1960s reveal similarities between the art and visual cultures on both sides of the Iron Curtain.

By the time Gerhard Richter became a successful painter in Düsseldorf, West Germany, in the mid-1960s, he had already experienced a spectrum of political regimes: Nazi Germany as a child, communist East Germany for his formative years, and democratic West Germany after his arrival there in 1961 at the age of 29. He also graduated from art schools in both Germanies. In 1951, Richter enrolled in the famed Dresden Art Academy, where he was trained in Socialist Realism, specifically mural painting. He had a successful mural practice in East Germany after his graduation in 1956, even completing a monumental painting for Dresden's headquarters for the East German Communist Party. While his work was never charged with running afoul of strict East German guidelines, he did

privately experiment with abstract painting after seeing the work of Pollock and others in Documenta 2 in 1959. After escaping East Germany through West Berlin in 1961 (only months before the Berlin Wall would have made this impossible), he enrolled in Düsseldorf's art academy, where he eventually worked under the well-known abstract painter Karl Otto Götz. Richter pursued modernist distortions and his own version of Art Informel during his first year in the West, but he was dissatisfied with his efforts and subsequently destroyed most of these works in a bonfire in the school's courtyard. Having rejected both Socialist Realism and Western abstraction, Richter wanted to find a Third Way of his own—an art practice that somehow could bridge his divided Cold War training.

Richter turned to a practice that we now associate with Pop art: painting copies of photographs onto canvas, with the results often gently blurred with a dry brush or rag. *Terese Andeszka* (1964) is typical (FIG. 3.11); the work clearly derives from a photograph of a family on a beach, but the artist's painted translation renders that image strange. Richter's photo-paintings are crucially related to the Cold War context for two primary reasons. First, befitting his own divided history, they scramble and mediate the accepted Cold War styles of figuration and abstraction. With what degree of blurring does a copy of a figurative photograph become an abstraction? *Terese Andeszka*'s middle passage, where the boy's right leg disappears into the background, demonstrates this sliding scale of legibility. Second, Richter's photo-paintings indicate the potential conspiracies lying within any image, and the ways the Cold

Fig. 3.11
Gerhard Richter
Terese Andeszka, 1964,
oil on canvas, 67 x
59 in. (170 x 150 cm).
Museum Wiesbaden,
Wiesbaden.

Ein Wunder rettete ! Terese Andeszka und ihr Mann Fran

War engendered such a paranoid mindset. A happy family in a Socialist Realist photograph is not that different from its counterpart in a Western advertisement; their smiles simply endorse a different ideology. Furthermore, given an appropriate caption and context, even a grainy image can "prove" an ideological point to a global audience, as did the U-2 photographs of Cuba in 1962 (see p.12). Richter placed this new artistic practice in direct relation to the Cold War, initially calling it "Capitalist Realism"—a direct rejoinder to his years of producing Socialist Realist murals.

Richter's Capitalist Realism acknowledges the flimsy utopian dreams promoted by both sides. Advertising sold the promise of an easy life of personal fulfillment; Socialist Realism, among other things, peddled images suggesting the satisfaction of a communal existence. Taken out of context, *Terese Andeszka* could be a socialist *or* a capitalist family enjoying the fruits of either society: a family trip out to the beach. One evening in 1963, Richter and his friend Konrad Lueg presented a performance in a Düsseldorf furniture store called *Living with Pop: A Demonstration for Capitalist Realism*. While each artist showed four paintings, they were more interested in highlighting for their visitors the various model rooms across the store's four floors, filled with furniture for sale. The idea of a showroom also applies to Socialist Realist paintings like *Youth of the World—for Peace* (see FIG.1.2). Both present sanitized versions of lived experience designed to inspire—one attempting to spur purchases, and the other ideological conviction. No wonder Richter situated this "demonstration of Capitalist Realism" in a store: Once a sofa was sold and removed from a model room with precisely coordinated décor, it did not look as good in one's own home. Richter and Lueg's performance reminded viewers that display creates desire.

Terese Andeszka also shows a more explicitly political side of Richter's Capitalist Realism. The artist based the painting on a press clipping, as he makes clear by leaving part of the caption—in translation, "a miraculous rescue"—visible at lower left. In the source (archived by Richter in a collection of photographs, source materials, and drawings known as the *Atlas*), more text is visible, including the word "Flüchtling." This was a Cold War term applied to those who, like Richter himself, had left East Germany for the West. The painting, therefore, depicts a family

who has escaped communism, even after the construction of the Berlin Wall. The artist's choice to omit this crucial bit of text obscures the painting's historical specificity, visually erasing its story of Cold War escape. Richter's blurred forms in the painting, especially in the middle section, underscore the caption's excision. Both textually and visually, then, Richter renders the narrative of the family escape unintelligible. *Terese Andeszka* hides its Cold War story; it is a painted spy, dissembling in its intention and message. Even without knowledge of the source, the painting remains mysterious. As pictured, the family group provides no clue as to the "miraculous rescue."

Many of Richter's photo-paintings from this 1960s period reveal such Cold War intrigue when scrutinized. In *Bombers* (1963), Richter copied a press photograph of American aircraft dropping their lethal payloads on Nazi Germany, and the following year, he painted *Phantom Interceptors*, based on another media photo depicting new American jets that had been deployed to protect West Germany in the 1960s. Viewed together, the works register how the political realities of the Cold War quickly transformed former enemies into trusted allies. In both form and content, Richter's work from the early 1960s straddles East and West. Considering that Richter did not acknowledge the Cold War significance of his subject matter until after the conflict's end makes the conspiratorial readings of these paintings all the more urgent.

The practice of appropriating and re-presenting found images with little transformation was not Richter's alone; it became one of the most prevalent aspects of Pop art. Andy Warhol's silk-screen paintings fall into this category, as does the work of many British Pop artists. Other practitioners include Richter's friend (and fellow former East German) Sigmar Polke, the Latvian-born Vija Celmins, and many others. Most of these artists, like Richter and Warhol, demonstrate how the act of copying a photograph in paint—transmitting it from magazine to the gallery wall, via the artist's studio—degrades image clarity. In other words, the replication of an image, whether in paint or in the mass media, increases its ambiguity. The public's first view of the already-unclear reconnaissance photos taken high above Cuba, for instance, was either on a flickering television or in a blurry, halftone reproduction in a newspaper. As was clear with

Gerald Laing's *Souvenir* (see p.11), one's political position often shaped how media images were interpreted; in this painting, viewers saw Kennedy, Khrushchev, or a confusing mixture of both, depending on where they stood. While working in London (as did Laing), the Austrian-born art historian E. H. Gombrich theorized what he called "the beholder's share" (see p.13) in the 1950s: the way that blurry passages in a painting allow viewers to project their own desires, political or otherwise, onto the work. The ambiguity of many Pop paintings demonstrated how a single picture could be contorted to serve different political ends during the Cold War's "battle of information and images." While the beholder's share's applicability transcends the Soviet–American conflict, it provides a useful theoretical model for understanding the politics of Pop art around the world.

Christo (born Christo Javacheff) is another artist whose work in the capitalist West is inextricable from his experience in the communist East. Born and raised in Bulgaria, Christo witnessed the sudden transformation of the country from a capitalist monarchy to one of the most repressive client states of the Soviet Union after World War II. Even before his official training in Socialist Realism at the Sofia Academy of Art, beginning in 1953, Christo was known as a talented draftsman and was asked to produce materials for the country's Communist Party, including portraits of Vladimir Lenin and Karl Marx for public spaces. While at art school, Christo helped manufacture propaganda that went beyond painting: He was tasked with staging the landscape alongside the railway tracks of the Orient Express in order to impress Western travelers from Paris. Along with other students, he advised farmers how to arrange new machinery and hay bales for optimal visual effect, and suggested that they cover up clutter or other unsightly elements. In the fall of 1956, Christo left Bulgaria on a visit to relatives in Prague, escaping from there in early 1957 by slipping across the border into Austria. He settled in Paris the following year, where he immediately immersed himself in abstraction and other Western styles of contemporary art. Whereas Richter's photo-painting constituted his artistic Third Way, Christo, after experiencing both Cold War sides, chose to wrap and conceal objects.

Fig. 3.12
Christo
Package, 1961, wood,
linen, rope, filling
material, 84⅝ x 72⁷⁄₁₆
x 15¾ in. (130 x 180 x
33 cm). Kröller-Müller
Museum, Otterlo.

Christo's *Package* (1961) is yet another Cold War conspiracy, but it wears its secrecy proudly (FIG. 3.12). Viewers see an object that has obsessively, if irregularly, been wrapped in a tight tangle of rope and cords. If Socialist Realist painting concealed hardship, shortages, and repression behind a sunny façade, then Christo's many wrapped objects call attention to the very act of artistic concealment; he discovers an abstract version of Socialist Realism's censorship and its hiding of actual lived conditions.

But *Package* also engages capitalism and the Western avant-garde. Covering objects first emerged as a Surrealist strategy in the 1930s—a way to render them strange—but Christo's tight web of excessive rope also suggests Pollock's intertwined tendrils of paint. Furthermore, capitalism also relies upon covering: Elaborate packaging erases traces of labor, differentiates nearly identical goods produced by different companies, and allows for the sale of mundane products at a premium. Conversely, Christo's packaging renders his object drab and anonymous. *Package* reflects his experiences in Bulgaria and Paris; it is a hybrid object, split between Cold War artistic narratives and experiences. The Polish artist Tadeusz Kantor, whose abstract paintings were discussed in Chapter 1, adapted a similar aesthetic after a visit to the United States in 1965, attaching wrapped packages and sealed envelopes to canvas.

In 1962, in collaboration with his soon-to-be-wife Jeanne-Claude, Christo constructed a work explicitly about Cold War division: *Wall of Oil Barrels—The Iron Curtain*. Deeply affected by the construction of the Berlin Wall in August 1961, the pair blocked the Rue Visconti in Paris one evening the following summer by stacking 89 empty oil barrels to create a barricade reaching over 13 feet (4 meters) high. The authorities ordered the dismantling of the work, which had ensnarled traffic for miles around, after eight hours. Its brief staging nevertheless symbolically enacted the trauma of Berlin, divided without warning, according to the borders hastily drawn at the end of World War II. The use of oil barrels was possibly also significant. Since oil

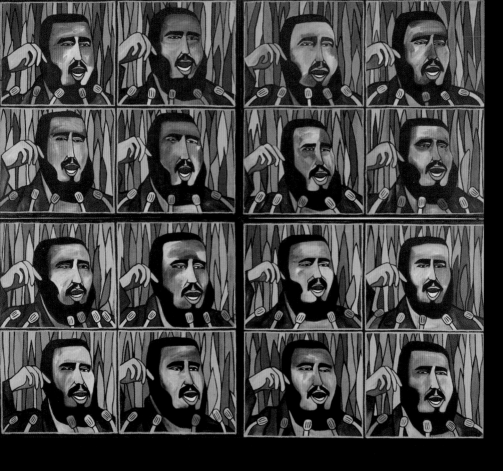

Fig. 3.13
Raúl Martínez
Oye America (Listen America), 1967, oil on
canvas, 115 x 100¾ in.
(292 x 256 cm). Museo
Nacional de Bellas
Artes, Havana.

(converted into gasoline) powers the automobile, that recurring symbol of American individualism, did this work suggest the stifling implications of the Americanization of Western Europe, thereby making this another hybrid work of art?

What happened when an artist remained in a country during a period when it changed Cold War sides? Cuba's Raúl Martínez, discussed in Chapter 1, is a case in point. In the 1950s, he viewed his version of Abstract Expressionism (see FIG. 1.12) as a gesture of political resistance against the conservative, U.S.-backed regime of Fulgencio Batista, thus reiterating the style's origins in left-wing politics. Fidel Castro overthrew Batista in 1959 and pushed Cuba into the Soviet sphere of influence after increased American hostilities. Castro soon instituted social policies reminiscent of the Soviet Union and its European satellites, including the jailing of political opponents and control of the press. Cuban artists, however, were largely able to steer clear of what was required of every official Soviet artist: the retrograde and figurative fictions of Socialist Realism. Martínez abandoned abstraction by the mid-1960s and began a lively graphic design practice, which he believed to have a liberating, collective function—an attempt to forge a truly popular and public art that was not tied to a capitalist art market. He did keep painting, however, as *Oye America* (*Listen America*) from around 1967 demonstrates (FIG. 3.13). The hand-painted images of Castro are not mechanical and cynical like Warhol's gridded repetitions, but instead connote political passion. The title even attempts to reclaim Pop art, so associated with the United States, for the Cuban revolution; it declares, "Listen America, this is what Pop should be." Martínez's socialist-inflected Pop made a strange kind of sense by the end of the 1960s. Not only did Socialist Realism always rely upon Pop's repetition—images of Stalin across hundreds of different paintings, for instance—but international socialism had its own superstars. As will be discussed in the next chapter, Castro, Che, and Chairman Mao appeared on the banners of protesters around the world in the years surrounding 1968.

Collaging the Military–Industrial Complex

As the 1960s wore on, American involvement in Vietnam became more entrenched. After French colonial troops were defeated by nationalist forces at Dien Bien Phu in 1954, an international conference in Geneva divided Vietnam into a communist north and an anti-communist south—to be unified after national elections. Serious American involvement on the ground started under President Kennedy, initially sending military advisors in 1961, as a means to prevent all of Vietnam falling under communist rule. President Lyndon Johnson dramatically escalated the war in 1964: the near-constant bombing of the north began in 1965, and by 1968 over 500,000 American troops were on the ground—all to prevent a small country from slightly tipping the international balance of power. With its potent combination of postcolonial nationalism, the Cold War, and the full display of the American military against a small, developing nation, the Vietnam War became one of the defining issues of the mid- to late 1960s.

During this period, popular consumer goods began to be perceived as embroiled in American militarism. Even the most common products, in the right context, could be linked to deaths in the jungles of Vietnam. How did this happen? For one, official links existed between American industry and the military; President Eisenhower and President Kennedy had each appointed a head of a giant American automaker as their secretary of defense (from General Motors and Ford in 1952 and 1960, respectively)—suggesting affinities between the two positions. The 1959 "Kitchen Debate," referenced at the end of the previous chapter, forged an analogous link. In an American model home, American Vice President Richard Nixon and Nikita Khrushchev discussed, in the same breath, the latest advancements in both nuclear missiles and color televisions. Considering the enormity of American military spending during the period—resulting in both lucrative government contracts and civilian applications of the resulting technological innovations—these implied connections were very real. The Cold War was undisputedly good for the American economy.

President Eisenhower coined the phrase "military–industrial complex" in January 1961 during the final speech of his presidency, warning against its "unwarranted influence." A permanent state of

war may keep corporate profits high, but at what human cost? In some ways, Pop art in the mid- to late 1960s also cautioned against the interlinked worlds of Cold War military power and American commodities. Artists often used collage and photomontage—whether actual images from a magazine or a painted approximation—to imply connections between these consumer and military worlds. In one work from 1962, Wolf Vostell, a West German Pop artist, appropriated a photograph of an American B-52 and showed it dropping a payload of actual tubes of lipstick. And in 1966, he ironically proposed that Americans should bomb Vietnam with consumer goods—not only suggesting the economic links between commodities and war, but also the cultural power of American capitalism. If the consumer "bombardment" associated with the Marshall Plan could keep communism out of Europe, why could it not work elsewhere?

James Rosenquist addressed the military–industrial complex in his monumental *F-111* (1964–65), its 86 feet (26 meters) centered upon a fractured view of an advanced jet then being developed by General Dynamics for the American military (FIG. 3.14). The artist punctuated his depiction of this massive war machine with meticulous renditions of other images both mundane and frightening: an automotive tire, an easy-bake cake, light bulbs, sauced spaghetti, and a mushroom cloud. The painting's most striking passage features a young girl seated under a hair dryer; in the context of the war plane, the dryer resembles a jet engine. Rosenquist corrupts an image of childhood innocence with this

Fig. 3.14
James Rosenquist
F-111, 1964-65, oil on
canvas with aluminum,
23 sections, 10 x 86 ft
(304.8 x 2621.3 cm).
Museum of Modern Art,
New York.

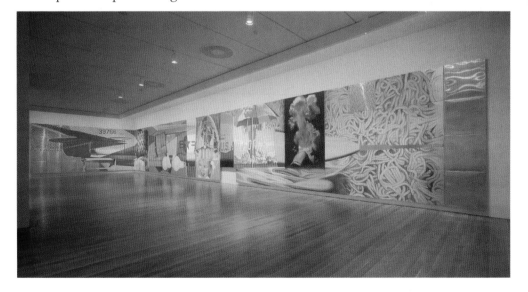

specter of militarism. Painted just as President Johnson escalated American involvement in Vietnam, Rosenquist's pictured world is one where the pleasures and distractions of the consumer economy are literally intertwined with the period's most visible manifestation of bloated military contracts, the F-111. The artist himself concurred, stating that the painting addressed "the collusion between the Vietnam death machine, consumerism, the media, and advertising." While Rosenquist's earlier work channeled Surrealism and linked disparate objects and people in a seamless and strange painted field—President Kennedy with a car door and a piece of cake in his *President Elect* from 1961, for example—this later work employed his same aesthetic to demonstrate consumer complicity in the American military machine. Rosenquist's canned spaghetti, featured in a number of his paintings of the 1960s, never connoted bodily trauma more so than here. As with Warhol's crashed automobiles, *F-111* posits that death can reside within our consumer products.

While ostensibly critical of the military–industrial complex, *F-111* could also be viewed as part of the problem: a massive painting meant to be shown at a high-end art gallery, ultimately intended for a wealthy collector or museum—likely with their own ties to the military–industrial complex. Martha Rosler's series of photomontages made from 1967 to 1972, called *House Beautiful: Bringing the War Home*, occupies similar conceptual ground as *F-111*, but its images are less ambiguous and its presentation is not nearly as grandiose. They are, in a sense, better propaganda. In one example from the series, *Balloons*, Rosler pastes an image of a Vietnamese mother carrying her gravely wounded child up the stairs of a modern American living room (FIG. 3.15). The war had already been dubbed the "living-room war" in 1966 for its extensive television coverage; Rosler eerily extends this metaphor by literally bringing the war's violence into the safe

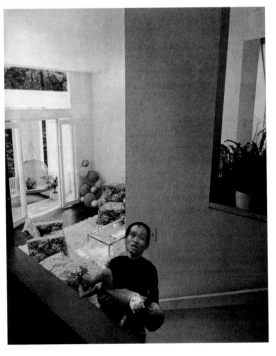

Fig. 3.15
Martha Rosler
Balloons, from the series *House Beautiful: Bringing the War Home*, c. 1967-72, photomontage, dimensions variable.

and pristine domestic environment featured in contemporary shelter magazines. The work also summarizes the war's presentation in magazines like *Life*: graphic images of the war's victims interspersed among color advertisements for booze, cigarettes, and processed foods. Rosler clearly understood the complicated dialectic of the Vietnam War and American capitalism: the conflict enabled economic prosperity for certain classes, and this prosperity generated complacency and amnesia. Put simply, she implicated American consumerism for its involvement in the pictured child's injury. The Paris-based Icelandic artist Erró made work similar to Rosler's in 1968 in a series known as *American Interiors*—paintings that show Viet-Cong or Maoist soldiers outside American homes. But Rosler's message also took place at the level of medium: Recalling the Weimar-era photomontages of John Heartfield, her works were designed not to be unique art objects but to be re-photographed for mass reproduction. Her critique is also predicated upon gender; the Cold War was largely a boys' club, with macho, cowboy individualism in both art and politics mutually reinforcing each other. Pop, with its significant number of gay men and women artists, subverts this Cold War masculinity prevalent on both sides.

In their explicit linking of consumerism and militarism, Rosenquist and Rosler represent a relatively rare breed of American Pop artist. Photomontage and collage, however, were common in the communist world, whether in cartoons, posters, or works intended as art. The photomontages of Josep Renau, a Spanish communist who moved from Mexico to East Germany in 1958 (when thousands were heading to the West, like Gerhard Richter), are examples of the latter. His series, eventually published as *Fata Morgana USA* (begun in the 1950s), combined images of American violence with those of U.S. currency, pin-ups, and commodities. The series title refers to a character from Arthurian mythology who generates mirages to enchant her enemies, an apt metaphor for Rosenquist, Rosler, and Renau; capitalist spectacle not only fuels the military–industrial complex, but also distracts from it.

A three-dimensional form of Pop collage—what became known as "assemblage"—was also popular in both Europe and America. In Paris in the early 1960s, Arman created vitrines full of different examples of the same type of discarded goods—shoes,

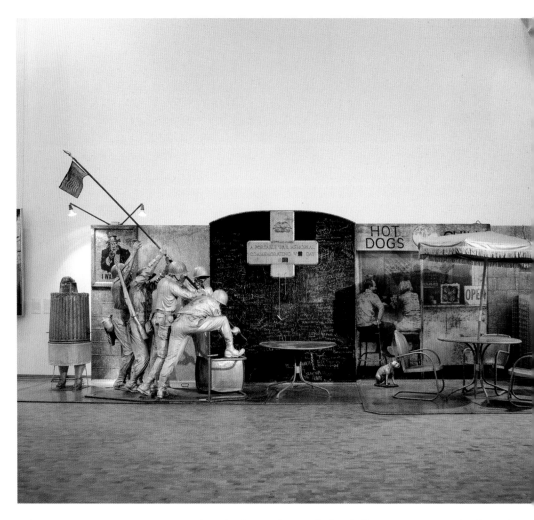

gas masks, clocks, and even baby dolls—to connect the forced obsolescence associated with capitalism to a lack of historical consciousness. Put simply, the impulse to throw out the old for the new implied a broader cultural amnesia. But the eccentric assemblage practice of Edward Kienholz provides a sculptural corollary to Rosenquist's and Rosler's political concerns, especially his *The Portable War Memorial* from 1968 (FIG. 3.16). Viewers confront a life-size hotdog stand—complete with an overturned trash can, three outdoor tables, a Coke machine, and a large photograph of the service counter. But things are not quite right. Not only has the entire scene been given a pallor of silver paint, but a group of faceless American soldiers struggle to hoist a cheap paper flag—Iwo Jima–style—into the umbrella hole of

one of the tables. If this is a war memorial, are the soldiers fighting for freedom, or for the frivolity of American life? One area of the tableau breaks the silver monotony: the black chalkboard at back center-left, filled with the scribbled names of 475 "conquered nations" that no longer exist, with space to add more. Centered on this blackboard is a silver cross with the relief text "The Portable War Memorial," which has its own blank spaces that are ready to be customized for any war—past, present, or future. The work's shocking conflation of the iconography of war commemoration and a reconstruction of a roadside hotdog stand is yet another dramatization of the repressed connections between the realities of death in Vietnam and everyday consumer life in America. If Warhol's *Green Disaster #2* revealed the hidden violence of consumer capitalism, Kienholz directly ties such notions to the war in Vietnam. As the next chapter will make clear, many artists, like Kienholz, wanted to make such connections more explicit by the late 1960s.

Fig. 3.16
Edward Kienholz
The Portable War Memorial, 1968, tableau (plaster casts, tombstone, blackboard, flag, poster, restaurant furniture, photographs, working Coca-Cola machine, stuffed dog, wood, metal, and fiberglass), 112³⁄₁₆ x 374 x 91⁷⁄₁₆ in. (285 x 950 x 240 cm). Museum Ludwig, Cologne.

Coca-Cola and Global Pop

Kienholz's installation included a Coke machine, thus transforming this everyday object into something complicit in, or at least related to, the war in Vietnam. Given its status as an iconic American brand, other artists associated with Pop art appropriated Coca-Cola's logo and bottle design from the very start—two examples being Andy Warhol, who painted the bottle in an early Pop work from 1961 (see FIG. 3.9), as well as in another series in 1962, and Marisol, a French-Venezuelan artist working in New York, who employed an actual bottle in a work entitled *Love* in the same year. *Love* incorporated a bottle of Coke, with brown liquid still inside, inserted into a plaster cast of the lower half of a human face. Considering the erotic connotations and

the title of the work, the artist used the phallic bottle to equate consumer and sexual desire. While Warhol's and Marisol's examples can easily be read as critical takes on capitalism's cult of brands, they nevertheless retain a degree of ambivalence as works of art. Especially in the early 1960s, critics viewed such works as celebrations of the product and, by extension, of American-style capitalism.

The Cold War was also the moment of Coca-Cola's global expansion. The company broadened its international operations after World War II, and the term "Cocacolonization" began to be used in Europe soon thereafter to denote American cultural and economic dominance, often associated with the Marshall Plan's soft imperialism. Thus, Coca-Cola—and really any soda—became a symbol of increasing Americanization to audiences outside the United States. A number of international artists mentioned in this chapter used Coke iconography in such critical ways, including Wolf Vostell and Josep Renau, and there were many more. Three additional examples of artists deploying imagery associated with Coke will demonstrate some of the differing political valences of Pop art globally and bring this chapter to a close.

While American-style Pop art did not emerge in the Soviet Union or its strict satellites such as East Germany, the authorities in other Eastern Bloc nations, such as Czechoslovakia, Poland, and Hungary, tolerated such forms, especially in graphic design. The Hungarian artist György Kemény primarily designed posters, but also made paintings, such as *Childhood Self-Portrait* from 1968—full of the bright colors and striking geometric design associated with international Pop and his graphic work (FIG. 3.17). While the work does not feature Coca-Cola specifically, it does picture a glass of soda in the upper right corner, with its straw and bubbles, alongside an image of a couple on a pier basking under a stylized sun. Coke was introduced in Hungary this same year, the first American product to be sold there. On the other side of the canvas, a close look reveals a more dystopian scene: an image of Mickey Mouse in flames, just below a depiction of a soldier leading a mass of people. Between these two sides, a self-portrait of the artist as a child dominates the work, made even more palpable through the use of an actual coat with buttons to stand in for his body.

This painting stages a conflict: the boy pulled between the Western seduction of Coca-Cola and the symbolic socialist murder of a popular Disney character—both flat images in comparison to his own concrete reality, signified by the shabby coat. Kemény's allusion to a soft drink here is not anti-American, but instead represents his longing for individual freedom outside the drab reality of Hungarian socialism. Along these lines, one Soviet artist called his first sip of Coke "the milk of paradise." In a society with very little resembling Western consumerism, American products like Coke and Levi's, as well as Pop art, offered an alternative to communism and Socialist Realism. Hungary did experience a relative consumer boom in the 1960s, and its economic reforms, known as "Goulash communism," gave residents greater access to consumer goods than their Eastern European neighbors.

Japanese artist Shinohara Ushio also incorporated Coca-Cola into his brand of Pop art. In an assemblage work from 1964 called *Drink More*, viewers encounter a plaster hand offering them an actual bottle of Coca-Cola (FIG. 3.18). The canvas background features a slanted, bright, and miscolored American flag, with a stenciled command: "Drink More." While this work could be viewed as a mere imitation of American Pop—a dramatization in line with its celebratory, complicit reputation—the reality is more complicated, as art historian Hiroko Ikegami has argued. Japan's transformation from a divine monarchy and America's

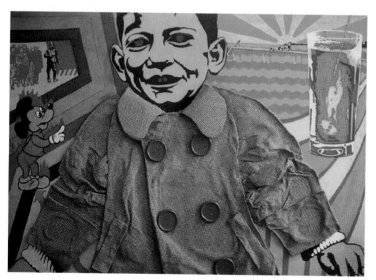

Fig. 3.17
György Kemény
Childhood Self-Portrait, 1968, mixed media, 55⅛ x 39⅜ x 3⅛ in. (140 x 100 x 8 cm). Private Collection.

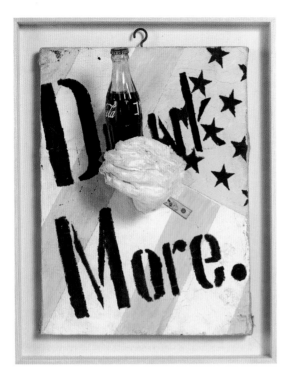

bitter enemy during World War II to a de-militarized and democratic country was sudden and traumatic—leading to a suspicion of authority figures, especially among its young citizens. By the mid-1960s, however, Japan was inundated by American mass culture, including television programs, movies, magazines, and rock music. In this context, *Drink More* becomes an ambivalent work that expresses unease toward American consumerism. Considering that advertising of the period was subtly instructing the Japanese to "Drink more Coke" (Coke was introduced there in 1964), Shinohara's work connects this idea to notions of cultural imperialism—especially its friendly, non-political overtures. It may be a softer version of propaganda, but is advertising so very different from the ideological exhortations that imperial Japan had made just 20 years previously? Shinohara produced another work around this time with the same visual appearance as *Drink More*, but with a different text: "No Thanks!" To refuse the invitation to consume Coke becomes a symbol of anti-American resistance. Shinohara's example shows a Pop art that mimics *and* negates American versions of the style.

Pop art in Brazil proved even more contentious. As discussed in the previous chapter, the military coup in 1964 that ousted a progressive regime resulted in a dictatorship aligned with American interests. This led to anti-American sentiment, especially by 1968, when young Brazilians rallied against both the United States (because of the Vietnam War) and the regime at home (because of its new violent modes of political repression). Some artists transformed American forms of Pop art into modes of resistance. Rubens Gerchman, for instance, used Warhol's organizing grid and flat colors to paint deadpan portraits of anonymous victims of the regime—thus recasting Warhol's machine-like indifference toward death to demonstrate the ruthlessness of the ruling government.

In 1970, Cildo Meireles began *Insertions into Ideological Circuits*, which reimagined Pop art as an actual political act, not simply as an artistic representation. For one component of this project, the artist subtly transformed empty glass Coke bottles and put them back into circulation (FIG. 3.19). (Bottles were not thrown away at this point, but were always returned, washed, and refilled.) Carefully mimicking Coke's existing design and font, Meireles screen-printed anti-American messages such as "Yankees Go Home" on the bottles, and even instructions on how to transform that particular Coke bottle into a popular weapon of protest: a Molotov cocktail. Practically invisible when the bottles were empty, Meireles's interventions required the actual commodity—the brown liquid providing the necessary background—for legibility. In the artist's hands, Coke bottles became double agents, at once capitalist icons and revolutionary weapons.

Insertions into Ideological Circuits represents an important shift in global artistic practices in the years surrounding 1968. While the works of Pop art associated with *The Family of Man*, as well as Rosenquist, Kabakov, and others, derived subject matter from their respective worlds of commonplace images and objects, Meireles took the additional step of aligning his practice with the actual networks and spaces of everyday life. His Coke bottles look back to Warhol's examples from the early 1960s, which critically examined the iconography of capitalism, yet they also speak to Meireles's contemporaries who inserted their bodies and practices into the public sphere as a means to disrupt Cold War norms. This shift reflects increasing political tensions on both ideological sides by 1968—protests, whether anti-capitalist in Paris, or anti-communist in Prague, dominated the news. If the politics of most Pop art remained coded and conspiratorial, much of the art made in the late 1960s could not avoid taking a political stance, as the next chapter will explore.

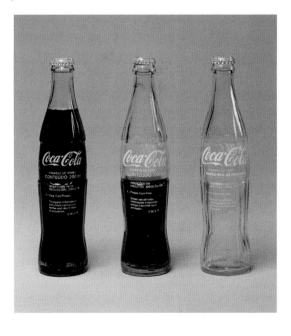

Fig. 3.19
Cildo Meireles
*Insertions into
Ideological Circuits:
Coca-Cola Project*,
1970, 3 glass bottles,
3 metal caps, liquid,
adhesive labels with
text, each object:
9¹³⁄₁₆ x 2⅜ x 2⅜ in. (25
x 6 x 6 cm). Tate,
London.

The Cold War and Global Pop Art

133

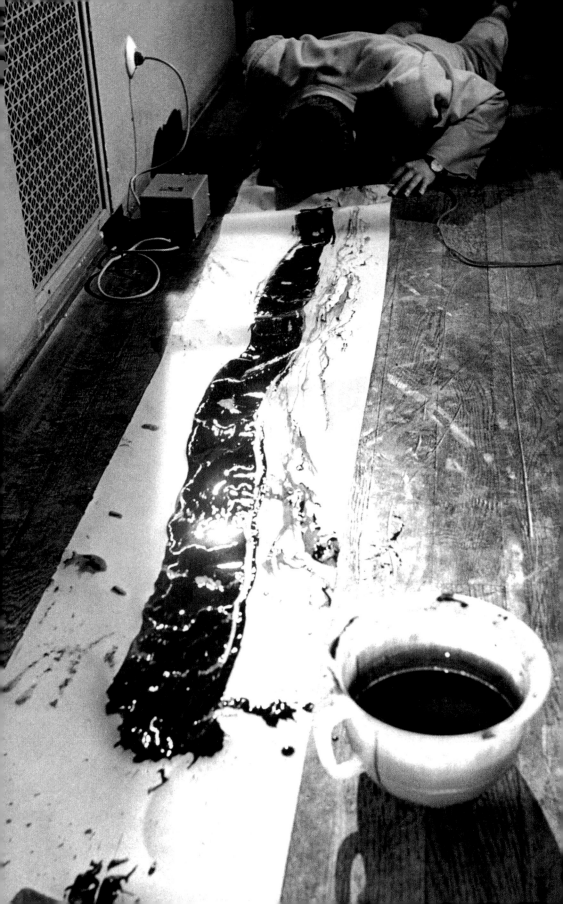

Chapter 4

1968—Art and Politics on the Barricades

A Spanish collective of artists known as Equipo Crónica painted *Socialist Realism and Pop Art in the Battlefield* in 1969—a picture that depicts Cold War battles on several fronts (FIG. 4.1). First, viewers see American soldiers, along with former president Lyndon Johnson at far left, fighting those associated with the communist world. The "battlefield" of the title and depicted jungle makes patent reference to the Vietnam War and its guerrilla combat. This conflict was easily the most publicized, politically contentious conflict of the late 1960s. In the years following President Johnson's escalation of the war in 1964, it became the most prominent symbol of American overreach in the Cold War and demonstrated how the "rational" policy of containment, which sought to limit the spread of communism, could quickly spiral into irrationality. American credibility seemed to be at stake, as a "loss"—at least in the minds of Johnson, his successor Richard Nixon, and the political and military establishment—would embolden Chinese and Soviet plans for communist expansion in Asia, Latin America, and Africa. With well over one million Vietnamese deaths by its end (and more than 50,000 American soldiers killed), the Vietnam War raised crucial questions in the late 1960s: Was the commitment to anti-communism in a small, faraway nation really worth such a human cost? Did the Cold War simply provide ideological cover for the Vietnam War's racist and imperialist overtones? Of course, there were other conflicts active in the late 1960s—mainly wars for colonial independence and the civil wars that often followed liberation—but

Nam June Paik
Zen for Head,
performance of La Monte
Young's *Composition
1960 #10*, 1962.
See fig 4.10

135

Fig. 4.1
Equipo Crónica
*Socialist Realism
and Pop Art in the
Battlefield*, 1969,
acrylic on canvas, 78¾
x 78¾ in. (200 x 200
cm). Museo Nacional
Centro de Arte Reina
Sofía, Madrid.

no conflict, save perhaps the Soviet invasion of Prague in 1968, better demonstrated to a global audience the real human stakes of the Cold War's ideological abstractions.

Socialist Realism and Pop Art in the Battlefield also depicts an artistic battle, with the iconography associated with American Pop art, especially the comic-book imagery of Roy Lichtenstein, pitted against the figurative and propagandistic forms of Socialist Realism. In a sense, the painting captures Spain's own Cold War confusion, since the country had been ruled since the 1930s by a fascist, anti-democratic dictatorship nonetheless aligned with the United States through their shared anti-communism. For the members of Equipo Crónica, as well as many Latin

American artists, the United States—in its support of dictatorial regimes friendly to its Cold War aims—stood decidedly *against* freedom. Thus, works of international Pop art frequently displayed American commodities as agents of cultural imperialism or as embroiled in the U.S. military–industrial complex (see Chapter 3). In this way, the colorful Campbell's Soup can visible in the top center, referencing Andy Warhol's iconic paintings of the product, becomes a surrogate American soldier. By the late 1960s, antagonism to consumerism had become more entrenched throughout the capitalist world: even shops were now marked for political violence. When two radicals, later associated with the West German terrorist group Red Army Faction in the 1970s, chose their first targets in 1968, they set fire to two department stores in Frankfurt as a way of battling what they saw as the public's "indifference to the war in Vietnam."

A detail at lower left is important to the canvas: Equipo Crónica presents the scene on view as a thought bubble of Diego Velázquez—an artist who struggled to reconcile the political function of painting at the seventeenth-century Spanish court with its autonomous value as a work of art. In *Las Meninas* (1656), for example, he depicted himself in the process of painting the royal family, thus explicitly positioning the canvas both as a historical record and an autonomous artwork. By drafting Velázquez into their painting, Equipo Crónica posed questions that plagued artists especially in the late 1960s: What is the relationship between political events and works of art? Should art objects stand outside contemporary political debates, or should they attempt to intervene in daily life? Velázquez wanted it both ways, but was this position still tenable by the end of the 1960s?

The question of Pop art's Cold War politics emerged in earnest when the American artist Robert Rauschenberg was awarded a Golden Lion at the Venice Biennale in 1964, a prestigious prize that declared his works the best in this vast, important international exhibition. Many artists and critics, especially in Italy and France, immediately cried foul—charging that the decision was based more on American political and economic influence than the quality of Rauschenberg's large silk-screen paintings. A French art newspaper even ran a headline soon afterward that identified Pop art as yet another way for America "to colonize Europe." The ostensibly nationalistic imagery of the

prize-winning works—a number featuring President Kennedy, pictures from the space race, and even a bald eagle—only furthered such imperial suspicions. Despite these criticisms, Rauschenberg's achievement was a feather in the Cold War cap of the American art establishment. If American Abstract Expressionism was a subtle form of propaganda in the 1950s, then the Pop art of Rauschenberg, Warhol, and others—with what many viewed as its uncritical acceptance of capitalism—could be seen as a more overt form of nationalism, especially as the American involvement in Vietnam continued to grow. Such sentiments were far from universal, however, as some West German critics viewed American Pop art as a Marxist critique of consumerism, for example.

Socialist Realism and Pop Art in the Battlefield thus demonstrates the ways that artistic styles remained implicated in the Cold War throughout the 1960s—with Pop art replacing Abstract Expressionism as the perpetrator of American cultural imperialism. However, the painting also expresses an internal conflict for many artists around 1968: Was it possible to stake out a position between both the stylistic and political poles of the Cold War? In the middle of the decade, the French filmmaker Jean-Luc Godard described the student generation of Western Europe as the "children of Karl Marx and Coca-Cola." Many wanted political change or even revolution, but they had also been indoctrinated, thanks partially to the Marshall Plan, into the commodity and entertainment cultures of capitalism. Godard's strange capitalist/communist hybrid registers the ideological confusion of the second half of the 1960s.

The Swedish artist Öyvind Fahlström also demonstrated this conflict brilliantly in his *Mao-Hope March* in 1966, in which individuals carried seven oversized placards down Fifth Avenue in New York City in what seemed to be a protest march (FIG. 4.2). Six of the signs featured a photo of the famous American comedian Bob Hope, with the other depicting Chairman Mao—a potent icon of the growing global protest movement. As part of this march, a popular radio host asked pedestrians along the route the simple question "Are you happy?"—referencing the "pursuit of happiness" invoked in the American Declaration of Independence. While some answered the query—"Oh yes, I love the television" was a typical answer—others wondered aloud

Fig. 4.2
Öyvind Fahlström
Mao-Hope March, 1966,
16-mm black-and-white
film, sound, 4 min 30
sec. Öyvind Fahlström
Foundation.

about the implied connection between a Chinese communist revolutionary and an American television personality. While Hope and Mao might seem like opposites, Fahlström suggests a similarity: both were media icons—the former emblematic of jocular capitalist distraction, and the latter of armed revolutionary struggle. Fahlström realized the power of the culture industry, as signs of the comedian outnumbered Mao six to one. Poignantly, "Hope" in the work does not signify optimism for the future but rather a continuation of the status quo, with silly jokes by the likes of Bob Hope keeping Cold War anxiety at bay. The battle between capitalism and communism was clearly a concern of Fahlström, especially considering an important earlier work called *The Cold War* (1963-65). This interactive piece was divided into two and allowed viewers to move around magnetic components that would alter the compositional balance of the conflict.

The political confusion staged by Fahlström's march captures the changed state of the Cold War in the mid- to late 1960s. The utopian dreams fostered by both capitalism and socialism lay largely shattered by the end of the decade, with 1968 often singled out as the year when the ideological certainty associated with the conflict evaporated. The West had its share of protest movements and social unrest on display that year in France, West Germany, Mexico, Argentina, and the United States, among other nations; there were also major uprisings in communist

Poland and Czechoslovakia, as well as the revolutionary destruction in Chairman Mao's China as part of the Cultural Revolution (which had begun in 1966). While the unrest in each site arose from specific local circumstances, these events can also be viewed as part of a global current that stretched across ideological and geographic lines. As historian Jeremi Suri has argued, the global counterculture emerged in response to the Cold War: Students and others were frustrated that the promises offered by both capitalism and communism remained largely unfulfilled. The hunt for a Third Way, discussed in previous chapters, became even more crucial to both the art and the politics of the moment. Activists in the West, for instance, looked broadly toward communism and its new heroes, untainted by Soviet excesses and crimes: Che Guevara and Fidel Castro from the Cuban revolution, and Mao from China. Conversely, dissidents in the East were fixated on the democratic and open ideals associated with the West, such as a free press and representational government. Broadly speaking, protesters on each side wanted what the other seemed to have. The erosion of the Cold War's binary culture was well underway.

Several important theorists from this period, such as Guy Debord and Herbert Marcuse, noted key similarities linking the Cold War adversaries—namely that both capitalist and communist systems eradicate individuality, whether through propaganda mandating mass consumption or communal production. The cover of the left-wing French magazine *Opus International* from December 1967 reflected this ideological jumble: it showed mirror images of the same illustration of Superman, pictured in the process of running toward the reader, one identified as representing the CCCP (or the USSR), the other the United States. The background of the poster's designer, Roman Cieslewicz, perhaps allowed him to see East and West as more similar than different: he was trained in Socialist Realism in Poland before moving to France in 1963. Both Cold War sides promised fulfillment, but their outlandish promises proved as fantastical as the idea of Superman.

This chapter will explore the confusion and the conflicts surrounding the making and exhibiting of art during this contentious moment of the late 1960s. This was a period that not only witnessed intense debates over the political positioning of various styles of art, especially in how such styles resisted

and/or complied with American political and cultural aims, but also saw artists themselves looking for ways to merge their own aesthetic practices with explicitly political ones, often with Cold War implications. From Paris to Beijing to Prague and beyond, artists grappled with the ideological meaning of materials and the pervasiveness of consumerist and media cultures.

Steel, Lettuce, and Dead Hares: The Politics of Materials

It was not only American Pop art that became, however superficially, associated with an uncritical embrace of capitalism and its homeland's military interventions in Vietnam, and support of repressive regimes elsewhere. Minimalist art, with its blankness, rigid geometries, and industrial materials, also came to signify, for some European critics, a complicity with American actions abroad. Donald Judd's *Untitled (DSS 123)* from 1968 is a typical example of Minimalist art—ten stainless-steel boxes

Fig. 4.3
Donald Judd
Untitled (DSS 123),
1968, stainless steel
and yellow Plexiglas,
10 units, each 9¹⁄₁₆ x
40 x 31 in. (23 x 101.6
x 78.7 cm). Froehlich
Collection, Stuttgart.

stacked vertically, each iteration having a translucent yellow Plexiglas panel covering its top and bottom (FIG. 4.3). Produced by craftsmen according to Judd's precise specifications, this work shows no evidence of the human hand. Its sterile materials and industrial fabrication could connote dehumanization and mechanical rigidity, values loosely associated with the American military.

If an object like *Untitled (DSS 123)* could appear complicit with American Cold War aims, this was by no means Judd's intention. The artist's aesthetic evolved out of the theories of Clement Greenberg, discussed in previous chapters. Greenberg had required that paintings eschew traditional illusionism and reinforce their own status as physical objects—as Pollock did by creating works of allover flatness (see FIG. 1.1). Judd went further, dispensing with painting altogether and instead

1968—Art and Politics on the Barricades

offering viewers what he called "specific objects" that unambiguously occupy space. In the essay of the same name, published in 1965, Judd explained his embrace of sculpture: "Actual space is intrinsically more powerful and specific than paint on a flat surface." But despite this claim of concrete legibility, Judd's objects also negate their physical presence through their luscious optical qualities. In *Untitled (DSS 123)*, for instance, the boxes seem to float weightlessly on the wall, their fastenings hidden from view. Additionally, the yellow hues emanating from above and below the boxes melt and distort their individual autonomy. The result is a contradiction: *Untitled (DSS 123)* is a group of discrete objects—each reinforcing the specific shape and materials of the others—that also creates optical illusions negating such objecthood.

Although Judd opposed the Vietnam War—he helped raise money for anti-war causes, for example—he nevertheless viewed his work as distinctly *American*, famously stating that European art was "over with," dismissing contemporary practitioners from France and elsewhere in the process. Concepts such as intuitive composition—where an artist subjectively relates colors, shapes, and lines—were for Judd stuck in an Old World way of making art. Instead, he touted physical matter and specificity, as well as a systematic repetition that emphasized both these qualities. And it was just these "American" traits that allowed his critics to perceive militaristic connotations in his work. Furthermore, the softening of hard American steel in the service of a gravity-defying optical exercise—its beautification, in other words—could also be related to the exercise of power; Judd was vulnerable to the accusation that he had hidden steel's functional violence through recourse to the aesthetic. These connections became more explicit when the artist began installing

Fig. 4.4
Giovanni Anselmo
Untitled (Structure that Eats Salad), 1968, granite, salad, brass thread, 25⁹⁄₁₆ x 11¹³⁄₁₆ x 11¹³⁄₁₆ in. (65 x 30 x 30 cm). Deposited with the MAMC Saint-Etienne.

many of his works in the vast, raw spaces of a decommissioned American military base in Marfa, Texas, in 1979. While such a move might be viewed as subverting American militarism, it also confirms an affinity between his sculptures and the surrounding spaces. The works, in some sense, feel right at home.

American Pop and Minimal art dominated international exhibitions in the mid- to late 1960s, including such conspicuous events as Documenta in West Germany, and the high-profile biennales mounted in São Paulo and Venice. While American critics identified the stark differences between the forms of Pop and Minimalism, some in Europe—especially Italy—instead saw continuity: both were viewed as products of the United States and its advanced consumer and industrial society. Such artworks were linked to the exports acquired through Marshall Plan aid that helped rebuild much of Western Europe after World War II: these were objects of fascination *and* agents of cultural imperialism. In 1967, the Italian curator Germano Celant authored a manifesto on behalf of a group of Italian sculptors, provocatively entitled "Arte Povera: Notes for a Guerrilla War." Published in a major international art journal, Celant's text railed against American art and capitalism. He likened his core artists, who included Mario Merz, Pino Pascali, and Giovanni Anselmo, to a military counterinsurgency comprising peasants who used "poor" materials to fight the industrial might of the United States. (Che Guevara's *Guerrilla Warfare*, published in 1961, was a touchstone for Celant.) In 1967, Celant's "guerrilla war" metaphor immediately inspired thoughts of outgunned communist Viet Cong soldiers holding their own against their American opponents. This was an anti-American artistic position that had nothing to do with Socialist Realism.

So what sort of work did Celant's "guerrilla artists" produce? In a follow-up essay from 1969, he championed the "artist-alchemist" who "organizes living and vegetable matter into magic things." Anselmo's sculpture *Untitled (Structure that Eats Salad)* from 1968 is an example of just such an enchanted object (FIG. 4.4). It features a square block of granite loosely roped near the top of a larger granite stele, kept snuggly in place via the addition of fresh lettuce between the two stones. If the lettuce wilts, then the brass thread slackens, and the smaller block falls to the ground. According with its parenthetical title, this work of art

needs to be fed—that is, the lettuce must be changed regularly—and is ready to spring to life, unlike the static and sterile works of American Pop and Minimalism. Having been fashioned with preindustrial materials, Anselmo's work could, in theory, have been made at any time after the introduction of stone cutting, and therefore it consciously rejects modern technological materials. While the stones' sharp geometries could refer to Minimalist Art, the work's inclusion of organic and entropic materials such as lettuce negates the coldness of such simple shapes.

The year 1968 was a contentious one in which to write criticism or make artworks in Italy, as mass protests and strikes against the Vietnam War were common. While objects associated with Arte Povera might not have directly participated in such unrest, they nevertheless offered a powerful statement of artistic resistance against American economic and military dominance. Additionally, the artists' reliance upon unadorned natural materials, presented with little or no material alteration, allowed viewers to confront objects that had not been subjected to the distortions of industry, consumerism and the mass media. In other words, Arte Povera's simple, materialist honesty resonated with the period's protest culture. Perhaps more so than the other examples in this chapter, these sculptures waged their political guerrilla war primarily through the aesthetic.

Organic materials also took on political significance in the sculpture of the West German artist Joseph Beuys, but to less antagonistic ends. Throughout his career, the artist consistently returned to a core group of materials, including fat, felt, and other sorts of organic matter (sometimes juxtaposed with steel and other industrial materials). According to Beuys's "myth of origin," these materials saved his life: while serving in the Luftwaffe during World War II, his plane crashed in the Crimea, where local Tartars apparently nursed him back to health by wrapping his body in fat and felt. The rejuvenating qualities of these materials were also metaphorical for the artist—not only as a means to heal the deep wounds stemming from Germany's Nazi past, but also as a stand-in for certain ways of thinking. With its malleable qualities, fat represented, for Beuys, flexible creativity, unlike the rigidity imposed by industrial materials and overly rational thinking. Although his work looked backwards, grappling with the traumas of World War II, Beuys was also

a crucial Cold War artist. For instance, he discussed at some length the need for intellectual warmth and openness—qualities that he viewed as countering the inflexible posturing of the Cold War. For him, the cripplingly rigid mindsets of capitalism and communism, especially as they existed on either side of a divided Germany, each stood in the way of true democracy. His absurd proposal to raise the Berlin Wall by five centimeters, as a way to make its appearance more pleasing, demonstrates his utopian naïveté about human abilities to transcend real political barriers: "Don't talk so much about the Wall! Establish through self-education a better morale in mankind and all walls will disappear." He believed—or feigned belief—that his art practice could do just this.

Beuys was also a performance artist, and he often incorporated objects from his actions into sculptures. Such is the case with *Eurasia Siberian Symphony 1963* from 1966, where a taxidermied hare is perched along the top edge of a chalkboard, supported by wooden dowels emanating from the animal's front

Fig. 4.5
Joseph Beuys
Eurasia Siberian Symphony 1963, 1966, panel with chalk drawing, felt, fat, taxidermied hare, and painted poles, 6 ft x 7 ft 6¾ in. x 20 in. (183 x 230 x 50 cm). Museum of Modern Art, New York.

feet (FIG. 4.5). While this work is subject to Beuys's complex allegorical galaxy of materials and ideas, of special interest is "Eurasia" clearly written on the blackboard; this is the contiguous landmass that links Europe and Asia, including Western Europe, Eastern Europe, the Soviet Union, and China. In Beuys's mythological world, Eurasia was a utopian concept that transcended the Cold War's ideological and geographical divisions, combining the rational West and the more spiritual East. (Beuys was not afraid of essentializing stereotypes.) He considered the hare a revolutionary creature, equating its burrowing into the earth with the potential of human thought to shape the surrounding world. In this particular work, the hare is "an inhabitant of Eurasia," who, in Beuys's estimation, even "surmounts the Berlin Wall," hence, its elevation and connection to the horizontal dowel spanning the length of the work and beyond. While some of Beuys's political gestures became more intelligible by the end of the 1960s—when he founded a political party—his sculptural practice of the 1960s resists technological materials as a means to undercut Cold War division. Although produced in vastly different contexts, the work of Beuys and Arte Povera, wedded to the use of organic materials, repelled both the dominant American languages of Pop and Minimalist art, and the didacticism of Socialist Realism.

Close examination of certain examples of American Minimalism, however, suggest a more complicated Cold War story. Despite the criticisms of Celant and others, some American artists positioned their work in direct opposition to capitalism, even finding inspiration in the forms and ideologies of Soviet Constructivism from the 1920s, which attempted to dissolve art into the practices of everyday life, using industrial or simple materials to make useful, efficient, and geometric objects (see FIG. 1.8). When reintroduced to artists in the 1960s through new publications in English, Soviet Constructivism suggested aesthetic strategies that were both politically progressive and modern in appearance in this decade of protest. Dan Flavin, who arranged simple configurations of fluorescent light tubes on walls, named a series of works after the Constructivist and revolutionary Vladimir Tatlin, for instance. But Carl Andre, who used specific industrial materials in his work, best embodies this new Constructivist ethos.

Fig. 4.6
Carl Andre
Steel Zinc Plain, 1969,
steel and zinc plates,
⅓ x 72⅖ x 72⅖ in.
(9 x 1840 x 1840 mm).
Tate, London.

Andre described his work in 1970 as "communistic," even directly comparing himself to Rodchenko. While Andre had no revolutionary desire to discard the category of "art," he took inspiration from the Constructivist commitment to working-class materials, and he used these in ways that emphasize their physical properties. *Steel Zinc Plain* of 1969, for instance, comprises thin squares of two metals not often associated with art, arranged in a simple six-by-six configuration on the ground (FIG. 4.6). Viewers could distinguish the different properties of the steel and zinc both through sight (when looking down on the work) and feel (when they walked on it). Andre's process was also workmanlike: He simply acquired the necessary plates from a manufacturer and arranged them on the floor, without making material alterations or using a bonding agent. When the exhibition was over, he could even return the squares to the supplier for reuse. In the early 1970s, Andre took his interest in class and Marxism further, individually pricing sculptures based on the income of the potential collector. The richer the buyer, the more the sculpture would cost.

It was not only Andre's materials and efficient configurations that engaged with the oppositional politics of the 1960s, but also the participatory aspect of this work. *Steel Zinc Plane* emphasizes the surrounding gallery space with its nearly invisible profile, but it also makes the more radical move of requiring viewers to walk upon it. A shift from the 1950s is clearly evident: if

Jackson Pollock was an "action painter," stepping into his floor-bound canvas, Andre's work here is a kind of "action viewing" for those who step onto its metal stage. The kind of self-awareness the sculpture engenders—a moment where viewers can experience their bodies seemingly outside of a utilitarian capitalist existence—corresponds to some of the rhetoric found in the widely circulated brand of Marxism espoused by the German émigré Herbert Marcuse. Marcuse's books and essays (written in English), especially *One-Dimensional Man* (1964), provided rallying cries for protesters in both the United States and Europe looking for an updated Marxism not tied to the concerns of the working or peasant classes. Marcuse decried the ways that industrial capitalism had flattened individual experience and stifled critical thought. For him, consumerism and the culture industry served to numb the populace, especially those once-radical classes, into mute complacency. He thus called for citizens to "break their servitude and seize their own liberation." By physically engaging with the viewer's space and body, Andre's art thus provided an abstract model for more explicit political interventions dedicated to reclaiming one's freedom, à la Marcuse. For the theorist, art, like a kind of laboratory, could open "the established reality to another dimension"—that of real freedom.

Despite his Marxist intentions, Andre's materials and matter-of-fact presentation were nevertheless viewed by some in Europe as evocative of American industry and militarism. (This had as much to do with his American nationality as with his actual art.) Similar to a number of the works discussed in previous chapters, his sculptures are thus conflicted Cold War objects; their political alignment shifts, depending on who is looking. Are they complicit with American imperialism? Are they subversive? Can they be both?

China's Cultural Revolution
If Carl Andre looked to a Marxist tradition to create simple, forthright, and empowering objects, while still relying on galleries and the classification of his work as "art," then officials in China, beginning in 1966, took a harder communist line: They attempted to eradicate bourgeois artistic conventions and reinstate revolutionary ones as part of a "Cultural Revolution."

Launched in 1966 and lasting until Mao's death in 1976, this was a concerted effort to reignite faith in communism—both through violent purges of people, ideas, and objects deemed "rightist," and attempts to inspire proletarian unity and fervor. Part of the impetus for China was to capitalize on the Soviet Union's waning global influence and prestige, and attempt to assume the mantle of leadership in the communist world. While the extent of the rift between the Soviets and Chinese was not fully known in the United States and Europe until later, it was deep and highly significant by the mid-1960s. The Cultural Revolution aimed to reinvigorate all aspects of communist life in China, and the visual arts played a crucial role in this.

An official directive from the Communist Party launched the Cultural Revolution in May 1966: Mao suggested that all aspects of cultural life—from magazines to textbooks, from novels to paintings—had been corrupted by bourgeois elements. While the leader soon purged many important party bosses and seized editorial control of China's major newspapers, the legacy of these chaotic years remains the violence of student groups—"Red Guards"—acting independently, albeit in the name of Mao. The Red Guards strived to overthrow any subversive elements within the Party and to eradicate anything related to the "Four Olds"—old ideas, old culture, old customs, and old habits—which were seen to be holding back Mao's permanent revolution. As a result, especially in the Cultural Revolution's early years, the Red Guards destroyed countless cultural artifacts from China's long history, including books, art, and architecture. For example, many ancient objects and buildings associated with Confucius were obliterated, as well as artistic materials related to the capitalist West.

An anonymously produced poster from 1967, widely reproduced and displayed, illustrates a young man ready to bring a sledgehammer crashing down on a still life of subversive objects at the bottom, both non-Chinese and old—including a crucifix, dice for gaming, a Buddha, and a vinyl record (FIG. 4.7). The text at the top ensures the image will not be misinterpreted: "Destroy the Old World: Establish the New World." The red band around the protagonist's arm—clearly set off against the black ink of his body—identifies him as a Red Guard member. In terms of art history, the Cultural Revolution was perhaps

the most consequential period of the Cold War; its quest for ideological purity led to the destruction of a significant portion of China's long artistic heritage.

While the content of the poster communicates the destructive aims of the Cultural Revolution, its medium emphasizes its artistic mandate: to move art away from tradition and cultural elites, enabling it to realize its full political potential. While oil paintings continued to be produced, mostly of Mao in various triumphs, political posters embody the Cultural Revolution's ethos: Their creators remain mostly unknown; they employ clear, propagandistic messages with striking graphics and/or bold text; and they were reproduced in massive numbers and hung in public spaces. One particular poster featuring Mao, based on a painting by a Red Guard artist, was printed over 900,000 times during this period. Additionally, most posters were not commissioned and, as a result, are not the products of top-down mandates from the Party. Instead, they represent a truly popular—yet dangerous—revolutionary fervor. And once the initial Red Guard violence died down around 1968, Party authorities championed works created not by trained artists but by "worker-peasant-soldiers": that is, untrained practitioners motivated only by revolutionary zeal. Many artists in the West in 1968 aimed for just such a potent fusion of art and politics, but they were not nearly as successful in merging the two spheres.

France and Czechoslovakia: Art and Protest

In a 1969 essay, the French artist Jean-Jacques Lebel connected the momentous anti-capitalist protests of May 1968 in France to some of the prevailing artistic developments of the 1960s,

namely performance-based strategies manifested in Happenings and Fluxus. On the whole, the artists affiliated with both movements staged works of art that were actions—some simple, some complex—that dissolved the barrier between the performer and the audience. Lebel himself ceased to produce his own anarchic, sexualized Happenings after May 1968, declaring that his works' aims had been fulfilled by protesting students and workers. Lebel's theory is provocative in its suggestion that experimental performance art provided a model for a political protest that nearly toppled the French government. In the late 1960s, in both France and communist Czechoslovakia, where another mass movement attempted government reform, certain artists attempted to move away from the idea of the artwork as a discrete object in a gallery or museum space, gravitating instead toward a practice that viewed the everyday urban world as the site for artistic interventions.

While Lebel cited Happenings and Fluxus as having anticipated the protests and strikes in France, another group of artists and theorists known as the Situationist International (SI) were a more likely influence. Led by the theorist Guy Debord, the SI aimed to destroy the category of art by attempting to transform everyday life into something exhilarating and liberating, like the best works of art. In his 1967 book *The Society of the Spectacle*, he argued that Cold War differences no longer mattered; both camps relied upon "an immense accumulation of spectacles"— whether advertising, mindless diversions, or total propaganda— for social control. Despite the illusion of freedom in the capitalist West, its citizens had been trained to enjoy the deadening and preprogrammed choices they were offered, and in the East, the one-party system had constructed a vast, manipulative mirage. For Debord, true liberation was not possible under either system.

The SI believed in reconfiguring the everyday life of the city through a rubric of play, creating urban "situations" that could turn the utilitarian products and experiences of capitalism and communism against themselves. The practices of a number of French artists, although they were not officially affiliated with the SI, align with the group's theories in the 1960s. Beginning in late 1949, Jacques Villeglé, for instance, followed urban vandals around Paris who ripped advertising hoardings. Villeglé would then remove, mount, and glue the layered and torn results for

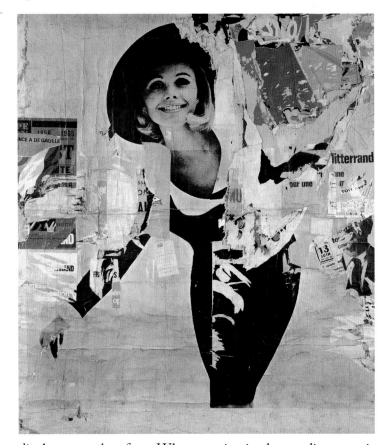

Fig. 4.8
Jacques Vieglé
*Rue Desprez-
Vercingétorix (La
Femme)*, 1966, torn
poster glued on canvas,
101³⁄₁₆ x 87 in. (257 x
221 cm). Museum Ludwig,
Cologne.

display as works of art. What remains in these palimpsests is almost like a psychoanalytic examination of the city's unconscious, with past commercial messages erupting unintentionally into the hoardings' present tense. Politics—whether the colonial war in Algeria (which ended in 1962) or the domestic political battles leading to the events of 1968—emerge as well. In an example from 1966, a black-and-white image of a woman happily engaging the viewer, clearly derived from an advertisement, dominates the composition (FIG. 4.8). A close look at other elements in the work, however, unveils remnants from the previous year's presidential campaign. On the left, a small piece of blue paper reveals the last name of the militant incumbent Charles de Gaulle, while most of the name and a partial portrait of the leftist challenger François Mitterrand are visible on the right side of the work. While perhaps not intentional, the vandals' actions archaeologically reveal a profound ambivalence lurking in the piles of posters: both politicians are subservient and powerless

in comparison to the advertisement. What is the point of casting a vote for a politician working within the system, the work seems to ask, when the problem is the system itself? Villeglé's work has affinities with some of Debord's theories, namely the transformation of a "useful" part of the urban fabric—a place for advertisements—into a playful work of art. And the vandals were certainly consumers of the city as a playground, not as a site dictated by the concerns of commerce. Villeglé displayed the results as "art"—something Debord would have opposed—and thus enabled these transformed hoardings to acquire significance, as they would not have likely been scrutinized if not in a gallery.

Such a work also stressed the anonymity of its creation, becoming, according to Villeglé, "the most remarkable manifestation of 'art made by all and not by one' of this period." Furthermore, by titling his work after the geographic origin of its raw material—an intersection in the working-class 14th arrondissement—Villeglé gives the city itself a degree of creative agency. The work's top right corner resembles the forms of painted abstraction, the flat surfaces so tied to American artistic identity in the 1950s and early 1960s; the artist translated these marks into an object embodying the anonymous, illegal attacks of the disenfranchised against capitalist advertisements.

It was these disenchanted people—including hundreds of thousands of students—who demanded to be heard in May 1968. Originating with student activists on college campuses in and around Paris, their movement eventually led to the largest general strike in history, with some ten million people refusing to work, and the occupation of factories and universities, shutting France down for two weeks. Many of the slogans that appeared in graffiti and on thousands of posters recalled the theories of Debord: "Imagination takes power," "The walls are ears, your ears are walls," and "Under the cobblestone, the beach," to name only three. The latter, with its utopian reconfiguration of the street—the sand that secured paving stones becoming a place of leisure—is especially akin to the ideas and general stance of the SI.

The posters that contained such slogans are some of the most striking artistic artifacts of this global period of unrest. Using one-color screen printing, students from the Paris art schools formed the *atelier populaire* (people's studio) and produced thousands of posters (with at least 200 designs): a vast deployment of

graphic and textual power displayed all over the city. If public posters were usually commercial in nature, then these students negated one of the pillars, so to speak, of capitalist urban culture. A photograph of a university building in Paris showcases the diversity and wit of the posters (FIG. 4.9). In the top right corner a poster with a tank decries the discrepancy between workers' wages and military spending: "Light wages—heavy tanks." The example pasted to the door near the photograph's center features a policeman with a paintbrush in his mouth, with the text: "The police post themselves at the School of Fine Arts—the Fine Arts' students poster the streets." Appreciating the visual and verbal wit, the Museum of Modern Art in New York even exhibited a selection of these posters in late 1968. Given their central role in China's Cultural Revolution and France's own near-revolution, posters were perhaps the most politically consequential art of the late 1960s. And like the artists of Arte Povera, these students rejected twentieth-century technology, returning to a revolutionary strategy—the simple poster—used in many of the upheavals of the nineteenth century.

Fluxus, under whose umbrella were gathered an international group of artists, provided another model for protest on both sides of the Cold War. Graphic work was also central to Fluxus, as a graphic designer organized the movement. But George Maciunas conceived of Fluxus not as a coherent group of artists with a singular aim or style, but rather as a clearing house for various artistic activities with an international reach—namely experimental publishing and performance. Maciunas's biography is heavily inflected by the Cold War: born in Lithuania, he immigrated to America with his parents in 1948, via West Germany, after fleeing advancing Soviet troops in 1944. He then returned to West Germany in 1961, taking a job as a designer for the U.S. Army at its important base in Wiesbaden. Despite working for the American military, Maciunas was sympathetic to the Soviets; Fluxus, for example, was inspired by artists affiliated with Soviet Constructivism during the 1920s. These revolutionary artists wanted to make art useful, and were committed to destroying bourgeois values through an eradication

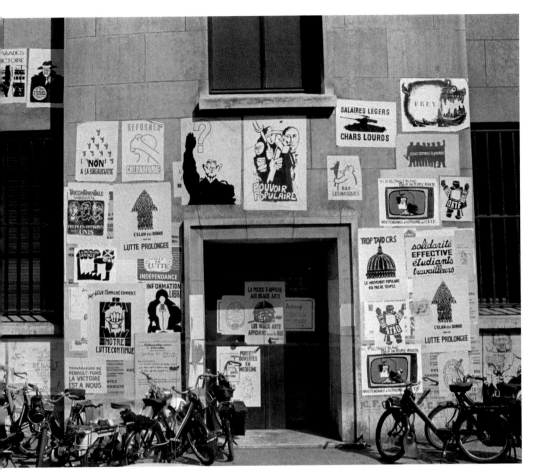

of the autonomous sphere of art. (Maciunas, an expert in Soviet history, even proposed a detailed scheme for the construction of affordable prefabricated housing in the Soviet Union in 1965.) When viewed through this revolutionary lens, Fluxus works can be viewed as providing moments of liberation within the deadening routines endemic to consumer capitalism and stilted Soviet communism alike. Furthermore, the geography of the Cold War—the American base at Wiesbaden was vital for the protection of West Germany, for example—helped Maciunas forge the international connections necessary for Fluxus to thrive. The early Fluxus festivals that the movement's impresario staged in the vicinity of the base were some of the most influential in European art after 1945.

The legacy of Fluxus primarily rests on their introduction of "event scores" into art: short sets of written instructions that

Fig. 4.9
Bruno Barbey
*Political posters,
May 1968, Medecine
University, Paris.*
Photograph.

can be performed by anyone, in any number of ways. In 1960, the American composer and artist La Monte Young composed one such score: "Draw a straight line / and follow it." In 1962 the Korean artist Nam June Paik, best known for his pioneering work with television and video (discussed later in this chapter), "completed" the score during a Fluxus festival in Wiesbaden in an unorthodox way. He dipped his head into a soupy mixture of ink and tomato juice and then, crawling backward, dragged it along a scroll of paper (FIG. 4.10). By creating something similar to both the brash gestures of American abstract painting and the expressive calligraphy associated with East Asia, all the while adopting, physically, a posture of utter subservience, Paik deflated and decentered the dominant form of Western art in 1962. His emigration had also been a result of Cold War conflict; the son of a wealthy industrialist, Paik fled South Korea at the age of 18 when the Korean War broke out. He earned his college degree in Japan before moving to West Germany in the early 1960s. Paik's performance in Wiesbaden—considering Macinuas's organizational role and the artist's own history—was inextricably linked to the political and artistic structures of the Cold War.

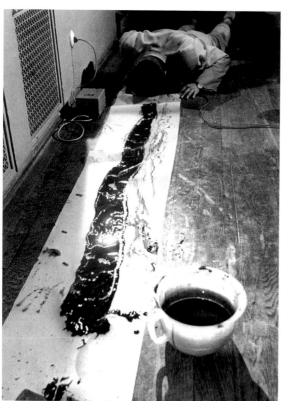

While not dealing with the Cold War in terms of topical imagery, this work nevertheless demonstrates the heart of Fluxus's politics. La Monte Young's original score parodied the expectations of social and political conformity expected on both Cold War sides, "draw a straight line and follow it," while Paik's performance exploded such obedience via his self-consciously abject and creative interpretation of Young's directive. That event scores were often neatly typed on an IBM electric typewriter and distributed on index cards only added to the absurdity of performing them. Fluxus artists also produced nonsensical objects—or what might

be called anti-commodities, undercutting capitalist efficiency—which were made available through mail-order catalogues. Examples include the French artist Ben Vautier's *A Flux Suicide Kit* (a small plastic box including a razor blade and an electrical plug with a frayed cord, among other things) and a bedside clock by the American Robert Watts with only ten hours on its face.

Befitting Maciunas's global ambitions, Fluxus also had a presence in Eastern Europe. Another important member, George Brecht, appointed a Czech artist, Milan Knížák, to be the head of "Fluxus East" in 1965. Some of Knížák's early event scores adopt the Fluxus mold; in 1965, one simply said "Cut a circle into all parts of your clothing," for example. But such a playful act took on a different significance in the repressive context of communist Czechoslovakia—it rebuked the controlling authorities by usurping their role of dictating orders. Devising moments of creativity within the fabric of everyday life acquired a sharper political edge when such acts could carry serious repercussions. Indeed, Knížák was jailed a number of times in the 1960s—a crucial reminder that Cold War ideologies continued to shape responses to art in the 1960s in different ways: What was laughed at in the West could be deeply subversive in the East.

By this logic, Knížák's public performances in Prague in the mid-1960s become even more consequential. Like the Situationist International, they encouraged participants to experience the city as a playground, not as a repressive apparatus. For *A Walk around Nový Svět—Demonstration for All the Senses* in 1964, Knížák planned a route for his friends along a famous street in Prague. Each carrying a different object for the duration of the performance, the participants experienced varied situations along the way that were designed to heighten their senses. To name a few, they were locked in a small room for five minutes where perfume had been spilled on the floor; they came across a man lying on his back in the street playing a double bass (FIG. 4.11) and, when handed a book, each participant was instructed to rip out a page. Knížák's aim here, and in other participatory works like this one, was to interrupt the flow of "normal" life under communism, and in doing so to promote creative and irrational expression in a culture that stifled it.

Other artists working in Czechoslovakia attempted to fuse art and everyday urban life as a means to critique the state-imposed

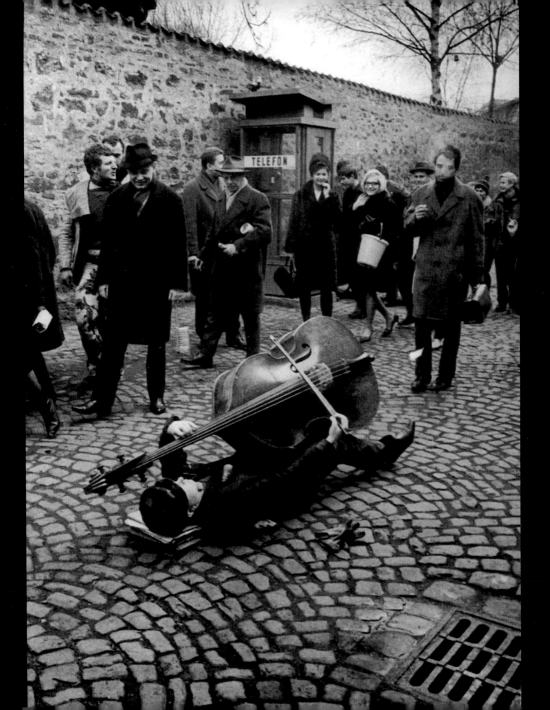

mindset of Socialist Realism. In Bratislava in 1965, the artists Stano Filko and Alex Mlynárčik (with the assistance of the theoretician Zita Kostrová) produced the action *HAPPSOC I*—a neologism that could mean either "happy society," "happy socialism," or even "happening socialism." For this work, the artists declared the entire city of Bratislava to be a work of art during perhaps the most ideologically important week for the city—the one falling between May Day (May 1) and the anniversary of the Soviet army's liberation of Slovakia in 1945 (May 9). To document *HAPPSOC I*, the artists issued a manifesto, two photographs of official parades in Bratislava on May 1 and May 9, 1965, and an invitation that also outlined the "objects" that were part of the work—including 137,936 women, 3,505 electric stoves, and 128,726 TV antennas. In its scope, *HAPPSOC I* was, among other things, a critique of the logic of Socialist Realism, in which every individual or object was theoretically vital to the revolution's success. Any photograph taken in Bratislava during this first week in May could thus be considered part of the work's documentation, and if the city was indeed a "happy socialist" community, then each should express the values and virtues of socialism as it manifested itself in Bratislava. Of course, many citizens ignored the parades and celebrations, and *HAPPSOC I* ironically reveled in the gap between official pronouncements and individual experience.

Knížák's urban works of the 1960s provided a symbolic protest against the ideological urban spectacles of communism parodied by *HAPPSOC I*. But things were about to change. When Czechoslovakia was faced with an economic downturn in January 1968, its Stalinist leader, Antonín Novotný, was replaced with a younger reformer, Alexander Dubček, who pledged to create "socialism with a human face." Dubček's reforms included the relaxation of controls on the press and the abolition of censorship; writers and artists were allowed far greater freedom of expression. These changes, in tandem with the new political attitude that accompanied this transition to a softened socialism, ushered in the optimistic time known as the Prague Spring. But Soviet authorities watched these changes with increasing alarm, especially as newspapers and other outlets began openly criticizing Soviet authorities. The Soviet leader, Leonid Brezhnev, who had taken power in 1964 after the ousting of Nikita Khrushchev,

Fig. 4.11
Milan Knížák and Aktual Group (Vít Mach, Soňa Švecová, Jan Trtílek) *A Walk around Nový Syět—Demonstration for All the Senses* (detail of performance), 1964.

became nervous, believing that changes in Czechoslovakia would be pursued elsewhere in Eastern Europe and thus lead to the collapse of the Bloc. On the night of August 20, 1968, some 200,000 troops and 2,000 tanks—mostly Soviet, but some from other Eastern Bloc states—invaded Czechoslovakia. Many students responded with non-violent countermeasures such as human blockades. Nevertheless, the country was occupied by the following day. Arrested and sent to Moscow for questioning, Dubček was eventually replaced by Gustáv Husák, who instituted hardline policies of "normalization" that rolled back the Prague Spring reforms. The invasion was retroactively justified by the "Brezhnev Doctrine," which affirmed the Soviet Union's right to intercede in the affairs of Warsaw Pact nations.

In the weeks and months that followed, students and others did not make things easier for the occupying forces: They removed street signs to confuse soldiers, organized three-day general strikes, and created "slogan centers" that transformed parts of the city into a cacophonous echo chamber of posters, graffiti, petitions, and jokes. The Czech artist Július Koller described the events of 1968 as a "superpower happening" that "absorbed us all." In fact, when Tamás Szentjóby, a Hungarian Fluxus artist, heard of one of the students' subversion strategies in occupied Prague, he emulated it as a work of art. Since radios were outlawed in the occupied Czech city, students began carrying concrete blocks (sometimes with antennas) to distract the police and waste their time. For *Czech Radio 1968*, Szentjóby made a few objects in this vein and encouraged anyone to do the same as part of this work. He later described it as a new Socialist Realism—a kind of anti-art "for and by all."

In January 1969, political and aesthetic protest overlapped when Jan Palach, a university student in Prague, doused himself in gasoline and set himself ablaze in perhaps the most important square in the city. Palach was protesting the Soviet occupation and the return to the repressive practices of the past, like censorship. (Self-immolation has a specific history in the Cold War—monks in South Vietnam had performed this extreme act of martyrdom to protest the U.S.-backed regime there in 1964, for instance.) While not a work of art, Palach's suicide does have correspondences with the artistic practices discussed in this chapter: This was a simple act performed in an urban space

that was designed to transform everyday life. Jean-Jacques Lebel commented that Happenings and Fluxus performances ceased after the events of May 1968; the same might be said for such activities in Czechoslovakia after Palach's self-immolation. As will become clear in the next chapter, performance and indeed art practices more generally in Eastern Europe, turned inward—to private spaces and the limits of the body.

Television: The Electronic Street

In 1970, the African-American musician and poet Gil Scott-Heron released his famous song "The Revolution Will Not Be Televised"—his reminder that American network television was controlled by corporations dedicated to maximizing profit and, thus, maintaining the capitalist status quo. Furthermore, the one-way nature of broadcast television reduced its revolutionary potential, as viewers lacked any meaningful modes of feedback to counter its numbing and biased broadcasts. It is not surprising that thinkers from this period believed that revolutionaries should first seize television stations as a way to silence and transform the government's most effective weapon.

Regardless, some artists and activists endeavored to use broadcast television as a kind of virtual street, attempting to negate the medium's commercial utility, not unlike Villeglé's playful recontextualization of urban advertisements. In 1968, the charismatic American protest leader Abbie Hoffman—who co-founded the Youth International Party (the Yippies)—professed a counterintuitive notion of what was needed for a revolution in America: some combination of Andy Warhol and Fidel Castro, because "Warhol understands modern media" and "Castro has the passion for social change." Highlighting the centrality of television to any understanding of American politics at the end of the 1960s, Hoffman produced "commercials for the revolution." If commercials interrupted the flow of a program to sell a product (often with great success), Hoffman wanted to interrupt "normal" broadcasting with telegenic images that exposed the absurdity of politics as usual. These actions owed a creative debt to Fluxus, especially its occupation of everyday sites as stages for irrational acts. Hoffman's activities reached their apex at the 1968 Democratic Convention in Chicago, where

networks broadcast his antics outside the hall for a few minutes each hour, almost like a commercial break. (One such activity entailed the Yippies attempting to run a pig named "Pigasus" as a presidential candidate, even demanding secret-service protection for the animal.) According to David Joselit, Hoffman's absurd actions should be considered art historically: They were the "figure" that stood against, and inflected, the "ground" of the usual broadcast coverage. John Lennon and his wife, the Japanese Fluxus artist Yoko Ono, adopted a similar strategy for their *Bed-In* in March 1969 in Amsterdam. Using their fame to lure reporters to their honeymoon bedside for a week, they refused to talk about their relationship or other gossip but instead only discussed world peace. Lennon, echoing Hoffman's aims, called *Bed-In* a "commercial for peace." Other American activist groups, most notably the Black Panthers, with their interest in producing content for local cable television stations, also attempted to use the medium of television against itself.

Other artists tampered with television's one-way broadcast capabilities in more fundamental ways, by literally altering its signal through magnets or rewiring and thus exposing how the medium's pervasive and persuasive images are simply abstract waves organized in a certain way. (Similarly, Andy Warhol and other Pop artists had exposed the ambiguity inherent in halftone newspaper photographs, as discussed in Chapter 3.) Nam June Paik was also a pioneer in the field of video art. In *Electronic Opera #1* from 1969, he used magnets to alter the scan lines of a television, transforming images of the recently elected President Nixon and Attorney General John Mitchell into a swirling vortex of lines (FIG. 4.12). These were not mere formal exercises for gallery goers, since Paik was able to broadcast them on a public television station in Boston, albeit to a small audience. If Hoffman's professed aim was to disrupt images of political power on television, then Paik, according to Joselit, took to the mechanics of the medium to actually do so, making the public airwaves conform to notions of democratic participatory feedback. Similar to the Arte Povera artists, Paik was a guerrilla artist, attacking power from the margins.

The communist authorities in Eastern and Central Europe, in some ways, mimicked Paik's innovations, but for opposite ends: to prevent politically damaging information from reaching the

people. While secure borders and the Berlin Wall proved effective at preventing a mass exodus of dissidents from communist Eastern Europe, officials had a much more difficult time keeping out potentially subversive radio and television broadcast signals from the West—especially in parts of Czechoslovakia, East Germany, and Hungary. An illicit use of television in the East simply involved pointing an antenna west and receiving broadcasts from the other side of the Iron Curtain, however fuzzy and distorted the sound and images might be. When the reception worsened, it was often the result of intentional "jamming" by Communist officials—using electronic mechanisms to degrade the picture and soundtrack. But the "buzz" and distortions of jamming also served to pique the curiosity of those watching; the very act of obscuring a program's content marked the broadcast as subversive and worthy of deciphering.

Hoffman used television in a rebellious way, but American broadcast news followed suit with its negation of official narratives of military achievements in Vietnam. In January 1968, North Vietnamese forces launched the Tet Offensive—a surprise attack that was eventually repelled, but not before television cameras had captured images of panicked American soldiers and even communist troops inside the American embassy compound in Saigon. Despite assurances from the Pentagon that the United States and its South Vietnamese allies were "winning," claims that had been endlessly repeated on air, the images broadcast from the Tet campaign suggested the opposite. This inability to control the flow of information and images in both East and West went a long way to undercut ideological beliefs on both sides. So while there was no successful revolution in 1968 in the United States or Europe—televised or not—the medium certainly contributed to ideological fatigue in the decade that followed.

Fig. 4.12
Nam June Paik
Electronic Opera #1,
1969, video still. 4:45
min., color, sound.
Courtesy of Electronic
Arts Intermix (EAI),
New York.

Banding Together, Attacking Museums

Befitting the progressive spirit of the late 1960s in the West, artists often banded together in groups, primarily to escape from the popular mythology of the singular artist making luxury goods for a capitalist market. In 1966, a coalition of American artists, for instance, collaborated to create the *Peace Tower* in downtown Los Angeles as a protest against the Vietnam War. Designed by the sculptor Mark di Suvero, the tower's interlaced geometric shapes, made out of steel, reached 58 feet (17.7 meters) in the air, while providing an armature along the bottom for over 400 small paintings (each two feet square) by the likes of Roy Lichtenstein, Robert Motherwell, James Rosenquist, and Donald Judd. The site became a locus of antiwar activity, while also provoking violence against both the artworks and volunteers.

A lesser-known yet more dramatic moment of communal production occurred in Havana, Cuba, in 1967. The Cuban-born surrealist Wifredo Lam organized a major exhibition of international art (sent over from Paris), which included works by older artists such as Pablo Picasso and Joan Miró, as well

as more contemporary figures like Enrico Baj (see FIG. 2.3). For the opening, a diverse set of artists and writers from the United States and Europe were invited to Havana—including the important Abstract Expressionist Willem de Kooning and the modern European masters René Magritte and Jean Arp. Of those who were asked, many made the trip (although not de Kooning, Magritte, or Arp), and more than 80 artists worked simultaneously in a festive, televised atmosphere to produce a massive mural. Known as the *Cuban Collectiva*, its divided and spiraling form (with organizer Lam given the central circle) featured portraits of workers and revolutionaries

like Che and Castro, political symbols and slogans, and other, more abstract imagery (FIG. 4.13). For socialist commentators, the project embodied the utopian and romantic spirit of the Cuban Revolution, and its ability, counter to what the Soviets had done, of producing a truly collective, socialist art—one with incredible stylistic diversity (both figurative and abstract examples) and a capacity to forge an international consensus among artists. As a gesture of revolutionary solidarity, the mural was shipped to Paris and shown in the 1968 Salon de Mai, just as students were taking to the streets there. In addition to exporting its version of socialist art, Cubans also tried to export revolution—sending soldiers to fight in wars of liberation in places like the Congo, Bolivia, and Angola. (Che was famously captured and killed in Bolivia in October 1967.) Some of these struggles will be detailed in the next chapter.

Other collective artistic projects—such as Equipo Crónica's *Socialist Realism and Pop Art in the Battlefield* (see FIG. 4.1)—were widespread at this time. In another important instance, young artists banded together on the national university's campus in

Fig. 4.13
Cuban Collectiva, 1967, six panels: oil and mixed media on canvas. 16 ft 5¼ in. x 35 ft 8¾ in. (501 x 1089 cm). Museo Nacional de Bellas Artes, Havana.

Mexico City to produce the *Ephemeral Mural* over the course of several weeks in 1968. For the massive three-dimensional work, the painters used the corrugated metal hoarding covering the remains of a vandalized political monument to former Mexican president Miguel Alemán—a leader derided for his links to corporations at the start of the Cold War. As a product of a number of different hands, the resulting mural was a work that looked more like a collage of different paintings—with both abstract and figurative elements—than a unified composition. Since it was planned as temporary, the *Ephemeral Mural* stood as a critique of Mexican muralists such as Diego Rivera and José Clemente Orozco, who had been institutionalized by the state and had become, by the end of the 1960s, emblems of centralized government power, not resistance. As a visual marker of the ongoing social protests against government oppression in a land once defined by Marxist promise, the mural was still up at the time of the Tlatelolco Massacre in October, when state security soldiers shot hundreds of peacefully protesting civilians just ten days before the start of the summer Olympics in Mexico City. This use of extreme violence to ensure the success of a globalized spectacle celebrating peace exemplified the political contradictions of 1968.

Collectivity in the late 1960s went beyond the making of art objects, however. For instance, a group of students in Paris occupied the grounds of the Musée National d'Art Moderne in May 1968, temporarily forcing its closure. The protesters charged that the museum was a "cemetery," a place where objects went to die—a position antithetical to the utopian vision of a vital, living art held by students (and embodied by their posters lining Parisian streets, and the Cuban mural on view in the city). Furthermore, informed by the critiques of the philosopher Pierre Bourdieu, students came to recognize that public museums were deeply political institutions that promoted an elite culture at odds with the interests of working classes and immigrants. While this particular museum occupation is seldom mentioned in popular accounts of May 1968 in France, the conception of museums and exhibitions as active political spaces—neither autonomous nor immune to ideological bias—became another vital front for politically engaged artists in the late 1960s. International exhibitions such as the 1968 Venice Biennale and the 1969 São

Paulo Bienal, for example, experienced boycotts and other disruptive actions.

As the 1960s drew to a close, American artists increasingly viewed themselves as being embroiled, unavoidably, in the era's contentious politics. This sense of complicity can be viewed as a logical outgrowth of Pop art discussed in the previous chapter; if paintings like James Rosenquist's *F-111* forcefully connected consumerism to the military–industrial complex (see FIG. 3.14), then certain artists began to conceptualize their own wares—especially those collected by wealthy individuals and institutions—as tacitly supporting American Cold War policy. Founded in January 1969, the collective known as the Art Workers' Coalition (AWC) wrestled with fundamental questions concerning art's social role, attempting to create a broad coalition that agitated for a menu of progressive causes, including feminism, racial equality, and an end to the Vietnam War. Members included Carl Andre and the art critic Lucy Lippard, among others. On the whole, as the art historian Julia Bryan-Wilson attests, this group grappled to find new ways that artists and institutions could affect social change within the realm of art and its various networks.

The AWC pursued a number of strategies, including the popular one from this period—seen in Beijing, Paris, and Prague, especially—of making posters. One in particular achieved significant visibility. It employed Ronald Haeberle's famous color photograph from *Life* magazine showing the aftermath of the My Lai massacre—where American soldiers killed several hundred innocent civilians in March 1968. On top of this image, the AWC printed a crucial portion of Mike Wallace's interview with one of the U.S. soldiers involved in the incident, which confirmed the massacre's indiscriminate brutality: "Q: And babies? A: And babies." Initially, the Museum of Modern Art in New York had agreed to fund an antiwar poster on the AWC's behalf, but when presented with the final design of the poster, the museum balked, due to the disapproval of powerful board members William S. Paley, head of CBS, and Nelson Rockefeller, the pro-war governor of New York. Nevertheless, the AWC published 50,000 copies of the poster in late 1969, and some of these were shipped worldwide. In January 1970, members of the AWC protested inside MoMA, standing in front of Pablo Picasso's *Guernica* (the

Fig. 4.14
Art Workers, Coalition
demonstration at the
Museum of Modern Art,
New York, 1970.

painting was only given to Spain after Franco's death), holding copies of the poster—thereby connecting the fascist bombing of Spanish innocents in 1937 with the American military's gunning down of noncombatants, including babies (FIG. 4.14).

The parading of the poster at MoMA suggests the most visible and important legacy of the AWC—their politicization of the art museum, which demonstrated to the public that this seemingly hermetic space was, in fact, complicit with particular forces within the larger world of the Cold War. The governing boards of major New York museums—the Metropolitan Museum and the Guggenheim, in addition to MoMA—were packed with wealthy corporate executives with direct business ties to Vietnam, and AWC members exploited these connections. A sign from a protest at the Metropolitan Museum in 1970, tying General Electric's weapons production with the museum's investment in the company, sums up the sentiments: "Met Pays for Art with Death Earnings." Other AWC members tried to bring the war into the museum through other means. In the groundbreaking exhibition *Information* in 1970 at MoMA, German-born artist Hans Haacke installed *MoMA Poll*, which featured two Plexiglas boxes beneath a placard with the question:

"Would the fact that Governor Rockefeller has not denounced President Nixon's Indochina policy be a reason for you not to vote for him in November?" Visitors, who received a ballot when they entered the museum, would then vote in the "yes" or "no" box. Haacke's work crystallized one of the AWC's primary points: aesthetic choices and preferences—that is, artistic taste—have political consequences. And perhaps the confusingly worded question—with its double-negative construction—also critiqued the typically misleading wording of polling questions.

The most dramatic efforts in this regard were made by the Guerrilla Art Action Group, a collective affiliated with the AWC. Seeking to force the resignation of members of the Rockefeller family from MoMA's board, for instance, four members of the group walked nonchalantly into the museum and suddenly began tearing one another's clothes off while screaming. After exploding bags containing almost two gallons of blood, they writhed around on the ground among leaflets that detailed the connection of the art-loving Rockefellers to the American war machine. For the AWC, art museums allowed corporations and their wealthy executives to transform blood money into pure, aesthetic experiences, so they brought the repressed blood of the Vietnam War back into these buildings. If Martha Rosler tried to "bring the war home" to expose the complicity and complacency of the American home, then the Guerrilla Art Action Group did the same for the art museum (see FIG. 3.15).

The Cold War, 1968, and Deconstruction

In a sense, the AWC acted as an alternative CIA—gathering intelligence that proved the alignment of ostensibly neutral museums with corporations and politicians actively supporting the Vietnam War. (Student activists at the time viewed universities in much the same way.) It should then come as no surprise that an AWC member, the art critic Max Kozloff, was among the first to note how Abstract Expressionism came to be a means of covert Cold War propaganda—part of the story outlined in Chapter 1. While his essay "American Painting during the Cold War" was not published until 1973, it came out of a late 1960s conspiratorial mindset: how paintings with ostensibly no "content" came to champion American aims abroad. In fact, Abstract

Expressionism needed a perceived sense of autonomy for its political effectiveness: the singularity of Pollock's individual expression required its separation from everyday life. Kozloff's essay brings us back to the question posed by *Socialist Realism and Pop Art in the Battlefield* (see FIG. 4.1): What was the relationship between art and politics at this moment of the Cold War?

Commentators have long acknowledged the intersection between art and politics, but such issues acquired a pointed urgency at the end of the 1960s. Artists were called out for using materials supplied by corporations with any ties to the American government or military; abstract painters in both Europe and the United States came under fire for seeming to ignore the politics of the moment; and the AWC even organized two one-day "Art Strikes" in 1969 and 1970—persuading many museums and commercial galleries to close their doors in protest against the Vietnam War. The AWC, as well as other artists and critics discussed in this chapter, thus strove to expose the connections between art and contemporary national and international issues. The AWC's questioning of deep-rooted assumptions was close in spirit to the philosophical movement of deconstruction, which came to prominence in France in the years surrounding 1968. Deconstruction challenged the existence of binaries—nature/culture, mind/body, and good/evil among them—and attempted to unmask the ways such constructions artificially privilege certain types of knowledge. For thinkers associated with deconstruction, reality was seldom black and white, but instead found in the blurry areas in between.

Considering deconstruction's origin in this moment of Cold War ideological confusion, did the artificial and rigid binary of capitalist West/communist East encourage the emergence of otherness—whether pictorial, national, or philosophical? By this logic, the events of 1968, which had undermined the Cold War's binary distinctions, created a chain reaction in which other artificial dichotomies also exploded. The historian Tony Judt suggested the ways 1968 complicated the conflict's ideological certainty: "On both sides of the iron curtain, illusions were swept aside." Individuals began to see through the partisan utterances paraded before them, whether "evidence" of American victories in Vietnam, or "proof" of Western subversion and sabotage in Prague. Over two decades of ideological blindness and bloated

rhetoric came to a head in the late 1960s, ultimately damaging the credibility of both Cold War powers.

The protests in 1968, which cut across Cold War adversaries, were largely driven by promises of alternatives to the conflict's binaries, not material needs. Whether in Prague, Paris, Chicago, West Berlin, or Mexico City, activists were not seeking basics like bread and water. Rather, they agitated for a government that blended utopian rhetoric taken from both Cold War sides: individual freedom, peace, and economic and racial equality. Artists in this period also forged new ways of making art that crossed ideological boundaries, visible in Carl Andre's adoption of attitudes related to Soviet Constructivism or Arte Povera's "guerrilla" artistic strategies that critics aligned with communist insurgencies in Vietnam and elsewhere. This widespread and public confusion of ideological positions and artistic styles signaled, at least in retrospect, the beginning of the end of the Cold War. Although the conflict dragged on for another 20 years, activists and artists had begun to pull aside the Iron Curtain.

Chapter 5

Art and Détente

I n his inaugural address in 1969, American President Richard
Nixon made the provocative statement, "After a period of
confrontation, we are entering an era of negotiation." These
words reflected what was to become a decided shift in the
Cold War—an easing of tensions that came to be known as
"détente." Playing out throughout most of the 1970s, this desire
for cooperation across ideological lines aimed for "peaceful coex-
istence" between Cold War adversaries, thus preventing misun-
derstandings and flare-ups that could lead to widespread war
among proxies, or the nightmare scenario of nuclear war between
the principals. Détente, however, proved to be short-lived. By
the end of the 1970s, too many regional and civil wars in the
developing world had been subsumed into the framework of the
Cold War: American-backed soldiers were fighting against those
supported by the Soviets or the Cubans. Nevertheless, détente
remains an important chapter in the history of the Cold War,
and this pause in explicit hostilities allowed artists to ruminate
on and deconstruct the conflict's artificial structures. If the events
of 1968 across the globe questioned Cold War binaries, then
détente encouraged artists to explore the full implications of this
radical position. It is no coincidence that postmodernism, with
its relativistic outlook, began to take root during this decade, a
time when sworn enemies attempted to occupy some sort of
demilitarized zone together.

Andy Warhol's monumental painting *Mao* from 1973, one
of many from his vast series of paintings of the Chinese leader,
captures détente's spirit of ideological confusion (FIG. 5.1). As a

Jan Mlčoch
20 Minutes (detail),
Prague, 7 December 1975
See fig 5.5

source for the series, Warhol used a classic image of Mao: the frontispiece of the Chairman's *Little Red Book*, the leader's collection of aphorisms that amounted to a theory of revolution, with reportedly more than a billion copies in circulation by the end of the 1960s. (The image is also similar to the huge painting hanging in Beijing's Tiananmen Square.) As discussed in the previous chapter, Mao had inspired millions of protesting students in 1968, in both China and the West, who were looking for a model of revolutionary change not tied to the Soviets' bloated, stilted, and bureaucratic model of communism. But Warhol did not paint Mao until after President Nixon's historic surprise trip to China in 1972; that is, at the moment when China— previously an unambiguous enemy of the U.S. government—became something more like a friend, or, at the very least, a diplomatic relation. Nixon was attempting to exploit years of escalating tensions between the Soviets and Chinese. Although they had been strong allies after Mao assumed power in 1949, the Soviets and Chinese had grown hostile to each other throughout the 1950s and 1960s, as each saw itself as the true leader of global communism. By the late 1960s, relations had become particularly strained, with border skirmishes and troop divisions on both sides perched for war. If Nixon and his National Security Advisor Henry Kissinger could carefully position the United States between the Soviet Union and China, the logic went, then they could garner concessions from both nations. When Warhol produced this painting in 1973, then, the figure of Mao marked the pragmatic fluidity of Cold War ideological positions during the era of détente, and not necessarily a partisan revolutionary.

Warhol emphasized this ideological muddle by fusing the Cold War's classic artistic styles. The source of the painting is an example of Socialist Realism. Like so many of the Soviet examples discussed in Chapter 1, this ubiquitous picture of Mao appears natural, as if it were something photographic and not the product of human hands. Yet while Warhol's black-and-white silk-screened *Mao* retains the original image's structure, bright flourishes of visceral painterly expression layered underneath and on top—the frenetic and gestural yellow slashes in the bottom right, for instance—place American-style abstract painting in the same pictorial space. Rather than cancel each other out, Warhol's painting demonstrates that, analogous to

Fig. 5.1
Andy Warhol
Mao, 1973, synthetic polymer paint and silk-screen ink on canvas, 14 ft 8½ in. x 11 ft 4½ in. (448.3 x 346.7 cm). Art Institute of Chicago.

Mao's and Nixon's political maneuvering, art could also participate in détente, forging new cultural expressions of compromise and accommodation, not division. Warhol's colorful additions also transform Mao into something of a drag queen—note his blue eye shadow and rosy red cheeks and lips. If strategies of "queering" aim to dissolve the male–female binary, then Warhol's treatment of China's communist leader takes delight in playing with a political binary that was losing its relevance. The artist continued to play with Cold War norms; in 1976 (the year of the American bicentennial, no less), he made large silk-screen paintings featuring different configurations of a hammer and sickle purchased from a local hardware store, thereby reducing the frightening Cold War emblem to a pair of rudimentary and unremarkable tools.

Détente is notable for the numerous agreements made between Cold War adversaries—the Strategic Arms Limitations Treaty (SALT) signed in 1972, and the Helsinki Accords from 1975 were two high points of American and Soviet cooperation. The former was historic, as it capped the number of nuclear arms each side could possess, while the latter symbolically accepted the borders in Europe after World War II (essentially sanctioning Soviet postwar annexations), and opened discussions of human rights that would give the West much rhetorical and moral leverage over the Soviet Bloc until the end of the Cold War. However, despite SALT, Helsinki, and many other tangible signs of friendship and cooperation, the concept of détente as a global phenomenon can be somewhat misleading. The 1970s saw repeated acts of horrific violence committed in the name of Cold War ideologies, whether those of genocidal regimes such as Cambodia's militantly communist Khmer Rouge, which killed millions of civilians as part of its "social engineering" programs, or Mao-inspired terrorist groups like West Germany's Red Army Faction, who targeted the police, the American military, and other agents of "imperialist capitalism." Just as the Cold War was by no means "cold" for developing or newly independent nations in Latin America, Africa, and elsewhere, détente was not experienced by all. Some political tensions relaxed, others contracted; some nations experienced greater openness, others incredible repression. How art objects registered these contradictions form part of this chapter's story.

This tension between armed, revolutionary struggle and détente's encouragement of dialogue became clear in the international exhibition Documenta 5, held in 1972 in (as always) Kassel, West Germany. Here, Joseph Beuys staged *Organization for Direct Democracy by Referendum*. Sitting daily behind a desk with seven blackboards available for the sketching of ideas, Beuys transformed art-making into a platform for discussing the role of creativity in political transformations. He called this "social sculpture"—molding and shaping not physical materials but minds and conversations. Topics of discussion included the Cold War, university education, atomic energy, and West German political parties, among others. However, Beuys prompted controversy one day by suggesting that his works might have prevented the recent political violence committed by the Red Army Faction. Specifically, he implied that he could "re-socialize" the group's revolutionary leaders Andreas Baader and Ulrike Meinhof, if he were given the opportunity to lead them personally through the Documenta exhibition. For Beuys, open discussion and creativity—and, crucially, the idea of art's spiritual and mystical transcendence—could solve real political problems. If Beuys's discussions at Documenta 5 captured the spirit of détente, then his romantic and naïve assertions concerning Mao-inspired political assassinations, bombings, and kidnappings perhaps marked its limitations.

Détente grew out of the upheavals of 1968. Officials on both Cold War sides welcomed the break from the crisis mode that defined the international arena of the 1950s and 1960s. Stability became the goal, meaning that nations could focus on managing internal dissent. As the superpowers, as well as nations in Europe, turned their attention inward, art generally followed suit, and became less ostensibly concerned with external political and civic questions. This turn inward—whether into the parameters of art itself or into explorations of the artist's body—defined a significant amount of the art made in the 1970s. Artists on both sides of the Iron Curtain, as well as in non-aligned countries, produced works that critiqued the long tradition of the discrete, autonomous artwork. This "dematerialization of the art object"— as the American critic Lucy Lippard termed it—had begun in previous years (with the practices associated with Fluxus, for

example, as mentioned in Chapter 4), but became widespread and, indeed, the norm by the early 1970s. Despite this aesthetic alignment across Cold War cultures, the reasons behind individual practices nevertheless grew out of specific political and artistic climates.

The emergence of these differences can be seen in the use of an odd object in both American and Soviet contexts during the first half of the 1970s: a bulldozer. First, bulldozers were crucial in the Earthworks movement, in which artists abandoned the creation of gallery-bound objects to make works of art in the landscape, primarily in the vast deserted spaces of the American West. Robert Smithson and Michael Heizer, two well-known practitioners, both used bulldozers, dump trucks, and other machines to construct monumental works. The former constructed a path that circles inward for a quarter mile into Utah's Great Salt Lake, known as *Spiral Jetty* (1969–70). Since few made the trip to see it, the work was itself displaced, experienced primarily though documentation, including photographs and a film made by the artist. The concept of a "nonsite" was important to Smithson—a place existing between a material, geographic specificity and the abstraction associated with maps and other "scientific" representations of a place. The spiral form also questioned the very idea of linear progress, which had defined artistic modernism in the United States, at least as defined by Clement Greenberg.

In 1974, Soviet authorities responded to an outdoor exhibition of unofficial art—that is, artworks not sponsored by the State's official union of artists—with three bulldozers of their own. The exhibition, organized by artist Oscar Rabin and unofficial art collector Aleksandr Glezer in an abandoned lot outside Moscow, featured paintings and other works informally propped up on wood. While the works were not stylistically radical relative to international contemporary art, the KGB nevertheless ordered the destruction of the exhibition. Artists were also intimidated and, in some cases, arrested. Subsequently known as the "Bulldozer Exhibition," the heavy machinery literally eradicated a show of paintings and sculptures.

While the uses of the bulldozer in these contexts differed fundamentally—one making an artwork, the other destroying them—they both demonstrate that traditional notions of

art and its display had become untenable for many Soviet and American artists. Smithson, seeking to escape art's connection to the commodity and the discourses of power centered in New York, used bulldozers to create remote works that exist largely as anti-aesthetic documentation, while the "Bulldozer Exhibition" in Moscow demonstrated the continuing need for unofficial artists to work underground, making and showing their work in small, secret venues. This common thread is perhaps best expressed in a joke from the period: "What's the difference between socialism and capitalism? Under capitalism, man exploits man. Under socialism, it's the other way around." Smithson felt constrained by the repressive commodification of art; Soviet artists experienced a more literal repression: the state censoring and destroying their works.

Likewise, similarities across the Cold War in 1968—American aggression in Vietnam and the Soviet invasion of Prague, for example—set the stage for the 1970s, engendering a blending of artistic practices during a time when the superpowers were negotiating with each other, and such overlaps were fostered by an increased exchange of artistic ideas, through magazines and traveling exhibitions. While national and individual artistic distinctions remained crucial, the perforations in the Iron Curtain during the era of détente could not be denied.

Nothing to Say: Conceptual Art

A major thrust of détente was back-and-forth discussions between representatives of both Cold War sides—negotiations establishing a shared set of core principles or the codification of rules of military engagement, for instance. Instead of episodes of dangerous excitement—the Cuban Missile Crisis, for instance, which generated epic headlines and apocalyptic forebodings—détente was premised upon diplomatic boredom. When Marshall McLuhan argued in 1964 that the Cold War was waged through "information and images," it is doubtful that he could have foreseen the reams of reports, hundreds of embassy cables, and mountains of draft treaty text required by the important business of détente, housed in filing cabinets and archives and requiring a substantial bureaucracy. When the American artist Lawrence Weiner defined his works in 1968 in terms of

the transparent relationship between the artist and the viewer, he was, in a sense, forging an art of negotiation. An initial Soviet and American diplomatic agreement—the "Basic Principles of Mutual Relations," agreed to 1972—could conceivably be the title for a work of Conceptual art from this period, from either country.

Conceptual art links up to an important theme of this book: the similarities between the opposed cultures of the Cold War. Such overlaps became increasingly explicit in the early 1970s, thus continuing the undermining of the binary structure that began in earnest in the late 1960s. As the previous chapter detailed, the confusion between adversaries reached a critical mass at this moment, with theorists such as Guy Debord and Herbert Marcuse describing both sides as dystopian—each violently suppressing individuality and producing a regimented, controlled existence. Ideological pronouncements extolling the utopian virtues of American capitalism or Soviet communism thus carried little weight by the early 1970s; paradise, whether one for workers or for consumers, had been permanently deferred. With meaningful reform of either system no longer seeming possible, resignation, and the boredom that accompanied it, began to set in. A comparison of two works of Conceptual art—one American, one Soviet—from this period illustrates how artworks themselves could internalize bureaucratic structures and acknowledge their political inefficacy, thereby transforming the drudgery of both sides into a kind of artistic freedom.

Although it was produced in the year before the disturbances of 1968, Joseph Kosuth's series *Titled (Art as Idea as Idea)* is a typical example of language-based American conceptual art (FIG. 5.2). Appropriating the definition for the word "theory" from a dictionary, the artist enlarged and reverse-printed the text on a four-foot (1.2 meter) square panel. Like fellow American Ed Ruscha's paintings from the early 1960s that focused on a single word, Kosuth's transformed his depicted words into something pictorial; note how their magnification reveals the text's painterly and feathered edges. If Andy Warhol's and Gerhard Richter's blurred renditions of press photographs questioned the veracity of media images (see FIGS. 3.1 and 3.11), then Kosuth's fuzzy words do something analogous with language. And with six different definitions of "theory" on view, the artist finds a concrete and

Fig. 5.2
Joseph Kosuth
Titled (Art as Idea as Idea), 1967, photostat on board, 48 x 48 in. (121.9 x 121.9 cm). Yale University Art Gallery.

obvious way to give form to language's strangeness, namely by showing the ways a single word can suddenly misbehave, acquiring alternative, poetic, or even conflicting meanings when placed under scrutiny. Considering the ways politicians and other commentators deployed language in the age of Vietnam—famously, an American army officer was quoted as saying, without apparent irony, that "it became necessary to destroy the [Vietnamese] town to save it"—Kosuth's work expressed a growing distrust of language, while also withholding the salve of art's usual visual pleasure. A mechanical enlargement of text would not tempt collectors as effectively as large oil paintings.

Kosuth's work, in one sense, fulfills the old communist clichés about art produced under capitalism: it really *is* about nothing, considering the ambiguity of the word "theory." Or, more specifically, it addresses art's inability to communicate anything specific, much less ideology. This underlines the absurdity of the continued evolution of American Cold War modernism since the 1950s: the ultimate logic of Greenberg's self-reflexive model of criticism was to jettison objects altogether. Art had moved from paintings addressing the condition of painting, to text pieces addressing the limits of art. And, as Benjamin Buchloh noted in an important essay from 1990, Kosuth's work participated in an "aesthetic of

administration" that differed little from the prevailing social order demanded by American capitalism (not to mention Soviet communism). If someone like Carl Andre (see FIG. 4.6) drew on the traditions of the factory worker to make his industrial sculptures, then Kosuth's practice perhaps mimicked white-collar jobs in banking, insurance, and other burgeoning fields—not to mention the diplomatic bureaucracy of détente, parsing the precise meanings of certain words. The artist Sol LeWitt, not without irony, noted this shift from factories to the service industry in art: The Conceptual artist "does not attempt to produce a beautiful or mysterious object but functions merely as a clerk cataloging the results of his premise." Other conceptual artists, such as Robert Barry, took LeWitt's logic to irrational extremes, even producing a work comprising numerous bound volumes, which contained, as his title suggests, *One Billion Dots* (1971). After coming up with the idea, the execution of the concept was tedious, repetitive, and absurd.

What has become known as Moscow Conceptualism channeled its own notions of bureaucratic boredom. Its artists

Fig. 5.3
Ilya Kabakov
*Everything about Him
(The Answers of the
Experimental Group)*,
1971, oil and enamel on
Masonite, 57⅞ x 144⅔
in. (147 x 370 cm).
The State Tretyakov
Gallery, Moscow.

produced unofficial work, so their objects and actions initially found no audience outside of its small group of practitioners, other than the KGB who routinely monitored their activities. Instead of simply producing anti-Soviet propaganda, these artists explored the nature of propaganda itself, as well as the mundane realities of their existence. As Boris Groys has argued, individuals living under Soviet communism existed in a strange temporal space: the Communist Party instructed them to dedicate their entire lives to the utopian, socialist future. As life took on a meaningless, deferred quality, the Moscow Conceptualists targeted this uncanny aspect of the "present" in Moscow during the 1970s.

Ilya Kabakov, whose *Pipe, Stick, Ball, and Fly* was discussed as an example of Soviet Pop in Chapter 3 (see FIG. 3.10), was a key member of the Moscow Conceptualist circle. In 1971, for example, he painted *Everything about Him*, a Masonite panel over 12 feet (3.6 meters) long, comprising a regular grid with 52 dully colored cells (FIG. 5.3). Each rectangle features a quote attributed to a specific person, ostensibly about the painting's

ч Сипин: медленно на ходу.	Лидия Аркадьевна Квасницкая: Он был здесь.	Иван Филимонович Михайлов: Когда будешь ремонтировать сени, позови его.
Заревский: извилистая	Лидия Кузькова: Это могло быть только с ним.	Бахран Ростанович Исламбеков: Цветет он только летом.
...киасян: ...жду деревьев ...ома.	Евдокия Климовна Пушкова: И поставили его вон в тот угол комнаты.	Мария Игнатьевна Яблонская: Садитесь ближе к нему и согреетесь.
...ба: праздники.	Иван Сидорович Кудрявцев: Я съедал его целиком, немного поперчив.	Сергей Анатольевич Пахаржебский: Вспомни, ты у него был с Леной и Александрой Шынчен!
...ингельсон: ...не вернется	Алексей Серебряный: Здесь он оставил для тебя письмо.	Володя Розенцвейг: Может быть, он здесь?
Непейвода: ...а улице.	Анатолий Косолапов: Вместе с Мариком он ходил в далекий лес.	Маргарита Робинсон: Вечером он ушел один.
...седенский: ...ити не видел.	Софья Никитична Шиборошова: Покрасил его в ярко зеленый цвет.	Рафик Мисропян: Он живет за той горой?
...ящий: ...на колени ...а	Марк Антонович Городовин: Он привозил Власовым свежий хлеб, молоко и фрукты.	Анечка Листовина: Можно мне пойти к нему?
...Покровская: ...и его.	Любовь Петровна Молоканова: Когда он окончился, то все было покрыто битым кирпичом, бревнами и обрывками обои.	Алексей Дмитриевич Лисицын: Он четвертый, если считать от угла.

НАША ЦЕЛЬ

unnamed protagonist. Contributing to the institutional aesthetic, Kabakov painted these texts carefully in the standard font of the Soviet housing authority. Some examples include: "Maria Fedorovna Skarabut: He only makes promises that he can keep" and "Masha Kolesova: I waited for him in the garden on the corner of Stretenka." With its visual standardization, the work communicates, even to non-Russians, a sense of regimented boredom; it reveals nothing of consequence about the mysterious "him" of the title, despite the profusion of text. The snippets could be the recollections of the inhabitants of his communal apartment building, or the banal findings of KGB surveillance. While Socialist Realist paintings would often lionize everyday communists, Kabakov not only rejects their underlying utopian ideology, but also the style's aesthetic satisfaction, thus exposing the sheer drabness of Soviet life. Kabakov also discovered another means to figure such vacuity in a group of paintings from 1974: He painted 18 small peasant figures, regularly spaced, along each edge of a rectangular painting, thereby leaving the vast majority of the composition vacant. Kabakov and others placed themselves and their unofficial work on the margins; this was where one might find some outside perspective, some critical distance from which to observe the all-encompassing but increasingly vapid promises of the Soviet state.

Vitaly Komar and Aleksandr Melamid decided to work as a team after their graduation from art school—perhaps consciously mimicking the communal practices that Socialist Realism officially encouraged (see FIG. 1.2). They soon began producing a body

КОММУНИЗМ!

КОМАР, МЕЛАМИД

Fig. 5.4
Vitaly Komar and Alek-
sandr Melamid
Our Goal is Communism,
1972, tempera on
fabric, 15³⁄₁₆ x 76¹⁵⁄₁₆
in. (39 x 195 cm).
Zimmerli Art Museum at
Rutgers University,
Norton and Nancy
Dodge Collection of
Nonconformist Art from
the Soviet Union.

of work that brilliantly captured the hollowness of official communist rhetoric by simply appropriating and recontextualizing it. In the early to mid-1970s, they painted readymade Communist Party slogans, without alteration and in a standard font, on horizontal cloth banners: *Our Goal is Communism!* from 1972 is a typical example (FIG. 5.4). The only indication that something was amiss was the presence of the artists' names beneath the quote, a gesture that claims the slogan as their own. The work is only slyly subversive; depending on the context, it could have been viewed as supportive of the regime. Did these loyal artists internalize official ideology to such a degree that it became second nature to them? Of course, for like-minded artists and intellectuals—the only audience for these unofficial objects at the time—this indoctrination was exactly the intended critique. In a society predicated on achieving a unifying communal vision through a relentless propaganda machine, an artist needed only to re-present political slogans to register their absurdity.

An essay from 1978 by the Czech playwright and dissident Václav Havel came to a similar conclusion. In describing retailers who hung such official slogans in their shops, he suggested they did so to blend in and avoid the significant personal consequences for refusing. Havel concluded that the meaning of the displayed slogan had "nothing to do with what the text of the slogan actually says," but instead suggested a coerced conformity and fear of independence. Other works by Komar and Melamid from this period emphasize this point. In *Quotation* from 1972, small white squares replace text in a banner, thus highlighting the

meaninglessness or interchangeability of any slogan. In *Essence of Truth*, a performance in 1975, the artists transformed pages of the official Soviet newspaper *Pravda* ("Truth") into hamburger patties, implying that citizens had been ingesting state propaganda for years—and had been left malnourished by it.

Another vital force in Moscow Conceptualism was the Collective Actions Group (CAG), formed in 1976 by a handful of artists including Andrei Monastyrsky and Nikita Alexeev. Their first action, *Appearance* from this same year, served as a basic template for later ones. Thirty participants, including Kabakov, received a cryptic invitation, summoning them to the largest park in the Moscow suburbs. When they arrived, they gathered at the edge of an open, snow-covered field, where they waited—unsure of what to expect, or when it might (or might not) occur. After some time, the participants observed two men walking toward them out of a wooded area at the far end of the clearing. These men proceeded to hand each participant an envelope reading: "Documentary confirmation that [name of invitee] was a witness of APPEARANCE which occurred on the 13th of March 1976." Participants then rode the train back to the city, during which time they processed and discussed what they had experienced. Subsequent CAG actions became more complex, with most performed in another snow-covered field some two hours outside Moscow. On one occasion, participants were instructed to pull on a long rope until they found its end; on another, an electric bell cryptically rang under the snow in the field. CAG members meticulously documented each of these actions, including the participants' written reactions to them; some have suggested that the events became the excuse for what soon became an extensive archive. These files, filled with pages of closely observed details and photographs, could parody official surveillance archives.

As Matthew Jesse Jackson has remarked, the typical anxieties of Soviet citizens shaped the CAG's activities: Individuals were all used to waiting outside for essential goods; they would sometimes receive invitations to events of ambiguous purpose; and they knew they were being watched by others. The CAG thus took the forms associated with the bureaucratic drabness of Soviet life and reinvested them with mystery and romantic anticipation, as a way of de-socializing perception and experience.

Better yet, these actions could be said to have re-socialized their lives—based on a true community of like-minded friends and artists, not the hollow communal existence mandated by the oppressive State.

In the 1970s, some American and European artists combined the insights derived from the work of Kosuth and Barry with those associated with deconstruction (discussed in Chapter 4) and other philosophical ideas that attempted to dismantle social hierarchies. These artists applied Conceptualism's abstract explorations of art's linguistic structure and limits to specific questions of institutional power, race, or gender. In her *Post-Partum Document* (1973–79), for example, Mary Kelly rigorously documented her son's physical, emotional, and social development from his birth until his sixth birthday. Identity is not fixed, the work argues, but rather constructed over a long period through socialization. Between 1973 and 1974, David Hammons explored the arbitrary nature of racial stereotypes through visual means. He constructed a sculpture from a small garden spade and also made prints with the spade symbol from a deck of cards, investigating how "spade" came to be a racist slur, for instance. At the Guggenheim Museum in 1971, Hans Haacke revealed connections between art and urban poverty by systematically detailing the slumlord practices of a New York real-estate mogul, whose money had earned him a seat on the Guggenheim's board of trustees. While these three examples have little to do with the geopolitical battles of the Cold War, they nevertheless reveal crucial differences between Western and Soviet conceptual practices in the 1970s. While artists in America and Europe generally used Conceptual art's bureaucracy-inspired practices to deconstruct the diverse systems that structured their everyday existence, Soviet artists did not have the luxury of choosing which target to take aim at. For them, the Party controlled everything, from theories of child-rearing to art museums.

Bodies and Surveillance

Conceptual practices were not the only common artistic currency on both sides of the Cold War in the late 1960s and early 1970s; artists also tested the limits and social positions of their bodies.

They did so, of course, under vastly different circumstances. After Jan Palach's public self-immolation in protest against occupying Soviet troops in 1969, for example (see Chapter 4), Czech artists increasingly used their bodies to express the repression and control exerted by the State—trading the irony of Fluxus-like activities for an emphasis on the primacy of a threatened human body. Furthermore, as the art historian Kristine Stiles has noted, artists who lived under constant surveillance and fear, who agonized about their possible arrest and the physical safety of themselves or their family under state communism, had a heightened awareness of their own corporal existence. As

such, artists across the Eastern Bloc—from Bulgaria, Romania, Hungary, and Poland—turned inward toward their own bodies.

In 1975, the Czech artist Jan Mlčoch performed an action in a Prague basement called *20 Minutes*. The artist sat shirtless against a wall, while a sharp knife—attached to a long iron rod with its other end secured to the floor—rested on his torso (FIG. 5.5). Mlčoch instructed an audience member to sit on a wooden plank that rested on the rod, and when that participant noticed that the artist "wasn't concentrating," he could move "up any distance he chose"—thus making the knife put more pressure on the artist's skin. Mlčoch had set the performance to last 20 minutes, but due to a broken clock, it went on for more than twice that length. While the explicit political implications of the piece are not altogether clear, the artist used the potential for self-harm as a means to probe the relationship between the powerful and powerless. Did those citizens opposed to the regime need to keep vigilant to remain safe? Were dissidents being watched by their friends and co-workers for moments of political distraction? If Socialist Realism offered false illusions in paintings, sculpture, and photography, what could be more real or honest about the implications of an oppressive government than a body in pain?

Such extreme bodily practices also dominated the art of the United States and Western Europe in the early 1970s. Los Angeles–based artist Chris Burden was well known in this regard: In 1974 he staged works in which he was shot in the arm in a gallery space (*Shoot*), and had himself crucified to a Volkswagen Beetle (*Trans-Fixed*). The extreme nature of his work made him an international press sensation, influencing artists around the world, including those in Eastern Europe with access to art magazines.

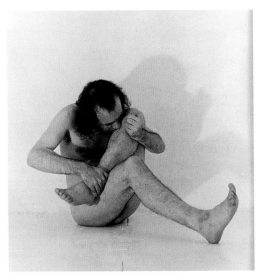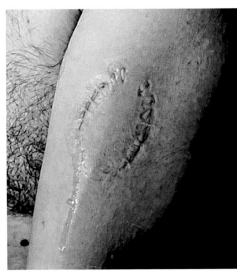

Fig. 5.6
Vito Acconci
Trademarks (detail),
1970, six black-and-
white photographs,
typewritten and
handwritten sheets,
contact printing,
book page - mounted
on cardboard in five
frames, 34⅞ x 98⅞ in.
(87.8 x 250.5 cm).

In a key work called *Trademarks* (1970), another American artist, Vito Acconci, used his body as a canvas. The artist described the work: "Sitting naked on the floor, and biting myself: biting as many parts of my body as my mouth can reach. Printers' ink is applied to each bite; bite prints are stamped, like finger prints." He documented the action both through photographs and the series of resulting prints (FIG. 5.6). Acconci's work, however, had origins as much in American modernism as in the period's awareness of bodily vulnerability: His notion of testing the limits of where his mouth could mark his body was a self-consciously perverse understanding of Clement Greenberg's calls to entrench art firmly within its own discursive boundaries. Rather than exploring and exploiting the limits of the canvas, Acconci directed such a process toward his own body. Furthermore, by selling the prints and calling the work *Trademarks*, Acconci recognized that his body was defined by the structures of the capitalist market—an ironic comment on the notion of the artist's unique gesture, as described by Harold Rosenberg in his conception of "action painting" (see Chapter 1). *Trademarks* is thus related to the widespread appreciation of the "heroic individualism" embodied in Abstract Expressionist painting. Acconci's implicit critique of Cold War notions of American abstract painting corresponds to the increasing realization during détente of the violent mythologies underpinning radical individualism.

Artists on both sides also thematized surveillance. One reason why Moscow's Collective Actions Group staged its events in remote locations was practical: to avoid KGB monitoring. Other artists in the Eastern Bloc would also travel to small villages for their performances. As a consequence, some artists confronted the surveillance apparatus in their works more directly than others. In Romania, one of the most repressive communist regimes in the 1970s, Geta Brătescu produced a video called *The Studio* (1978), in which the camera (filmed by fellow artist Ion Grigorescu) enters her studio as if a cat burglar, documenting the artist sleeping and at work, ostensibly unaware that she is being watched. Near the end, she seems to become aware of the surveillance and begins to perform a number of irrational actions, as if to frustrate whoever is watching. Eventually, the camera grows bored with her self-conscious performance and leaves.

The Czech artist Jiří Kovanda adopted another approach in the mid-1970s: He performed seemingly normal, trivial actions in Prague's urban environment—wiping his nose, or turning around backward when riding an escalator—while an accomplice recorded these behaviors with a camera. Although this sort of work built on Fluxus's everyday acts, no one other than the artist and his photographer would even realize that these subtle interventions constituted works of art. Such deception corresponds to what the historian Timothy Garton Ash has identified as the "double life" of individuals living in the Soviet Bloc—"the split between the public and the private self, official and unofficial language, outward conformity and inward dissent." In addition, Kovanda's actions certainly engage with the mechanics of spying, which depends on the performance of clandestine acts—such as sending a signal by sitting on a particular bench or wearing a hat of a certain color—while perceived to be doing nothing out of the ordinary. Kovanda thus internalizes an aesthetics of espionage and secret surveillance to create a powerful work about the watched body in urban space. To look at the resulting photographs—which mostly capture uneventful activities in the midst of the city—is to be put in the shoes of the secret police, compelled to identify the "person of interest."

American artists also addressed issues of surveillance at this time, but for altogether different reasons. In *Following Piece* from 1969, Acconci randomly selected a person on the street to follow,

and kept up his pursuit, often for hours, until that person entered a private location. To document the work, Acconci, like Kovanda, also hired a photographer. The resulting photographs, along with a typed, time-stamped, geographically specific text, constitutes the work in its entirety. And several other American artists—namely Bruce Nauman and Dan Graham—produced environments with closed-circuit television cameras and monitors, allowing viewers to watch themselves being watched. Graham's *Time-Delay Room I* from 1974, for instance, occupied a partitioned space, with a camera and two televisions in each portion. This arrangement allowed one group to spy on the viewers on the other side of the partition, as well as one group to see itself on an eight-second delay. The work thus employed the dynamics of surveillance: both the joys of watching others from a privileged distance and the discomfort of being watched. Graham's work appeared the same year that the *New York Times* revealed the CIA's surveillance of American anti-war protesters during the Johnson and Nixon administrations, a clear violation of the agency's charter. This was suitable art for Americans spying on other Americans.

While détente has come to signify a relaxing of tensions and a degree of normalization during the 1970s, the stability of certain individual states, as was clear in the Soviet Union, Czechoslovakia, and other socialist examples, relied upon networks of state terror. This was also the case in non-aligned nations like Yugoslavia, as well as in countries ruled by regimes whose anti-communism garnered them American support, especially in Latin America. After a 1966 coup, Argentina was ruled by an authoritarian government aligned with the United States, whose response to Marxist guerrillas was kidnappings and murder, resulting in thousands of the "disappeared." Reacting to this horrific violence were works like Graciela Carnevale's locking of visitors inside a Buenos Aires gallery in 1968, or Marta Minujín's staging of the abduction of 90 participants in *Kidnapping* (performed at the Museum of Modern Art in New York in 1973, after her relocation to the United States). The work of these and other artists made direct reference to the political violence that underpinned a fragile sense of stability during détente.

Détente and Artistic Exchange

This chapter began with the suggestion that Warhol's *Mao* embodied the spirit of détente—through not only its subject matter but also its mash-up of Socialist Realism and Abstract Expressionism. But exchanges during this period went well beyond the symbolic, as increasingly artists, as well as works of art, overcame the limitations of the Iron Curtain. (Exhibitions from the 1960s, discussed in Chapter 2, such as Yugoslavia's *New Tendencies*, were important forbearers in this regard.) For instance, the 1977 iteration of the Documenta exhibition featured East German Socialist Realism in tandem with contemporary works from Western Europe and the United States. The fact that Documenta—held in Kassel, West Germany, mere miles from the East German border—had been established in 1955 to highlight the West's artistic freedom only makes such a situation even more remarkable. (Some West German artists, such as Gerhard Richter, withdrew their work from the exhibition in protest.) Artists from the Soviet Union and Eastern Europe, in one of the key results of these exchanges, began slowly gaining an audience in the West, as détente eased travel restrictions. The Scottish gallerist Richard Demarco, for instance, championed Romanian and Polish artists in his Edinburgh gallery in the 1970s. Collectors also facilitated such exchange; the West German collector Peter Ludwig, for example, began adding East German Socialist Realism to his large collection of American Pop art in the late 1970s, while the American academic Norton Dodge amassed an enormous trove of Soviet unofficial art during détente, expanding a collection he began in 1955. An economics professor with a Soviet specialization who traveled frequently to the Soviet Union for research, Dodge quietly made connections and accrued more and more works. When he first displayed his collection in an exhibition in Washington, D.C., in 1977, American audiences caught their first glimpse of Ilya Kabakov and other important Soviet artists. While not an official diplomatic exchange, the show nevertheless participated in the process of artistic détente that was unfolding during the 1970s.

Artists also called for an international conversation. At the 1976 Venice Biennale, the West German artist Jörg Immendorff handed out leaflets that advocated global exchange between artists, even between Cold War enemies. Alliances formed, whether

through direct interactions or through networks like the mail. For instance, when the American artist Tom Marioni visited Prague in 1975, he collaborated with the local body artist Petr Štembera. The two artists symbolically linked themselves—East and West—by drawing a circle across their adjacent bodies, a half-circle on each, in milk and cocoa, before adding ants, who fed on the sweet materials. Partnerships across the Iron Curtain, the pair seemed to say, were essential but might lead to unpleasant complications and prove difficult to maintain.

Immendorff's own story is instructive. A student of Joseph Beuys, he began to identify himself as a Maoist in the late 1960s, turning toward more politically direct art to advance his left-wing beliefs. In 1976, he traveled to East Berlin to meet with the artist A. R. Penck, with whom he formed a political and artistic alliance. Penck, as discussed in Chapter 2, did not paint in the style of Socialist Realism, but was rather inspired by cybernetics and used rudimentary stick figures in his paintings (see FIG. 2.2). The following year, Immendorff began his *Café Deutschland* series, which captured the spirit of his alliance with Penck: above all a desire to unify Germany, at least symbolically and pictorially. Such cooperation aligns with the German political world of the 1970s and the West German policy known as *Ostpolitik*. Championed by Chancellor Willy Brandt, this strategy normalized relations between East and West Germany. The centerpiece was the so-called "Basic Treaty," enacted in 1973: For the first time, the nations of East and West Germany recognized each other as sovereign states. Only by acknowledging divisions, the theory went, could politicians achieve agreements across the Berlin Wall. Immendorff's series expresses a similar sentiment of unity, but without supporting *Ostpolitik*'s specific policies.

Each canvas in the series of 16 is set in a nightclub, with the fictional "Café Deutschland" becoming a space shared by East and West Germany, and thus outside Cold War parameters. Immendorff populates this imagined space with important figures from recent German political and cultural history; Penck himself even appears in a number of canvases. In the initial work in the series, *Café Deutschland I* (1976–77), viewers witness a chaotic nightclub scene, complete with a bar and dance floor (FIG. 5.7). Near the center of the painting, Immendorff depicts

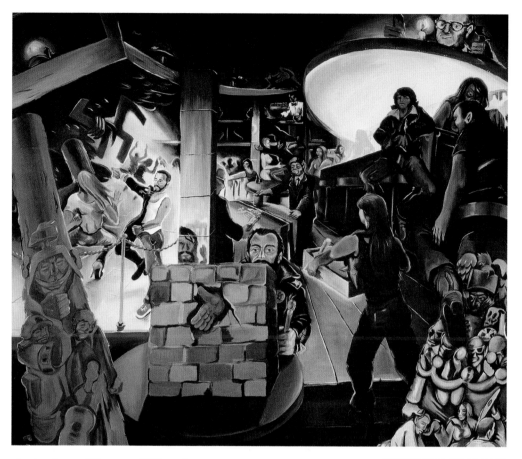

the leaders of East and West Germany—Erich Honecker and Helmut Schmidt (who replaced Brandt after a scandal)—with paintbrushes in hand, seated across a table, each side draped in the black, yellow, and red colors found in the flags of both Germanies. Honecker has just finished painting a crest on his flag that resembles the emblem found on the GDR's standard, while Schmidt has just dipped his own brush in a can of paint. Will his design mimic Honecker's? Is this a call for a unified Germany? In the central foreground, viewers are confronted with another male figure grasping a paintbrush; his other hand literally punctures a section of the Berlin Wall, extending a welcoming handshake. As a self-portrait of the artist, Immendorff suggests that art can help destroy German division and reunify the nation. While painterly in style, he nevertheless channels the logic of Socialist Realism, picturing a fantasy utopian world in an everyday setting.

Fig. 5.7
Jörg Immendorff
Café Deutschland I,
1976-77, oil on canvas,
9 ft 4³⁄₁₆ in. x 10 ft 11⅛
in. x 2⅜ in. (285 x 333
x 6 cm). Museum Ludwig,
Cologne.

Another common way for artists—especially those living in the Soviet Bloc—to communicate internationally was to utilize the postal system. Again, while this strategy was employed by important artists with links to galleries and exhibitions in the West—most notably the American Ray Johnson, the Italian Alighiero Boetti, and the Japanese On Kawara—it flourished in the Eastern Bloc and other repressive communist states, taking on an increased political importance there. While letters and packages sent to and from communist countries were often monitored, officials could not possibly keep tabs on every piece of mail. Developments in so-called Mail art went hand in hand with Conceptual art's dematerialization strategies, and the "event scores" of its unruly sibling Fluxus; it was much easier to send an index card through the international mail than a painting. While many artists in Eastern Europe distributed works and ideas via mail, the Hungarian artist Endre Tót is exemplary in this regard.

Expelled from art school for his quarrels with Socialist Realism in the late 1950s, Tót began to practice a version of Art Informel (the European variant of Abstract Expressionism discussed in Chapter 2), even incorporating, like Robert Rauschenberg, fragments from the mass media into his paintings of the 1960s. Tót abandoned painting by 1970, turning to a more conceptual practice that largely utilized the mail for its distribution. He compiled a mailing list of international artists by asking various contacts in the art world and consulting international art magazines—whose very presence in Hungary highlights the importance of postal networks for transmitting information about Western artists. Tót's mail projects largely fell into two bodies of work: a series called *Zero Post* and another entitled *Gladnesses*. As will become apparent, both series presented different aspects of life under Hungarian communism to foreign audiences. To ensure that his works were not impounded by local mail censors, Tót sometimes even traveled to Yugoslavia to post them. As a result, his art was shown in the 1970s in Paris and West Berlin, among other sites. To ensure their international legibility, he would use either English or a combination of English and Hungarian.

For *Zero Post*, Tót used the number zero as the basis for negative communication, covering over what was once legible text in his missives, as seen in *Ten Questions* from 1973 (FIG. 5.8). In

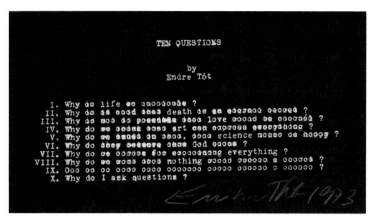

Fig. 5.8
Endre Tót
*Ten Questions
(Documents make me
glad/sad/mad)*, 1973,
typewriting on paper,
4 x 7¼ in. (10 x 18.4
cm). Collection of the
artist.

other words, he used the number "null" to nullify content and even to replace text—marking his own act of censorship with an allegorically appropriate symbol. His negations struggled against the legibility of the text beneath, again marking a specific condition in the Soviet Bloc of actively interrogating communiqués, reading between the lines. If Kosuth's work forces viewers to think about the gaps between language and meaning (see FIG. 5.2), then Tót's work underlines the difficulties for honest and direct communication when subject to constant surveillance and censorship. These works thus make John Cage's famous dictum "I have nothing to say, and I am saying it" relevant to the Cold War. Expressing nothing was certainly *something* in the context of censorship and surveillance. In some ways, as art historian Klara Kemp-Welch has observed, Tót's work also played into Western expectations of the censored artist living under communism, which no doubt contributed to his international recognition.

If *Zero Post* dramatized the lives of silent artists in the Eastern Bloc, then Tót's *Gladnesses* series, begun in 1971, parodied the rhetoric of happiness that defined the visual culture of socialism—the happy faces that populated the paintings and photographs of official publications, despite the grim resignation of these years. Each of these works, which were also mailed rather than exhibited in Hungarian galleries, began with "I am glad that I" and ended with words signifying some seemingly mundane action. The first example, which was produced on some kind of commercial printer, simply read "I am glad that I could have this sentence printed." In Hungary, access to commercial printing equipment was something carefully observed,

as producing underground newspapers, manifestos, or unofficial posters was decidedly illegal; this led to so-called "samizdat" practices of reproducing copies slowly through manual processes like re-typing texts by hand with carbon paper. Tót thus put himself at grave risk by using such a printing press after hours. In 1975, he continued this theme with a similar work addressing a newer technology of replication: *I am glad if I can Xerox*. While similar in spirit to the Western use of photocopiers in exhibitions organized by Mel Bochner and Seth Siegelaub in the late 1960s, Tót's practice highlighted the repressive environment of the East; these machines were also closely monitored for political use in the communist East. Tót's postal network provided his work enough visibility in the West to garner him a fellowship to work in West Berlin in 1977, although he was refused a travel visa for some time. After the Western press picked up the story, Hungary relented and Tót made the journey, where, among other actions, he marched carrying a poster that read, "I am glad if I can advertise on posters." The artist's postal exchanges thus led to a physical exchange, again mimicking the logic of détente.

Artistic exchanges during détente also became more intellectual: Many Western art historians adopted Marxism as a crucial tool of their practice, achieving high visibility in the process. The British art historian John Berger, who even in the contentious 1950s had identified with progressively socialist artists such as Renato Guttuso (discussed in Chapter 2), scripted and hosted a multi-part television special on the BBC in 1972 called *Ways of Seeing*. This program, along with a best-selling companion book, attempted to link traditional Western aesthetics to notions of class and elite power. If an Italian Renaissance painting had long been viewed as a "window on the world"—the replication of a religious or historical scene according to some of the laws governing human vision—then Berger instead identified it as a "safe on the wall," arguing for art's repressed function as elite currency, whether actual or symbolic. In addition to highlighting the misogyny inherent in Old Master painting, as well as countering traditional art histories that assumed that Western art was not ideological, Berger also attacked more recent capitalist advertising. With such a trenchantly Marxist framework broadcast to millions of English viewers, *Ways of Seeing* also corresponded with the spirit of détente, as the ideology of the "other" achieved

mainstream visibility. Other, more academic, art historians, such as T. J. Clark and Michael Baxandall, also published vastly influential volumes in the early 1970s that established Marxist and materialist approaches to historical art as the cutting edge of Western scholarship. Even the Cold War's influence over the heroic interpretation of American painting in the 1950s was first articulated at this time. Max Kozloff's "American Painting during the Cold War" (1973) was mentioned in Chapter 4, but in 1974 Eva Cockcroft went further, publishing an essay that explicitly detailed the ways that Abstract Expressionism came to be a "weapon of the Cold War." Détente thus not only helped relax international tensions, but also inspired retrospective looks at the Cold War's past that transcended the conflict's rigid mentality.

Limits of Détente

Détente was built upon agreement and exchange between Cold War adversaries, thus blurring ideological distinctions and diffusing tensions. A number of art practices followed suit, with styles like Conceptual art and Performance art, albeit in different circumstances, coalescing across the Iron Curtain. But this was far from the only story of the decade. As with the other phases of the conflict, the period of détente also witnessed countries torn apart by regional and civil wars, with their clashing sides supported, respectively, by American and Soviet military aid. Furthermore, coups continued around the world—often with superpower backing—that only heightened the decade's instability. The world was divided not only between capitalist and communist systems after 1945, but also in another crucial way that overlapped and played into the Cold War struggle: the colonizer versus the colonized. As mentioned previously, the Cold War was really only cold for the United States, the Soviet Union, and its major allies. While not every war and coup could be blamed on the Cold War, the conflict nevertheless played a decisive role, especially since anti-imperialism paired so well with anti-capitalist theories of communism. The Vietnam War, for instance, was as much a colonial battle for independence as it was a battle of political ideologies: Why was the United States interfering in the internal politics of a newly independent nation? Was this little

more than a neocolonialist power grab? At the very least, the fact that so many battles for colonial independence happened during the Cold War allowed such struggles to acquire an international, ideological significance—a place for Americans and Soviets to acquire and hold on to allies and to keep each other in check.

In the 1960s and 1970s, many such struggles occurred in Africa, with 17 countries alone gaining independence in 1960. Many attempted to carve out neutral positions in the Cold War, pursuing a "Third Way"—similar to Egypt, Yugoslavia, and a number of nations in Latin America—but the conflict's global realities made such a position difficult to maintain. With the Americans and Soviets each wanting to maintain footholds in Africa to counterbalance the other, substantial monetary and military aid were often on offer. For new countries requiring vital infrastructure, such assistance was difficult to turn down.

The early artworks of El Anatsui, a well-known contemporary artist who works in Nigeria, reveal the complex overlap among questions of African independence, art, and the Cold War. Best known today for works that weave together the metal components of small liquor bottles—transforming them into shimmering, monumental tapestries—Anatsui began making art in the 1960s as a student in his native Ghana. Led by the dynamic nationalist Kwame Nkrumah, Ghana achieved its independence in 1957, the first sub-Saharan nation to do so. Nkrumah was an inspiration around the continent and the rest of the developing world for his strong statement of neutrality and African unity. He knew that decolonization entailed more than simply achieving independence: it also required a liberation from Western, colonial modes of thinking. As such, might one consider the Cold War as just another way for foreign powers to control African resources? Nevertheless, Nkrumah—like Egypt's Nasser before him (see Chapter 2)—sought economic assistance from global superpowers to achieve his nationalist goals. And when President Eisenhower refused to commit American funds, the Soviets jumped at the opportunity to provide aid. Continuing the parallels with Egypt, Eisenhower then labeled Nkrumah a communist, and Ghana suddenly found itself a site of Cold War contention. It is thus no surprise, considering fears of a communist Africa tipping the global balance of power, that a CIA-backed military coup overthrew Nkrumah in 1966.

Anatsui personally experienced this nationalist euphoria and the later disappointments of this period. While a student, he was asked to produce a sculpture for a meeting of the Organisation of African Unity (OAU) in 1965, taking place in the nation's capital, Accra. The OAU was a group that promoted a pan-African agenda, which meant trying to stay neutral in the Cold War as a means to develop Africa as a unified and independent power. Anatsui taught art in Ghana until he received a job in a Nigerian university in 1975. Nigeria, another former British colony that had only recently come out of a bloody civil war, underwent two military coups soon after Anatsui's arrival—the latter of which resulted in a Soviet tilt in its foreign policy. Following this political instability, the artist began a series of sculptures known as the *Broken Pots* in 1977, of which *Writing on the Wall II* from 1979 is part (FIG. 5.9). Nigeria had a long, indigenous tradition of pottery, which Anatsui gravitated toward soon after his arrival.

Fig. 5.9
El Anatsui
Writing on the Wall II, 1979, ceramic, 10 x 15 in. (25.4 x 38 cm). Collection of the artist (now destroyed).

While this work was molded and forged anew by the artist, *Writing on the Wall* nonetheless visually recalls a reassembled archaeological relic—its discrete shards carefully grafted back into a whole. In so doing, the artist fashions a fitting allegory of the battles between African unity and Cold War realities in the 1960s and 1970s, suggesting the need to excavate and resuscitate indigenous traditions, despite past colonial plunder and the continued destruction wreaked by civil wars and coups. Fitting the pieces together—with gaps and glue evident—approximates the challenges of Pan-Africanism during the Cold War. Cold War actors, who viewed everything through the conflict's macro-, us-versus-them perspective, often ignored site-specific histories and circumstances in making their decisions, thus marginalizing local cultures in the name of geopolitics. Anatsui's title serves as a warning for viewers to reassemble local Nigerian political and cultural traditions before they are lost.

With its intentionally fragmented and incomplete nature, *Writing on the Wall* also corresponds with Western Conceptualism. The art historian Chika Okeke-Agulu has termed such local–global artistic hybrids as indicative of "postcolonial modernism." Artists in newly independent African nations—as well as in other developing countries—looked for ways to demonstrate a newfound modernity away from their colonial past, while also asserting their independence from dominant forms of Western art, which would smack of imperialism. Artists across the Islamic world, to provide another example of postcolonial modernism, turned to thinking about the overlaps between local calligraphic traditions and Western abstract painting. The Sudanese artist Ibrahim El-Salahi, who has worked in this idiom since the 1960s after a period of study in London, is a prime example. His paintings often use Arabic text as a starting point for modernist, formal explorations, thus simultaneously signaling Sudan's independence from Great Britain in 1956, the nation's relationship to a larger pan-Arabic community, and an artistic internationalism signifying modernization (FIG. 5.10). Like the artists from around the world embracing the forms of geometric abstraction discussed in Chapter 2—from Cuba, Brazil, and Yugoslavia, among others—many artists in Africa and the Middle East used their work to forge their own positions independent of Cold War norms.

Fig. 5.10
Ibrahim El-Salahi
Vision of the Tomb,
1965, oil on canvas, 36
x 36 in. (91.5 x 91.5
cm). Museum for African
Art, New York.

Latin America continued to be a contentious Cold War site in the 1970s. Repressive, anti-communist dictatorships—supported by American aid—continued to flourish in Argentina, Brazil, and many other nations. Civil wars, with communists battling anti-communists, were taking shape in Nicaragua and El Salvador, and these would soon become high-profile Cold War hotspots in the 1980s. But perhaps events in Chile, and specifically the overthrow of the popularly elected socialist president Salvador Allende, best exemplify the limits of détente in the 1970s. After years of increasing popular support, despite CIA attempts to discredit his various election campaigns, Allende won a plurality in the 1970 presidential election and assumed power. A democratically elected socialist government in Latin America was deeply troubling for President Nixon's administration; the United States was always wary of another Cuba. It is perhaps no surprise that the United States backed a failed coup in 1970 and, at very least, tacitly supported the coup that deposed Allende in 1973. Just before General Augusto Pinochet assumed power and instituted a reign of terror that would last until the end of the Cold War, Allende fatally shot himself in the presidential palace. As with other dictators in Latin America, U.S. officials praised Pinochet for his anti-communism and were content to ignore his government's many human rights violations, including the kidnapping, torture, and murder of Allende supporters and other leftist sympathizers. The exiled socialist economist Orlando Letelier was even killed by Pinochet's secret police in Washington, D.C. in 1976.

Artists in Chile responded to Pinochet's rule in ways consistent with the international trends of the 1970s—employing conceptual and body-based strategies that were often politically direct. Elías Adasme, for example, made censorship and subtle references to torture part of his work. *To Chile* (1979–80) features four large photographs of a series of the artist's actions, in which his lanky body appears alongside the long, skinny cartographic image of Chile itself (FIG. 5.11). By placing his body, either shirtless or fully nude, into dialogue with the form of the

Fig. 5.11
Elías Adasme
To Chile, 1979-80,
digital print on cotton
paper, each 68⁹⁄₁₀ x 44½
in. (175 x 113 cm).
Museo Nacional Centro
de Arte Reina Sofía,
Madrid.

Art and Détente

nation, Adasme compares his body to that of the body politic—suggesting through the display of his own vulnerable flesh that the state relies upon torture and violence. The work's fifth panel demonstrates the actual political power of these photos, documenting the ways the artist displayed his photographs illegally in the streets of Santiago and how long they remained visible before the police or other Pinochet supporters destroyed them. Another artist, Eugenio Dittborn, began a series of *Airmail Paintings* in 1983, in which he would mail tableaux comprising photographs of missing persons, drawings, and newspaper clippings, among other things, abroad for exhibition. Finally, a group known as CADA (Colectivo Acciones de Arte)—original members include artists Lotty Rosenfeld and Juan Castillo—started performing public actions in 1979. Their best work embraced the rigor of Conceptual art with high visibility and political legibility. In *Oh, South America!* from 1981, the artists distributed 400,000 leaflets from six planes high above Santiago that suggested, Beuys-like, that everybody can be an artist and transform everyday life. By using a once-popular means for distributing political propaganda to disseminate romantic ideas of the artist, CADA's act reminded residents of their own sovereignty in the face of oppression.

The limits of détente were also demonstrated by a momentous regime change in 1979 which was neither orchestrated nor supported by the United States or Soviet Union: the Iranian revolution. Situated between the Soviet Union and the oil-rich Persian Gulf, Iran had been strategically important to the conflict since its inception. In fact, it was the site of one of the Cold War's first crises in 1946, and additionally where an American-backed coup ousted a democratically elected leader and installed the more compliant Mohammad Reza Shah in 1953. His decadent "Western" lifestyle, complete with a fleet of luxury cars and airplanes and an important cache of American paintings by the likes of Pollock and Warhol, angered fundamentalist Muslim clerics by the 1970s. After a year of general strikes and protests, Muslim cleric Ayatollah Khomeini returned from exile and, with popular backing, established Iran as an Islamic Republic.

In an early speech, the Ayatollah made it clear that he had no interest in taking sides in the Cold War: "We have turned our backs on the East and the West, on the Soviet Union and

America, in order to run the country ourselves." And when students stormed the American embassy in Tehran, taking over 50 hostages in November 1979, the United States faced its first major international crisis since World War II that did not concern communism. While it might not have been apparent at the time, the Cold War had become a different animal by 1980.

The End of Détente

By the end of the 1970s, détente was in serious danger. This was due to increasing mistrust between the superpowers, largely spurred by proxy wars between the Soviets and the Americans. In 1977, for instance, fighting broke out in the Horn of Africa between Somalia and Ethiopia. Even though Somalia was only a recent American ally, Ethiopia was aligned with the Soviets, with both nations receiving aid and weapons. The positioning of these countries near the Persian Gulf turned this regional war into an important Cold War conflict, though its causes were rooted more in longstanding local rivalries than in geopolitics. When seen in tandem with other events, such as Soviet and Cuban involvement in the civil war in Angola, many American officials viewed the USSR's activities in East Africa as consistent with a new pattern of Soviet aggression. These beliefs seemed to be confirmed in late 1979 when the Soviet Union invaded Afghanistan to ensure that a friendly regime remained in power. President Carter announced the boycott of the 1980 Summer Olympics in Moscow soon thereafter. If Cold War nations could not compete together in an event defined by ideals of peace and international cooperation, then clearly détente was over. In only a matter of months, the Cold War again became outwardly antagonistic, abetted by the anti-communist bluster of candidate, and then newly elected president, Ronald Reagan, and the military buildup initiated by his administration, discussed in the next chapter.

A number of artists corresponded to this shift, becoming more involved in explicitly geopolitical issues. While Chris Burden spent the mid-1970s testing the limits of his own body by being shot in the arm or nailed to a car, by the end of the decade he broadened his view to include international political issues. In 1979, for example, he exhibited *The Reason for the Neutron Bomb* (FIG. 5.12), which addressed a controversial Cold War weapon.

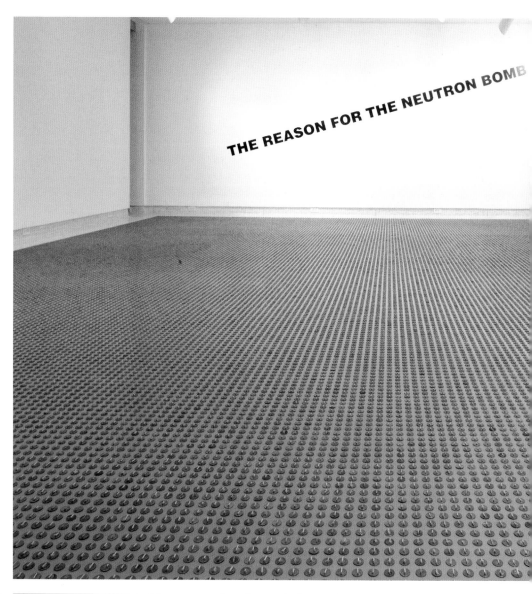

THE REASON FOR THE NEUTRON BOMB

Fig. 5.12
Chris Burden
*The Reason for the
Neutron Bomb*, 1979,
50,000 nickels, 50,000
matchsticks, ¾ in.
(1.9 cm) in length,
514 sq. ft (47.7 sq.
m), 30 ft 8 in. x 17
ft 6 in.(9.3 x 5.3
m), signage variable
dimensions. Museum of
Contemporary Art San
Diego.

The neutron bomb was different from conventional nuclear war-heads, as it emphasized the potency of radiation over the power of the blast—resulting in a high number of casualties without the physical destruction of infrastructure. Nicknamed "the capitalist bomb" for its sparing of property, it was controversial in the United States: President Ford authorized its development; President Carter shut down the program a few years later; then President Reagan restarted it soon after his inauguration in 1981. As Burden explained in a text accompanying the exhibition, the

neutron bomb was designed to compensate for the 50,000 Soviet and Warsaw Pact tanks available for an attack on Western Europe, as the Americans and NATO had less than half that number on its side of the continent. The neutron bomb was viewed as a more "humane" nuclear weapon that could kill Soviet soldiers without devastating European landscapes and cities.

With the work's title stenciled on the gallery wall, Chris Burden constructed and precisely arranged 50,000 Soviet "tanks"—each comprising a nickel with an affixed matchstick—on the gallery floor to literalize "the reason for the neutron bomb." This American nuclear strategy certainly had bureaucratic origins: one can readily imagine its presentation by a government think-tank in a thick vinyl binder, supported by charts and graphs. By turning these bureaucratic Cold War abstractions into something tangible, Burden reminded viewers of the unthinkable potential human costs (indeed using actual currency) of the conflict: damage wreaked by thousands of Soviet tanks in Western Europe and the gruesome human effects of the neutron bomb. If Burden's early performance works localized trauma in his own flesh, then this work reminds viewers of the more general bodily peril of the Cold War. As antagonism again took center stage in the 1980s, this would again become common.

A Return and then the End

Released in 1985, the American blockbuster *Back to the Future* told the story of a California teenager who, in a nuclear-fueled DeLorean automobile, travels back in time and gets stuck in 1955. Its entertainment value aside, the film's international popularity corresponds to the Cold War in the early to mid-1980s—namely, a return to 1950s-era hostility between the United States and the Soviet Union. With détente in ruins by the end of 1979, mutual suspicion and antagonism replaced attempts at Soviet–American cooperation, leading to the most dangerous time of the Cold War since the early 1960s. The year 1983 proved to be particularly tense: the Soviets shot down a Korean civilian airliner that had accidently entered its airspace, mistaking it for an American spy plane, killing 62 Americans; the Soviets suspected that Abel Archer 83, a joint U.S.–NATO military exercise in Western Europe, was a prelude to a real invasion and came close to launching a pre-emptive nuclear strike; and the heated rhetoric of the 1950s returned, with Ronald Reagan referring to the Soviet Union as an "evil empire." In another flashback, the arms race also heated up again, especially the competition for ever more powerful nuclear weapons and creative ways to deliver them. The binaries and belligerence of the Cold War so prevalent in the 1950s thus again held currency in the 1980s, especially during the first half of the decade.

But the 1980s was also the decade of postmodernism's full emergence, and its ideas contradicted entrenched Cold War assumptions. For example, in 1979 French philosopher

Erik Bulatov
Danger, 1972-73
(detail).
See fig 6.11

Fig. 6.1
Vito Acconci
Instant House, 1980,
flags, wood, springs,
ropes, and pulleys,
closed: 96 x 60 x 60 in
(243.8 x 152.4 x 152.4
cm), open: 96 x 252 x
252 in. (243.8 x 640.1
x 640.1 cm). Museum of
Contemporary Art San
Diego.

Jean-François Lyotard described "the postmodern condition," which was predicated upon skepticism toward what he called "grand narratives." Accordingly, big, monolithic ideas, like communism and capitalism, which had long attempted to make sense of world history through a singular perspective, were deemed insufficient to capture the messy, local complexity of experiences across the globe. Postmodernism insisted that there was no one "correct" view of history; the days of stable reassuring binaries appeared to be over. By this logic, Lyotard seems to have been questioning the very idea of the "Cold War" at precisely the moment when it was again fearfully relevant. These two worldviews were in conflict: the Cold War as *the* organizing principle behind contemporary global events versus the Cold War as an irrelevant concept that papered over ideological nuance and local

specificities. In other words, while the conflict reemerged with vigor around 1980, its defining armature was collapsing beneath its feet. A number of artistic practices during this decade responded to this confusion. Vito Acconci's *Instant House* from 1980, for example, encapsulates the simultaneous relevance and irrelevance of the Cold War model during its last decade (FIG. 6.1).

Approaching this work, viewers encounter a swing hanging in the gallery, surrounded by four sheets of wood resting on the ground, each decorated with an American flag. When a visitor sits on the swing, her weight activates a series of pulleys, which then draw the four sheets upright to create the "instant house" of the title. This act leads to a big reveal: A Soviet flag decorates the outside of each piece of wood. While Acconci is certainly exploring the politics of engaged, active spectatorship, the work also presents the Cold War in postmodern terms: When erected, the house posits a world sharply divided between inside and outside, us and them. But when the viewer gets off the swing, these divisions—along with the house itself—literally fall apart. Acconci himself viewed the work in such terms, noting that it aimed "to put a clinker into existing political systems," such as the Cold War. The interactive sculpture mirrors a culture that maintained belief in the conflict's certainties while questioning the foundations of that belief.

The photographs of Sibylle Bergemann in East Germany from the 1980s capture this contradiction in more direct

language. In one series, she shot the installation of communist monuments throughout the country, such as one in East Berlin memorializing the authors of *The Communist Manifesto*, Karl Marx and Friedrich Engels. In one of the pictures from 1986, Engels is hanging from a crane, suspended in air (FIG. 6.2). The photograph thus prompts the question: Is the monument being constructed or dismantled? Bergemann's photographs uncannily anticipate the period immediately following the fall of the Berlin Wall in 1989, when many such statues were pulled down throughout East Germany and other Eastern Bloc nations. Her pictures remind viewers that these countries continued to propagate strict socialist ideology in the 1980s by installing prominent sculptures, despite the erosion of public faith in such a vision.

The Cold War's position as seemingly both primary and ancillary to global experience also informed other strands of art production around the world during the 1980s. From the rise of Neo-Expressionism—a return to a fetishization of paint and individual expression—to works deconstructing images of political power through strategies of appropriation, artists in this decade reveal the stubborn, lingering mythologies of a bipolar Cold War world, but also, wittingly or not, the arbitrary and

illusory structures of such mythologies. The conflict disintegrated a mere four years after Mikhail Gorbachev assumed power in the Soviet Union in 1985. The collapse resulted from a confluence of factors—especially the continuing disillusionment of individuals living in the Soviet Bloc—but Gorbachev was certainly a catalyst. Like many of the artists in this chapter who were informed by postmodernism, Gorbachev understood the conflict to the point where he could also see through its blinders and beyond the division of Europe and the world.

Neo-Expressionism: Common Ground in the 1980s?

During détente in the 1970s many artists turned toward conceptual or performance approaches, thus rejecting the production of discrete, marketable objects like paintings and sculptures. In the early 1980s, painting regained its commercial viability and, in some quarters, garnered critical acclaim. The artists especially lauded were, for the most part, male artists who touted painting's messy, expressive immediacy—another version of the return to a 1950s mindset. If American Abstract Expressionism and Art Informel elsewhere helped to propagate the values of democratic capitalism in the 1950s (see chapters 1 and 2), then the emergence 30 years later of what became known as Neo-Expressionism, especially in the United States and Europe, had similar ideological resonance, with notions of alienation and freedom again becoming a viable artistic strategy during a return to an Eisenhower-era level of hostility between the superpowers. A crucial difference existed, however, between painters of the earlier moment and the main exponents of Neo-Expressionism: the later artists eschewed the pretensions of abstraction and painted the human figure without reservation.

Zeitgeist, an important exhibition of Neo-Expressionist works, opened in West Berlin in late 1982. The early 1980s were a particularly contentious time in West Germany in terms of the Cold War, as there were, for example, mass protests against the deployment of American Pershing nuclear missiles there. Staged in the Martin-Gropius-Bau, a nineteenth-century building beside the Berlin Wall, *Zeitgeist* forced its viewers to confront the Cold War's most visible symbol upon both their arrival and departure. Considering the exhibition's title and its

frontline location, the show's focus on Neo-Expressionist painting around the Western art world must be considered in its Cold War context. While the exhibition also showcased well-known painters such as the Americans Julian Schnabel and David Salle, as well as the Italians Francesco Clemente and Enzo Cucchi, West German artists—with their brash, aggressive style—stole the show and became the international standard-bearers of Neo-Expressionism.

Georg Baselitz's *Away from the Window* (1982), on view in the exhibition, demonstrates the Cold War stakes and contradictions of this reemergence of expressionist painting (FIG. 6.3). Baselitz had been painting in an expressionist vein for at least 20 years,

Fig. 6.3
Georg Baselitz
Weg vom Fenster (Away from the Window), 1982, oil on canvas, 98⅜ x 98⅜ in. (250 x 250 cm). Foundation Beyeler, Riehen/Basel.

and by 1960, he had already rejected the artistic choices the Cold War afforded him. Initially trained in Socialist Realism at the East Berlin Art Academy, he defected to West Berlin in 1958 (before the building of the Wall) due to his dissatisfaction with the school's rigid aesthetic program. At the art academy in West Berlin, his new instructors pushed abstract art, which he quickly dismissed as merely an equally stifling inversion of the directive for Socialist Realism in the East. Beginning with several provocative paintings first shown in a 1963 exhibition in a West Berlin gallery (and subsequently seized by police for their obscenity), Baselitz mauled and manipulated pigment in explicitly subjective ways that also delineated abject figures. In 1969, he began decades of painting and exhibiting his subject matter upside-down. This inversion became Baselitz's trademark, especially in the 1980s, allowing him to straddle that old Cold War divide: he made figurative paintings that also negated their recognizable content through their flipped orientation and their painterly qualities.

Well known in West Germany, Baselitz did not attract international attention until his appearance at the 1980 Venice Biennale. The timing of this success indicates that there was something about his works that appealed to this specific historical moment of a reheated Cold War. But what? The *Zeitgeist* catalogue claimed that the works on display shared their "closest affinity" with expressionist paintings of the 1940s and 1950s— that is, with Abstract Expressionism and Art Informel. In other words, Baselitz's canvases revisit values extolled by Harold Rosenberg's "Action Painters," discussed in Chapter 1: namely, the heroic artist struggles alone to create a work that expresses the anxiety of the age through the physical act of painting, the resulting canvas providing evidence of an existential confrontation. One of the most vocal proponents of Neo-Expressionism, the Dutch curator Rudi Fuchs, proclaimed that the works on display in *Zeitgeist* characterized painting as a kind of "salvation" that "represents freedom of thought which is triumphant expression." While critics did not explicitly contrast this return of painting with repressive art practices in the communist world, these works nevertheless revisited notions of the medium rooted in the Cold War's ideological battles of the 1950s. Perhaps the return to open hostilities and nuclear brinkmanship spurred the need for an art constituted through the artistic signs of anxiety.

The expressive qualities of Baselitz's *Away from the Window* are clear. Even the painting's white field, which occupies three-quarters of its surface, conveys a frenzied body at work. With its upside-down orientation, the lone figure in the painting becomes an explicit formal element, anchoring the right side of the canvas. This man is in agony: He grabs his crotch and screams, expressing what seems to be both physical and mental trauma. The squiggly crimson shadow lining the figure's back only adds to the visceral pain on view. Alone in a barren room, turning away from the outside world—here represented by a spindly tree viewed through a window—this painted figure exudes alienation, which is only heightened through the canvas's flipped orientation, as the upside-down, gravity-defying world depicted on canvas does not correspond to the viewer's. The original German title pushes the estrangement of the subject yet further, as *Weg vom Fenster* is also an idiomatic phrase meaning "not important anymore." All eight pictures that Baselitz showed in *Zeitgeist* featured the same sort of solitary subject who seemed both emotionally and physically unmoored from reality. The return to existentialism on view throughout the exhibition emphasized the artist's outsider subjectivity, the ways he existed outside of ideological frameworks and indeed history. And the "he" is deliberate: *Zeitgeist* included only one female artist (out of 43). Apparently, painterly expression, following again the individualist mythology of Jackson Pollock, remained the near-exclusive purview of men in the 1980s. Whether Abstract Expressionism or Neo-Expressionism, art could reinforce the aggressive and masculine Cold War militarism of both moments—with many important women painters marginalized in the process.

Neo-Expressionist paintings channeled the capitalist West in another way. The popularity of such painting in the early 1980s was, in part, due to newly wealthy collectors (who largely made their money in the exploding fields of finance and banking) looking for works that looked like "art"—unlike the archival photographs and Xerox copies that largely constituted Conceptual art in the 1970s. With their depictions of alienation, works by Baselitz appeared to protest against the mundane yet slick world of global capitalism; however, as Benjamin Buchloh remarked in an important essay from 1981, such paintings actually expounded

a deeply conservative view of art and politics. So, despite the universalist aspirations of its painters, Neo-Expressionism was securely rooted to structures of capitalism in the early 1980s. Even though he positioned himself self-consciously as "German" and thus an alternative to the American-dominated art world, Baselitz and others nevertheless relied upon a rhetoric of expressionism that had also fueled the international popularity of American abstraction in the 1950s.

Visitors to *Zeitgeist* might have come away thinking that the "figurative expressionism" on view had replaced Abstract Expressionism in terms of mythologizing the autonomous, liberal-democratic individual that stands, however symbolically, against communist oppression. The vibrant graffiti on the West Berlin side of the Wall, visible when entering and exiting *Zeitgeist*, only reiterated expressive painting's seemingly anti-communist stance. And, at the same time as *Zeitgeist*, a group of graffiti artists—namely Jean-Michel Basquiat and Keith Haring—emerged in the United States. While their work depended on its specific New York context, initially resisting the revivified art market through making works that could not be sold, they too were eventually brought into the Neo-Expressionist fold. (Indeed, Haring was invited to paint a 350-foot (106.7 meter) mural on the West side of the Wall in 1986.) Rainer Fetting, a painter based in West Berlin, solidified the connections between graffiti and Cold War notions of individual freedom: He made a series of paintings featuring Vincent van Gogh, one of the first Expressionists, striding along the Berlin Wall, perhaps ready to add his own alienated marks to the concrete barrier. The point seems clear; an East German artist could not emulate the model of artistic liberty emblematized by van Gogh.

The reality, however, proved much more complicated than such binaries imply. By the late 1970s, for example, there were clear significant formal connections between West German painters such as Baselitz and some "official" East German painters. Fetting's van Gogh, stalking the Wall, can also be seen as registering the ways that painterly expression could link the two Germanies. As discussed in Chapter 1, East Germany had always tolerated a good degree of expressionist leeway in its orthodox brand of Socialist Realism, because of the problematic formal similarities between Stalinist painting and Nazi-approved

canvases. But in 1971, perhaps in the spirit of détente, the East German leader Erich Honecker made such a policy official, announcing that there were to be "no taboos in the realm of art and literature," as long as artists and writers continued to believe in the tenets of socialism. Bernhard Heisig was among a group of East German artists whose paintings, especially in the 1970s, explicitly dismantled stereotypes about Socialist Realist art.

While Heisig had run into trouble with East German officials in the 1960s for advocating too much artistic experimentation, by the 1970s he had been awarded numerous official prizes in the GDR, and was the subject of a major retrospective exhibition. Following the *Ostpolitik* cooperation of the 1970s, his works also gained notice in West Germany, where he showed a number of canvases in Documenta 6 in 1977. His painting *The Dying Icarus* (1979) is typical of his style (FIG. 6.4). While perhaps not as frenzied as Baselitz's *Away from the Window*, the picture nevertheless depicts the Greek boy who fell to his death after flying too close to the sun, in a scene full of painterly flair and exuberance. The mythological subject can be read any number of ways. Are capitalists, with their false dreams of transcendence stoked by advertising, bound like Icarus to fail? Or is this a comment on

the artist's own temptations—and reservations about such feelings—to don metaphorical wings and overcome the Berlin Wall and German national division more generally, not unlike Beuys's elevated hare (see FIG. 4.5)? Either way, Heisig's painterly style and use of a "universal" subject from Greek mythology place the work securely in the context of Neo-Expressionism, even though it was lauded as an example of Socialist Realism. The art historian Claudia Mesch has even argued that East German artists like Heisig influenced and laid the groundwork for the return to prominence of painting in West Germany. The acceptability of Heisig and other East German artists was certainly helped when the famous West German industrialist and Pop art collector Peter Ludwig began acquiring such works in the late 1970s and publicly exhibiting them the following decade.

The Cold War's artistic confusion grows when one considers the popularity of Neo-Expressionism in Czechoslovakia and Hungary by the mid-1980s. Here, the style was not viewed as necessarily subversive, but rather as apolitical (Czechoslovakia) or a way to present a forward-thinking face to an internal or international public (Hungary). Hungarian officials even exhibited the work of three of its Neo-Expressionist painters in the country's pavilion at the Venice Biennale in 1986—a further sign of collapsing Cold War distinctions in the art world, as well as the increasing autonomy of individual nations.

The other major nations involved in this Neo-Expressionist "return to the figure" were Italy and the United States. But the painters associated with these countries relied upon appropriation in their practices; in other words, artists would crib images from older paintings or from the mass media to populate their new works. While certain critics praised these canvases as exemplary instances of the expressive power of painting, the artists also seemed to be winking at the spectator while producing such works. If the paintings of Pollock and Baselitz were perceived to have sprung from some unmediated confrontation between artist and canvas, then their quotation-laden Italian and American cousins displayed painting's expressive limitations and inscrutability even as they celebrated the medium and its return. Whether manifesting itself through the shared styles across the Berlin Wall or the ironic commitment of American and Italian painters to the medium, Neo-Expressionism was profoundly of

its conflicted, early-1980s Cold War moment: a time when martial rhetoric and bipolar structures again seemed to be defining the international situation, but also when these political commitments did not inspire blind devotion. Postmodernism, which cautioned against such ideological certainty, had taken hold, even in parts of Eastern Europe.

President Reagan himself, the primary instigator of this renewed Cold War belligerence, also demonstrated this conflict between rhetoric and reality. Not only was he a former film actor who understood how to project a certain image, but he was largely elected in 1980 based on a nostalgic vision for the United States that sought a return to 1950s ideals, thus erasing the international embarrassments of Vietnam, Watergate, and Iran. As a self-styled renegade fighting communist "evil," Reagan also seemed to be reprising some of his most famous film roles in the White House: a good cowboy fighting evil, with godless communists replacing heathen Native Americans. Reagan's belligerence began to wane in 1985 when he began working closely with the Soviet leader Mikhail Gorbachev. Recalling the half-hearted commitment of the American Neo-Expressionists, the President's own Cold War determination at the start of his administration proved superficial, or at least flexible, in light of new developments.

Other Alternatives to Socialist Realism

In the Soviet Union in the 1980s, Socialist Realism began to embrace ambiguity in ways that would have been unimaginable in previous years. Geli Korzhev, active since the 1950s (see FIG. 3.6) and among the best known and most decorated Socialist Realist painters (named "National Artist of the USSR" in 1979), began making paintings in the 1980s that gently seem to question the socialist project. Korzhev's series of paintings depicting Don Quixote from around 1980 ask pertinent questions: Is the socialist quest based on collective self-delusion? Does being a devout communist mean seeing enemy elements where none exist? Korzhev's paintings are a fitting way to close out Soviet Socialist Realism: they admit the lie but still are painted in the offending style. Thus considered, they are not that different from the American, Neo-Expressionist works of Julian Schnabel,

which explore the fictions of the medium in which the artist nonetheless continues to work and revel.

Other Soviet artists turned from Socialist Realism toward a more mechanical style of realism—Photorealism—in their paintings. Especially after détente-era exhibitions of American art in Moscow that had included the canvases of Photorealists such as Richard Estes and Chuck Close, the style found a number of Soviet adherents, especially in the Baltic States, even though it was not officially sanctioned. Such artists strove meticulously to capture a photographic look in their canvases—both a haphazard snapshot quality and that unique photomechanical sheen—through traditional processes of painting. With its reliance upon skilled, naturalistic depictions, Photorealism came to be viewed as a compromise between the Soviet artistic requirements of realism and developments in the international art world; it was Socialist Realism crossed with postmodern irony and ambiguity.

A work by Romanas Vilkauskas, a Lithuanian painter, called *Interior X* from 1981 exemplifies this hybrid quality (FIG. 6.5). Viewers see a meticulous depiction of a room with its walls papered in old copies of *Pravda*, the official Soviet newspaper, perhaps making literal the idea that Soviet citizens were surrounded by ideology, even at home. But personal pictures and a cross used to hang on the wall, as evinced by the effects of sunlight on the surrounding areas. Why has the room been abandoned? The cross was certainly subversive in the anti-religious Soviet state: Were the other missing objects also ideologically problematic? The original pictures had covered a newspaper portrait of Josef Stalin; considering his renunciation by Khrushchev in 1956, this detail was proof of the changing nature of *pravda* (truth) in Soviet life. As a painting that utterly rejects the depiction of depth, emphasizing the flatness of the medium, *Interior X* nevertheless remains committed

Fig. 6.5
Romanas Vilkauskas
Interior X, 1981, oil on canvas, 35½ x 43⅜ in. (90.2 x 110.2 cm). Zimmerli Art Museum at Rutgers University, Norton and Nancy Dodge Collection of Nonconformist Art from the Soviet Union.

to traditional painting techniques. However, Vilkauskas's realism lacked explicit ideological commitment. It is no wonder that this painting could not be officially exhibited until after Lithuania achieved independence.

Photorealist techniques also played a role in Chinese art after Mao's death and the upheavals of the Cultural Revolution. If truth was deemed absolute under Mao—not changing based on context—then things shifted when Deng Xiaoping assumed power in 1978. Rejecting the ideological rigidity of the Cultural Revolution, he advocated a more contingent model of truth that was shaped by the practical realities of everyday life. Artists, in turn, sought out alternatives to Socialist Realism and other explicitly ideological practices, with their broad political messages. In addition to a critical realism that explored the violent excesses and terrible human consequences of the Cultural Revolution, Photorealism became a viable option. In *Father* from 1980, the young artist Luo Zhongli took an image of an old peasant—what could have been a detail from a Socialist Realist canvas — and turned his tightly cropped visage into the subject of a monumental painting over seven feet (2.1 meters) high (FIG. 6.6). The canvas brims with details—the wrinkles in the subject's headdress, face, and hands; the individual beads of sweat dripping down his forehead; the fish decoration on his porcelain bowl. Portraits on this scale had, in the past, been reserved for Mao alone. Was Luo suggesting that this peasant was one of many true "fathers" of China, an alternative to the country's official patriarch, the "great leader" Mao? Furthermore, the picture did not have a clear socialist meaning. On the advice of an older artist, Luo added a ballpoint pen tucked behind the old man's left ear, suggesting, at least, that a socialist education had taught him how to write. If Photorealism was largely viewed in apolitical terms in the United States—as explorations of the ambiguity and/or superficiality of photography—it wielded political agency in the Soviet Union and China, precisely due to its lack of political commitment. No longer was reality painted as ideologically ideal: instead, only its mundane details were presented, seemingly mediated through the camera lens.

Fig. 6.6
Luo Zhongli
Father, 1980, oil on canvas, 84⅝ x 59¹⁄₁₆ in. (215 x 150 cm). National Art Museum of China, Beijing.

A Return and then the End

Fig. 6.7
Art & Language
Portrait of V. I.
Lenin in the Style of
Jackson Pollock VII,
1980, enamel on canvas
mounted to board, 41¾ x
39⅜ in. (105 x 100 cm).
Private Collection.

Strategies of Appropriating the Cold War

While paintings on either side of the Cold War shared similarities in the 1980s, a group of British Conceptual artists, known collectively as Art & Language, questioned the conflict's binaries in explicitly art-historical terms in a series of paintings called *Portrait of V. I. Lenin in the Style of Jackson Pollock*, completed at the start of the decade (FIG. 6.7). The artists produced works that were dead ringers for Pollock's classic drip paintings, but with a crucial difference: When viewers looked closely, some of the drips and skeins of paints constructed a profile, facing left, of the Soviet revolutionary hero of the title. Not only does the series

suggest the Marxist origins of Pollock as an artist, as discussed in Chapter 1, but it also collapses the stylistic distinctions that had defined the artistic Cold War until at least the early 1960s. By combining two emblems of the conflict—Pollock's drips, signifying freedom, and the propagandistic face of the communist revolution featured in countless Socialist Realist works—Art & Language themselves revisited the 1950s to suggest that the "master narrative" of abstraction versus figuration could not adequately describe the Cold War. Viewers were compelled to adopt a postmodern frame of mind through which they could see how similarities emerge in two ostensibly irreconcilable systems.

In cribbing Pollock's style and Lenin's visage, Art & Language used appropriation, as did artists in both the United States and the Soviet Union: that is, capturing images from the lived environment, which were then deployed in a work of art with little or no modification. The point of such works is to call attention to the ways that these borrowed images function in and circulate through society. In other words, viewers come to see images as *images*, not as autonomous or as innocent conveyers of narrative. Works of appropriation art, then, become a means to understand the complex, subtle, and stubborn ways that images wield ideological power—practices that had much to do with the Cold War. A group of American artists, collectively known as the Pictures Generation, including Cindy Sherman, Barbara Kruger, and Richard Prince, exposed the powerful inner workings of capitalism. Generally speaking, their works reveal how repressive capitalist ideology was expounded everywhere, especially in seemingly apolitical magazines, films, and television programs. And since Soviet communism was predicated upon the idea that every aspect of life should be an expression of the socialist project, Soviet artists used appropriation to highlight the pervasiveness, and hollowness, of socialist visual culture. While the art market eventually absorbed the critiques of the Americans, the subtly critical Soviet appropriation strategies of conceptual artists such as Vitaly Komar and Aleksandr Melamid, discussed in the previous chapter, and of Erik Bulatov perhaps added to the chorus demanding domestic reforms by the middle of the 1980s.

President Reagan himself turned to appropriation in an attempt to dial down his belligerent rhetoric at the start of 1984. In an important speech, he invented two fictional couples—Jim

and Sally from the United States, and Ivan and Anya from the Soviet Union—and suggested that if they all found themselves together in a waiting room or bus shelter, without a language barrier, they would become friends. Like the artists of the Pictures Generation, Reagan's speech relied upon stereotypes perpetuated by the media; each person who heard the speech would have conjured their own version of a "typical" American or Soviet family. And while the president was not interested in dismantling these national stereotypes or discussing their limitations, his media-savvy appropriation nevertheless finds some affinities with artists of the period.

Before he turned to making art through the photographing of existing images, Richard Prince worked for Time-Life—the American print-media conglomerate—where he learned the ways that images create consumer desire. In his most famous series of works, begun in 1980, Prince photographed and enlarged images of cowboys and horses in vast, desolate landscapes from advertisements for Marlboro cigarettes—crucially omitting any text referencing the brand name in the final product (see detail in FIG. 6.13). American and many other viewers familiar with this international advertising campaign thought immediately about Marlboro. Calling attention to how viewers assign meaning to images, Prince's work exposed the power of capitalist advertising—the ways that, despite consumers claiming otherwise, repeated exposure to commercial material can rewire one's consciousness, not unlike communist propaganda. Drawing on the mythology of the American cowboy, Marlboro cigarettes are invariably associated with notions of rugged, masculine independence. Prince, then, explores the construction of masculinity and its use as a sales tool; this series might even be related to Jackson Pollock's rough-and-tumble persona or even President Reagan's own constructed image of a cowboy. Other American artists also deflated the maverick pretensions of Abstract Expressionism during this time by treating earlier works as found images, as mere signs. Louise Lawler's photographs are apt examples. In one characteristic work from 1984, she turns her camera on a Pollock hanging in a wealthy collector's home, taking pains to include the baroque soup tureen beneath it. In such a context a Pollock canvas no longer communicates radical individuality, but money and privilege.

Fig. 6.8
Vitaly Komar and
Aleksandr Melamid
Stalin and the Muses,
1981-82, oil on canvas,
68⅛ x 52 in. (173 x 132
cm). Museum Ludwig,
Cologne.

In the early 1980s, Komar and Melamid also produced paintings that commandeered the style of Socialist Realism. Just as they had appropriated and painted real communist slogans on banners as a means to demonstrate the absurdity of propaganda in the stagnation of the early 1970s (see FIG. 5.4), they turned to mimicking Soviet Socialist Realism once they emigrated from the Soviet Union, ending up in New York in 1978. One example from this *Nostalgic Socialist Realism* series, *Stalin and the Muses* (1981–82), features an image of Stalin familiar from paintings made during his lifetime: dressed in his white military jacket, he graciously receives visitors (FIG. 6.8). In fact, at first glance, this pastiche might even be mistaken for a genuine Socialist Realist canvas from the early 1950s. Based on the painting's title and the attributes each woman holds, Stalin is greeting several muses, the ancient goddesses charged with inspiring artists and writers. The muse of painting—not one of the nine classical muses, but here seen holding a palette—introduces Clio, the muse of history, to Stalin. In this canvas, Komar and Melamid unveil how Socialist Realism works; by exaggerating the style's legitimizing tropes—its mining of poses and motifs from icons of art history, for example—they show how examples of Socialist Realism constructed a believable, but partisan, view of the world. Stalin's acceptance of Clio's gift of a book reminds viewers how his regime had manipulated and rewritten history—often through the very medium of painting. As Chapter 1 discussed, artists would alter details, even leaving undesirable figures out of historical scenes. Even before they left the Soviet Union, Komar and Melamid called their work "Sots Art"—short for "Socialist Art" but with the linguistic directness of "Pop art." If Warhol had images of Marilyn and Elvis in the early 1960s to appropriate, Komar and Melamid, as well as some of their Soviet cohort, had Lenin and Stalin. And, according to the title of the series, there was something nostalgic about Socialist Realism by the early 1980s—it had become an emblem of a time when one could believe the myths of a state, or even believe in painting as a humanistic institution. No longer. Artists throughout the Eastern Bloc, as well as Cuba, also appropriated the signs and symbols of communism to express disillusion.

In Cuba, for instance, Flavio Garciandía transitioned from Photorealism to appropriation in the 1980s. In his series

Fig. 6.9
Flavio Garciandía
From the series
Tropicalia, 1987,
mixed media on canvas,
36 x 48 in. (91.4 x
121.9 cm). Private
Collection.

Tropicalia, he painted stylized versions of the hammer and sickle—that form so essential to communist propaganda—mingling in a cacophony of palm trees and sexualized stick figures (FIG. 6.9). Adding to the confusion, this imagery appears on the background of what looks to be a Jackson Pollock drip painting (see FIG. 1.1), augmented with glitter. The work not only gives viewers an alternative reading of Cold War iconography—reframing both Pollock's marks and the hammer and sickle—but also puts these marks in the context of a "tropical" iconography. The painting seems to argue that Cuba must discover its own local style, despite having its identity lodged between American and Soviet political and artistic traditions.

American and Soviet artists also both placed text on images as a way to "correct" them, in a sense, and reveal their participation in ideology. After working as a graphic designer for *Seventeen* magazine, the American artist Barbara Kruger applied her layout skills to making works of art. She appropriated black-and-white images from the late 1940s and 1950s—that is, the early Cold War period—and overlaid text (always in the same font, Futura Bold Italic), which caused viewers to question the assumptions of the given images. Many of her works deconstruct gender bias in profound ways, but others deal with more abstract notions of masculine power. In an untitled example from 1981, Kruger prints the text "Your manias become science" over a photograph of one of the American nuclear test blasts from 1946 on the

Fig. 6.10
Barbara Kruger
*Untitled (Your Manias
Become Science)*, 1981,
photograph, 37 x 50 in.
(94 x 127 cm).

Bikini Atoll (FIG. 6.10). Her intervention suggests that the logic behind the development of nuclear weapons, which had escalated again in the 1980s, is not based on rational "science," but instead on destructive (and masculine) "manias."

Beginning already in the early 1970s, Soviet artist Erik Bulatov created paintings that shared affinities with Kruger's works from the 1980s: both featured a layer of graphically distinctive text over a seemingly unrelated image. Among his first works in this vein was *Danger* (1972–73)—a bucolic scene in a hazy Photorealist style suggestive of photographic source material (FIG. 6.11). The Russian word for "danger"—in a font derived from warning signs around railroads—surrounds the image on all four sides, painted to create the illusion that the words are floating in the picture's three-dimensional perspectival space. The scene could be depicting any Soviet couple enjoying a picnic on a sunny afternoon next to a stream, so what is the danger? Are they facing some kind of threat? Or are they themselves

the threat—are they subversives or spies? Through his dual acts of appropriation—the photo-derived image and the standard text—Bulatov captures the unease of living in a society predicated upon surveillance and repression. Danger can literally come from anywhere at any time.

If artists like Gerhard Richter and Christo, who had experienced both sides of the Cold War (as discussed in Chapter 3), presented viewers with subtle ways to see beyond the artistic and political divisions of the conflict (see FIGS. 3.11 and 3.12), then Alexander Kosolapov, a Soviet artist who moved to New York in 1975, made such connections explicit. In 1982, Kosolapov painted *Symbols of the Century: Lenin and Coca-Cola*, a work that featured a stylized portrait of Lenin on the left and the Coca-Cola logo on the right, with the product's slogan, "It's the Real Thing" just below (FIG. 6.12). By placing the face of Soviet communism in the same space with the embodiment of capitalist imperialism (the popular phrase "Coca-colonization" refers to just that), Kosolapov suggests a relationship between the two. First off, the color red is both the international color of communist

Fig. 6.11
Erik Bulatov
Danger, 1972-73, oil
on canvas, 42¾ x 43⁵⁄₁₆
in. (108.6 x 110 cm).
Zimmerli Art Museum at
Rutgers University,
Norton and Nancy
Dodge Collection of
Nonconformist Art from
the Soviet Union.

propaganda and Coke's signage. Furthermore, Soviet ideologues exhorted that Lenin was the true "real thing"—a messianic figure whose ideas could save the world from the evils of capitalism. Despite the apparent differences between capitalism and communism, *Symbols of the Century* suggests that both systems rely on promises of authenticity—the "real"—in the dreams they sell, whether through the optimism linked to a sugary beverage via advertising or through a personification of a society that had done away with private property and claimed to have eradicated social inequality. Kosolapov's own experience informed this work: When he arrived in the United States, he immediately sought out the drink, believing it would taste like "paradise." Instead, he found a brown sickly-sweet liquid that was not to his taste. This anecdote is an allegory writ small: like his experience under communism, he also found capitalism to be based upon broken promises and disappointment. As such, the painting relates back to other international works dealing with the cultural influence of the popular American soft drink (see FIGS. 3.9 and 3.17 to 3.19).

In the early 1980s, Soviet society seemed especially stagnant and backward-looking—an impression crystallized by the nation's aging leaders. By 1980 Leonid Brezhnev, who had ruled since 1964, was too ill to lead effectively. He died in late 1982, and the next two leaders were also of advanced age—each dying after a little more than a year in power. Thus, three Soviet leaders died in office between 1982 and 1985, conveying an impression that the Soviet revolutionary project was now in a terminal phase—something further emphasized by Sots Art's critique during that period. The ascension of Mikhail Gorbachev to power in 1985, the first Soviet leader born after the 1917 revolution, signaled something very different. In a speech delivered soon before taking power, Gorbachev outlined two concepts that would be central to his regime. *Perestroika*, meaning restructuring, aimed to revamp the Soviet economy to make it more

competitive and efficient, with concessions even being made to the free market. *Glasnost* allowed for a greater "openness" in society, whether freedom of the press or the tolerance of unofficial and directly critical art practices.

Gorbachev could see beyond the Cold War's bipolar assumptions of superpower competition, perhaps unintentionally embracing the spirit of postmodernism and certain unofficial Soviet artists. And, crucially, his attitude persuaded Reagan, starting after their first meeting in Geneva toward the end of 1985, to abandon his cowboy persona and embrace a new role: a peacemaker working together with the Soviets to forge a safer world. Tensions—as manifested in the conflicts in Nicaragua and Afghanistan—did not disappear overnight, but the leaders came to a number of important agreements, such as the banishment of nuclear missiles from Europe as part of the INF treaty, signed in 1987. By the time Gorbachev visited the United States that year, he was more popular there than Reagan himself, according to an opinion poll. This was a remarkable—and, from the perspective of 1983, unthinkable—turn of events. Was this to be just another short-lived thaw, or was it the final act of the Cold War?

Total Environments: Installation Art and the Cold War

While conceptual and performance practices on both Cold War sides in the 1970s had expanded the parameters of art, the 1980s witnessed the acceptance of what came to be categorized as "Installation art" in the 1990s. Certain American, Soviet, and Chinese artists used large-scale environments to immerse viewers in an overwhelming field of information and detail. As with the appropriation practices discussed above, these installations turned upon artists critiquing their system—be it capitalism or communism. In place of viewers critically considering an image hanging on the wall, installations assume a physically active subject who must process and interpret a teeming, three-dimensional field of material. A number of these installations encouraged viewers to confront issues central to the Cold War.

The New York artist collective Group Material opened *Timeline: A Chronicle of U.S. Intervention in Central and Latin America* in 1984 (FIG. 6.13). Occupying a room in a former school turned art museum in New York, the exhibition presented a

divergent array of materials organized by a timeline wrapping around the room, which included press photographs and clippings, original works of art (some historical, some created for the exhibition itself), political banners, and even food. While not didactic in a direct way, *Timeline* engaged with contemporary events in Latin America through confronting 161 years of U.S. involvement in the region.

The 1979 socialist revolution in Nicaragua, as well as the insurrection in nearby El Salvador, contributed to the erosion of détente—especially since American officials (wrongly) suspected Soviet involvement in these uprisings as a sign of a renewed and coordinated communist offensive in Latin America. The ghosts of Vietnam thus loomed large in the region, especially as it was clear that the CIA was intervening in both Nicaragua and El Salvador, working to defeat the communists. In 1983 American troops even invaded the small island nation of Grenada, not far from the coast of Venezuela, because Reagan was convinced, though he lacked any evidence, that Grenada had become a Soviet–Cuban colony that was planning "to export terror and undermine democracy."

Fig. 6.13
Group Material
Timeline: A Chronicle of U.S. Intervention in Central and Latin America, 1984.
Installation at PS1, New York.

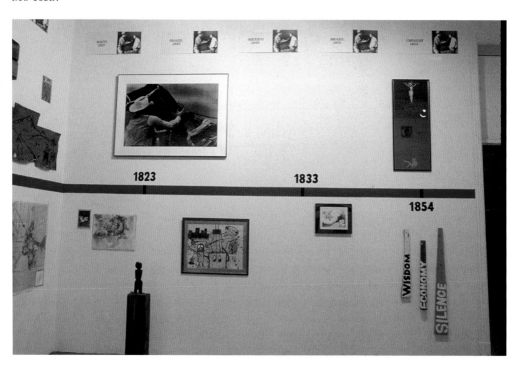

While protests in the early 1980s did not approach the level of unrest in the late 1960s, Reagan's aggressive policies, especially in Nicaragua, did spark an activist movement among artists. For instance, two members of Group Material, Julie Ault and Doug Ashford, also participated in the actions of another organization, "Artists' Call Against U.S. Intervention in Latin America."

How does *Timeline* function in this oppositional context? It adopted an overwhelming model of appropriation, implying loose connections between its vast array of materials and American involvement in Latin American affairs. The presence of bananas and coffee grounds—their aromas filling the space—might remind viewers of the ways that American commercial and political interests overlapped in the region. The 1954 coup in Guatemala, for example, was initiated by the CIA after the freely elected president attempted to nationalize lands owned by the American-controlled United Fruit Company.

Although the work's red timeline, with frets denoting important years, made its chronological way along the room's four walls at about eye level, the work also engaged postmodernist non-linearity by working against the very concept of a timeline. For one thing, there were no obvious correlations between the dates on the wall and the materials hanging in the vicinity. Instead, viewers were assigned the role of a detective or even a historian: trying to work out, for instance, why a Richard Prince cowboy photograph (visible in FIG. 6.13) was positioned near the start of the timeline, at the fret for 1823. Astute viewers might realize that this was the year that President Monroe proclaimed what came to be known as the Monroe Doctrine, which dictated that foreign powers stay away from colonizing Latin America. To put it in Cold War terms, Monroe was hoping to use a strategy of "containment" to keep foreign powers out of what was increasingly viewed as America's "backyard." Basically, the doctrine claimed Latin America as a sphere of influence of, and only of, the United States. Considering that cowboys and soldiers on horseback helped "domesticate" the so-called Wild West by violently expropriating Native American lands, Prince's work, in the context of *Timeline*, is deployed as a metaphor for American neocolonialist attitudes toward Latin America.

The work fosters these kinds of conceptual leaps; as Group Material themselves wrote, "We encourage greater audience participation through interpretation." If visitors could adopt the same

attitude toward the everyday world, perhaps, they could decode, demystify, and resist the workings of Cold War ideology as deployed in the many visual materials that constitute the mass media.

Considering that Group Material assembled and exhibited *Timeline* during a time of American attempts to neutralize the 1979 socialist coup in Nicaragua—among other covert Latin American activities—the work engages the Cold War in a direct way. But considering its chronological sweep, the timeline going back to the early nineteenth century, it also positions American activities in the 1950s and 1980s as part of a repeated pattern, and therefore independent of immediate Cold War concerns. Like other works explored in this chapter, *Timeline* responded to contemporary Cold War events, but also dismantled the assumptions that underpinned the conflict. The work did so through an overload of information arranged as an installation that formulated the difficulty of interpreting history: How can any single narrative, whether that of the Cold War, capitalist imperialism, or any other distinct cause, explain American interventions in Latin America since the early nineteenth century?

Ilya Kabakov, in the middle of the 1980s, also turned to installations to present characters that first emerged in his detailed and elaborate suites of drawings from the 1970s. Eventually meeting with great success when exhibited in the United States, these installations were created and initially exhibited in his small Moscow apartment. Among the first, *The Man Who Flew into Space from His Apartment* was completed in 1985 (FIG. 6.14). Through a partially boarded-up door, viewers looked into a small bedroom (about eight foot [2.4 meters] square), with Soviet propaganda posters surrounding a cot and other simple pieces of furniture. Immediately apparent, however, was the presence of a hole in the ceiling, and the homemade, slingshot-like contraption anchored in each of the four corners of the room. It seems, from the title and Kabakov's supplied text (in the form of pseudo-documentary accounts from neighbors), that the room's inhabitant has propelled himself into outer space, smattering the room with the ceiling's plaster detritus. The work thus provides its own powerful metaphor—meticulously created with a profusion of convincing details—of the ways that Soviet citizens dreamed of escaping their dreary mundane realities. This individual, in a sense, has tried to launch himself

into orbit as a way of living up to the utopian and liberating promises of the communist propaganda papering the room. These dreams, palpably real in the heady days of Sputnik and Yuri Gagarin, had evaporated by 1985. Other Kabakov installations from this period featured additional characters whose fanciful actions revealed the depths of Soviet boredom and despair in the early 1980s. For the artist, installation art also provided a way to approximate, for foreign viewers, the total absorption of Soviet citizens in ideology; as they experienced the room, visitors could not help but be overwhelmed by the ways that each poster, drawing, and other details contributed to the work's meaning. In other words, Kabakov employed Socialist Realism's immersive techniques to posit ways out of Soviet drudgery.

Fig. 6.14
Ilya Kabakov
The Man Who Flew into Space from His Apartment, 1985 (interior view), mixed media, 9 ft 2¼ in. x 7 ft 11¼ in. x 20 ft 1⅓ in. (280 x 242 x 613 cm). Musée National d'Art Moderne/Centre Georges Pompidou, Paris.

The Man Who Flew into Space from His Apartment was shown to great acclaim in New York in 1988, as part of Kabakov's ten-room installation *Ten Characters*. Its American success was certainly a sign of rapidly decreasing Cold War hostilities. His works, while indebted to his own experiences in Moscow, nevertheless could appeal to curious Americans who wanted to see a "Soviet" artist who was not making propaganda. Furthermore, the works could also demonstrate to American viewers the failures of Soviet communism. As a whole, the installations comprising *Ten Characters* functioned as an approximation of a dreary communal apartment, that mainstay of Soviet urban life. As a result, gallery goers in New York could walk away feeling smugly superior about their own material situation; Kabakov's work in some ways reinforced Cold War preconceptions. As Matthew Jesse Jackson argues, Kabakov soon began to produce works that seemed expressly designed for the Western market, stripped of the complex Soviet specificity of his previous output. It turns

out that having one's work exhibited in prestigious American institutions was not all that different from negotiating the terms set by the Union of Soviet Artists. Acceptance by both required compromise.

As the 1980s progressed, a number of Chinese artists also turned toward installation practices and other art forms outside of Socialist Realism and more indigenous styles. In 1986, Wu Shanzhuan produced *The Big Characters*, a room completely plastered—including floor and ceiling—with the hand-painted placards of texts described by the title (FIG. 6.15). Considering that Wu's messages appeared to mock the official culture of Mao's Cultural Revolution—a time when such text posters were ubiquitous—and adopted a form of installation art increasingly common in the West, this was certainly a departure for art in China. What had happened?

Major political events in the early part of the decade made such a shift possible. The country had moved on from the Cultural Revolution and the legacy of Mao, who had died in 1976. In 1981, the Gang of Four—the powerful political figures who had presided over the excesses of the late years of the Cultural Revolution—were belatedly convicted for their crimes; two were even sentenced to death (though these sentences were later reduced to life imprisonment). And, crucially, the Chinese Communist Party officially condemned Mao's mistakes, as well as his theory of "continuous revolution"—thus paving the way for significant economic and political reforms under Deng Xiaoping. Among Deng's most profound shifts was a pivot toward private enterprise, even encouraging citizens to "get rich." He also instituted an "open door" policy that allowed foreign corporations to invest in China. These changes began the nation's rapid transition to a mixed economy that was soon to become one of the primary engines of global capitalism.

This "open door" was not only political and economic, but artistic: Books and exhibitions covering modern and contemporary Western art suddenly became available. Considering these reforms—which constituted an abandonment of Marxist principles—China increasingly became "communist" in name alone. These policy shifts changed Chinese art profoundly: Not only was a monopoly on realism broken up, but artists discovered a myriad of ways to express themselves outside of traditional styles and practices. Despite this openness, however, there remained official fears of excessive Western bourgeois influence, and laws

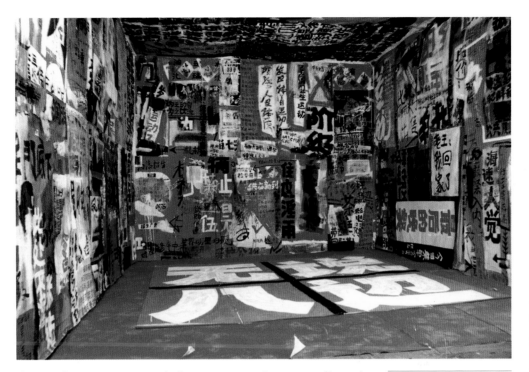

designed to counteract such forces were in play, especially in the early 1980s, and again in 1987.

With these increased freedoms, groups of underground artists began to flourish, even as early as the late 1970s. One such group, known as Stars, organized and set up—without obtaining the necessary government permissions—an exhibition of mostly paintings and sculptures in the park outside the China Art Gallery in Beijing in 1979. Because it was not officially sanctioned and some of the works were critical of the state, the police closed the exhibition and confiscated its contents (not unlike what happened at the "*Bulldozer Exhibition*" in Moscow in 1974, discussed in Chapter 5). Nevertheless, a second Stars show opened in 1980, this time with official support. By 1985, Robert Rauschenberg, the American artist known for works incorporating all manner of materials, was the subject of a one-person exhibition at the same gallery—a signal that artistic culture had changed.

To experience Wu's *The Big Characters*, viewers stepped into a profoundly chaotic space that exaggerated the strategies of the Cultural Revolution—namely the hanging of handmade posters and banners, with text colored in black,

Fig. 6.15
Wu Shanzhuan
Today No Water (also known as The Big Characters [Dazibao], Red Humour Series, and Red Character—Several Natural Paragraphs from the Second Chapter of the Novel—Today No Water), 1986, installation, poster color and ink on rice paper, c. 138 x 158 x 236 in. (350 x 400 x 600 cm). Artist's studio, Institute for Mass Culture, Zhoushan.

red, and white. During that chaotic time, such "red oceans" broadcasted an overwhelming number of strict ideological pronouncements in urban areas. But Wu's propaganda messages were no longer solely political slogans about Mao or the revolution; they had been transformed into something else entirely. He used the contemporary world of information as his quarry: Some were political messages, but he also included commercial announcements that had recently become a greater part of the urban and media landscape, commonly used phrases, newspaper titles, and even lines from Buddhist texts. Some translated examples are: "do you want to know how tall your child will be," "box for complaints," "selling stone poles," "pissing forbidden," and even the title of the classic American movie "Gone with the Wind." In discussing the work, Wu referenced the Chinese text character *chi*, which can mean both "red" and "empty." How could red, with all of its communist associations in China, also connote a lack of meaning? Wu's installation provides one answer. Within the overwhelming experience of the room, meaning disappears in a vertiginous cacophony of visual material. By appropriating forms from China's communist and newly capitalist worlds, Wu's room captures a nation in the midst of transformation. In other works of the period, Wu constructed similar environments filled with layered posters of text, but the messages in these rooms comprised dummy, nonsensical Chinese characters—again contrasting the Cultural Revolution's profusion of exhortations with an evacuation of meaning. Other important figures of the period, including Xu Bing, also created artworks centered upon fake Chinese words. Artists at this time were thus marking a profound distrust of official language, one of the primary legacies of the Cultural Revolution.

Some artists even took on the sacrosanct image of Mao himself. Wang Guangyi, for instance, painted a triptych in 1988 by copying the same Mao portrait three times. In addition to slightly altering the cloud cover and facial contours in each example, the artist superimposed a regularized grid over the three portraits—a common way for artists to produce quick and accurate copies. The repeated imagery and the grid were used to expose the means of propagandistic replications, demythologizing Mao's cult of personality. In a work from the early 1990s,

Wang culled images of revolutionary workers from Cultural Revolution–era posters and placed them alongside the Coca-Cola logo—producing a work similar to Kosolapov's (see FIG. 6.12), which compared strategies of communist propaganda with those underpinning capitalist advertising.

Wang's Mao triptych was included in the important, officially sanctioned 1989 exhibition *China/Avant-Garde*, which featured the work of 186 Chinese contemporary artists associated with the so-called New Wave. There existed a palpable optimism about the new freedoms granted artists under Deng's hybrid "market communism;" many works used Western strategies to criticize Chinese leadership, especially Mao—something that would have been unthinkable only a few years before. But the contradictions of such artistic freedom in an autocratic, one-party state could not be sustained. Just a few weeks after the exhibition's opening, thousands of students and other protesters began to gather in Tiananmen Square demanding democratic reforms. In early June, Deng ordered the square to be force-fully cleared out by the military, resulting in an untold number of deaths. Art students played a crucial role, constructing the international emblem of the uprising, a sculpture called the *Goddess of Democracy*, which they placed under the gaze of Mao's monumental portrait. Made out of plaster and Styrofoam and clearly referencing the Statue of Liberty, it was destroyed by the Chinese military. Surviving photographs nevertheless serve as a reminder of the limits of political expression in China, despite the newfound artistic freedoms. After Tiananmen, optimism quickly evaporated, with artists in the first half of the 1990s either mocking the communist project (like Wang's blending of communist and capitalist iconographies) or producing darkly sarcastic and bitter paintings. While Tiananmen seemed to spell the end of activist art in China for a number of years, artists played a crucial role in other political uprisings in the 1980s.

Art as Activism in the 1980s

With the return of explicit Cold War hostilities between the United States and the Soviet Union in the early 1980s, political unrest, civil wars, and coups in foreign countries assumed an even greater importance than during the previous decade. News

about the Soviet war in Afghanistan and the socialist revolution in Nicaragua, for instance, dominated the international media. In a number of the era's hotspots—especially Nicaragua, South Korea, and Poland—art played a formative role in defining and mobilizing efforts for political change.

Ruled by the Somoza dynasty since the 1930s, Nicaragua was staunchly anti-communist and thus a key U.S. ally in the Cold War. Inspired by the Cuban revolution, the socialist Sandinista National Liberation Front was founded in the early 1960s. It agitated against the excesses and abuses of the state, especially the torture, kidnapping, and intimidation practiced by the autocratic leader Anastasio Somoza DeBayle in the 1970s. In 1979, the Sandinistas overthrew DeBayle and established a socialist government, predicated on agrarian reforms, the nationalization of industries, and efforts to increase literacy. The new regime, of course, raised the ire of the United States, and Reagan initiated covert activities to support the anti-socialist Contras.

This civil war made Nicaragua a lightning rod for international debates during the Cold War, as reflected in Group Material's *Timeline* (see FIG. 6.13). American hawks, though not wanting a repeat of the failures in Vietnam, feared communism exerting a potential domino effect in Latin America, as nearby El Salvador had its own problems with socialist agitators. When American legislators outlawed direct or covert support to the Contras in 1982 (aligned with public opinion, this was also an attempt to punish Reagan for undertaking various interventions without seeking congressional approval), the CIA adopted a more creative approach: the secret sale of arms to Iran, which was also illegal, and the channeling of profits to the Contras. (Revelations about these dealings resulted in a significant political scandal in 1987, known as the "Iran-Contra Affair.") Apparently, the goals of fighting a communist enemy were more important than the perils of arming a non-communist foe who had taken American hostages just a few years before. Ultimately, the American-supported counter-revolution in Nicaragua took its toll: more than 40,000 deaths, and billions of dollars in damage to state property. Such detrimental effects certainly played a role in the electoral loss of the Sandinistas in 1990.

As one Nicaraguan revolutionary suggested, when DeBayle was ousted in 1979 he left a legacy not only of violence and

torture, but also bad taste in art and literature. The Sandinistas attempted to rectify these aesthetic shortcomings with an ambitious cultural program. Nicaragua became, in the words of the art historian David Craven, "the world capital of mural painting" in the 1980s, and fostered the rise of *pintura primitivista* (primitive painting), in which untrained, working-class artists produced vibrant canvases that suggested a move away from international trends of contemporary art or staid examples of Socialist Realism. Redolent of socialist values, many examples depicted figures formally integrated into fields of cotton or other crops, implying a non-alienated unity between labor and the landscape. But most surprisingly, a number of Sandinista-era artists turned to the forms of Abstract Expressionism, as is clear from a canvas by Juan Rivas called *Untitled (After Pollock)* of 1985, in which the artist paints a thin layer of dripped lines reminiscent of Pollock over a Nicaraguan landscape. The works of Abstract Expressionism, as interpreted by local critics, retained a critical sense of rebellion against the standardization associated with American capitalism. Pollock did not signify American imperialism in Nicaragua; rather, his example could be used to celebrate socialist individualism. By layering the aesthetic signs of non-alienation over a landscape, Rivas symbolically reclaimed the depicted terrain from the Somoza dynasty.

Another site of Cold War tension in the 1980s also harked back to the 1950s: Korea. When the Korean War ended with the signing of an armistice in 1953, Korea remained divided into a North, aligned with the Soviets, and a South, on the American side—separated by a demilitarized zone. Like so many American client states during the Cold War, South Korea was not a democracy and quickly transformed itself into an autocratic state fiercely opposed to communism or indeed any opposition. A 1961 coup brought General Park Chung-hee to power for nearly 20 years, during which time South Korea experienced massive economic growth. Park ran an increasingly militant government, which responded to political dissent with censorship, torture, and even murder. During the second decade of Park's rule, a minimalist style of abstract painting known as *tansaekhwa* held sway in South Korea. These works employed a sparse, monochromatic palette that emphasized the process through which paint was applied to canvas. The artists associated with the style,

including Lee Ufan and Park Seo-bo, engaged a Western language of abstract painting and ideas emanating from traditions of Korean art and culture. The resulting canvases were thus local–international hybrids, like others discussed in this book. While some of these paintings formally explored issues of legibility and censorship—contentious issues under General Park's leadership—the pensive, esoteric canvases largely came to be viewed as being out of touch with the country's violent political realities. They were even linked to the repressive South Korean political establishment, due to their promotion and success abroad.

After Park's assassination in 1979, General Chun Doo-hwan led another coup, and after securing power he declared martial law, prohibiting political opposition and heavily limiting the freedom of the press. These acts were condoned by the United States. Student-led protests erupted, which the government violently suppressed, especially in Gwangju in 1980, when hundreds of citizens were killed and thousands detained based on their political views. This, in turn, only spurred a more organized oppositional culture—and one that attempted broad cultural reforms—known as *Minjung*. Translated as "the masses," *Minjung* pitted itself against the elites in South Korea and aimed to forge a new, truly democratic culture that would reform South Korea's government and its cultural institutions. A key part of this strategy was a rejection of the United States and other Western influences—how could they have Korean interests at heart if they allowed such oppression? Art played a very important role in *Minjung*, as adherents imagined works that eschewed rarefied galleries and museums, picturing instead accessible art objects that merged with everyday life. Considering *Minjung*'s rejection of elitism and embrace of peasant culture, it confronted the vehemently anti-communist South Korean government with a Marxist fervor.

Minjung paintings positioned themselves in opposition to *tansaekhwa*, producing narrative canvases inspired by local folk or Buddhist traditions. In an example from 1982, Kim Bong-jun placed decadent bourgeois individuals—cabaret dancers and consumers, for example—in a depiction of Buddhist hell, with common peasants residing in heaven. Some painters incorporated brand logos, like Coca-Cola, and other American symbols into dystopian scenes. Other artists turned to more conceptual strategies, whether this meant posting fake political posters,

or collecting and displaying commercial portrait photographs of U.S. soldiers stationed in South Korea. But one artist, Choi Byung-so, who had established his reputation as a painter of monumental protest banners, applied his talents to the design of blueprints for massive public funeral processions, such as the one for Lee Han-yeol, a protesting student killed by police in 1987. The focal point of this ceremony was Choi's large portrait of Lee—painted overnight and then mounted on a truck and slowly wheeled along the funeral route, where it was visible to more than a million people (FIG. 6.16). With its Photorealist depiction, not unlike a mugshot, surrounded by fanciful and stylized clouds, the painting's form thus recalls state surveillance but also suggests that in death Lee can transcend and help defeat such oppression. Note how Choi gives the victim's face a look of sheer determination. These protests, and the role of *Minjung* in them, was significant, as they forced Chun to agree to direct elections, which resulted in his historic loss in 1987. Despite this, the Cold War continues on the Korean peninsula, with North Korea the last significant Stalinist nation on earth still provoking the United States.

Change was also afoot during these years in Poland. At the start of the 1980s, the country was beginning to exude some confidence in a future freed from Soviet control. For one, the new pope—John Paul II—was Polish. He inspired millions during a visit to his homeland in 1979, proclaiming that Jesus would help "renew the face of this land"—a comment widely

Fig. 6.16
Choi Byung-so
The Funeral of Lee Han-yeol, 1987, documentary photograph.

interpreted as anti-Soviet. (The attempt on the pope's life in 1981 was likely a communist plot originating in Moscow.) In 1980 things began to change when a massive strike broke out in the Gdansk shipyard and quickly spread to factories and other dockyards around Poland. Realizing strength in numbers, the workers formed a group called "Solidarity." Solidarity quickly added political demands—such as an end to censorship and the institution of democratic elections—to their list of labor grievances, which struck fear in the Kremlin. Led by a charismatic unemployed electrician, Lech Walesa, Solidarity became the most significant threat to communism in Eastern Europe since the Prague Spring in 1968, and its membership soon ballooned to ten million. Pressured by the Soviet leadership to assert control over the rapidly unfolding events, the Polish government declared martial law in December 1981—arresting thousands, banning Solidarity, prohibiting group assembly, and even cutting domestic telephone lines. The remains of the group went underground, largely centered around the Catholic Church.

Artists were active during this period and indeed throughout the decade. For instance, Joseph Beuys (see FIG. 4.5) took notice of the situation and, without advance notice, appeared at an art museum in the city of Łódź in 1981, where he donated some 700 objects and documents in what he called *Polentransport '81*. In the Solidarity movement, the artist recognized a viable Third Way outside of Cold War bipolarity: a form of government rooted in human desires not that different from what Beuys himself championed. Variants of Neo-Expressionism also found popularity in Poland during these years—thus linking notions of painterly freedom with political liberation—as did the complicated allegorical performance practices of Jerzy Bereś, an artist active from the 1960s, whose work acquired heightened political urgency under martial law.

A collective of artists known as the Orange Alternative were more direct in their politics, staging more than 60 actions in the mid- to late 1980s. Led by Waldemar Major Fydrych and indebted to Fluxus (see Chapter 4), they began their brand of "socialist surrealism" in 1982 by targeting public censorship, specifically sites where anti-communist political graffiti had been recently painted over. To highlight the absurdity of such censorship, the Orange Alternative spray-painted an image of a fantastical dwarf on the site of the eradicated text (FIG. 6.17). In

Fig. 6.17
Waldemar Major Fydrych
(and Orange Alternative
friends)
*Dwarf, Warsaw Old Town,
1982*, photographed by
Thomas Sikorski, 1983.

other words, when citizens saw a dwarf, they knew that oppositional political expression had been silenced. By the middle of the decade their activities found broad appeal by pinpointing some of the basic failures of socialism: namely, its inability to provide citizens with essential goods. The Orange Alternative would mark major communist holidays, for example, by publicly distributing products like toilet paper and tampons, to highlight the negligence of the ruling government. Getting arrested for such generous acts only solidified the ruling party's image of ineptitude and stoked the public's outrage. Polish police even detained 77 individuals dressed as Santa Claus during a protest march; the Orange Alternative was brilliant at crystallizing the increasing absurdity of the regime into memorable images. Aided by Gorbachev's Soviet reforms and his reluctance to interfere in Eastern Europe, the Polish Communist Party finally agreed to talks with Solidarity in 1989, the first time in eight years. By the middle of that year, the country held free elections, with Solidarity gaining 99 out of the 100 seats in the senate. In Poland, the communist grip on power had relented. No one realized how quickly the rest of Europe would follow suit.

The End of the Cold War

Two events in 1988—one artistic, one political—signaled that the Cold War was coming to an end. In July, Sotheby's held its first auction of Soviet contemporary art in Moscow. Drawing

wealthy collectors from around the world seeking the next prof-
itable frontier of contemporary art, the auction was an explicit
example of capitalist speculation staged in the heart of global
communism. Featuring works by Ilya Kabakov and many others,
it spelled the end of critical "unofficial art" practices in the Soviet
Union, as these forms quickly gained acceptance in the Western
art world. In a sense, the market made these works "official" as a
form of international contemporary art, stripping them of any
oppositional thrust. Before this, the works had existed in a con-
text without real market structures, one where the Communist
Party was the only patron. And they were not buying.

In an address to the United Nations in December 1988,
Mikhail Gorbachev made a stunning pronouncement: Soviet
troops would withdraw from Eastern Europe, and the Eastern
Bloc's nations could now choose their political destiny without
Soviet interference. Referring to the most famous rendition of
the song "My Way," the policy became known as the "Sinatra
Doctrine." Hungary quickly took steps to exit the Soviet Bloc,
with Czechoslovakia's bloodless "Velvet Revolution" ousting the
communist regime by the end of 1989. Romania and Bulgaria
came not long after. But the most dramatic moment of the
end of the Cold War—at least as far as the media coverage it
attracted—came in East Germany in early November.

A few weeks before, in mid-October, the longtime East
German leader Erich Honecker had been forced out of office
after local officials in Leipzig had refused to follow his orders
to fire on peaceful protesters. His reformist replacement, Egon
Krenz, was greeted with massive peaceful gatherings demanding
change. In response, he announced on November 9 that exit visas
would become available, beginning the next day, to allow visits
to West Berlin, no questions asked. He was not likely expecting
thousands of East Germans to gather at the eight border-cross-
ing checkpoints in East Berlin that night, demanding to enter
West Berlin immediately. Overwhelmed by the sheer numbers
and not receiving clear orders, the guards simply opened the
gates. After a few brave souls crossed the threshold, thousands
followed. And just like that, the Berlin Wall—the symbol of
a divided Cold War Europe since its construction in 1961—
was rendered obsolete, and Germans from both sides imme-
diately began to literally dismantle it with hammers, chisels,

and whatever else they could find. The German Democratic Republic was officially abolished less than a month later, with plans for German reunification put into the works for 1990. If the end of communist regimes in Europe did not signal the end of the Cold War, then Gorbachev's statement at a Malta summit to American president, George H. W. Bush in December 1989 certainly did: "We don't consider you an enemy anymore." Considering that just a year earlier Europe had still been divided, the decades-long Cold War imploded at a dizzying, disorienting speed. The Soviet Union itself would be dissolved in 1991.

West German artist Marcel Odenbach's video installation *Nobody Is Where They Intended To Go* (1989–90) visualizes the explicit and underlying anxiety concerning the end of the Cold War. Through a carefully constructed montage sequence, he combined archival footage of the political parades of the Third Reich and East Germany with news coverage of the dramatic, candle-lit protest procession just days before the Wall fell. In Odenbach's work, a glass of milk that had potentially been poisoned—appropriated from a famous scene in Alfred Hitchcock's 1941 film *Suspicion*—was transformed into a key prop in an allegory for the events of 1989. Would the collectivity and nascent nationalism associated with unification nourish the German people? Or would they reawaken the poisonous ghosts of the past? By perilously installing the video's heavy monitor atop a platform of glasses—like the one featured in the film—the artist only adds to the perception of a fragile situation. In another portion of the work, Odenbach splits the television screen with a narrow band, and, cleverly, this strip becomes a cross-section of the Berlin Wall itself. In footage captured some time after the border opened in November, viewers witness the casual crossings of pedestrians, bikes, and cars across the band, from East into West Berlin and vice versa. In the narrow strip itself, Odenbach gives viewers another film track (however narrow), first showing the celebrations on November 9, then presenting figures systematically hammering away at the Wall long after the party had ended. Physically and psychologically dismantling Cold War barriers, Odenbach seems to say, will be difficult work. The aftermath of the conflict had begun.

Conclusion

Art and the Legacy of the Cold War

By January 1, 1990, the Cold War was over. Although the Soviet Union was not officially dissolved until the end of 1991, the sudden fall of the Berlin Wall and the collapse of communist governments throughout Eastern Europe in 1989 marked the effective end of the conflict.

The end of the Cold War was traumatic, or at least shocking, especially to those living in the Soviet Bloc. In a matter of a few months, one half of the binary that had defined international politics and culture since the end of World War II suddenly disappeared. Party ideologues, teachers, and everyday citizens surrounded by propaganda posters at work suddenly found themselves in a new world. Furthermore, capitalism lost its competitive foil on the global stage. As such, 1989 immediately acquired watershed status, standing alongside other highly symbolic years like 1789, 1917, and 1945. There was no doubt that the end of the Cold War would usher in a new world, but would this simply entail the unfettered dominance of unbridled capitalism, or would lessons from socialism help to temper the free market's excesses? In 1995, Christo and Jeanne-Claude, discussed in Chapter 3, realized their audacious proposal (first outlined in 1972) to wrap Berlin's Reichstag in white fabric. By transforming this iconic building, which had stood along the Berlin Wall and hosted the German reunification ceremony in October 1990, into a sort of cocoon for two weeks, the artists gave visual form to this post–Cold War dilemma. What kind of Germany—and indeed world—would emerge from this protective shell?

Josephine Meckseper
Untitled (Hammer and Sickle No. 2), 2005 (detail).
See fig 7.5

Like Christo and Jeanne-Claude, key thinkers of the period wrestled with the implications of the Cold War's end. Some celebrated the American and Western European "victory" over communism—most famously articulated by Francis Fukuyama in his 1989 essay "The End of History," in which he argued that the defeat of Soviet communism marked the "universalization of Western liberal democracy as the final form of human government." In other words, democratic capitalism had vanquished its last foe, and the world would now experience a permanent condition of open markets that would inevitably raise living standards for all. In addition to embracing the present without criticism, Fukuyama's words also encouraged readers to turn a blind eye to the Cold War past; it was a period best forgotten now that the United States and its allies had prevailed. Other not-so-optimistic commentators embraced the period after the Cold War as a moment to reflect on the conflict's past, and how its legacies and lessons might help to enlighten the future. Such an attitude led to the explorations of long-repressed commonalities between sworn enemies, as well as a coming to terms with the incredible human toll taken by the Cold War's deep commitments to ideology. In short, some wanted to forget the Cold War in its immediate aftermath, while others persevered in remembering.

Artists also felt the gravity of 1989, and various works align with the two positions articulated above: Some seemed to register capitalism's triumph, while others probed the Cold War's past as a means to address a contested present. Jeff Koons's work from the early to mid-1990s, for instance, can be seen as a celebration of a capitalism newly liberated from the pressures of Cold War competition. A number of large-scale

sculptures (each over ten feet [3 meters] tall) begun in 1994 as part of the aptly named *Celebration* series are a fitting example. They each depict the most trivial of objects: a balloon dog, like those made by clowns at children's birthday parties (FIG. 7.1). Fashioned in colored stainless steel and shined to a mirrorlike finish, these are, at least retrospectively, akin to absurd Cold War victory trophies. They transform what communist art critics long admonished about American art, from Pollock's drips to Warhol's soup cans—its frivolity and lack of seriousness—into works explicitly monumentalizing just such characteristics. While Koons, like Warhol in the early 1960s, may be reaffirming capitalist values to such an exaggerated extent that his *Balloon Dog* can assume some critical function, many thinkers nevertheless view this work and others from this post–Cold War period to be giddy, meaningless baubles meant for the personal collections of the global titans of capital. Its shiny surface only exacerbates the work's appeal to narcissism, as whatever surrounds it—the art and other luxury goods possessed by the owner—becomes part of the work through reflection.

The works of the German photographer Andreas Gursky from the 1990s can also be viewed as exercises in post–Cold War triumphalism. Often described as a global flaneur, Gursky crisscrosses the world in search of images, and many of his resulting photographs—printed at large scale—depict the diverse yet interconnected networks of late capitalism: corporate finance, industrial production, distribution networks, and shopping locales. Specific images include, among many others, a modern hotel atrium in Shanghai catering to business travelers, a chaotic commodities-trading floor in Chicago, a skyscraper banking headquarters in Hong Kong, a high-tech factory in Germany, and an immaculate display of shoes in a Prada store. Their titles serve as the only markers of geographic place. Taken as a group, Gursky's pictures demonstrate the decentralized and all-pervasive nature of international capitalism by 1990—how, say, a T-shirt purchased at a mall in Montreal, Munich, or Melbourne could be financed through Hong Kong, designed in New York, produced in China with cotton from India, transported internationally by a German shipping company, and then put on consumer display in a way that eradicates any evidence of this history. As Alix Ohlin has noted, Gursky's photographic project

can visually suggest the "late capitalist sublime"—so that even the origin story of a simple T-shirt can prove too complex to grasp spatially or, indeed, conceptually. Gursky's photographs are large and aesthetically pleasing (often digitally altered with Photoshop), which makes them objects of desire for museum visitors and collectors alike. As such, when critics emphasize the beauty and formal qualities of a photograph like *Salerno I* from 1990, they demonstrate how the commodity form itself can provoke amnesia when it comes to questioning the nature of capitalism (FIG. 7.2). Gursky's trick is remarkable: The aesthetic power of his photographs eclipses the economic consequences of his subject matter.

Salerno I depicts the busy Italian port of its title from the ambiguous, hovering perspective of what the artist calls an "extra-terrestrial being." While shipping containers awaiting transport are piled up in a swath on the dock, viewers are undoubtedly drawn to the pointillist grid made up of hundreds of tightly packed cars—mostly white, red, or blue. The cars have just been

unloaded from a boat (perhaps from Asia), awaiting their carriage inland in Italy and beyond. While the mountains in the background might identify the port as Salerno, the unremarkable environs that occupy the majority of the space reveal nothing specifically Italian about the cargo. The city has become just another global port, another weigh station in the vast network of global capitalism—despite its rich history as an ancient harbor. Global commerce has thus erased anything specific to Salerno, as it does so often in major international metropolises, with the same highly visible collection of chain stores and fast-food restaurants in each. Throughout the 1990s, Capitalism would increasingly homogenize cities worldwide, especially those formerly behind the Iron Curtain, with the same brands, goods, and basic infrastructure. Along these lines, McDonald's opened its first outlet in the disintegrating Soviet Union in 1990, with Coca-Cola announcing its own long-term commitment there the following year. If Gursky's photographs of the 1990s are viewed as one giant cycle of history paintings—indeed, they each convey the massive scale of that genre—they proclaim, in a sense, Fukuyama's "end of history." The expansion of markets engendered by the end of the Cold War erases local narratives, and capitalism seems to be, at least by the late 1990s, the only game left in town. But all of this prompts a question: What is Gursky's role in all of this? By omitting the human toll associated with global capitalism, is he willingly participating in such amnesia? Or is he documenting and exposing the nature and consequences of capitalism's victory in the Cold War?

Many other artists took a different approach: explicitly interrogating materials in Cold War archives as a way to address the present circumstances. This was also a strategy for artists during the conflict. Beginning in the 1960s, but mostly in the 1970s and 1980s, the Czech artist Július Koller began amassing a massive collection of press clippings, old magazines, postcards, photographs, books, and other found materials—some cut out and pasted to paper, some annotated with drawings and hand-written text, and others simply archived as is. Now housed in dozens of boxes, this archive was a way for Koller, in his words, to "observe the rotten old corpse of politics to unveil its essentials." While not revealed until after the Cold War, Koller's archival impulse can serve as a model for many artists in the 1990s who sought

to understand the conflict and its legacies through archaeologically interrogating related materials. Archives of state security apparatuses in Eastern Europe were frequently of great interest to these artists. East Germany's Stasi presided over a vast surveillance network that spied on about a third of East Germany's 19 million citizens, and was perhaps the most notorious and hated organization of its kind. In January 1990, a furious mob of East Berliners took a modicum of revenge by storming the Stasi's headquarters there. Photographs of ransacked rooms—with emptied file cabinets and papers scattered everywhere—became some of the most iconic photographs of the end of the Cold War.

The (West) German artist Thomas Demand took his typical approach in his 1995 work *Office*: he reconstructed in cardboard and paper just such a room in the Stasi's headquarters, photographed the model, and then destroyed it (FIG. 7.3). The final image generally resembles its photographic source, but the blankness of the visible documents and its overall generic quality suggest something is uncannily awry. Demand's photograph speaks powerfully about the need and desire to remember the Stasi and its vast archive, but also the ways that memories quickly lose specificity—becoming something flimsy and unreliable, not unlike his paper reconstruction. Demand's work acquires added poignancy when one considers that the reunified German state continues its attempt to reconstitute the Stasi archive—employing a dedicated team of ten individuals (as of this writing) to piece together more than 15,000 sacks full of hand-torn documents. (After their shredder broke in the waning days of East Germany, agents turned to ripping documents manually.) This literal attempt to reassemble, painstakingly and by hand, this Cold War surveillance archive informs Demand's and other artists' symbolic acts of piecing together the fragments of the Cold War. In 1997, the British artists (and twin sisters) Jane and Louise Wilson chose the same subject matter when they produced a four-channel video called *Stasi City*. Their cameras probed and investigated the vast network of abandoned corridors and wrecked interrogation rooms in the Berlin headquarters. With a paranoid and haunting soundtrack recalling the buzz, clicks, and white noise of surveillance equipment, the installation suggests the ways that Cold War memories continued to haunt the 1990s, despite the desires of many to forget.

Fig. 7.3
Thomas Demand
Office, 1995, C-Print/
Diasec, 72¼ x 94½ in.
(183.5 x 240 cm).

Some artists also addressed their own roles, or those of family members, in the Cold War past. As Bulgaria's communist government was dissolving in late 1989 and early 1990, Nedko Solakov completed a work called *Top Secret*. The work resembles a two-drawer card catalogue from an old library, and in the drawers, the artist alphabetically organized a collection of 179 remembrances—drawings, photographs, and text—of a startling secret: his temporary collaboration with the Bulgarian secret police when he was a young art student in the early 1980s. This revelation was shocking when the work was exhibited in Sofia, the nation's capital, in April 1990, a moment when the wounds inflicted by more than 40 years of communist rule remained fresh. Key to Solakov's piece is its ambiguity; there is no "objective" proof of his role as a state informer in this personal archive. Rather, it thematizes the ways that individuals living under repressive communist regimes had their own histories from the Cold War: active resisters, enthusiastic supporters, or, like most citizens, somewhere in between. *Top Secret* remains powerful, as Bulgaria's secret-police archives remain classified to this day.

Themes related to an individual's experience with Cold War memories were perhaps most compellingly explored in a 1998 video by the Albanian artist Anri Sala entitled *Intervista*, which documents the unraveling of a Cold War mystery. The work began when Sala traveled from Paris back home to Albania for a visit with his mother. While at home, he discovered a 16-millimeter film that revealed silent footage of his mother meeting with Communist Party leaders and being interviewed during a party congress in the 1970s. His mother, however, had no recollection of the interview. Determined to piece together the story, Sala hired lip-readers to recover his mother's words, which he added as subtitles to the film-within-a-film. Her statements—filled with communist jargon—demonstrated that she was once a true believer in the Albanian socialist project, or at least publicly supported it. And Albania's regime—led by Enver Hoxha from 1946 to 1985—was particularly repressive, as it remained Stalinist long after Khrushchev's denunciation of the dictator in 1956, even breaking with Moscow as a result.

The crux of *Intervista* features footage of the artist's mother reacting to the ideological beliefs of this earlier, socialist version of herself. While watching and reading the subtitles, she shakes her head in disbelief, incredulous at what she is seeing. Should she be ashamed of her past enthusiasm for the repressive Albanian government? Did she really initially forget that she had vehemently supported the regime, or is such selective amnesia essential for functioning in a post–Cold War world? Are there aspects of the mother's former political commitments that viewers can admire in an age without commitments—her passion, expressed with rhetorical intensity, for social equality, for example? *Intervista* brilliantly charts the ways that Cold War pasts continued to shape the present during the 1990s. Formerly communist nations quickly transformed themselves into capitalism-friendly countries after 1989, partly as a way to bury the past, but decades of socialism had produced plenty of ghosts. The repressed returns with a vengeance in *Intervista*. Some cities in the former Eastern Bloc—like Budapest—made peace with some of these Cold War ghosts by transferring communist statues to dedicated sculpture parks on the outskirts of town.

More recently, as the Cold War drifts farther back in history's rear-view mirror, a different kind of remembering has emerged in

the Soviet Union and some of its former satellites: recalling Josef Stalin and communist repression fondly. Since Vladimir Putin assumed power in Russia in 1999, Stalin's image has gradually undergone a rehabilitation: According to a 2017 poll among Russians, he was named the "most outstanding person" in world history. Such nostalgia can help justify Putin's own brand of authoritarian rule, as well as signal frustration with the social inequities of capitalism and Russia's diminished global role since the height of the Cold War. This nostalgia goes beyond Russia; many people in former Eastern Bloc nations engage in what Germans call *Ostalgie*, the affectionate recall of a time of full employment and a guaranteed social safety net. Many of these citizens who lived through the end of the Cold War feel adrift among the uncertainties of global capitalism, and this dissatisfaction has fueled the growth of far-right political movements. If Koons and Gursky portray capitalism as smooth and polished— devoid of friction and violence—then perhaps something similar is now happening in the former Soviet Union with regard to its communist past. Older individuals perhaps miss the purpose, drive, and structure communism provided—forgetting the associated hardships, repression, and violence.

Artistic Dilemmas after the Cold War

With some major exceptions, such as Ilya Kabakov (see FIG. 6.14), artists and critics living in Eastern Europe and the former Soviet territories after the end of the Cold War suddenly found themselves facing an acute identity crisis. State-sponsored "official" artists lost their prestigious institutional positions and livelihoods, and "unofficial" artists lost having their nation's totalitarian regime as a repressive foil, which had made even slightly critical work feel urgent and important. A Hungarian art critic summed up the situation facing artists, critics, and curators from the former Eastern Bloc in 1995: "We don't really know why we do what we do, what the dominant characteristic of our art is, what the rest of the world expects of us, or what art's purpose is anyway." Artists found themselves in a double bind: To produce work in the old ways was to be irrelevant, just as any belated struggle to catch up with international trends in contemporary art would equally be ignored as passé. Based on this predicament,

the German painter Neo Rauch, who trained in Leipzig in East Germany under Bernard Heisig (see FIG. 6.4), is an interesting case study. His works, especially from the mid- to late 1990s, stage the conflicts facing artists who matured under socialism but were then suddenly forced to confront a new, utterly foreign world dominated by capitalism and market forces.

In the 1980s, like his teacher and many artists in West Germany, Rauch painted in a Neo-Expressionist style. This was a *blending* of figurative content with the painterly qualities of 1950s abstraction. But after the fall of the Wall, Rauch came to paint in a style that *separated* these components, featuring both flat areas of painterly color and clearly delineated figures. His painted narratives proved to be as confused as his style. With a motley collection of isolated figures ambiguously populating mid-century environments—channeling the early period of the Cold War—critics have likened his scenes to Surrealist dreamworlds where nothing makes sense. Do his pictures thus transform the ostensible certainty of Socialist Realism into something approaching the "meaninglessness" of Western abstraction? The art historian April Eisman has suggested an even more significant post–Cold War specificity to Rauch's works: they addressed the confused state of German painting in the 1990s. In the wake of national reunification, specters of socialism—and indeed Socialist Realism—remained.

In *Choice*, a canvas from 1998, Rauch depicted a painter's studio, with three nearly identical works resting on separate easels (FIG. 7.4). The studio space is fractured and provisional: a flattened staircase, off-kilter windows, and painterly drips work together to negate any clear illusionism or depth. Each painting features a simple black-and-white abstract design that also resembles a rudimentary face with eyes and mouth. (On the right edge of the

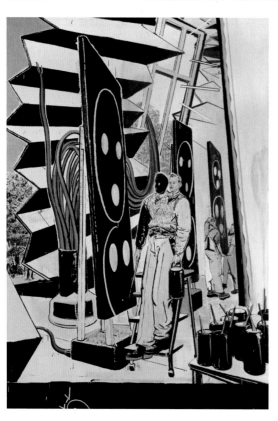

Fig. 7.4
Neo Rauch
Choice (Wahl), 1998,
oil on canvas, 118⅛ x
78¾ in. (300 × 200 cm).
Bayerische Staat-
gemäldesammlungen,
Pinakothek der Moderne,
Munich.

work, a fourth painting is viewed from the rear, and its visible black edge suggests that it, too, is the same as the others.) The "artist" appears near the middle of the composition on a stepladder, working on one of the canvases; however, he is really two figures, or at least a single figure with two heads—with one of the faces resembling the dotted design on the abstract paintings. Does this artist represent the uncomfortable effects of German reunification—two bodies uncannily grafted together, a forced whole divided against itself? Is this central figure a kind of self-portrait of the conflicted, post-socialist artist in the 1990s? Will the East German artist transform these abstract designs into more realistic portraits, or will the West German artist succeed in eradicating a specific history through the painting of banal abstractions? That this three-dotted form is also the German sign for blindness only emphasizes Rauch's point—that German artists have failed to recognize either the legacies of the Cold War or the persistence of social and political divisions within a reunited Germany. Commentators often interpreted Rauch's work from this period as being critical of his East German background; instead, his canvases should be seen as marking the impossible, conflicted position of an artist who matured in the socialist world, then found himself suddenly immersed in capitalism. Germany might be reunified, but as artists, Rauch and others remained divided. Thomas Schütte's series of sculptural figures from 1993 to 1994, entitled *United Enemies*, shares such concerns. In each example, the (West) German artist binds together two grotesque male forms through clothing and cord, again suggesting the uneasy alliance of *Ossis* and *Wessis*, East and West Germans, after the Cold War.

Although Rauch dwelled on stubborn divisions within Germany during the early years of reunification, his works were enthusiastically embraced by the contemporary art market. He emerged as a star, with his new paintings selling for tens of thousands of dollars by the end of the 1990s. Part of Rauch's allure was precisely, as early critics never failed to note, the relation of his work to the tradition of Socialist Realism. Here, an apparent contradiction arises. If the Cold War was best forgotten, then why would American collectors and other global elites desire these paintings? Perhaps, like the spoils of war, they signified America's victory in the Cold War—or at least expressed a

nostalgia for a time when the world could be reduced to simple us-versus-them formulations. Selling the pictures had an additional benefit: the integration of the signs and markers of socialism into the logic of capitalism. Highly saleable works by Chinese and Soviet artists that combined capitalist and communist iconography (see Chapter 6) are an explicit manifestation of this same dynamic. Considering the market for superficial signs of Cold War nostalgia in the 1990s—whether atomic-age design, images of Che, fragments of the Berlin Wall for sale at gift shops, Soviet propaganda posters decorating hip bars, or socialist trinkets picked up in stalls throughout the former Eastern Bloc—remembering the conflict, however trivially, became big business. This wholesale appropriation of socialist imagery in consumer contexts after the Cold War signaled the ways that capitalism could, by this point, readily transform its opposite into a desirable commodity. The German artist Josephine Meckseper's *Untitled (Hammer and Sickle No. 2)* from 2005 addresses the situation by transforming the emblem of Soviet communism into commodities to be fetishized (FIG. 7.5). She places immaculate examples of the tools atop a large mirrored cube, stripping them

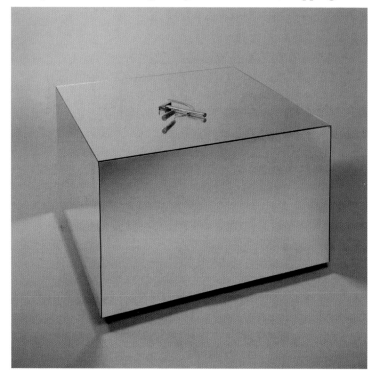

Fig. 7.5
Josephine Meckseper
Untitled (Hammer and Sickle No. 2), 2005, silver-painted tools and mirror on wood, 32½ x 48 x 48 in. (82.6 x 122 x 122 cm). Private Collection.

of any connotation of use and emphasizing the quaint, desirable romanticism of their simple wood and polished steel construction. However, the persistence of such imagery can nevertheless express, at least to those who remember or study the Cold War, the desire for some alternative to global capitalism—the kernel of a memory of some political alternative.

Fig. 7.6
Ai Weiwei
Dropping a Han Dynasty Urn, 1995, three gelatin silver prints, each 58¼ x 47⅔ in. (148 x 121 cm). Private Collection.

While Neo Rauch referenced Socialist Realism to demonstrate the persistence of psychological divisions in Germany, one of the world's most famous contemporary artists has more explicitly mimicked communism's artistic strategies, albeit to different ends: the Chinese artist Ai Weiwei. Ai lived in the United States between 1981 and 1993, where he became interested in Andy Warhol and other American artists, and then returned to China. Since then, he has utilized tactics associated with the Cultural Revolution—but without the human violence—to critique the last remaining global power with a communist government. One scholar has even identified him as "China's last Communist." Ai was especially attuned to the Cultural Revolution, as his own father, a renowned poet, was sent to a remote labor camp for "re-education" during this period. Ai's *Dropping a Han Dynasty Urn* from 1995 deals with this legacy. As discussed in Chapter 4, during the Cultural Revolution the Red Guards destroyed many ancient artifacts in order to eradicate any sense of a non-communist past. While Ai's destructive gesture was shocking to Western critics—captured in a photo triptych showing the urn first in the artist's hands, then in midair, and finally shattered in pieces on the ground—Chinese viewers might read it differently (FIG. 7.6). Although the Cultural Revolution's iconoclastic violence subsided after 1976, government power—even under

China's subsequent mixed economy—still relies upon destruction, whether of ideas, artifacts, individuals, or information. Ai has "destroyed" ancient pots in other ways as well. In 1993, he painted the Coca-Cola logo on one, and, more recently, he has dipped them in brightly colored industrial paint—thus transforming them into design objects by covering the outward evidence of their history. These iconoclastic actions highlight China's particular post–Cold War situation: Its capitalist economy and the communist government both desire an erasure of historical consciousness.

In more recent work, Ai has adopted the directness usually associated with political propaganda—not unlike that of Socialist Realism, or the posters of the Cultural Revolution (see FIG. 4.7)—but in ways that criticize China's communist leadership. For instance, *Names of the Student Earthquake Victims Found by the Citizens' Investigation* (2008–11) is hard to misinterpret. As the work's title implies, it is a chart containing more than 5,000 names of schoolchildren killed in the massive Sichuan earthquake in 2008. Ai's research into the human toll of this disaster has bristled against the official government silence on the matter, thus implicating Chinese officials and the shoddy building practices they sanctioned for schools in the massive loss of life. Because of this project and related efforts, Ai was beaten and detained by government officials—events that the artist documented for other internationally exhibited works. As with "unofficial" art practices in the Soviet Union and Eastern Europe during the Cold War, his work often needs the repressive foil of the Chinese state for its legibility. He has even referred to China's "totalitarian regime" as a "readymade" that he repeatedly appropriates for his art. But any post–Cold War consideration of Ai's art turns upon a central question: What kind of China does Ai actually desire? Is American-style democratic capitalism the answer? Some return to a more equitable and humane socialism? Or some kind of "third way"? It is not clear.

Socialism and Marxism did not perish after the end of the Cold War, despite the pronouncements of Fukuyama and others. Many artists remained hostile to capitalism and some even continued to expound socialist beliefs. However, by the dawn of the new millennium, it was becoming clear that no viable alternative to global capitalism was going to emerge, at least not in

the near future. Boris Groys's assessment of the art world after the Cold War reached a similar conclusion: contemporary art had become "synonymous with the notion of the art market." Any artistic practices that attempted to avoid the exhibition and financial structures of commercial galleries and corporate-funded museums continued to be largely ignored. So how do artists with deep political commitments work within this system?

The example of the Swiss artist Thomas Hirschhorn provides one answer. He succinctly articulated, in 1995, the dilemma of socialist artists after the Cold War. In an artist's book full of crude collages inspired by the look of handmade political signs, he appropriated a famous propaganda poster designed by Gustav Klutsis in 1932 (see FIG.1.9). Next to the image he added a sloppy handwritten caption: "Help me!! I find this poster beautiful, but I know what Stalin did. What to do?" While indulging in irony and perhaps acknowledging his own work in a communist graphic-design collective in Paris in the 1980s, the work nevertheless suggests that Socialist Realism could not provide a political alternative in the 1990s; its images had even been transformed by both nostalgia and a newfound commercial appeal. To resist, artists had to work within the system, especially considering Groys's words. For Hirshhorn, this meant mining materials from what he calls "the capitalist garbage bucket"—cardboard, magazine pages, tin foil, packing tape, and plastic wrap, among others—to make sprawling, makeshift, temporary installations. If Gursky depicted global capitalism as a well-oiled production and distribution network, Hirschhorn's clunky assemblages symbolically halt or impede such flows. By making these excessive and unwieldy works from materials that actually enabled the physical flow of goods across the world, he employs the very forms of capitalism against themselves.

Hirschhorn's chaotic arrangements and diverse subject matter also impede any sense of clear understanding—placing pop cultural figures in dialogue with more esoteric sources, for instance. Between 1999 and 2013, Hirschhorn erected four memorials to important, but far from popular, philosophers: Baruch Spinoza, Gilles Deleuze, Georges Bataille, and Antonio Gramsci. While each memorial was distinct, these pieces included elements such as reading rooms, cafes, and performance platforms, all constructed out of his usual throwaway materials. Crucially, the artist sited

Fig. 7.7
Thomas Hirschhorn
The Bridge, 2000,
installation at the
Whitechapel Gallery,
London.

these temporary structures in peripheral, working-class areas and designed them to engage members of their communities. Individuals from these neighborhoods also helped build and maintain these structures during the run of the exhibition. While assembling a dynamic memorial dedicated to the Italian Marxist Gramsci in a poor area of the Bronx might seem patronizing, Hirschhorn sees things differently: Why can't Gramsci be as popular as a movie star or some other pop idol? Millions of copies of books detailing various Marxist theories were sold in communist societies during the Cold War; along these lines, Hirschhorn views the struggling classes as precisely the audience for such radical ideas. By rescuing and highlighting erudite philosophers—whose ideas might form the basis for some future alternative to capitalism—in materials that connote capitalist waste, Hirschhorn opens a potential portal for an alternative politics within the system itself.

For one of his most compelling installations, *The Bridge* (2000), the artist smashed a hole in a second-floor wall of London's Whitechapel Gallery to build a bridge—again, out of his usual disposable materials—across a dark alleyway into the anarchist bookshop next door (FIG. 7.7). Walking across this perilous, yet surprisingly sturdy, structure in some ways literalized the artist's work, which has taken to using capitalist trash to forge connections between art and radical political thinking. The Whitechapel's own history—founded as a gallery in the late

nineteenth century to bring art to working-class East London—placed this attempt to fuse art and radical politics into a larger context. But there was also something elegiac and impossibly utopian about *The Bridge* and Hirschhorn's other monuments, as if the work's outmoded appearance predicted its own failure. Hirschhorn himself might agree. As he has stated, "You can't outsmart capital. Capital always wins."

Globalization and the End of the Cold War

In 1989, the Italian artist Alighiero Boetti, in collaboration with Afghan weavers, produced one of his trademark embroidered world maps, with each nation patterned with its flag design (FIG. 7.8). With text in both Italian and Farsi framing the map, the textile marks its European–Afghani hybridity; this is a globalized work of art in both form and content. Although Boetti had been making these works since 1971 (the Soviet–Afghan War, however, sometimes prevented him from collaborating onsite in Afghanistan), this particular example is especially poignant. Not only was the world map to change profoundly with the end of the Cold War and the imminent dissolution of the Soviet Union, but 1989 has come to represent another important shift in the art world: its internationalization. The confluence of these events is not likely a coincidence; the diminished importance of the Cold War allowed for artistic peripheries to receive long overdue consideration. In 1989, an important and controversial exhibition opened in Paris: *Magicians of the Earth*, which presented 50 artists from North America and Europe, alongside the same number of artists from areas outside those continents. And the 1990s welcomed a host of new contemporary art biennials around the world that soon challenged the primacy of Venice's own storied exhibition: Dakar, Senegal (1992); Sharjah, United Arab Emirates (1993); Gwangju, South Korea (1995), and Shanghai, China (1996), to name a few. In fact, many of the Latin American, Asian, and African artists examined in this book have only received international scholarly attention since 1989. The end of the Cold War, which coincided with the full effect of postmodernism's leveling of center/peripheries binaries, brought an unprecedented number of international artists to worldwide attention.

For Boetti, the Italian and Farsi text surrounding the textile's map suggested a utopian cultural alliance between Italy and Afghanistan, bridging the gap between the so-called first and third worlds. But the presence of these two languages could also suggest conflict, especially as the 1990s came to an end. If 1989 represented a watershed moment with the conclusion of the Cold War, events around that year also demonstrated the initial stirrings of what has become one of the central conflicts of the early twenty-first century: Western capitalist liberalism versus Islamic fundamentalism. Not only did 1988 witness the founding of Al-Qaeda in Afghanistan as a force fighting Soviet troops (with the Americans as allies of convenience at this point), but the following year, Iran's Supreme Leader Ayatollah Khomeini issued a *fatwa* calling for the death of British-Indian author Salman Rushdie for what were deemed blasphemous passages in his novel *The Satanic Verses*. While Rushdie survived, Al-Qaeda went on to organize attacks on two American embassies in Kenya and Tanzania in the late 1990s, an American warship in 2000, and on the World Trade Center and the Pentagon on September 11, 2001. Pondering the future of the post–Cold War world order in 1993, political scientist Samuel Huntington predicted that just such a "clash of civilizations" would replace the Cold War—with fault lines no longer organized around economic or ideological issues, but rather on notions of cultural and/or religious identity. It is important to note that Huntington's

Fig. 7.8
Alighiero Boetti
Map of the World, 1989,
embroidery on fabric,
46¼ x 87¾ x 2 in.
(117.5 x 227.7 x 5.1
cm). Museum of Modern
Art, New York.

theory is largely based on ideology and does not view economic disparity (generated by an unbridled capitalism) as a source of international strife. Regardless, the framework for this new ideological struggle emerged in the ashes of the Cold War.

With the connections between the Cold War's end and rampant globalization, it is no wonder that the conflict remains embedded in the practices of numerous contemporary artists, whether through the revisiting of the Cold War's utopian and illusory promises or the clumsy and often violent applications of its rigid ideologies. Dahn Võ is one of the most important artists working today, and his biography, which informs all his work, is deeply intertwined with the Cold War, especially its most contentious proxy war, the conflict in Vietnam. After Saigon and the rest of South Vietnam fell to communist North Vietnam in 1975—thus providing the Vietnam War with its dénouement—Võ's parents were relocated, along with 20,000 other anti-communists, to an island at the southern tip of the country. The artist was born and spent his early years not far from this remote island. When Võ was 4 years old, his family hatched an audacious immigration plan: to sail, in a boat with more than 100 others, thousands of miles to the United States. The Võ family's loyalty to American ideals—despite the excessive and racist violence of the war—is remarkable. After being rescued from certain death at sea by a Danish frigate, the family settled in Denmark. The course of Võ's life was literally shaped by the outcome of the Vietnam War, global tides, and shipping lanes. He attended art school in Copenhagen and was soon inspired by a chance encounter during a fellowship in Los Angeles, where he met and befriended an American who had served as a military consultant in Vietnam during the war. Võ's work thereafter increasingly became obsessed with probing what he calls "the infinite traces of history"—or, more specifically, the ghosts of the Cold War—that had informed his own life story.

In a group of works from 2013, Võ worked with historical artifacts that had once belonged to Defense Secretary—and architect of American military strategy in Vietnam—Robert McNamara. Acquired at auction with the help of his gallery, some of these objects were exhibited in an unaltered state in backlit wall niches, reminiscent of reliquaries; others Võ artistically transformed. For instance, he dismantled two chairs that

had been in President Kennedy's cabinet room before McNamara used them himself after the president's assassination in 1963. The chairs represented actual seats of power—specifically, a massive military power that was unleashed on a developing nation, beginning with the Kennedy administration. One can readily imagine McNamara sitting in one such chair while calculating and planning bombing raids that would decimate civilian populations later in the 1960s. Vō's interventions attempt to unearth some connection between these banal pieces of furniture and the murderous and indiscriminate violence carried out in the name of containing communism. One of the chairs, stripped of its leather upholstery, stood unadorned in the gallery, as if vultures had picked its flesh down to its staple-ridden wooden skeleton (FIG. 7.9). Both the leather covering and its burlap lining appeared as other works, each hanging formlessly on a wall, like removed flesh hung out to dry, while the chair's horsehair innards were piled separately on the floor. It was as if Vō was dissecting these chairs in a fruitless archaeological endeavor to uncover their hidden links to violence in his homeland. In the process of trying to understand these historical objects, he destroys them—perhaps enacting some kind of symbolic revenge.

Vō's *We the People*, completed between 2010 and 2014, is a fitting place to end this book. It is a full-size replica of the Statue of Liberty, produced in many individual sections, like Frédéric Auguste Bartholdi's original, which was forged in France and then shipped to New York where it was assembled and erected in 1886. Bartholdi's statue soon became one of the nation's most profound ideological symbols, especially during the Cold War's valorization of American liberty. Vō's version has a number of significant differences from the original. First, it is destined to never coalesce into a monument. Instead, the forces of the globalized art world—namely, collectors and exhibitions—continue to distribute and redistribute its more than 200 parts around the world. The work thus suggests both American imperialism—parts of an American icon occupying foreign lands—and how trade and globalization have literally dismantled this symbol of American liberty. Vō's reliance upon the logic of capitalism also produced the second key difference: *We the People* was fabricated by scores of workers in Shanghai. Put into the frame of the Cold War, Vō's

Fig. 7.9
Danh Vō
(Left) *Lot 20, Two
Kennedy Administration
Cabinet Room Chairs*,
2013, mahogany, metal,
40½ x 26 x 25¾ in.
(102.8 x 66 x 65.4 cm).
Private Collection.

(Right) *Lot 20, Two
Kennedy Administration
Cabinet Room Chairs*,
2013, burlap, 90 x 20
x 18 in. (228.6 x 50.8
x 45.7 cm). Private
Collection.

gesture is deeply ironic: having the sign of American liberty produced by a country that still, at least in name, is communist.

We the People enacts the contradictions of this post–Cold War world. National borders and identities might seem to be rendered meaningless by global flows of goods, people, and information, but national symbols and ideologies continue to matter—especially in an age of stricter borders and increased xenophobia. In this context, Vō's appropriation and dismantling of the Statue of Liberty asks important questions: What is liberty and who gets to define it? If capitalism is the same as liberty, then did the Cold War victory of this type of "liberty" also help to hasten the destruction of the environment and exaggerate global disparities of wealth? Revisiting the Cold War today not only reminds us that there once were alternatives to capitalism—and can be again—but also of the importance of seeing through and beyond ideology. And art remains one of the best ways to reimagine better futures and to expose powerful fictions.

Art and the Legacy of the Cold War

273

Bibliography

Alberro, Alexander. "The Dialectics of Everyday Life: Martha Rosler and the Strategy of the Decoy." In *Martha Rosler: Positions in the Life World*. Edited by Catherine de Zegher, 72-112. Cambridge, MA: MIT Press, 1998.

Alexander, Darsie. "Introduction: The Edge of Pop." In *International Pop*. Edited by Darsie Alexander and Bartholomew Ryan, 77-84. Minneapolis: Walker Art Center, 2015.

Alloway, Lawrence. *The Venice Biennale 1895-1968*. Greenwich, CT: New York Graphic Society, 1968.

Amaral, Aracy. "Abstract Constructivist Trends in Argentina, Brazil, Venezuela, and Colombia." In *Latin American Artists of the Twentieth Century*. Edited by Waldo Rasmussen, 86-99. New York: Museum of Modern Art, 1993.

Andrews, Julia F. *Painters and Politics in the People's Republic of China, 1949-1979*. Berkeley: University of California Press, 1994.

——. and Kuiyi Shen. *The Art of Modern China*. Berkeley: University of California Press, 2012.

Antliff, Alan. *Joseph Beuys*. London: Phaidon, 2014.

Ash, Jared. "Gustav Klutsis: The Revolutionary Arsenal of Arms and Art." In *Avant-Garde Art in Everyday Life: Early Twentieth-Century European Modernism*. Edited by Matthew S. Witkovsky, 45-66. Chicago: Art Institute of Chicago, 2011.

Ash, Timothy Garton. *The Uses of Adversity: Essays on the Fate of Central Europe*. New York: Random House, 1989.

Baigell, Renee and Matthew Baigell. *Soviet Dissident Artists: Interviews after Perestroika*. New Brunswick: Rutgers University Press, 1995.

Bailey, Julie Tatiana. "Haring Paints the Berlin Wall." *Espionart* (blog). August 16, 2013. Accessed July 15, 2017. https://espionart.wordpress.com/2013/08/16/haring-paints-the-berlin-wall/

——. "Raúl Martínez and the Ambiguous Art of Post-Revolutionary Cuba." *Espionart* (blog). January 20, 2017. Accessed May 15, 2017. https://espionart.wordpress.com/2017/01/20/raul-martinez-and-the-ambiguous-art-of-post-revolutionary-cuba/

——. "Ridiculing the Regime: The Orange Alternative in Poland." *Espionart* (blog). February 24, 2017. Accessed June 30, 2017. https://espionart.wordpress.com/2017/02/24/ridiculing-the-regime-the-orange-alternative-in-poland/

Baudin, Antoine. "'What is Soviet Painting Hiding from Us?': Zhdanov Art and Its International Relations and Fallout, 1947-53." In *Socialist Realism without Shores*. Edited by Thomas Lahusen and Evgeny Dobrenko, 881-913. Durham, NC: Duke University Press, 1995.

Baxandall, Michael. *Painting and Experience in Fifteenth-Century Italy: A Primer in the Social History of Pictorial Style*. Oxford: Oxford University Press, 1972.

Bedford, Christopher. "The Reason for the Neutron Bomb." (review). In *The Sculpture Journal*. 15:1 (June 2006): 126-127.

Beke, László. "Conceptualist Tendencies in Eastern European Art." In *Global Conceptualism: Points of Origin, 1950s-1980s*. Edited by Philomena Mariani, 41-51. New York: D.A.P., 1999.

Berger, John. *Ways of Seeing*. London: Penguin, 1972.

Bernatowicz, Piotr and Vojtěch Lahoda. "Picasso and Central Europe after 1945." In *Picasso: Peace and Freedom*. Edited by Lynda Morris and Christoph Grunenberg, 44-51. London: Tate Publishing, 2010.

Bird, Robert, ed. *Vision and Communism: Viktor Koretsky and Dissident Public Visual Culture*. New York: New Press, 2011.

Bishop, Claire. *Installation Art: A Critical History*. London: Tate Publishing, 2005.

——. *Artificial Hells: Participatory Art and the Politics of Spectatorship*. London: Verso, 2012.

Bois, Yve-Alain. "1915", "1942a," "1946," "1947b," "1955a," "1955b," and "1959e." In *Art since 1900: Modernism, Antimodernism, Postmodernism*, vol. 1. Edited by Hal Foster, et. al., 142-146, 348-352, 393-398, 404-410, 435-446, 494-501. 3rd ed. New York: Thames and Hudson, 2016

Borgen, Maibritt. "Fundamental Feedback: Öyvind Fahlström's *Kisses Sweeter Than Wine*." In *ARTMargins* 4:3 (October 2015): 17-39.

Bown, Matthew Cullerne. *Art under Stalin*. London: Phaidon, 1991.

——. *Socialist Realist Painting*. New Haven and London: Yale University Press, 1998.

Bowron, Astrid. "Gustav Metzger." In *Gustav Metzger*. Edited by Kerry Bougher and Astrid Bowron, 20-74. Oxford: Museum of Modern Art Oxford, 1998.

Boyer, Dominic. "Ostalgie and the Politics of the Future in Eastern Germany." In *Public Culture* 18:2 (2006): 361-81.

Bradley, Mark Philip. *Imagining Vietnam and America: The Making of Postcolonial Vietnam, 1919-1950*. Chapel Hill: University of North Carolina Press, 2000.

Braun, Emily. "Sex, Lies, and History." In *Modernism/Modernity*. 10:4 (November, 2003): 729-56.

Breslin, James E. *Mark Rothko: A Biography*. Chicago: University of Chicago Press, 1993.

Brett, Guy. "The Century of Kinesthesia." In *Force Fields: Phases of the Kinetic*. Edited by Suzanne Cotter and Cathy Douglas, 9-68. Barcelona: Museu d'Art Contemporani de Barcelona, 2000.

Brougher, Kerry. "Radiation Made Visible." In *Damage Control: Art and Destruction since 1950*. Edited by Deborah E. Horowitz, 12-103. Munich: Prestel, 2013.

Brugioni, Dino A. *Eyeball to Eyeball: The Inside Story of the Cuban Missile Crisis*. Edited by Robert F. McCort. New York: Random House, 1990.

Bryan-Wilson, Julia. *Art Workers: Radical Practice in the Vietnam War Era*. Berkeley: University of California Press, 2009.

Buchloh, Benjamin H. D. "Figures of Authority, Ciphers of Regression: Notes on the Return of Representation in European Painting." In *October* 16 (Spring 1981): 39-68.

——. "From Faktura to Factography." *October* 30 (Autumn, 1984): 82-119.

——. "The Primary Colors for the Second Time: A Paradigm Repetition of the Neo-Avant-Garde." *October* 37 (Summer, 1986): 41-52.

——. "Conceptual Art 1962-1969: From the Aesthetic of Administration to the Critique of Institutions." In *October* 55 (Winter 1990): 105-43.

——, *Neo-Avantgarde and Culture Industry: Essays on European and American Art from 1955 to 1975*. Cambridge, MA: MIT Press, 2000.

——. "Andy Warhol's One-Dimensional Art: 1956-1966" (1989). In *Andy Warhol*. Edited by Annette Michelson, 1-46. Cambridge, MA: MIT Press, 2001.

——. "Cold War Constructivism" (1986). In *Formalism and Historicity: Models and Methods in Twentieth-Century Art*, 375-408. Cambridge, MA: MIT Press, 2015.

Buck-Morss, Susan. *Dreamworld and Catastrophe: The Passing of Mass Utopia in East and West*. Cambridge, MA: MIT Press, 2000.

Bugajski, Jill. "Tadeusz Kantor's Publics." In *Divided Dreamworlds: The Cultural Cold War in East and West*. Edited by Peter Romijn, et. al., 53-74. Chicago: University of Chicago Press, 2012.

Carlirman, Claudia. "Pop and Politics in Brazilian Art." In *International Pop*. Edited by Darsie Alexander and Bartholomew Ryan, 119-30. Minneapolis: Walker Art Center, 2015.

Carter, Miranda. *Anthony Blunt: His Lives*. New York: Farrar, Straus, and Giroux, 2001.

Casey, Michael. *Che's Afterlife: The Legacy of an Image*. New York: Vintage Books, 2009.

Celant, Germano. "Arte Povera: Notes for a Guerrilla War." In *Flash Art 5* (November/December 1967): 3.

Chave, Anna. *Mark Rothko: Subjects in Abstraction*. New Haven and London: Yale University Press, 1989.

——. "Minimalism and the Rhetoric of Power." *Arts Magazine* 64: 5 (1990): 44-63.

Chernow, Burt. *Christo and Jeanne-Claude: A Biography*. New York: St. Martin's, 2002.

Churchill, Winston, "The Sinews of Peace" (1946). https://www.winstonchurchill.org/resources/speeches/1946-1963-elder-statesman/the-sinews-of-peace

——. *Painting as Pastime* (1948). New York: Cornerstone, 1965.

Císař, Karel. "The Alphabet of Things." In *Běla Kolářová*. Edited by Alice Motard, 17-25. London: Raven Row, 2013.

Clark, T. J. *Image of the People: Gustave Courbet and the 1848 Revolution*. Berkeley: University of California Press, 1973.

——. *Farewell to an Idea: Episodes from a History of Modernism*. New Haven: Yale University Press, 1999.

Clark, Toby. *Art and Propaganda in the Twentieth Century: The Political Image in the Age of Mass Culture*. New York: Harry N. Abrams, 1997.

Cockcroft, Eva. "Abstract Expressionism, Weapon of the Cold War" (1974). In *Pollock and After: The Critical Debate*, 2nd ed. Edited by Francis Frascina, 147-154. London: Routledge, 2000.

Coffey, Mary K. *How Revolutionary Art Became Official Culture: Murals, Museums, and the Mexican State*. Durham, NC: Duke University Press, 2012.

Cooke, Lynne and Karen Kelly, eds. *Robert Smithson Spiral Jetty: True Fictions, False Realities*. Berkeley: University of California Press, 2005.

Cooper, Harry. "Rothko's Soup." In *Mark Rothko: The Decisive Decade, 1940-1950*. Edited by Bradford R. Collins, 120-129. New York: Skira Rizzoli, 2012.

Craven, David. *Art and Revolution in Latin America, 1910-1990*. New Haven: Yale University Press, 2002.

Crow, Thomas. "Saturday Disasters: Trace and Reference in Early Warhol." In *Reconstructing Modernism: Art in New York, Paris, Montreal 1945-1964*. Edited by Serge Guilbaut, 311-31. Cambridge, MA: MIT Press, 1990.

——. *The Rise of the Sixties: American and European Art in the Era of Dissent*. New Haven: Yale University Press, 2005.

Crowley, David. "In the Image of the Revolution." In *Cold War Modern: Design 1945-1970*. Edited by David Crowley and Jane Pavitt, 205-227. London: V&A Publishing, 2009.

——. "Pop Effects in Eastern Europe under Communist Rule." In *The World Goes Pop*. Edited by Jessica Morgan and Flavia Frigeri, 29-37. London: Tate, 2015.

Cullinan, Nicholas. "From Vietnam to Fiet-Nam: The Politics of Arte Povera." In *October* 124 (Spring 2008): 8-30.

Curley, John J. "Fuzzy Language: Joseph Kosuth's Titled (Art as Idea as Idea), 1967." In *Yale University Art Gallery Bulletin* (2005): 125-29.

——. "Gerhard Richter/Marcel Odenbach." In *Art of Two Germanys: Cold War Cultures*. Edited by Stephanie Barron and Sabine Eckmann, 354-55. New York: Harry N. Abrams, 2009.

——. *A Conspiracy of Images: Andy Warhol, Gerhard Richter, and the Art of the Cold War*. New Haven: Yale University Press, 2013.

——. "Readymade Disasters: The Art and Politics of Andy Warhol and Ai Weiwei." In *Andy Warhol/Ai Weiwei*. Edited by Max Delany and Eric Shiner, 141-154. Melbourne: National Gallery of Victoria, 2016.

Cushing, Lincoln. "Republic of Cuba, 1959-." In *Communist Posters*. Edited by Mary Ginsberg, 321-343. London: Reaktion Books, 2017.

Daftari, Fereshteh. "Redefining Modernism: Pluralist Art before the 1979 Revolution." In *Iran Modern*. Edited by Fereshteh Daftari and Layla S. Diba, 25-43. New York: Asia Society Museum, 2013.

De Salvo, Donna M. "Learning the Ropes: Some Notes About the Early Work of Andy Warhol." In *"Success is a Job in New York…": The Early Art and Business of Andy Warhol*. Edited by Donna M. De Salvo, 1-25. New York: Grey Art Gallery, 1989.

Debord, Guy. *The Society of the Spectacle*. Translated by Donald Nicholson-Smith. New York: Zone Books, 1994.

Degot, Ekaterina. "Socialist Realism or the Collectivization of Modernism." In *Aleksandr Deineka: An Avant-Garde for the Proletariat*. Edited by Alessandro De Magistris. Madrid: Fundacion Juan March, 2011.

Dengari, Ješa. "Inside or Outside 'Socialist Modernism'?: Radical Views on the Yugoslav Art Scene." In *Impossible Histories: Historical Avant-Gardes, Neo-Avant-Gardes, and Post-Avant-Gardes, 1918-1991*. Edited by Dubravka Djurić and Miško Šuvaković, 170-208. Cambridge, MA: MIT Press, 2003.

Derrida, Jacques. *Of Grammatology* (1967). Translated by Gayatri Chakravorty Spivak. Baltimore: Johns Hopkins University Press, 2016.

Diack, Heather. "Hand Over Fist: A Chronicle of Cold War Photography." *Visual Studies* 30: 2 (2015): 182-194.

Dobbs, Michael. *One Minute to Midnight: Kennedy, Khrushchev, and Castro on the Brink of Nuclear War*. New York: Alfred A. Knopf, 2008.

Dondero, George. "Modern Art Shackled to Communism" (1949). Reprinted in *Art in Theory 1900-1990: An Anthology of Changing Ideas*. Edited by Charles Harrison and Paul Wood, 656-658. Oxford: Blackwell, 1992.

Donovan, Molly. *Christo and Jeanne-Claude in the Vogel Collection*. New York: Harry N. Abrams, 2002.

Doss, Erica. "Introduction: Looking at *Life*: Rethinking America's Favorite Magazine 1936-1972." In *Looking at Life Magazine*. Edited by Erica Doss, 1-21. Washington: Smithsonian 2001.

Dossin, Catherine. *The Rise and Fall of American Art, 1940s-1980s: A Geopolitics of Western Art Worlds*. Farnham, England: Ashgate, 2015.

Drosos, Nikolas and Romy Golan. "Realism as an International Style." In *Postwar: Art between the Atlantic and Pacific, 1945-1965*. Edited by Okwui Enwezor, et. al., 442-447. Munich: Prestel, 2016.

Dubuffet, Jean. "Anticultural Positions" (1951). In *Theories and Documents of Contemporary Art*, 2nd ed. Edited by Kristine Stiles and Peter Selz, 216-220. Berkeley: University of California Press, 2012.

Dumett, Mari. "To Be an 'Exemplary' Machine: Tinguely's *Homage to New York*." In *Breathless Days, 1959-1960*. Edited by Serge Guilbaut and John O'Brian, 152-176. Durham, NC: Duke University Press, 2017.

Eckmann, Sabine. "Ruptures and Continuities: Modern German Art in between the Third Reich and the Cold War." In *Art of Two Germanys: Cold War Cultures*. Edited by Stephanie Barron and Sabine Eckmann, 48-63. New York: Harry N. Abrams, 2009.

Edwards, Paul N. *The Closed World: Computers and the Politics of Discourse in Cold War America*. Cambridge, MA: MIT Press, 1996.

Eisman, April A. "In Memoriam: Bernhard Heisig (1925-2011)." In *German Studies Association Newsletter* 36:2 (Winter 2011-12): 97-100.

——. "Painting the East German Experience: Neo Rauch in the Late 1990s." In *Oxford Art Journal* 35.2 (2012): 233-49.

——. "East German Art and the Permeability of the Berlin Wall." *German Studies Review* 38:3 (2015): 597-615.

Eklund, Douglas. *The Pictures Generation, 1974-1984*. New York: Metropolitan Museum of Art, 2009.

Elger, Dietmar. *Gerhard Richter: A Life in Painting*. Translated by Elizabeth M. Solaro. Chicago: University of Chicago Press, 2010.

Enwezor, Okwui. "The Short Century: Independence and Liberation Movements in Africa, 1945-1994: An Introduction." In *The Short Century: Independence and Liberation Movements in Africa, 1945-1994*. Edited by Okwui Enwezor, 10-16. Munich: Prestel, 2001.

——. *Archive Fever*. New York: International Center of Photography, 2008.

——. "1989." In *Defining Contemporary Art: 25 Years in 200 Pivotal Artworks*. 53-57. London: Phaidon, 2011.

Erofeev, Andrei, "Abstract Art: A Second Birth" and "Russian Pop Art." In *Breaking the Ice: Moscow Art 1960s-80s*. Edited by Andrei Erofeev, 28-30, 112-13. Moscow: Maier Publishing, 2012.

Faust, Wolfgang Max. "The Appearance of the Zeitgeist." In *Artforum* 21:5 (January 1983): 86-93.

Fehér, Dávid. "Where is the Light?: Transformations of Pop Art in Hungary." In *International Pop*. Edited by Darsie Alexander and Bartholomew Ryan, 131-48. Minneapolis: Walker Art Center, 2015.

Feldman, Hannah. *From a Nation Torn: Decolonizing and Representation in France, 1945-1962*. Durham, NC: Duke University Press, 2014.

Folgarait, Leonard. *Mural Painting and Social Revolution in Mexico, 1920-1940: Art of the New Order*. Berkeley: University of California Press, 1998.

Fontanella, Megan M. "A Vital Force: Abstract Art and Cultural Politics at Mid-Century." In *Art of Another Kind*. Edited by Tracey Bashkoff and Megan M. Fontanella, 49-57. New York: Guggenheim, 2012.

Foster, Hal. *Recodings: Art, Spectacle, Cultural Politics*. Seattle: Bay Press, 1985.

——. *The First Pop Age: Painting and Subjectivity in the Art of Hamilton, Lichtenstein, Warhol, Richter, and Ruscha*. Princeton: Princeton University Press, 2014.

——. *Bad New Days: Art, Criticism, Emergency*. London: Verso, 2015.

——. "1984b." In *Art since 1900: Modernism, Antimodernism, Postmodernism*, 3rd ed. Edited by Hal Foster, et. al., 698-701. New York: Thames and Hudson, 2016.

Fowkes, Maja and Reuben, eds. *Revolution I Love You: 1968 in Art, Politics and Philosophy*. Thessaloniki: CACT, 2008.

Fox, Claire F. *Making Art Panamerican: Cultural Policy and the Cold War*. Minneapolis: University of Minnesota Press, 2013.

Frascina, Francis. *Art, Politics and Dissent: Aspects of the Art Left in Sixties America*. Manchester: Manchester University Press, 1999.

Frei, Georg and Neil Printz, eds. *Andy Warhol Catalogue Raisonné Volume 1*. London: Phaidon, 2002.

——. *The Andy Warhol Catalogue Raisonné*, Volume 2. London: Phaidon, 2004.

Fried, Michael. *Art and Objecthood: Essays and Reviews*. Chicago: University of Chicago Press, 1998.

Frigeri, Flavia. "1966 in the World of Pop." In *The World Goes Pop*. Edited by Jessica Morgan and Flavia Frigeri, 43-55. London: Tate Publishing, 2015.

Fukuyama, Francis. "The End of History?." In *The National Interest* 16 (1989): 3-18.

Gaddis, John Lewis. *We Know Now: Rethinking Cold War History*. Oxford: Oxford University Press, 1997.

——. *The Cold War: A New History*. New York: Penguin Press, 2005.

Galimberti, Jacopo. "A Third-worldist Art?: Germano Celant's Invention of *Arte Povera*." In *Art History* 36:2 (April 2013): 418-441.

Gao Minglu. "Conceptual Art with Anticonceptual Attitude: Mainland China, Taiwan, and Hong Kong." In *Global Conceptualism: Points of Origin, 1950s-1980s*. Edited by Philomena Mariani, 127-139. New York: D.A.P., 1999.

——. *Total Modernity and the Avant-garde in Twentieth-Century Chinese Art*. Cambridge, MA: MIT Press, 2011.

Garcia, Manuel. "Josep Renau, An Artist's Theory and Practice." In *Josep Renau: Fotomontador*. Edited by Manuel Garcia, 248-257. Valencia: Institut Valencià d'Art Modern, 2006.

Gerovitch, Slava. *From Newspeak to Cyberspeak: A History of Soviet Cybernetics*. Cambridge, MA: MIT Press, 2002.

——. "The Cybernetic Scare and the Origins of the Internet." *Baltic Worlds* II:1 (2009): 32-38.

Gioni, Massimiliano. "Anri Sala, *Intervista*." In *Defining Contemporary Art: 25 Years in 200 Pivotal Artworks*. 228-29. London: Phaidon, 2011.

——. "Ostalgia." In *Ostalgia*. Edited by Jarrett Gregory, 24-30. New York: The New Museum of Contemporary Art, 2011.

Godfrey, Mark. "Thomas Demand." In *Artforum* 45:1 (2006): 368-69.

Gombrich, E. H. *Art and Illusion: A Study in the Psychology of Pictorial Perception*. New York: Bollingen Foundation, 1960.

Goldman, Shifra M. *Dimensions of the Americas: Art and Social Change in Latin America and the United States*. Chicago: University of Chicago Press, 1994.

Goldsmith, Kenneth, ed. *I'll Be Your Mirror: The Selected Andy Warhol Interviews*. New York: Carroll & Grad, 2004.

Goodrum Sarah. "A Socialist 'Family of Man': Rita Maahs' and Karl-Eduard von Schnitzler's Vom Glück des Menschen." *Studies in Contemporary History* 2 (2015): 370-382.

Goodyear, Anne Collins. "Expo '70 a Watershed: The Politics of American Art and Technology." In *Cold War Modern: Design 1945-1970*. Edited by David Crowley and Jane Pavitt, 198-203. London: V&A Publishing, 2009.

Govan, Michael. "Meditations on A=B: Romanticism and Representation in New German Painting." In *Refigured Painting: The German Image 1960-88*. Edited by Thomas Krens, et. al., 35-45. Munich: Prestel, 1989.

Grace, Claire. "Counter-Time: Group Material's Chronicle of US Intervention in Central and South America." In *Afterall* 26 (Spring 2011): 27-37.

Greenberg, Clement. *The Collected Essays and Criticism: Vol. 1, Perceptions and Judgments, 1939-1944*. Edited by John O'Brian. Chicago: University of Chicago Press, 1986.

——. *The Collected Essays and Criticism: Vol. 4, Modernism with a Vengeance*. Edited by John O'Brian. Chicago: University of Chicago Press, 1993.

Greenough, Sarah. "Disordering the Senses." In *Robert Frank's The Americans: Looking In*. Edited by Sarah Greenough, 120-39. Washington, D.C.: National Gallery, 2009.

Groys, Boris. "Moscow Romantic Conceptualism." In *Primary Documents: A Sourcebook for Eastern and Central European Art since the 1950s*. Edited by Laura Hoptman and Tomáš Pospiszyl, 162-74. New York: Museum of Modern Art, 2002.

——. *Art Power*. Cambridge, MA: MIT Press, 2008.

——. *History Becomes Form: Moscow Conceptualism*. Cambridge, MA: MIT Press, 2010.

——. *The Total Art of Stalinism: Avant-garde, Aesthetic Dictatorship, and Beyond* (1992). Trans. Charles Rougle. London: Verso, 2011.

Guilbaut, Serge. *How New York Stole the Idea of Modern Art: Abstract Expressionism, Freedom, and the Cold War*. Trans. Arthur Goldhammer. Chicago: University of Chicago Press, 1983.

——. "Brushes, Sticks, and Stains: Addressing Some Cultural Issues in New York and Paris after World War II." In *Be-Bomb: The Transatlantic War of Images and All That Jazz*. Edited by Ester Capdevila, 15-63. Barcelona: Museu d'Art Contemporani de Barcelona, 2007.

Gumbert, Heather. *Envisioning Socialism: Television and the Cold War in the German Democratic Republic*. Ann Arbor: University of Michigan Press, 2014.

Hales, Peter Bacon. "Imagining the Atomic Age: *Life* and the Atom." In *Looking at Life Magazine*. Edited by Erica Doss, 103-119. Washington: Smithsonian, 2001.

Harper, John Lamberton. *The Cold War*. Oxford: Oxford University Press, 2011.

Harris, Jonathan. "System, Totality, Representation: 'Utopian Globalist' Gestures of Dissent in Late Cold War Visual Arts and Culture." In *Cultural Politics* 10:2 (2014): 226-238.

Harrison, Charles. "On 'A Portrait of V. I. Lenin in the Style of Jackson Pollock.'" In *Artforum* 18:6 (February 1980): 34-37.

——. "Jackson Pollock." In *Varieties of Modernism*. Edited by Paul Wood, 117-145. New Haven and London: Yale University Press, 2004.

Harrison, Martin. *Transition: The London Art Scene in the Fifties*. London: Merrell, 2002.

Hauptman, William. "The Suppression of Art in the McCarthy Decade." In *Artforum* 12:2 (October 1973): 48-52.

Heibel, Yule F. *Reconstructing the Subject: Modernist Painting in Western Germany, 1945-1950*. Princeton: Princeton University Press, 1995.

Hillings, Valerie L. "Komar and Melamid's Dialogue with (Art) History." *Art Journal* 58:4 (1999): 48-61.

——. "Where is the Line Between Us?: Moscow and Western Conceptualism in the 1970s." In *Moscow Conceptualism in Context*. Edited by Alla Rosenfeld, 260-283. Munich: Prestel, 2011.

——. "Countdown to a New Beginning: The Multinational ZERO Network, 1950s-60s." In *ZERO: Countdown to Tomorrow, 1950s-60s*. Edited by Katherine Atkins and Jennifer Bantz, 16-43. New York: Guggenheim, 2014.

Hirai, Shoichi. "Gutai and Its Internationalism." In *Destroy the Picture: Painting the Void, 1949-1962*. Edited by Paul Schimmel, 204-211. New York: Skira Rizzoli, 2012.

Hoptman, Laura J. "Seeing is Believing." In *Beyond Belief: Contemporary Art from East Central Europe*. Edited by Laura J. Hoptman, 1-13. Chicago: Museum of Contemporary Art, 1995.

—— and Tomáš Pospiszyl. *Primary Documents: A Sourcebook for Eastern and Central European Art since the 1950s*. New York: Museum of Modern Art, 2002.

Hudson, Suzanne and Alexander Dubadze, eds. *Contemporary Art: 1989 to the Present*. Chichester: Wiley-Blackwell, 2013.

Hunter, Sam. *Jackson Pollock*. New York: Museum of Modern Art, 1956.

Huntington, Samuel. "The Clash of Civilizations?." In *Foreign Affairs* 72:3 (1993): 22-49.

Huyssen, Andreas. *After the Great Divide: Modernism, Mass Culture, Postmodernism*. Bloomington Indianapolis: Indiana University Press, 1986.

Hyman, James. *The Battle for Realism: Figurative Art in Britain during the Cold War, 1945-1960*. New Haven: Yale University Press, 2001.

Ikegami, Hiroko. "'Drink More?' 'No, Thanks!': The Spirit of Tokyo Pop." In *International Pop*. Edited by Darsie Alexander and Bartholomew Ryan, 165-80. Minneapolis: Walker Art Center, 2015.

Jackson, Matthew Jesse. *The Experimental Group: Ilya Kabakov, Moscow Conceptualism, Soviet Avant-Gardes*. Chicago: University of Chicago Press, 2010.

James, Sarah. *Common Ground: German Photographic Cultures across the Iron Curtain*. New Haven and London: Yale University Press, 2013.

Joselit, David. *American Art since 1945*. New York: Thames and Hudson, 2003.

——. *Feedback: Television Against Democracy*. Cambridge, MA: MIT Press, 2007.

Judd, Donald. *Donald Judd: Complete Writings 1959-1975: Gallery Reviews, Book Reviews, Articles, Letters to the Editor, Reports, Statements, Complaints*. Halifax: Press of the Nova Scotia College of Art and Design, 2005.

Judt, Tony. *Postwar: A History of Europe Since 1945*. New York: Penguin, 2005.

Kalinovsky, Artemy M. and Craig Daigle, eds. *The Routledge Handbook of the Cold War*. New York: Routledge, 2014.

Kee, Joan. *Contemporary Korean Art: Tansaekhwa and the Urgency of Method*. Minneapolis: University of Minnesota Press, 2013.

Kemp-Welch, Klara. *Antipolitics in Central European Art: Reticence as Dissidence under Post-Totalitarian Rule*. London: I. B. Taurus, 2014.

Kendall, Lee R. "Would the Real Pablo Picasso Please Stand Up?" *Pieces... Occasional and Various: A Journal of Art and Art Histories* (blog). May 30, 2010. Accessed February 15, 2016. http://piecesoav.blogspot.com/2010/06/outbreak-of-hostilities-in-korean.html

Kenney, Padraic. *A Carnival of Revolution: Central Europe 1989*. Princeton: Princeton University Press, 2002.

Kent, Sherman. "The Cuban Missile Crisis of 1962: Presenting the Photographic Evidence Abroad" (1972). In *Sherman Kent and the Board of National Estimates: Collected Essays*. Edited by Donald P. Steury, 189-209. Washington, D.C.: Center for the Study of Intelligence, 1994.

Khullar, Sonal. *Worldly Affiliations: Artistic Practice, National Identity, and Modernism in India, 1930-1990*. Berkeley: University of California Press, 2015.

Kiaer, Christina. "Lyrical Socialist Realism." *October* 147 (Winter 2014): 56-77.

Kim Youngna. *20th Century Korean Art*. London: Laurence King, 2005.

Klocker, Hubert. "Gesture and the Object: Liberation as Aktion: A European Component of Performative Art." In *Out of Actions: Between Performance and the Object, 1949-1979*. Edited by Russell Ferguson, 159-195. Trans. Nita Tandon. New York: Thames and Hudson, 1998.

Klotz, Heinrich. "Abstraction and Fiction." In *Refigured Painting: The German Image, 1960-88*. Edited by Thomas Krens, et. al., 47-50. Munich: Prestel, 1989.

Koepnik, Lutz. "Pause>Rewind>Play: Video Art in Cold War Germany." In *Art of Two Germanys: Cold War Cultures*. Edited by Stephanie Barron and Sabine Eckmann, 207-220. New York: Harry N. Abrams, 2009.

Kovach, Jodi. "Maria Sewcz/Helga Paris/Gundula Schulze Eldowy/ Barbara Metselaar-Berthold/Sibylle Bergemann." In *Art of Two Germanys: Cold War Cultures*. Edited by Stephanie Barron and Sabine Eckmann, 344-345. New York: Harry N. Abrams, 2009.

Kovalev, Andrei. "Yuri Zlotnikov." In *Breaking the Ice: Moscow Art 1960s-80s*. Edited by Andrei Erofeev, 54. Moscow: Maier Publishing, 2012.

Kozloff, Max. "American Painting during the Cold War" (1973). In *Pollock and After: The Critical Debate*, 2nd ed. Edited by Francis Frascina, 130-146. London: Routledge, 2000.

Krauss, Rosalind. "1948" and "1979a." In *Art since 1900: Modernism, Antimodernism, Postmodernism*, vol. 2. Edited by Hal Foster, et. al., 411-415, 672-675. 3rd ed. New York: Thames and Hudson, 2016.

Krens, Thomas. "German Painting: Paradox and Paradigm in Late Twentieth-Century Art." In *Refigured Painting: The German Image, 1960-88*. Edited by Thomas Krens, et. al., 12-21. Munich: Prestel, 1989.

Kreuger, Anders. "The Gely Korzhev Retrospective in Moscow: Why Him? Why Now?" *Afterall* 42 (Autumn/Winter 2016): 96-109.

Kruger, Barbara. "Interview with Anders Stephenson" (1987). In *Appropriation*. Edited by David Evans, 111-117. London: Whitechapel, 2009.

Kulik, Irina. "Francisco Infante" and "Mikhail Roginsky." In *Breaking the Ice: Moscow Art 1960s-80s*. Edited by Andrei Erofeev, 62, 116. Moscow: Maier Publishing, 2012

Kurlansky, Mark. *1968: The Year That Rocked the World*. New York: Random House, 2004.

Kwon, Heonik. *The Other Cold War*. New York: Columbia University Press, 2010.

Laïdi, Zaki. *A World without Meaning: The Crisis of Meaning in International Politics*. New York: Routledge, 1998.

Lang, Karen. "Expressionism and the Two Germanys." In *Art of Two Germanys: Cold War Cultures*. Edited by Stephanie Barron and Sabine Eckmann, 84-100. New York: Harry N. Abrams, 2009.

Langsner, J. "Adventurer in Poland." *Time*. April 6, 1959:79.

Lebel, Jean-Jacques. "Notes on Political Street Theatre, Paris: 1968." In *The Drama Review* 13:4 (1969): 111-118.

Lee, Pamela M. *Chronophobia: On Time in the Art of the 1960s*. Cambridge, MA: MIT Press, 2004.

——. *Forgetting the Art World*. Cambridge, MA: MIT Press, 2012.

—— and Fred Turner. "The Cybernetic Vision in Postwar Art." In *Postwar: Art between the Atlantic and Pacific, 1945-1965*. Edited by Okwui Enwezor, et. al., 696-703. Munich: Prestel, 2016.

Lee, Sohl. "Sites of Resistant Collectivity: Choi Byung-soo, Kim Dong-won, Labor News Collective, Park Jae-dong." In *Being Political Popular: South Korean Art at the Intersection of Popular Culture and Democracy, 1980-2010*. Edited by Sohl Lee, 18-39. Seoul: Hyunsil Publishing, 2012.

Leeb, Susanne. "Abstraction as International Language." In *Art of Two Germanys: Cold War Cultures*. Edited by Stephanie Barron and Sabine Eckmann, 119-133. New York: Harry N. Abrams, 2009.

Leja, Michael. *Reframing Abstract Expressionism: Subjectivity and Painting in the 1940s*. New Haven and London: Yale University Press, 1991.

Lenssen, Anneka. "Exchangeable Realism." In *Postwar: Art between the Atlantic and Pacific, 1945-1965*. Edited by Okwui Enwezor, et. al., 430-435. Munich: Prestel, 2016.

Lentini, Damian. "Cosmopolitan Contaminations: Artists, Objects, Media." In *Postwar: Art between the Atlantic and Pacific, 1945-1965*. Edited by Okwui Enwezor, et. al., 580-587. Munich: Prestel, 2016.

Leung, Godfre. "International Pop: A Visual Chronology." In *International Pop*. Edited by Darsie Alexander and Bartholomew Ryan, 11-74. Minneapolis: Walker Art Center, 2015.

Lippard, Lucy R., ed. *Six Years: The Dematerialization of the Art Object from 1966 to 1972*. Berkeley: University of California Press, 1973.

Lobel, Michael. *James Rosenquist: Pop Art, Politics and History in the 1960s*. Berkeley: University of California Press, 2010.

Lodder, Christina. *Russian Constructivism*. New Haven: Yale University Press, 1983.

Lubow, Arthur. "The New Leipzig School." In *New York Times Magazine*. January 8, 2006.

Lucie-Smith, Edward. *Latin American Art of the 20th Century*. New York: Thames and Hudson, 1993.

Luhn, Alec. "Stalin, Russia's New Hero." *New York Times*. March 11, 2016.

Lyotard, Jean-François. *The Postmodern Condition: A Report on Knowledge* (1979). Translated by Geoff Bennington and Brian Massumi. Minneapolis: University of Minnesota Press, 1984.

Mamiya, Christin J. *Pop Art and Consumer Culture: American Super Market*. Austin: University of Texas Press, 1992.

Mantecón, Álvaro Vázquez. "Visualizing 1968." In *The Age of Discrepancies: Art and Visual Culture in Mexico 1968-1997*. Edited by Olivier Debroise, 37-39. Mexico City: Universidad Nacional Autónoma de México, 2006.

Marcoci, Roxana. "Paper Moon." In *Thomas Demand*. Edited by Joanne Greenspun, 9-28. New York: Museum of Modern Art, 2005.

Marcuse, Herbert. *One Dimensional Man*. Boston: Beacon Press, 1964.

Massey, Anne. *The Independent Group: Modernism and Mass Culture in Britain, 1945-59*. Manchester: Manchester University Press, 1995.

Mathews, Jane De Hart. "Art and Politics in Cold War America." In *Pollock and After: The Critical Debate*, 2nd ed. Edited by Francis Frascina, 155-180. London: Routledge, 2000.

McCloskey, Barbara. "Dialectic at Stand Still: East German Socialist Realism of the Stalin Era." In *Art of Two Germanys: Cold War Cultures*. Edited by Stephanie Barron and Sabine Eckmann, 104-117. New York: Harry N. Abrams, 2009.

McEwen, Abigail. *Revolutionary Horizons: Art and Polemics in 1950s Cuba*. New Haven: Yale University Press, 2016.

McFadden, Sarah. "The World According to Solakov." In *Art in America*. 92:11 (December 2004): 114-118, 150.

McLuhan, Marshall. *Understanding Media: The Extensions of Man* (1964). Cambridge, MA: MIT Press, 2002.

McMahon, Robert J. *The Cold War: A Very Short Introduction*. Oxford: Oxford University Press, 2003.

McPherson, Alan. *Intimate Ties, Bitter Struggles: The United States and Latin America since 1945*. Washington, D.C.: Potomac Books, 2006.

Meecham, Pam. "Realism and Modernism." In *Varieties of Modernism*. Edited by Paul Wood, 75-115. New Haven and London: Yale University Press, 2004.

Mehring, Christine. "Painters, Germans, and Other Renegades." In *Neo Rauch: Renegaten*. Edited by Amy Baumann and Hanna Schouwink. New York: David Zwirner, 2005.

Mellor, David Alan. *The Sixties Art Scene in London*. London: Phaidon, 1993.

Menand, Louis. "Unpopular Front." In *The New Yorker*. 17 October 2005.

Mesch, Claudia. *Modern Art at the Berlin Wall: Demarcating Culture in the Cold War Germanys*. London: IB Tauris, 2009.

——. *Art and Politics: A Small History of Art for Social Change since 1945*. London: I.B. Taurus, 2013.

Meyer, James. *Minimalism: Art and Polemics in the Sixties*. New Haven: Yale University Press, 2001.

Miles, Malcolm. "Appropriating the Ex-Cold War." In *Art and Theory after Socialism*. Edited by Mel Jordan and Malcolm Miles, 55-66. Chicago: Intellect, 2008.

Molesworth, Helen. "This Will Have Been: Art, Love, & Politics in the 1980s." In *This Will Have Been: Art, Love, & Politics in the 1980s*. Edited by Helen Molesworth, 14-46. Chicago: Museum of Contemporary Art, 2012.

Morgan, Jessica. "Political Pop: An Introduction." In *The World Goes Pop*. Edited by Jessica Morgan and Flavia Frigeri, 15-27. London: Tate Publishing, 2015.

Morris, Lynda and Christoph Grunenberg. "What Picasso Stood For." In *Picasso: Peace and Freedom*. Edited by Lynda Morris and Christoph Grunenberg, 10-17. London: Tate Publishing, 2010.

Nelson, Adele. "Monumental and Ephemeral: The Early São Paulo Bienals." In *Constructive Spirit: Abstract Art in South and North America*. Edited by Mary Kate O'Hare, 127-42. Newark: Newark Museum, 2010.

Nemerov, Alexander. "Morris Louis: Court Painter of the Kennedy Era." In *Morris Louis Now: An American Master Revisited*. Edited by Kelly Morris and Lori Cavagnaro, 21-38. Atlanta: High Museum, 2006.

Nicholls, Mark and Anthony White. "Il gesto: Global Art and Italian Gesture Painting in the 1950s" in *Humanities Research* 19:2 (2013): 81-97.

Nye, David. *The American Technological Sublime*. Cambridge, MA: MIT Press, 1994.

Obrist, Hans Ulrich. "Alighiero Boetti, *Map*." In *Defining Contemporary Art: 25 Years in 200 Pivotal Artworks*. 58-59. London: Phaidon, 2011.

——and Dietmar Elger, eds. *Gerhard Richter: Writings 1961-2007*. New York: D.A.P., 2009.

Ohlin, Alix. "Andreas Gursky and the Contemporary Sublime." In *Art Journal* 61:4 (2002): 22-35.

Okeke-Agulu, Chika. "Mark-Making and El Anatsui's Reinvention of Sculpture." In *El Anatsui: When I Last Wrote to You about Africa*. Edited by Lisa M. Binder, 33-50. New York: Museum for African Art, 2010.

——. *Postcolonial Modernism: Art and Decolonization in Twentieth-Century Nigeria*. Durham, NC: Duke University Press, 2015.

Oles, James. *Art and Architecture in Mexico*. New York: Thames and Hudson, 2013.

Orton, Fred. *Figuring Jasper Johns*. London: Reaktion, 1994.

Painter, David S. *The Cold War: An International History*. London: Routledge, 1999.

Pavitt, Jane. "The Bomb in the Brain." In *Cold War Modern: Design 1945-1970*. Edited by David Crowley and Jane Pavitt, 101-21. London: V&A Publishing, 2009.

—— and David Crowley. "The Hi-Tech Cold War." In *Cold War Modern: Design 1945-1970*. Edited by David Crowley and Jane Pavitt, 163-91. London: V&A Publishing, 2009.

Pérez-Barreiro, Gabriel, ed. *The Geometry of Hope: Latin American Abstract Art from the Patricia Phelps de Cisneros Collection*. Austin: Blanton Museum of Art, 2007.

Peters, Ursula and Roland Prügel. "The Legacy of Critical Realism in East and West." In *Art of Two Germanys: Cold War Cultures*. Edited by Stephanie Barron and Sabine Eckmann, 64-83. New York: Harry N. Abrams, 2009.

Petersen, Stephen. *Space Age Aesthetics: Lucio Fontana, Yves Klein, and the Postwar European Avant-Garde*. University Park: Penn State Press, 2009.

Philippi, Desa. "Matter of Words: Translations in Eastern European Conceptualism." In *Rewriting Conceptual Art*. Edited by Jon Bird and Michael Newman, 152-68. London: Reaktion, 1999.

Phillips, Christopher. "The Judgment Seat of Photography" (1983). In *The Contest of Meaning: Critical Histories of Photography*. Edited by Richard Bolton, 14-46. Cambridge, MA: MIT Press, 1989.

Pidd, Helen. "Germans Piece Together Millions of Lives Spied on by Stasi." In *The Guardian*. March 13, 2011.

Piotrowski, Piotr. *In the Shadow of Yalta: Art and the Avant-garde in Eastern Europe, 1945-1989*. London: Reaktion, 2009.

Plamper, Jan. *The Stalin Cult: a Study in the Alchemy of Power*. New Haven and London: Yale University Press, 2012.

Poggi, Christine. "Vito Acconci's Bad Dream of Domesticity." In *Not at Home: The Suppression of Domesticity in Modern Art and Architecture*. Edited by Christopher Reed, 237-252. London: Thames and Hudson, 1996.

Potts, Alex. *Experiments in Modern Realism: World Making, Politics and the Everyday in Postwar European and American Art*. New Haven: Yale University Press, 2013.

Proctor, Jacob. "George Maciunas's Politics of Aesthetics." In *Fluxus and the Essential Questions of Life*. Edited by Jacquelynn Baas, 22-33. Hanover, NH: Hood Museum of Art, 2011.

Ramírez, Mari Carmen. "Tactics for Thriving on Adversity: Conceptualism in Latin America, 1960-1980." In *Global Conceptualism: Points of Origin, 1950s-1980s*, Edited by Philomena Mariani, 53-71. New York: D.A.P., 1999.

——. "The Necessity of Concreteness: A View from the (Global?) South." In *Postwar: Art between the Atlantic and Pacific, 1945-1965*. Edited by Okwui Enwezor, et. al., 490-495. Munich: Prestel, 2016.

Raskin, David. *Donald Judd*. New Haven: Yale University Press, 2010.

Ravenal, John B. "Jane & Louise Wilson, *Stasi City*." In *Outer & Inner Space: Pipliotti Rise, Shirin Neshat, Jane & Louise Wilson and the History of Video Art*. Edited by Rosalie West, 76-83. Richmond, VA: Virginia Museum of Fine Arts, 2002.

Richard, Nelly. "Art in Chile since 1973." In *Third Text* 1:2 (Winter 1987): 13-24.

Robecchi, Michele. "Living History." In *Art in America*. 100:9 (October 2012): 123-27.

Robinson, Julia. "Maciunas as Producer: Performative Design in the Art of the 1960s." In *Grey Room* 33 (Fall 2008): 56-83.

Rosen, Margit. "New Tendencies." In *Facing the Future: Art in Europe, 1945-1968*. Edited by Eckhart Gillen and Peter Weibel, 360-377. Tielt: Lannoo Publishers, 2016.

Rosenberg, Harold. *The Tradition of the New*. New York: Horizon Press, 1959.

Rosenblum, Robert. "Thoughts on the Origins of 'Zeitgeist'." In *Zeitgeist*. Edited by Christos M. Joachimides and Norman Rosenthal, 11-14. New York: George Braziller, Inc., 1983.

Rosenfeld, Alla. "Stretching the Limits: On Photo-Related Work in the Norton and Nancy Dodge Collection." In *Beyond Memory: Soviet Nonconformist Photography and Photo-Related Works of Art*. Edited by Diane Neumaier, 131-175. New Brunswick: Jane Voorhees Zimmerli Art Museum, 2004.

—— and Norton T. Dodge, eds. *Nonconformist Art: The Soviet Experience, 1956-1986*. New York: Thames and Hudson, 1995.

Rosenthal, Mark. *Joseph Beuys: Actions, Vitrines, Environments*. Houston: Menil Collection, 2004.

Rothkopf, Scott. "No Limits." In *Jeff Koons*. Edited by Scott Rothkopf, 15-35. New York: Whitney Museum of American Art, 2014.

Sandeen, Eric J. *Picturing an Exhibition: The Family of Man and 1950s America*. Albuquerque: University of New Mexico Press, 1995.

——. "The International Reception of The Family of Man." In *History of Photography* 29:4 (2005): 344-355.

Schapiro, Meyer. "The Liberating Quality of Avant-Garde Art" (1957). Reprinted in *Reading Abstract Expressionism: Context and Critique*. Edited by Ellen G. Landau, 215-220. New Haven and London: Yale University Press, 2005.

———. "The Social Bases of Art" (1936). Reprinted in *Art in Theory 1900-1990: An Anthology of Changing Ideas*. Edited by Charles Harrison and Paul Wood, 506-510. Oxford: Blackwell, 1992.

Schildt, Axel and Detlef Siegfried. "Youth, Consumption, and Politics in the Age of Radical Change." In *Between Marx and Coca-Cola: Youth Cultures in Changing European Societies, 1960-1980*. Edited by Alex Schildt and Detlef Siegfried, 1-35. New York: Berghahn Books, 2006.

Schimmel, Paul. "Painting the Void." In *Destroy the Picture: Painting the Void, 1949-1962*. Edited by Paul Schimmel, 188-203. New York: Skira Rizzoli, 2012.

Schneede, Uwe. "Gerhard Richter's Images of an Era." In *Gerhard Richter: Images of an Era*. Edited by Ortrud Westheider and Michael Philipp, 12-27. Munich: Hirmer Verlag, 2011.

Sekula, Allan. "The Traffic in Photographs." *Art Journal* 41:1 (Spring 1981): 15-25.

Selz, Peter. *New Images of Man*. New York: Museum of Modern Art, 1959.

———. *15 Polish Painters*. New York: Museum of Modern Art, 1961.

———. *Mark Rothko*. New York: Museum of Modern Art, 1961.

Shannon, Joshua. *The Recording Machine: Art and Fact during the Cold War*. New Haven: Yale University Press, 2017.

Sharp, Jane. "The Personal Visions and Public Spaces of the Movement Group (Dvizhenie)." In *Cold War Modern: Design 1945-1970*. Edited by David Crowley and Jane Pavitt, 234-41. London: V&A Publishing, 2009.

Sims, Lowery Stokes. *Wifredo Lam and the International Avant-Garde*. Austin: University of Texas Press, 2002.

Slifkin, Robert. "Donald Judd's Credibility Gap." In *American Art* 25:2 (2011): 56-75.

Smith, Terry. *Contemporary Art: World Currents*. New York: Pearson, 2011.

Sorace, Christian. "China's Last Communist: Ai Weiwei." In *Critical Inquiry* 40:2 (Winter 2014): 396-419.

Stalin, J. V. "Marxism and the Problem of Linguistics" (1950). In Stalin Reference Archive, marxists.org.

Stiles, Kristine. "Uncorrupted Joy: International Art Actions." In *Out of Actions: Between Performance and the Object, 1949-1979*. Edited by Russell Ferguson, 227-329. New York : Thames and Hudson, 1998.

———. "Inside/Outside: Balancing Between a Dusthole and Eternity." In *Body and the East: From the 1960s to the Present*. Edited by Zdenka Badovinac and Mika Briski, 19-30. Cambridge, MA: MIT Press, 1999.

Stimson, Blake. "Andy Warhol's Red Beard." *The Art Bulletin*. 83:3 (September 2001): 527-47.

Stonard, John-Paul. "Pop in the Age of Boom: Richard Hamilton's 'Just what is it that makes today's homes so different, so appealing?' *The Burlington Magazine* 149:1254 (September 2007): 607-20.

Storr, Robert. *Gerhard Richter: Forty Years of Paintings*. New York: Museum of Modern Art, 2002.

———. "Across the Great Divide." In *Moscow Conceptualism in Context*. Edited by Alla Rosenfeld, 242-259. Munich: Prestel, 2011.

Sung Wan-kyung. "From the Local Context: Conceptual Art in South Korea." In *Global Conceptualism: Points of Origin, 1950s-1980s*. Edited by Philomena Mariani, 119-125. New York: D.A.P., 1999.

Suri, Jeremi. *Power and Protest: Global Revolution and the Rise of Détente*. Cambridge, MA: Harvard University Press, 2003.

———. "The Rise and Fall of an International Counterculture, 1960-1975." In *The American Historical Review* 114: 1 (Feb. 2009): 45-68.

Taussig, Michael. "Scale is Everything." In *Parkett* 93 (2013): 178-183.

Tawadros, Gilane. "Egypt at the Venice Biennale: 1967 and the Year That Changed Everything." In *Imperfect Chronology: Arab Art from the Modern to Contemporary*. Edited by Omar Kholeif and Candy Stoobs, 63-68. London: Whitechapel, 2015.

Thompson, Joseph. "Blasphemy on Our Side: Fates of the Figure in Postwar German Painting." In *Refigured Painting: The German Image, 1960-88*. Edited by Thomas Krens, et. al., 23-33. Munich: Prestel, 1989.

Tiampo, Ming. *Gutai: Decentering Modernism*. Chicago: University of Chicago Press, 2010.

Tillberg, Margareta. "You are Leaving the American Sector: The Russian Group Dvizhenie, 1962-1978." In *Place Studies in Art, Media, Science and Technology*. Edited by Andreas Broeckmann and Gunalan Nadarajan, 147-65. Weimar: VDG-Weimar, 2008.

Tisdall, Caroline. *Joseph Beuys*. New York: Thames and Hudson, 1979.

Tumbas, Jasmina. "Tót and the Tótal Joy of Nothing." In *Sztuka I Dokumentacja* 10 (2014): 31-36.

Tupitsyn, Margarita. "About Early Soviet Conceptualism." In *Global Conceptualism: Points of Origin, 1950s-1980s*. Edited by Philomena Mariani, 99-107. New York: D.A.P., 1999.

Tupitsyn, Victor. *The Museological Unconscious: Communal (Post)Modernism in Russia*. Cambridge, MA: MIT Press, 2009.

Wallach, Amei. *Ilya Kabakov: The Man Who Never Threw Anything Away*. New York: Harry N. Abrams, 1996.

Warhol, Andy. *The Philosophy of Andy Warhol (From A to B and Back Again)*. New York: Harcourt Brace & Company, 1975.

Weibegen, Lara. "Performance as 'Ethical Memento': Art and Self-Sacrifice in Communist Czechoslovakia." In *Third Text* 23:1 (January 2009): 55-64.

Weiner, Jon. *How We Forgot the Cold War: A Historical Journey Across America*. Berkeley: University of California Press, 2012.

Weiner, Norman. *The Human Use of Human Being: Cybernetics and Society*. Cambridge, MA: Riverside Press, 1950.

Weiss, Rachel. "Performing Revolution: From *Volumen Uno* to *Memoria de la postguerra*." In *Adiós Utopia: Art in Cuba since 1950*. Edited by Ana Clara Sliva and Eugenio Valdés Figueroa, 44-59. Miami: CIFO, 2017.

Westad, Odd Arne. *Reviewing the Cold War: Approaches, Interpretations, Theory*. London: Frank Cass, 2000.

Whiting, Cécile. *A Taste for Pop: Pop Art, Gender, and Consumer Culture*. Cambridge: Cambridge University Press, 1997.

Wilson, Sarah. "From Monuments to Fast Cars: Aspects of Cold War Art, 1946-1957." In *Cold War Modern: Design 1945-1970*. Edited by David Crowley and Jane Pavitt, 26-32. London: V&A Publishing, 2009.

———. "Children of Marx and Coca-Cola: Pop in a Divided World." In *The World Goes Pop*. Edited by Jessica Morgan and Flavia Frigeri, 113-119. London: Tate Publishing, 2015.

Wölfflin, Heinrich. *Principles of Art History: The Problem of the Development of Style in Later Art* (1932). Translated by M. D. Hottinger. New York: Dover, 1950.

Wu Hung. *Contemporary Chinese Art: A History, 1970s-2000s*. New York: Thames and Hudson, 2014.

Picture Credits

11, 6 Private Collection/photo Christie's Images/Bridgeman Images © Estate of the Artist; **12** Dino A Brugioni Collection, The National Security Archive, Washington DC; **20** The Metropolitan Museum of Art, New York, George A Hearn Fund, 1957. Photo Art Resource/Scala, Florence © the Pollock-Krasner Foundation, ARS, NY and DACS, London; **23** Private Collection/Archives Charmet/Bridgeman Images; **24** A Burkatovski/Fine Art Images/Superstock © 1998 Kate Rothko Prizel & Christopher Rothko, ARS, NY and DACS, London; **27** Brooklyn Museum of Art, New York/Bridgeman Images © 1998 Kate Rothko Prizel & Christopher Rothko, ARS, NY and DACS, London; **30** Museum of Modern Art, New York, bequest of Mrs Mark Rothko through The Mark Rothko Foundation. Digital image, The Museum of Modern Art, New York/Scala, Florence © 1998 Kate Rothko Prizel & Christopher Rothko, ARS, NY and DACS, London; **32, 18** The State Tretyakov Gallery, Moscow; **34** Alfred H Barr, Jr Papers, 13.I.E. The Museum of Modern Art Archives. Digital image, The Museum of Modern Art, New York/Scala, Florence © Rodchenko & Stepanova Archives, DACS, RAO; **36** The State Tretyakov Gallery, Moscow; **42** Dr Werner Jerke, Recklinghausen, Germany. Photo Paul Schmitz, Germany. Artist © Maria Kantor & Dorota Krakowska; **43** Courtesy of Pan American Art Projects, Miami. Artist © Fernando Fors; **47** Moderna Museet, Stockholm. Photo Albin Dahlstrom © the Pollock-Krasner Foundation, ARS, NY and DACS, London; **48** Reproduced from *Socialist Realist Painting* by Matthew Cullerne Bown, Yale University Press, New Haven, 1998; **49** Springville Museum of Art, Springville, UT; **52** Harvard Art Museums/Busch-Reisinger Museum, Association Fund. Photo Imaging Department © President and Fellows of Harvard College © ARS, NY and DACS, London; **53** Akg-images © DACS, London; **55** Hyogo Prefectural Museum of Art. Artist © Hisao Shiraga; **57** National Art Museum of China; **58** Courtesy Archivi Guttuso © DACS; **62–63** 4X5 Collection/SuperStock © Succession Picasso/DACS, London; **66** Odyssey-Images/Alamy Stock Photo © DACS; **69, 60** Courtesy and © Archivio Baj, Vergiate, Italy; **70** Allen Memorial Art Museum, Oberlin College, Ohio. Gift of Joseph and Enid Bissett/Bridgeman Images © ADAGP, Paris and DACS, London; **71** Keystone/Hulton Archive/Getty Images; **73** The Solomon R Guggenheim Foundation/Art Resource, NY/Scala, Florence © Trustees of the Paolozzi Foundation. Licensed by DACS; **74** The Solomon R Guggenheim Foundation/Art Resource, NY/Scala, Florence © Maryland College Institute of Art (MICA), Rights Administered by ARS, NY and DACS, London. All Rights Reserved; **77** Courtesy Tsukanov Art Collection; **78** Zimmerli Art Museum at Rutgers University, Norton and Nancy Dodge Collection of Nonconformist Art from the Soviet Union. Photo Peter Jacobs © Francisco Infante, courtesy Krokin Gallery, Moscow; **82** Museum of Contemporary Art, Zagreb © Estate of Ivan Picelj; **84** Museum of Modern Art, New York. Gift of Patricia Phelps de Cisneros through the Latin American and Caribbean Fund in memory of Rafael Romero © Estate of the Artist; **85** courtesy and © O Mundo de Lygia Clark Cultural Association; **88** Photo courtesy of Barjeel Art Foundation, Sharjah, UAE © Estate of Effat Nagi; **91** Photo by David Gahr courtesy and © Estate of David Gahr © Jean Tinguely, ADAGP, Paris and DACS, London; **95** MMK Museum für Moderne Kunst Frankfurt am Main. Photo Axel Schneider, Frankfurt am Main © 2017 The Andy Warhol Foundation for the Visual Arts, Inc/Licensed by DACS, London; **96, 92** Yale Center for British Art. Exhibition catalogue © Whitechapel Art Gallery Archives and © R Hamilton. All Rights Reserved, DACS; **98** Digital image, The Museum of Modern Art, New York/Scala, Florence; **100** © The Estate of Garry Winogrand, courtesy Fraenkel Gallery, San Francisco; **101** Evelyn Richter Archiv der Ostdeutschen Sparkassenstiftung im Museum der bildenden Künste, Leipzig; **103** Reproduced from *Socialist Realist Painting* by Matthew Cullerne Bown, Yale University Press, New Haven, 1998; **104** Zimmerli Art Museum at Rutgers University, Norton and Nancy Dodge Collection of Nonconformist Art from the Soviet Union. Photo Peter Jacobs © Mikhail Roginsky Foundation; **105** Museum of Modern Art, New York, gift of Philip Johnson in honor of Alfred H Barr, Jr. Digital image, Museum of Modern Art, NY/Scala, Florence © Jasper Johns/VAGA/New York/DACS, London; **109** The Andy Warhol Museum, Pittsburgh. Founding Collection, Dia Center for the Arts © 2017 The Andy Warhol Foundation for the Visual Arts, Inc/Licensed by DACS, London; **113** Photo © Rheinisches Bildarchiv Köln © DACS; **116** © Gerhard Richter 2018 (0004); **120** Stichting Kröller-Müller Museum, Otterlo. Formerly in the Visser collection © 1961 Christo; **122** Museo Nacional de Bellas Artes, Havana. Artist © Fernando Fors; **125** Museum of Modern Art, New York.

Purchase Gift of Mr and Mrs Alex L Hillman and Lillie P Bliss Bequest (both by exchange). Digital image, The Museum of Modern Art, New York/Scala, Florence © James Rosenquist/DACS, London/VAGA, New York; **126** © Martha Rosler; courtesy of the artist and Mitchell-Innes & Nash, NY; **128** Photo © Rheinisches Bildarchiv Köln © Kienholz. Courtesy of L A Louver, Venice, CA; **131** Courtesy and © Gyorgy Kemeny; **132** Collection Jasper Johns; **133** Courtesy Galerie Lelong & Co, New York © Cildo Meireles; **136** Photographic Archives, Museo entro de Arte Reina Sofia © DACS; **139** © 2018 Sharon Avery-Fahlström; **141** Courtesy Froehlich Collection, Stuttgart, photo Uwe H Seyl, Stuttgart © Judd Foundation/ARS, NY and DACS, London; **142** courtesy Lévy Gorvy, NY. Photo Tom Powel Imaging © The artist courtesy Archivio Anselmo; **145** Museum of Modern Art, NY. Gift of Frederic Clay Bartlett (by exchange). Digital image, The Museum of Modern Art, New York/Scala, Florence © DACS; **147** Photo © Tate, London 2017 © Carl Andre/VAGA, New York/DACS, London; **150** IISG, International Institute of Social History, Amsterdam; **152** Photo © Rheinisches Bildarchiv Köln © ADAGP, Paris and DACS, London; **155** © Bruno Barbey/Magnum Photos, **156, 134** Harmut Rekort/dpa picture alliance/Alamy Stock Photo © Estate of Nam June Paik; **158** Courtesy and © of the artist; **163** Courtesy Electronic Arts Intermix (EAI), New York © Estate of Nam June Paik; **165** Museum Nacional de Bellas Artes, Havana; **168** Photo Jan van Raay; **175** The Art Institute of Chicago. Mr and Mrs Frank G Logan Purchase Prize and Wilson L Mead funds, 1974.230. Photo Art Resource, NY/Scala, Florence © 2017 The Andy Warhol Foundation for the Visual Arts, Inc/Licensed by DACS, London; **181** Yale University Art Gallery. Janet and Simeon Braguin Fund © Joseph Kosuth, ARS, NY and DACS, London; **182–83** The State Tretyakov Gallery, Moscow © DACS; **184–85** Zimmerli Art Museum at Rutgers University, Norton and Nancy Dodge Collection of Nonconformist Art from the Soviet Union. Photo Jack Abraham © courtesy the artist and Ronald Feldman Gallery, New York; **188, 172** Courtesy © Jan Mlčoch; **190** Courtesy Grieder Contemporary. Photo Gion Pfande © ARS, NY and DACS, London; **195** © The Estate of Jörg Immendorff, courtesy Galerie Michael Werner Märkisch; Wilmersdorf, Köln & New York. Photo © Rheinisches Bildarchiv Köln; **197** Courtesy of the artist and acb Gallery, Budapest © DACS; **201** Courtesy Museum for African Art, New York, from El Anatsui: When I Last Wrote to you About Africa, 2010, exhibition catalogue. Photo Kelechi Amadi-Obi © El Anatsui, courtesy of October Gallery, London; **203** Courtesy Museum for African Art, New York, from Ibrahim El-Salahi: A Visionary Modernist, 2012, exhibition catalogue. Photo Jerry L Thompson © Ibrahim El-Salahi. All rights reserved, DACS; **205** Photographic Archives, Museo entro de Arte Reina Sofia © Elias Adasme; **208** Museum of Contemporary Art San Diego © Chris Burden, licensed by The Chris Burden Estate and DACS; **212** Museum of Contemporary Art San Diego. Museum purchase © ARS, NY and DACS, London; **214** Sibylle Bergemann/OSTKREUZ; **216** Fondation Beyeler, Riehen-Basel, Beyeler Collection. Photo Robert Bayer © Georg Baselitz 2018; **220** Courtesy of Kunstsammlungen der Diözese Würzburg. Photo Thomas Obermeier © DACS; **223** Zimmerli Art Museum at Rutgers University, Norton and Nancy Dodge Collection of Nonconformist Art from the Soviet Union. Photo Peter Jacobs; **224** National Art Museum of China; **226** © Art & Language. Courtesy Lisson Gallery. Photo Ken Adlard; **229** Courtesy the artist and Ronald Feldman Gallery, New York. Photo D James Dee; **231** © Flavio Garciandía, Courtesy Mai 36 Galerie, Zurich; **232** © Barbara Kruger. Courtesy Mary Boone Gallery, New York; **233, 210** Zimmerli Art Museum at Rutgers University, Norton and Nancy Dodge Collection of Nonconformist Art from the Soviet Union. Photo Peter Jacobs © ADAGP, Paris and DACS, London; **234** Courtesy Tsukanov Art Collection © ARS, NY and DACS, London; **236** Courtesy of Group Material, New York and Four Corners Books, London. Photo Dorothy Zeidman; **239** Centre Pompidou, MNAM-CCI, Dist. RMN-Grand Palais/Philippe Migeat © DACS; **241** Courtesy of Wu Shanzhuan Archive at Asia Art Archive; **247** Patrick Robert/Sygma via Getty Images; **249** Photo Tomasz Sikorski; **254** © Jeff Koons. Château de Versailles, Jeff Koons Versailles, October 9, 2008 - April 1, 2009. Photo Laurent Lecat; **256** © Andreas Gursky. Courtesy Sprüth Magers Berlin & London/ DACS; **259** Courtesy Sprüth Magers © Thomas Demand, VG Bild Kunst, Bonn/DACS, London; **262** Courtesy Gallery EIGEN + ART Leipzig/Berlin, David Zwirner New York/London/Hong Kong. Photo Uwe Walter, Berlin © Neo Rauch courtesy Galerie EIGEN+ART Leipzig/Berlin/DACS; **264, 252** Photo courtesy Sotheby's, Inc © 2018 © DACS; **265** © Ai WeiWei. Photo courtesy Ai WeiWei Studio; **268** Whitechapel Gallery Archive © ADGP, Paris and DACS, London; **270** Museum of Modern Art, New York. Scott Burton Memorial Fund. Digital image, the Museum of Modern Art/Scala, Florence © DACS; **273** Courtesy of the artist and Marian Goodman Gallery.

Index

Index

283